Heatwave

Heatwave

THE SUMMER OF 1976
BRITAIN AT BOILING POINT

JOHN L. WILLIAMS

monoray

First published in Great Britain in 2025 by monoray, an imprint of
Octopus Publishing Group Ltd
Carmelite House
50 Victoria Embankment
London EC4Y 0DZ
www.octopusbooks.co.uk

An Hachette UK Company
www.hachette.co.uk

The authorized representative in the EEA is Hachette Ireland,
8 Castlecourt Centre, Dublin 15, D15 XTP3, Ireland
email: info@hbgi.ie

Distributed in the US by Hachette Book Group
1290 Avenue of the Americas, 4th and 5th Floors
New York, NY 10104

Distributed in Canada by Canadian Manda Group
664 Annette St., Toronto, Ontario, Canada M6S 2C8

ISBN: 978-1-80096-171-5
eISBN: 978-1-80096-174-6

A CIP catalogue record for this book is available from the British Library.

Typeset in 11.5/17pt Sabon LT Pro by Jouve (UK), Milton Keynes

Printed and bound in Great Britain

10 9 8 7 6 5 4 3 2 1

This FSC® label means that materials used for
the product have been responsibly sourced.

MIX
Paper | Supporting
responsible forestry
FSC
www.fsc.org FSC® C104740

This monoray book was crafted and published by Jake Lingwood, Alex Stetter, John English,
Giulia Hetherington, Mel Four and Sarah Parry.

For Nick Sanderson (1961–2008)
best friend of that summer, much missed.

Author's note

A handful of names – mostly those of petty
criminals mentioned along the way – have been changed.

CONTENTS

CONTENTS

Scan the QR code for a link to a playlist featuring a whole range of the sounds of the summer of 1976.

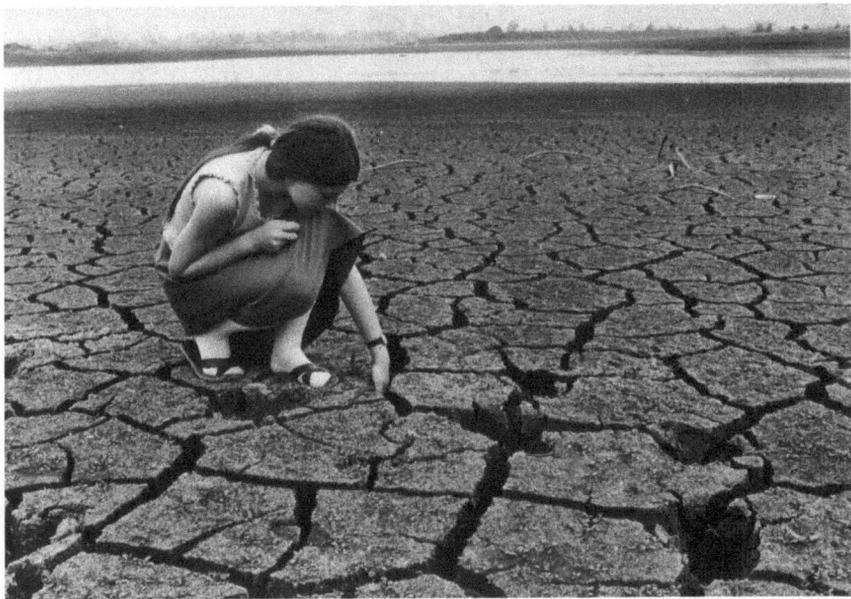

As the summer wore on, we got to see what lay at the bottom of our reservoirs.

INTRODUCTION

Summertime in Britain. Asian people are fighting back against a wave of racist violence, the Israelis are biting back after a Palestinian terrorist attack, the Labour government says we've run out of money, the trade unions aren't happy, a female gymnast is the star of the Olympics, the right wing media's in a lather about gay rights, America's gearing up for an election, soul boys are gathering down in Margate, there's an ultra-right British politician getting far too much coverage for ranting on about immigration, the West Indies are playing England at cricket, there's trouble at the Notting Hill Carnival – and down the pub someone's having a party and they're playing Abba's 'Dancing Queen'.

Welcome to 2024.

But welcome, also to 1976.

The summer of 1976 holds a special place in the popular imagination for one particular reason: It was long and hot, famously so, all the way from the beginning of May to the very end of August – and it followed on from a dry winter and a parched spring. Even before the temperature started to climb, there were warnings of drought. It was the driest Britain had been since records began, 250 years earlier. By August, this green and pleasant land was uniformly brown and arid. London had just ninety days' water supply left.

Water was rationed. In many places you could get it only from

municipal standpipes. The popular public information message was, 'Save Water – Bath with a Friend.' The government of the day even suggested that the British change the habits of many lifetimes and take a shower instead.

From late June into July the temperature climbed up above 30 degrees Celsius and stayed there. Trains caught fire, roads melted, cars overheated and kids engraved their names in the molten tarmac. Forest fires raged, without the water to put them out. Office workers sweltered in their compulsory suits and ties in this pre-air-conditioning time. On one day at Wimbledon four hundred spectators had to be treated for the effects of the heat. Teenagers taking their exams were fainting en masse. This was no ordinary summer – it was *the long hot summer.*

You might assume that hot summers in Britain would all be the same, like happy families: ice creams and sunburn; beaches and discos; everyone lying on towels in the garden and towels in the park. The rare luxury of waking up in the morning and just knowing it's going to be another hot one. These are times out of mind, such summers – times to be savoured, filled with the joy of wishing every day to be just like the last one.

When I remember the summer of 1976, the summer I turned fifteen, the first image that comes to mind is always the same one. It must be early in the summer, because the grass is still quite green. I'm walking through a small park in Clifton, Bristol, near the University Students' Union, where I see a group of young hippies, boys and girls, sitting on rugs laid out on the grass, drinks and snacks around them. The girls are all tanned and lovely in their bikinis, the boys slim and long-haired and bare-chested. A few of them are throwing a frisbee around. They seemed to be living the best of all possible lives – it's a snapshot of a perfect time.

Over the years that followed, this summer would be the one that all others would be compared to and found wanting. Mostly it would be idealised – so sunny, so lovely – but the novelists knew better. From Ian McEwan's incestuous nightmare, *The Cement Garden*, published just two years later, via *A Fatal Inversion*, Barbara Vine's psychological thriller set among lotus-eating students, to Maggie O'Farrell's tale of dysfunctional family life, *Instructions for a Heatwave* – they were all too aware that beneath the blanket of heat, something was stirring in 1976.

In fact it didn't take long to become clear that there was another side to that summer. Less than a year later, my favourite new album would have a picture from August 1976 on the cover – but it's not a cheerful snapshot of hippies in the park enjoying the sunshine. It's a photo of a riot in Notting Hill, London – Black people fighting with the police. The record itself is by The Clash, one of the new bands that had started life during the summer and were now blowing away all the hippie music those students listened to.

How could there have been riots and rebellion during those months of beachballs, jelly sandals, ladybirds, Fabs and Zooms and Orange Maid ice lollies? It's a puzzle that has increasingly preoccupied me across the years. That summer had always felt like a watershed in my own life, the time during which I sensed the beginnings of this new youth culture that could be my own and not a hand-me-down – the one that we were starting to call punk rock. Was it also a watershed in the life of the country, more generally? This book is my attempt to answer that deceptively simple question – and find out just what happened in the summer of '76.

There's one obvious answer: the heat itself caused widespread change – because sustained hot weather is no outright blessing, not unless you're

a child on school holidays. After a while, heat plays with people's temperaments, especially when they're unaccustomed to it. Tempers fray quickly – then it turns them up to boiling point. Indoors it leads to spikes in domestic violence. Outdoors, where people congregate, the potential for riot is always in the air. It just needs the right conditions to set it alight.

Britain in the summer of 1976 was all dry kindling, just waiting for a match. There were any number of people with reason to feel ready for rebellion: Black people, Asian people, gay people, women. All of them were used to being discriminated against in ways great and small. In the course of this summer they would all get to the point where they weren't going to take it any more – be they gay men, sick of being harassed by the police outside an Earl's Court pub; or Asian youths unwilling to stand by while one more of their number was murdered; women refusing to accept being paid less than their male counterparts; or Black youths rebelling against being continually stopped and searched.

At the time such incidents seemed to be isolated events – but seen from half a century later, this summer emerges as a pivot point in modern British history. It was during the months of drought and 32-degree heat that the old Britain of the post-war era – the all-white country with its monolithic class system and its imperial history – began the transformation into a genuinely multi-cultural Britain, if also an uncertain and divided one. And this change was not one that took place in Parliament, but rather on the cricket pitch and in the record shops, in the sun-baked parks and on the overheated streets. That's why this summer, which began with hippies playing frisbee in the park, would end four months later in blazing riot.

Of course, the summer of '76 wasn't just a series of political struggles, any more than it was simply months of unbroken fun in the sun. Writing

4

this book, talking to people about this time fifty years ago, it's striking how much clearer their memories are of pop culture than hard news events. It poses an interesting question: if we remember an ice lolly or a TV sitcom and not the collapse in the value of the pound, does that make it significant? Almost everyone I spoke to needed to be reminded of the identity of the prime minister, Jim Callaghan, but immediately recalled Elton John and Kiki Dee's 'Don't Go Breaking My Heart' or the *Confessions* films. That goes double for the Sex Pistols. There can be few historical events more written about than the early days of punk rock. It's easy to bemoan it as a sign of our age's obsession with trivia, but it also reflects the fact that for a whole swathe of my generation it was a defining moment.

This isn't a definitive account, of course – no single book could pretend to offer that. For starters I should stress that it's a book about that summer in Britain, as seen from a British perspective, and not about the world as a whole. Beyond that it's a book that deliberately reflects my own personal interests and concerns – one that tells the story of that summer by roaming across fields as various as music and crime, TV shows and race relations, strike actions and cricket matches. It examines events small and large, characters famous and forgotten, many of which turn out to have a surprising amount in common, and all of which add up to a portrait of a country that was already on the cusp of change – just needing a heatwave to propel it forward. There's a certain bias towards stories of youth, which is partly because I was young myself, but more importantly because it's a book that's always on the lookout for the harbingers of change, and change does tend to be driven by the young. It's not my story, then, but you'll be seeing it from my angle.

It will be told month by month through a mix of longer in-depth stories, with their own chapters, and shorter news pieces, covering

everything from politics and crime to new films, records and books. It's a portrait, it should be noted, of a time with a much simpler media landscape than today: just three TV channels and, for most people, only the BBC radio stations, plus the daily papers and plenty of magazines. Everyone watched the same TV shows, heard the same pop records, listened to the same news – whether you liked it or not.

When they come to write the books about the summer of 2024, things may be a lot more complicated, with so many competing realities to make sense of. But then, despite the many obvious and uncomfortable parallels to our lives fifty years later, I wonder if 2024 will ever hold such a special place in our collective mythology?

Because from the beginning of May to the end of August 1976, four months of heat and drought took a country from 'Save Your Kisses For Me' by Brotherhood of Man to 'Anarchy In The UK' by the Sex Pistols, with a scarcely comprehensible amount of shock, change and, frankly, revolution along the way.

Have you noticed, it seems to be getting hotter?

May

THE WEATHER

'Don't cast a clout till May is out' warned the *Daily Mirror* on the first of the month, reporting that meteorologists expected the month to be rainy and colder than average. The first sign that this summer wasn't going to follow the predicted pattern came the following weekend, when temperatures reached an unheard of 82 degrees Fahrenheit (28 degrees in newfangled Celsius) and while the heat then dipped down for a while, by the end of the month it was back above average, and the papers were already talking about a serious drought and the prospect of water rationing. The government was quick to reassure the populace that this was simply not the case. 'This is not a national drought', said Labour's Local Government Minister, John Silkin, when pressed on the subject, 'nor is there any danger of that at all.'

THE HEADLINES

People loved newspapers in the seventies. Take a morning train and everyone would be reading a paper. Few were keener than my dad, who bought four every day: *The Times*, the *Daily Telegraph* and the *Western Mail* in the mornings, plus the *South Wales Echo* in the afternoons.

In 1976 the seven mass-circulation national newspapers sold around fourteen million copies a day. The two big ones, the *Daily Mirror* and *The Sun*, sold 7.5 million of those. And that wasn't the whole story, as so many people bought a local paper as well. The Sunday papers were the most popular of all – nearly twenty million sold every weekend. The national papers gave you the big stories and the all-important TV schedules; the locals offered the news from down your way, plus cinema listings, classified ads and so on.

The national dailies were the clearest markers of class and political allegiance. Working-class people, by and large, bought the *Daily Mirror* or *The Sun*. The *Mirror* was the market leader and was solidly behind the governing Labour party. *The Sun* was its upstart rival, under the newish ownership of Rupert Murdoch, and had almost caught up in circulation, working to the mantra that 'sex sells'. It had supported Harold Wilson's Labour party in the previous election, but would soon switch its affections to the up-and-coming Tory star, Margaret Thatcher.

Further up the social ladder, and swinging to the right of the political spectrum, came the middle-market papers, the *Daily Mail* and the *Daily Express*, selling over four million copies between them. Both

9

made an effort to attract female readers and were keen supporters of the Conservative party, with the *Express* very much to the far right of the party.

That left the three upmarket broadsheets: the right-wing *Daily Telegraph*, the centrist *Times* and left-wing *Guardian*. They had two million readers between them, but tellingly two-thirds of those bought the *Telegraph*.

A look at some of the front pages on 1 May gives an idea of the papers' contrasting agendas.

The *Telegraph* led with the headline 'Tory Anger Over Timid Tycoons' – this was a report of a speech made by a Conservative MP, Geoffrey Rippon, decrying the laissez-faire attitude of Britain's business leaders. According to Rippon, they were allowing Britain to slide into socialism because they were too concerned with their individual fortunes rather than the good of the country. It was an early sign that under Margaret Thatcher, the Tory party was determined to move out of patrician torpor and into battle against the left.

If that may have alarmed some of the readership, the front-page photo was a reassuringly traditional photo of the Queen inspecting the Coldstream Guards, one of whom was holding her handbag for her.

The Guardian also covered the Rippon speech but not as a lead item, preferring to focus on a story about potential job losses at Leyland Cars, part of British Leyland, following a long-running industrial dispute. This was a huge company with 114,000 employees – emphasising just how reliant manufacturing was on human labour. Manufacturing as

a whole, while in gradual decline, still employed around seven million people in the UK in 1976.

British Leyland was in a curious situation. For a long time it had been Britain's leading car manufacturer, with brands like Rover, Austin, Triumph, Land Rover, Jaguar and Mini, but had nonetheless gone bust the year before. The company had been saved and effectively nationalised by the Labour government. But its fortunes weren't improving. The endless unofficial strikes were crippling its output, while its one big plan for the future was a new car known as 'ADO88', which was meant to be the new Mini – the compact car the whole world would clamour for. Sadly it was an uninspired, boxy-looking item that would eventually make it to market as the little-loved Mini Metro.

The scale of companies like British Leyland, with their vast unionised workforces, made them the perfect battleground for the power struggle between bosses and workers. Unionised workers had real power. At BL their leaders, among them Derek Robinson aka 'Red Robbo', were putting forward an agenda of further nationalisation, arguing for an entirely state-run car manufacturing sector. Very much the kind of socialist initiative that Geoffrey Rippon was fulminating against.

Surprisingly, *The Guardian*'s front-page photo was another shot of the Queen and the Coldstream Guard.

The *Daily Mirror*, despite being known as the workers' paper, didn't cover the car industry story at all. Instead it devoted its front page to an exclusive story on what was rapidly developing into the biggest, juiciest political scandal of the decade.

'Norman Scott to Take Yard Chief to Court over Letters' was the somewhat ungainly headline. Norman Scott was a young man, a

'former male model' as the newspaper put it, who was claiming to have had a homosexual relationship with the leader of the Liberal party, Jeremy Thorpe, a decade earlier. The letters were from Thorpe to Scott. Scott had given them to the police years before and they had so far refused to return them to him on the grounds that they were Thorpe's property.

Jeremy Thorpe was a major player in the politics of the time. A clever, confident old Etonian in his mid-forties, he had the saturnine air of a 1950s film star. He had led the Liberals back from near oblivion to the point at which they had briefly held the balance of power, following the February 1974 election.

But now he was waist deep in scandal and sinking fast. Norman Scott had been plaguing him ever since their affair ended. Not exactly blackmailing him but still making it clear that it would be in Thorpe's best interests to help him out here and there. It went without saying, at the time, that to be outed as having had a gay relationship was the end of a political career. So it emerged that Scott had been paid a weekly 'retainer' for some years, with the obvious implication that it was to keep him quiet. But then matters had descended into grisly farce. In March 1976 a man called Andrew Newton was up in court, charged with having shot Scott's dog, a Great Dane called Rinka, in an attempt to frighten him off from making any more allegations about Thorpe.[1]

There was no proven link between Newton and Thorpe, though, so the politician had continued to deny everything. But these letters would be the final straw. The following weekend – that first, unseasonably baking weekend of May – two of the missives appeared in the *Sunday Times*, and they showed he had had a much closer relationship with Scott than he had previously admitted. The killer line was the twee promise to Scott that 'Bunnies can – and will – go to France.'

Thorpe had clearly been lying about the nature of the relationship,

but much worse than that, he had made himself, the arrogant aristocrat, into a figure of fun. The newspaper-reading public just boggled at the idea of a senior politician writing such a thing. He resigned as Liberal leader on the Monday morning.

The *Mirror* didn't put the Queen on the front page, preferring a picture of a perky blonde girl in a miniskirt and a Manchester United scarf in advance of the FA Cup final. She may have been less cheery after the match.

The Jeremy Thorpe story would rumble on through the month, as did the coverage of the nation's economic woes. The economy was struggling, standards of living were slipping, and the pound was falling fast.

The other story that refused to go away was that of the sectarian Troubles in Northern Ireland, which had begun with Catholics marching for Civil Rights in the late sixties and had developed into a civil war in all but name. Protestant and Catholic paramilitaries seemed to be locked into a brutal and endless game of tit for tat. Between 14 and 16 May fourteen people were killed, among them five policemen.

The Protestant UDA (Ulster Defence Association) shot three Catholics dead in a pub in Charlemont, Armagh. Two days later the Provisional IRA (Irish Republican Army) crossed the River Blackwater to the village of Moy and shot two Protestant farmers through the head as they were packing eggs. The IRA then announced that this was part of their plan to stop the government from giving increased powers to the Protestant-dominated Royal Ulster Constabulary. They called this plan, with strange prescience, 'the long hot summer'.

The UDA replied with their own statement. 'A long hot summer can work both ways,' they said, and threatened to start targeting Catholics indiscriminately.

FOREIGN NEWS

There were signs of a changing of the guard all over the world. Mao Zedong was seen in public for what would be the final time. He was one of the last of the monolithic post-war leaders to leave the stage. Churchill, Stalin and Franco were all gone, Tito would not be far behind. After forty years of dictatorship Spain signed in a crucial bill paving the pathway to democracy. Gerald Ford and Leonid Brezhnev, the US and Soviet leaders, signed a treaty to limit the size of underground nuclear tests.

We were now living in a more uncertain age. For the last few years, Western Europe had been struggling to deal with the threat of terrorism, whether from full-scale independence movements, like the IRA in Northern Ireland or the Basque separatists ETA in Spain, or the ultra-leftist radical groups that had come out of the student movement of the late sixties, like the Red Brigades in Italy or the Baader–Meinhof Group in Germany.

May began with the collapse of the Italian government. A wave of political murders led to the resignation of the prime minister, Aldo Moro. Two years later, when on the political comeback trail, Moro was abducted and murdered by the Red Brigades along with five of his bodyguards.

In Germany, however, the threat of the Baader–Meinhof Group, or Red Army Faction, seemed to have been neutralised. The key leaders had been arrested, and then 9 May saw the death in prison of the group's co-leader, Ulrike Meinhof. She hung herself, said the authorities, but

who trusted the authorities? A lot of young Germans certainly didn't. Seven thousand people turned out for Meinhof's funeral and there were demonstrations across the country. Jean-Paul Sartre and Simone de Beauvoir published an open letter comparing Meinhof's death to a Nazi war crime.

Curiously, one of the Baader–Meinhof Group, the getaway driver Astrid Proll, had escaped Germany and in May 1976 she was living in a squat in Hackney, London, where she was an active member of the lesbian feminist scene.

Meanwhile the world got a little bit smaller, with the new Franco-British supersonic airliner, Concorde, starting to make transatlantic commercial flights for the first time. London to Washington in three hours and fifty minutes. That mean that, flying from London Heathrow, you took off at 1pm and touched down in the US at 11.50am – more than an hour earlier than when you'd left. Here was modern technology apparently overcoming the very laws of nature.

There was a maximum of 128 seats on Concorde, with tickets costing around £600 each way (roughly £6,000 today), though you did get caviar and Dom Perignon thrown in. Flying at twice the speed of sound, and at altitudes as high as 30,000 feet, you looked up and saw nothing but the blackness of space.

Sadly, there were already strong suspicions that the planes were too expensive to ever make commercial sense. Air travel would never be as fast again.

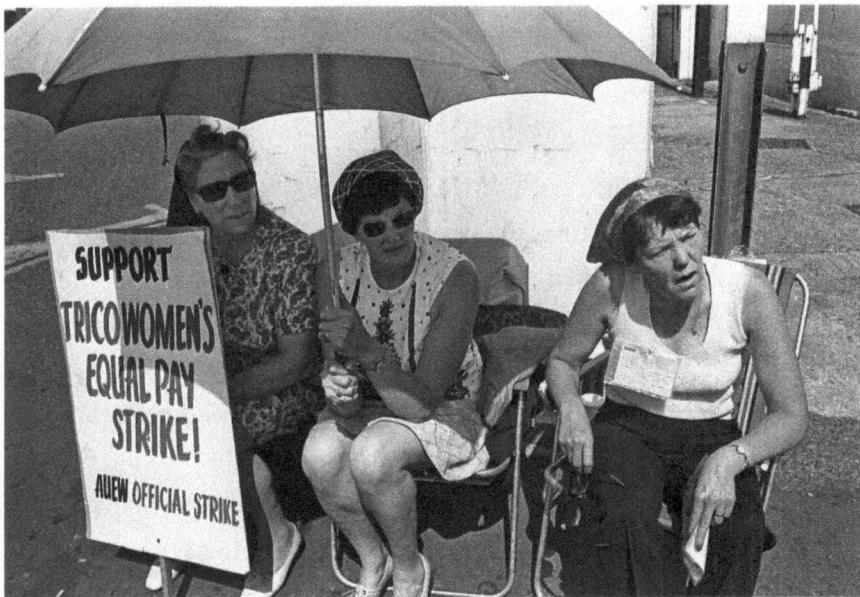

The struggle for equal rights reaches the Great West Road riviera.

OUT ON THE COSTA DEL TRICO

There's quite a scene outside the Trico Factory on the Great West Road in London's Brentford. It's a road that always had its landmarks – the Martini Clocktower, the animated electronic Lucozade sign, the art deco Firestone factory etc. – but for twenty-one weeks across the summer of '76 it's acquired a new one. They call it the Costa Del Trico.

That's because the usually quiet pavement outside the factory is alive with people, almost all of them women. Some are standing and holding up placards to wave at passing motorists; some are sitting on folding chairs and chatting or knitting or both. There's an old settee too and someone making tea on the Primus stove. There's Black women, white women, Asian women; young women, middle-aged women, older women. Most of them are in dresses, lots of colourful sixties-style prints, some are in saris, some in flares and T-shirts. A couple of younger ones are in hotpants and cropped tops. Headscarves and sunglasses are popular, near essential accessories in this weather. A few lucky ones have sun umbrellas to give some shade. Thanks to the blistering heat that seems like it's never going to end, everyone looks like they're at the seaside, not next to a dual carriageway in West London. Welcome to the Costa Del Trico.

The placards they're carrying say, 'Support Trico Women's Equal Pay Strike' or 'Wake up Trico! Equal Work Means Equal Pay'. A little handwritten one, hanging on the fence, says, 'Please Don't Say "I'm all right Jill" '. These women are done with being patronised. It's not for fun that they're camped out by the factory where they used to work.

They're there fighting for a principle. Equal pay for women. They've been out there since the end of May, and it doesn't look like they'll be giving in any time soon.

Strikes were always in the news in the seventies. I was a kid, so mostly this stuff went straight over my head. It didn't impact on my life in any way I could understand, these dockers or car workers striking in faraway places like Glasgow and Birmingham.

But then came the Miners' Strikes of 1972 and '73. We started having power cuts, which were quite annoying if you wanted to watch something on TV, but quite exciting at the same time. The second Miners' Strike, in the winter of 1973/4, really did impinge on me. It began with the miners declaring an overtime ban. This was immediately effective. Apparently there simply wasn't enough coal to go round and keep the power stations running. So the government brought in a three-day week and the power cuts became regular and long. I spent a day with my mum driving around Cardiff in search of a shop that sold Calor gas lamps and remember the triumph when she finally found one.

That second Miners' Strike signalled the end of Edward Heath's Tory government. Heath had mandated the three-day week from 1 January 1974, hoping that public resentment would bring the miners to heel and make them give up their overtime ban. It didn't work. On 24 January they voted for a total strike. Heath realised he had reached the end of the road. He called a general election, hoping that the public would agree with him and his party that the unions had too much power. 'Who governs Britain?' That was the question he put to the voters.

'Not you,' was the answer. The British public narrowly voted to return Harold Wilson's Labour party to power, in uneasy alliance with

the Liberals. The miners immediately got the pay deal they wanted and ended the strike.

Two years into the Labour government, though, the economy was struggling, and the message to the workers was that they should be moderate in their demands. In the public sector this was holding, more or less, with the main trade union leaders broadly sympathetic to the government position. But in the badlands of the private sector there were plenty of battles between bosses and workers. Most of them were local affairs that never attracted much attention and had no wider resonance, other than echoing the perennial battle for a fair balance between profits and wages.

Few of these struggles seemed to have much to do with bigger world issues that might resonate beyond the factory gates. Not all of them, though. In the case of the Trico Strike the issue at hand was fundamental – equal rights for women. That these still had to be fought for half a century after the Suffragettes was a sign of just how long and slow a struggle it was to change such fundamental inequality.

London's Golden Mile runs west from Chiswick through Brentford and on towards Osterley – so named because, for most of the last century, it was home to a long line of factories, many of them housed in distinctive art deco buildings. This was a time when London was a manufacturing hub, and one household brand name after another was being produced along this sophisticatedly industrial stretch of real estate. There was Smith's Potato Crisps, Firestone Tyres, Coty's Cosmetics, Macleans Toothpaste, Pyrene Fire Extinguishers, Gillette Razors, Harvey's Wines, MacFarlane Biscuits, and any number of car showrooms. And there was Trico, where they made most of the nation's car windscreen wipers.

By the mid-seventies the Golden Mile was past its heyday, but there was still plenty of work on offer. The Trico factory had a workforce of around 1,600 employees – so when a young woman called Sally Groves found herself urgently in need of a job, Trico came to the rescue. Sally Groves, still thoroughly lively and engaged nearly fifty years on, has written – with Vernon Merritt – an excellent history of the strike. She told me how it all started for her.

My marriage had just broken up. I needed to go out and get a job, so I went down to the Job Centre and the day I went there were a couple of jobs on offer. One was at the Walls food processing plant in Acton, and the other was Trico. Factories at that time paid better than other jobs. I said, 'What time do they start?' The Walls job started at 7:30 and I'm not good in the morning, so I asked, 'What about Trico?' And they said, '8 o'clock,' so Trico had my vote.

I started straight away and was put on the wiper arm assembly line, which was all women. The worst bit was trying to keep up with it all – if you didn't, you were in real trouble. But there were a lot of friendship, a lot of support, a lot of laughs.

Many people had relatives and friends working there too. That made it a very close-knit community. It was all female on the lines, a whole mixture, people from the Caribbean and Asia – mainly India – Portugal, Spain, a lot from Ireland, one or two from Poland. The women all stuck together.

In 1975 the Trico factory was run on largely segregated lines. Women worked on the assembly lines, while men did most of the other jobs as toolmakers, setters, labourers, forklift truck drivers etc. The only men on the assembly lines were on the all-male night shift. Overall, it was a

fairly harmonious working environment. There had only been one brief strike since the late sixties.

But then, in September 1975, Trico announced that they were phasing out the night shift. Most of the men involved took voluntary redundancy, but five of them stayed on and started working on the daytime assembly line alongside the women. This was a tactical mistake by the Trico management, because it soon became clear that the male workers were being paid £6.50 per week more than the women.

Once upon a time that would have been simply accepted as the way the world worked, but on 29 December 1975 the Equal Pay Act had become law, thanks to the efforts of the Labour star, Barbara Castle. It was no longer acceptable or legal to pay women less than men for the same work.

Trico, like any number of other firms, tried to wriggle out of their obligations. They attempted to use a popular loophole – claiming that the men were being paid more because they had greater 'flexibility' – they could work on a greater variety of machines than the women. This simply wasn't true – so Trico's next manoeuvre was to try to reduce the men's pay to the same level as the women. One of their number, Eric Fudge, told Groves how unimpressed he was by this: 'What the company was trying to do was implement equal pay by reducing our pay, which I didn't reckon much of, for obvious reasons.'[2]

Seventy per cent of the workers at Trico were members of the Amalgamated Union of Engineering Workers (AUEW), so the local union branch was called in to negotiate a fairer settlement. But Trico simply stalled and stalled some more. Eric Fudge again: 'It was quite obvious to me that as long as they pussy-footed around with endless negotiations dragging on for months on end, the company was quite happy to do that. What they needed was beating with a stick.'[3]

The stick made its appearance on Monday 24 May. It was grey and overcast, one of those May days that was more spring than summer. A union meeting was arranged, to take place during the lunch hour on the cricket pitch in Boston Manor Park, round the back of the factory. There were two matters to be discussed. The first was whether to stage a one-day strike in support of the 'National Day of Action on Unemployment'. There was no great enthusiasm for this – the male part of the workforce being particularly loath – and they eventually agreed to stage a half-day strike instead. At that point, all the men went back to work, while the women stayed behind to hear the latest on the equal pay negotiations.

They were told that Trico had flat-out refused to agree to increase the women's pay in line with their male colleagues. The union official in charge of the negotiation, Roger Butler, expected to leave it there, while people decided what to do next. The women standing on the cricket pitch were having none of it. It was time for action.

As Sally Groves remembers, it was the women from the micro motor and washer assembly line, which was where the five men had been put, who led the charge: 'They were the ones who knew all about it, because of looking at the payslips with these five men. That was the biggest mistake Trico ever made, letting those men work somewhere like that, because job segregation had been alive and well. Until then no one had realised how discriminated against we were, and so those women were absolutely furious.'

A series of one-off 'lightning' strikes was considered but rejected. Given Trico's intransigence, they felt that nothing short of an all-out strike would suffice. The motion was put to a show of hands and carried overwhelmingly. The Trico women were now on strike, all four hundred of them.

Phyllis Green, a young woman recently arrived in the UK from

Ireland, was one of those at the meeting. She had no real idea what she was getting herself into: 'We just heard that the union was holding a meeting in the field, so we all went out to have a nose about, see what was happening, and then everyone put their hands up for a strike and we came back in, got our coats, and clocked out.'

Sally Groves elaborates: 'Everyone was going, "So we're on strike, are we?" We were dazed. People were told they needed to get their coats, because we weren't going back to work. I remember walking out of the factory and another woman saying to me, "Do we clock out?" and I said, "I don't know!"'

She also notes that the strike would probably not have happened if the men had still been at the meeting: 'We would never have been out on strike, because the men in the factory, with a few exceptions, would have voted against us.'

The initial assumption, especially from the men, was that it would all be over quickly. Robert Singh was one of the few men who joined the women on strike. Of Jamaican origin, he had been working for Trico for a few years as a press setter, one of the elite skilled jobs. He told me that he stood out from his colleagues, not only because he was one of only two Black guys working as a setter, but also because he was a *Guardian* reader. His colleagues had him down as a leftie troublemaker: 'The men in my department were quite bemused because they thought, "It's just a few women, it won't go on long." They expected them to be back at work quickly, because, as far as they were concerned, women were working for pin money. That was the sexist mentality of the time.'

The concept that women's earnings were simply 'pin money' – insignificant amounts of cash earned to pay for feminine fripperies – was a bulwark in shoring up the male ego in a world in which men were supposed to be the breadwinners. The reality of the Trico women, of course, was that some were single, some were the family breadwinners

themselves, and in any case every wage in a working-class family was very much needed. It's a telling indicator of the lives of these women that, out of the four hundred who went on strike, only two owned their own cars.

But now they were on strike, what happened next? As Sally Groves told the *Women's Voice* radical magazine a few weeks after the strike began, it was quite a challenge:

> Hardly any of [us] has been involved in a strike before. We'd certainly never had such a long dispute in Trico. So at first we suffered from a lack of confidence, a lack of experience, not knowing exactly what to do . . . There was a kind of disbelief about it all – that we'd need to collect money, to organise. We had to take it into our own hands. And, like most women, we weren't used to taking the lead before.[4]

The first thing they did was to put on a show of strength. On the Wednesday morning, 26 May, there was a mass gathering of the strikers outside the factory. Press photos show a crowd of women of all ages and races waving banners saying, 'We only want women's rights' and 'Pay up your time is up'. The summer heat was clearly yet to kick in, as most of the women are wrapped up in their coats. A day later though, the sun came out and they marched around Brentford rallying support from the other factories in an array of summer dresses, saris and brightly coloured blouses.

At this point everyone still assumed that the dispute would be over soon. However, Trico showed no sign of backing down, so the women started to settle in for a battle. None of them had any experience of conducting a strike, but a de facto leader was emerging. This was the shop steward, Eileen Ward. She was a formidable presence, as Sally Groves remembers:

She'd come to work at Trico years before aged fifteen, and got sacked the same day! But then she came back and she'd been at Trico for eleven years by the time of the strike. She was remarkable. She was just an ordinary woman committed to being a shop steward, but not involved in anything else. She rose to the occasion and became quite a towering force of support and leadership.

And because we had mass meetings, roughly every week, she became great at speaking to all those on strike, all the women. She was humorous, but also she could really rouse people. She was so passionate and committed to the cause – and concerned about people. She was always worrying about the other women and if they would have enough money to get by on.

Money was indeed the immediate issue. Anyone who had holiday pay owed took it, but thereafter they would depend on the union giving them strike pay of nine pounds a week – and that was only for those who already belonged to the union. The hundred or so women who previously weren't members all joined up, but had to wait that much longer for the strike pay to come through. Once it did arrive, it was doled out weekly at the Griffin Pub just outside the Brentford FC ground.

Nine pounds a week, around a quarter of their regular wage and a bit less than the basic rate of unemployment benefit at the time, didn't go far at all. Some of the women picked up cleaning jobs at night. Some of the younger Irish women went back to stay with their families. Others, like Phyllis Green, were dependent on the kindness of the surrounding community:

I used to go to a café in Hanwell and all the bus drivers went there, some of them Irish, and they'd buy me a free meal. There were a lot of Irish

families living around, so at the weekends I'd go over to their houses and they'd give me dinner. That helped. And the bus drivers let you go free on the bus because they recognised all the Trico people.

Sally Groves discovered that while strikers couldn't claim regular unemployment benefit, as they weren't available for work, they might be able to apply for hardship payments. She led a group of women to the Ealing DHSS office, demanded to see the manager and succeeded in getting some payments made. However, when she led another group of women to another local DHSS office, in Hounslow, the manager declined to help and when the women refused to leave, they called the police.

Thirteen police arrived, and when they saw Sally Groves lying down in passive resistance mode, they didn't hesitate:

> They just picked me up, turned me upside down and proceeded to hurtle me down the three flights of stairs head-first, with the others following behind me shrieking. If they'd dropped me I doubt I'd be here today, but they didn't. They shot me out of the front door and dropped me in the gutter.

On their own it was hard to see how the Trico women were going to succeed. Trico had deep pockets – it was part of a big multinational American company, Trico-Folberth, and the UK division alone had made nearly £2 million in profits in the last year – while the strikers had very shallow ones. But they were not alone. Instead they were part of a labour movement that had real strength.

The Trico women were now all members of the AUEW and they were lucky in their union reps. There was the factory's union convenor,

John Inwood; the local official, Roger Butler; and further up the line, Bill MacLaughlin and Reg Birch. All of these were left-wingers in a largely right-wing union, and very committed to the cause of achieving equal pay. The local area gave the strike official status immediately, and Reg Birch was able to ensure that the national executive ratified the decision a few weeks later.

Meanwhile the strikers started to organise themselves, setting up a strike committee. Feminism had not, as yet, conquered all, so the chairman was the union convenor, John Inwood. But women held the key roles in the day-to-day running of the strike, with Eileen Ward as the secretary and in charge of picketing, Betty Aiston looked after social security and Sally Groves organised publicity.

Picketing was a crucial part of the strike action. Every day a group of women would arrive at the factory gates and stay there all day. They had several jobs to do. One was to remonstrate with those of their fellow workers – i.e. the great majority of the men – still going in to Trico. This had limited success.

Another key role was to attempt to stop lorries from delivering supplies to the factory. At the time most workers, if they were in a trade union, would refuse to cross a picket line. Thus a driver would turn up with a delivery for Trico, and he would be approached by the pickets, who would explain that they were on strike and that this was an official picket line. In general, if he was a union member, he would then turn around and leave without making the delivery.

As the strike got going, so too did the summer. It was mostly a blessing, as it would have been much harder to recruit numbers of pickets day after day in driving rain. Instead they were able to spread themselves along the wide pavements of the Great West Road. Chairs and a settee

were brought down, and primus stoves so they could make cups of tea. The 'Costa del Trico' had arrived.

Meanwhile the men who were still working had to troop inside to a baking hot factory without air-conditioning, with less and less actual work to do, the assembly line having ground to a halt, with the deliveries failing to come through.

The left-wing press – *Morning Star, Socialist Worker, Militant* et al. – soon began to take an interest in the strike, as did the feminist magazines, especially the ground-breaking and very popular monthly, *Spare Rib*.

The local press was interested, but divided in its coverage. In some cases, the newspaper owners were sympathetic to the Trico management. Worst of all, though, was a piece in *The Sun*. Their reporter took a passing joke at face value and wrote that the striking women were on 'sex strike' and refusing to perform 'their normal wifely duties'. Unsurprisingly this incensed the strikers and next time the reporter, an overweight man in a too-tight suit, arrived at the Costa del Trico, a group of women chased him down the road.

While the 'sex strike' innuendo trivialised the issue, there were real tensions for the striking women. Some had husbands or other relatives who were still working in the factory. *Spare Rib*'s Jill Nicholls quoted an unnamed striker as saying, 'I'm out and my old man's in. But it doesn't make much difference, because there's not much being done there now that all the women are out – one thing it has proved is who does the work in this factory. The women do it all!'[5]

There was well-founded resentment at the lack of support from their male co-workers. Some had genuine conflicts, because they belonged to different unions, but there were many others in the AUEW who still refused to strike. That included some of the shop stewards, who should have seen it as their bounden duty to join in.

At first there was only a small handful of men out on strike – fifteen or so including the five former night workers whose transfer to the assembly line had sparked the whole thing. Following the union's decision to make the strike official, another 150 joined in, but for the most part with little real enthusiasm. That still left the majority of the men working. And as far as many were concerned the dispute was at best trivial, and at worst an undermining of their status as male breadwinners.

Peggy Long, a widow, spoke to the *Women's Voice*: 'If I had a husband and he worked here and he didn't support me I wouldn't speak to him . . . Either you're a good trade unionist or a bad one. You can't be halfway. How can you teach your children to stand up for what is right if you haven't got the backbone to do it yourself?'

The days got hotter and hotter – the newspapers were reporting that you could fry an egg on the runways at Heathrow, just a few miles down the road, and the striking women could well believe it. It was now getting to be a challenge finding enough women ready to be roasted all day on the picket line. Trico were still refusing to give in. They offered the women a derisory 50p increase in wages and that was all. But the strike was certainly biting. The union estimated it was costing Trico £20,000 a day. The strikers could see the bosses' anxiety for themselves from the increasingly desperate lengths the company went to, to get goods in and out of the factory.

The picketing had been very effective. Only a very few lorries had got through. Factory managers had resorted to taking boxes of windscreen wipers out in their own cars. But as Roger Butler observed, 'You can't run the British motor industry from the boot of a car.' In this respect Trico was a victim of its own success. Its status, as the principal

manufacturer of windscreen wipers for the whole country, meant that it was under huge pressure to keep delivering the goods.

The Trico management side of the negotiations was led by two men: Sid Atkins, a local boy who'd worked his way up from the shop floor to works manager, and John Slidders, the recently recruited personnel manager. They decided that a tough approach was what was needed here. They would pay big bonuses to persuade non-union haulage drivers to come to the factory in the middle of the night.[6]

The first two nights they tried this new tactic – 1 and 2 July – were well chosen. After long, broiling hot days the striking pickets were exhausted and unprepared. First three and then six lorries made it through. And at this point the police made it very clear whose side they were on. The convoys of lorries were accompanied by police cars riding shotgun, so the lorries could approach the factory at speed at 2am. The few pickets who were there had to jump out of their way to avoid being crushed under the wheels.

Nine days later, on 11 July, they did it again. A convoy of seventeen lorries and fifteen cars arrived with a police escort. The police went to the lengths of closing the road off to other traffic, so the convoy could approach even faster than before.

Trico must have hoped that the effect of this would be to demoralise the strikers. The reverse was the case. To increase the numbers of pickets, the strikers decided to offer a small amount of money from their hardship fund for anyone who was prepared to picket at night. These were mostly men, as family responsibilities and social attitudes prevented most of the women from coming out at night. They started to work on a strategy. Sources inside the factory would try to find out when the next convoy was due, and then they could prepare for action.

Word leaked out that the next convoy was on 27 July. That night seventy pickets turned out, while others went out on motorbikes to act

as scouts, looking for any sign of approaching lorries. When they finally came thundering down the Great West Road at 2am, one of the scouts had spotted them, so the pickets were ready. They stood with linked arms in front of the gates and this time the lorries had no alternative but to turn back. It was a victory that gave the strikers new heart – a physical illustration of the power of workers' solidarity.

Two days later, though, the company hit back. A convoy of lorries arrived at 5pm, just when the number of pickets was at its lowest between daytime and night-time shifts. And this time the police didn't just help escort the lorries – they enforced an arbitrary limit of six pickets in front of the gate, which wasn't enough to stop them getting through. Women who tried to obstruct the convoy, including Eileen Ward, were dragged away. Sally Groves managed to throw herself to the ground in front of one of the lorries but was soon dragged away as well. This was a victory of sorts for Trico, but only a Pyrrhic one. A BBC film crew was there, and footage of the women being manhandled out of the way by the police was on the evening news. It helped swing public sympathy towards the strikers.

The cumulative effect was to make the strikers determined to stick to their guns. The union official Roger Butler told *Labour Weekly* that, 'The Trico management might be able to get lorry drivers without principles and get the police to act as company agents, but they cannot get women to work below the rate and they never will.'

This conviction now extended to members of the workforce who had never been politically aware before – Phyllis Green for instance: 'As it went on you got more interested in politics. When you're out there for a while, you start thinking – we're entitled to it, and we're not going back till this is solved.'

She was inspired by the older women, particularly the shop stewards Eileen Ward and Betty Aiston, and their determination to get a just settlement:

They were just ordinary working-class women. I wouldn't think they had an awful lot of education – and for them to come out so strong . . . They'd have a little handbag with them, and a hat on sometimes – they looked like 1940s ladies. I was there with my flares and flowers in my hair – a completely different generation. But they were good. They were a lot better than my generation was . . . They knew what they were out for. I was scared to stand in front of those big lorries, but they weren't. They'd stand there and the lorries would nudge up and nudge up till they were pushing them. I was well proud of those ladies of that age, of what they did.

The struggle wore on, through the dog days of July and August. The weather cooled a little then got hotter again. There was still no rain, no hint of green grass in Boston Manor Park behind the factory, just bare brown earth. The country was in the grip of a major drought, everything dry and dusty. Car drivers needed their windscreen wipers more than ever.

News of the Trico Strike began to spread. Radical groups and individuals started to come down to Brentford to lend their support on the picket line. Gradually they set up a picketing rota, which included the local Labour party (the future MP Stephen Pound among them), Brent Trades Council, the Working Women's Charter Group, and groups from local factories like Magnatex and AEC Southall. One slot on the rota was taken by the Gay Socialists, in an early example of gay solidarity with industrial action.

A hardship fund was set up to supplement the strike pay for those in greatest need, and to pay the pickets 50p a shift. Fundraising efforts included discos and a very well attended performance by the radical theatre troupe Belt and Braces Roadshow. Another radical theatre group, Broadside Theatre, put on a show for the strikers in Boston

Manor Park along with the fine folk singer Frankie Armstrong. The strikers would also tour local factories, asking for donations. As Eric Fudge, one of the assembly-line men, remembered, they would use whatever tactics worked:

> Raising money I went to Firestones, on the other side of the canal, and then to Duvall's . . . I used to take Ann [Fitzgerald] with me, and she used to be in a very nice little number – a pair of denim hot pants and a cropped top – and she used to stand there fluttering her eyelids while the mugs put all their money in the pot, trying to impress her . . . Well you know, all's fair in love and war. We were certainly in the warfare situation . . .[7]

Occasionally there was a certain amount of culture clash between the strikers and their new supporters. Union official Bob Bannister recalled what happened when one of these visiting supporters was offered a doorstep sandwich from the local café.

> One of our supporters was a rather refined person, not the average working-class woman. I mean no disrespect but she did have this, shall we say, precious way. And when she was given a sandwich, she looked at [it] and said, 'How am I supposed to eat this?' And one woman turned round and said, 'Whatever you do, love, don't drop it on your foot!'[8]

After a while, the strikers started to look further afield for their fundraising trips. Delegations from the factory went to all the great cities of British industry: Newcastle and Sheffield, Manchester and Glasgow. Four of the strikers, including Peggy Farmer, travelled to Glasgow where they shared a platform with Jimmy Reid. Reid was one of the big figures of the trade union movement at the time, the leader of the Shipbuilders' Union on the Clyde, and a great speaker.

Peggy Farmer was in awe: 'I was on stage with Jimmy Reid and I was shaking like a leaf . . . The thing that stuck in my mind was [Reid] saying, "These lassies need our help so dig deep in your pockets, boys, and give these people money because our sisters need our help".'[9]

Money came in from all sides. In one single week there were twenty separate donations of more than £20 (say £200 in 2024) from the likes of Acton Works, Fidelity Radio, the Peckham Labour party, Pontin's holiday camps, etc, etc. The biggest single donation of £120.70 came from a collection taken at the Young Liberals' conference. Over the course of the strike they would raise around £30,000 (around £300,000 today), much of it from trade unions, the miners and the AUEW in particular, but all of it coming ultimately from the pockets of ordinary people.

After the public relations disaster of their attempted strikebreaking, the Trico management declared that they would be happy to put the strikers' demands for equal pay before an Industrial Tribunal to be held on 18 and 19 August. These tribunals were theoretically neutral courts which would make their judgement without fear or favour. That was the theory, anyway. In practice the tribunals had dealt with a large number of equal pay claims since the Law came into action, and had turned the vast majority of them down. They were becoming notorious for allowing the employers to drive a coach and horses through the Equal Pay Act's many loopholes.

Memorably, and outrageously, women who worked at the Kraft Cheese factory on Merseyside were refused equal pay because the management said they would be unable to walk across a particular factory gantry, in case the men looked up their miniskirts, and therefore they would not be performing exactly the same duties as the men. The tribunal had been happy to rubberstamp this nonsense.

Therefore the strike committee, advised by Roger Butler, made the

decision to boycott the tribunal. It was a bold move, as they rightly anticipated plenty of press condemnation. However, had they appeared before the tribunal and lost, they would have had to accept the decision. Boycotting the tribunal would allow them to fight on.

So fight on they did. The tribunal went forward anyway. Trico's lawyers put their case, and the tribunal agreed with it. But the decision was irrelevant. The strike carried on with the women as united as ever. There was one supportive piece in the national press, an opinion column in the *Daily Mirror* by the broadcaster Joan Bakewell ('known as the thinking man's pin-up' according to the paper's sexist caption, entirely without irony). She declared that: 'The Equal Pay Act is not working as it was intended to do. The Trico women know that. It's time everybody else did too.'

That didn't stop Trico sending out letters to the strikers, telling them that the tribunal's verdict was fair and binding, and implying that they would lose their jobs if they didn't give in and come back to work. Eileen Ward's response at a mass meeting of the strikers was characteristic: 'As far as those letters are concerned, you can pin them on the toilet wall. The rest I leave to you.'

It quickly became clear that Trico were bluffing. The strike was biting hard. Summer was coming to an end and the Costa del Trico started to look more like a typical British holiday resort, as the rain and cooler weather returned, but its denizens still weren't backing down. On 1 September the company announced that they would be laying off staff. There was now some resentment shown towards the striking women by the laid-off men. The local National Front attempted to stir up this resentment. Robert Singh recalls an increase in racist attitudes: 'It was there before the strike, but it didn't come out. During the strike it became an issue.'

The strikers pressed on. They sent a delegation to the TUC conference

in Brighton and obtained agreements from unions at the major car manufacturers to 'black' Trico products – that's to say, to refuse to accept them. Trico tried offering another small pay rise in lieu of equal pay, but the women firmly rejected it. Sally Groves and others went to lobby for support at the Labour party conference at the end of September, where an increasing number of MPs, led by the redoubtable Jo Richardson, were taking an interest in their struggle. Trico made a 'final offer' of another wage increase. Eileen Ward brushed it away: 'He must think we're green as cooking apples. The offer was only worth ten bob!'

Trico finally had to face facts – the four hundred striking women were not going to be deterred by bullying or bribery. It was equal pay or nothing. And on Thursday 14 October they gave in. The women on the assembly lines would receive the extra £6.50 a week. The Trico women had won. Over the 21 weeks of the strike, they had seen spring turn into blazing, endless summer and retreat at last into autumn, and now they had won. Twenty-one weeks – the longest ever strike over equal pay – and they had actually won. It was a thrilling and momentous achievement.

The offer of equal pay was put to the women and men the following morning and unanimously accepted. 'There was a lot of jubilation,' Robert Singh remembers. They decided to go back into work on the Monday morning – and to all march in together.

After the long hot summer, it was now a very wet autumn, and the women made their triumphant return to work in the rain. Jill Nicholls of *Spare Rib* was there to report:

> After 21 weeks the equal pay strike at Trico's is over. We stood in the
> rain to cheer the strikers back to work – hundreds of women under

umbrellas, jostling on the pavement of the Great West Road, Brentford, at 7.30 on Monday morning.

'We are the champions,' they sang. A pensioner who had picketed nearly every day started chanting: 'What have we got? Equal Pay! When have we got it? NOW!'

Television cameras glared in the half-light, a young black woman hustled everyone to get into fours . . . and then they marched through the gates, past the settee they'd sat on all summer, now soaking up rain like a sponge.

The women laughed and waved to the crowd of supporters clustered round the gate – as we cheered and clapped I felt elated yet sad that victory had to mean return to the same old assembly lines. But so much has changed. The women have stuck together, stuck it out and won what they were fighting for.[10]

'It was easier for us women when we went back to work because it was all us women together,' remembers Sally Groves. 'That was a great feeling. Because we'd got to know people in a way we just didn't before. It was incredible, the bonds were very close. We were very proud of what we'd done.'

In particular she remembers the difference the strike made to the relations between the different ethnic groups: 'Before, you were working next to each other, but you didn't fully mix. Now a lot of people had made friends on the picket line and those friendships endured, many for a lifetime.'

Things were less harmonious for the male strikers, who had always been in the minority. They had to return to departments full of resentful scabs, as Robert Singh recalls:

I remember one particular incident when I went into the toilets next to our department and there was a big mirror and someone had written on it: 'Bob Singh – you dirty black commie bastard,' right there in big letters. It didn't faze me. I wasn't expecting anything that extreme, but I didn't expect them to say, 'Well done mate, welcome back to work.'

So it wasn't a straightforward, uncomplicated triumph, but a triumph it was, nevertheless. All the women and men who'd been a part of the strike were changed by it. Within days, one of the women had started work as the factory's first female forklift truck driver. And they were determined to use the knowledge they'd gained during the strike to help others. In particular, there was another strike they wanted to support. This was led by Asian women at a factory called Grunwick's in north-west London.

That strike would blow up into a huge power struggle between government and unions and has gone down in history. However, it was a struggle that the unions lost. It's telling that Grunwick is so well remembered and not Trico, where the women and the union actually won.

It's certainly not been forgotten by those who took part in it, though. Sally Groves regularly meets up with her fellow veterans of this 21-week war to win what should have been the most basic of rights. And now she has the last word, stressing that this was a victory achieved not simply by the women themselves and their enviable solidarity, nor by the trade union movement alone, but by the combination of the two: 'If it hadn't been for all the women sticking together, then obviously we couldn't have won, and that was vital. But also, if we hadn't had our strong trade union and local leadership – and women's movement – behind us all the way, we could never have won.'

Then she adds a final observation. 'The establishment and the media do not like that combination.'

THE INSIDE PAGES

The Jeremy Thorpe scandal had brought together most of Britain's obsessions of the time – sex, violence, class and prejudice. These were the stories that continued to dominate the inside pages of the newspapers. So much of the news spoke to the attitudes to sex in seventies Britain, particularly in the press. One thing was very clear – it was a bad time to be a woman. Just take these four stories, all from one single page from the *Daily Telegraph* on Thursday 6 May.

My Night with Blonde Described by Coal Board Official.
This was billed as the 'sex-for-bribes trial', involving a company called Rotary Tools which paid women to have sex with Coal Board executives, allegedly in the hope of persuading them to place orders. 'Crumpet was the order of the day when seeking orders from the Coal Board' hooted the *Daily Mirror*. A 25-year-old Polish woman called Anna G--- – a 'strawberry blonde model' who was happy to pose for all the tabloids – was paid £35 after attending Glasgow's Crazy Daisy restaurant before going back to the Excelsior Hotel at Glasgow Airport with 51-year-old John S--- – 'middle-aged, balding National Coal Board production manager'.

Husband's Killer for Hire Plot.
Sixty-one-year-old retired restaurant owner Joseph Peters decided to hire a hitman after his 31-year-old wife Erica left him for a publican. He took £4,500 from the bank and found a lorry driver called Peter

Bryan, who sold him a gun for £200 and agreed to murder Erica for £1,500. Fortunately for Erica, Bryan was no sort of hitman and just spent the money.

Actress 'Went Home to Mum' After Nudity Row.
A deliberately misleading and titillating headline. Actor Marilyn Gamble had taken a part in a play which would require her naked back to be on view. Her estate agent fiancé told the court that, 'This angered me considerably . . . I did not want her naked back to be seen by all.' However, this was all barely relevant, as the central issue in the court case involved Ms Gamble being sued for wilful damage after she discovered her fiancé was seeing another woman. She had allegedly responded by smashing a colour television, several mirrors, an antique pot and twelve bottles of wine, before soaking the other woman's clothes in bleach.

Shopgirl was fired because she couldn't smile all day.
Manageress Mrs Joy Cooke of the Subway Boutique, Wolverhampton, clearly expected stratospheric levels of sunniness from her staff, and was continually disappointed, as between twenty and forty other young women had quit her employ in the previous six months before they were joined by the insufficiently smiley seventeen-year-old Dawn Sellars.

Along with sex, race stories were another staple. Enoch Powell – the former Tory Cabinet minister notorious for his 1968 anti-immigration diatribe known as the 'Rivers of Blood' speech – was beating this particular drum as hard as he could, and out in the country there were plenty listening.

Midlands

Fascist Robert Relf was sent to prison for refusing to take down a sign saying that his house in Leamington Spa was for sale 'to an English family only'. He had previously been jailed for parading around in white robes and a hood as part of a minuscule British Ku Klux Klan.

Heathrow

National Front supporters demonstrated, opposing the arrival of a planeload of Asians expelled from Malawi.

Birmingham

At a technical college two white youths were badly beaten up by a gang of twenty West Indian teenagers. It was a tit-for-tat attack, after a Black boy got beaten up by a white gang three weeks earlier.

Smithfield, London

Meat porters from Smithfield market blocked the roads in support of the jailed fascist Robert Relf. The meat porters were a notoriously right-wing bunch who had previously demonstrated in favour of Enoch Powell and against the arrival of 'Ugandan Asians'.

Tottenham, North London

According to the *Evening Standard*, two hundred Black schoolkids rioted after a shopkeeper refused to serve one of them. The report in the *Socialist Worker* suggested the trouble was actually provoked by heavy-handed policing of an impromptu protest against the shop. Eighteen young Black people were arrested on nebulous charges.

Greenwich

Fascists broke into the Islamic Centre, smashed the water pipes causing flooding, razored a swastika into the wall and slashed up a copy of the Koran. The police blamed it on children and didn't investigate further.

East London

Two Asian students, Dinesh Choudhry and Ribhi Subhi Alhadidi, were stabbed to death, right outside their hall of residence, after going out for a Chinese meal. The man leading the police investigation, DS John McFadzean, claimed there was no apparent motive, while contradicting himself in the same breath saying that 'We are aware of a number of muggings and "Paki-bashing" offences on this division, though there is nothing that marks this area out as the stamping ground of a racialist gang.' Local Asians begged to differ, reporting regular violence and intimidation from gangs of white youths.

The Sus Laws

Time and again Black and Asian youths were being arrested for no apparent reason, while standing around in a group, protesting (as with the Tottenham kids), or even when the victims of a racial assault. The legal pretext the police relied on was the Vagrancy Act of 1824 which had introduced the notion of a crime defined as 'suspicion of intent to commit a criminal offence'. This meant a copper could stop and search anyone they liked, but almost invariably young people, on the meaningless basis that they looked 'suspicious'. This so-called offence became known on the streets as 'Sus' and was roundly loathed. Sometimes, by way of a change, the police might instead invoke the Metropolitan Police Act of 1839, which had the more specific charge of 'suspicion of carrying a stolen article'. This would be much used at the Notting Hill Carnival later in the summer.

IN OTHER NEWS

The press was liberally scattered with strange stories from a nation at odds with itself. In Stevenage a Chinese couple were hurt in a rice-flail gang fight. In Stafford a man nailed himself to a tree, while wrapped in a Union Jack, to protest against the police. In Wood Green a sacked bus driver dumped twenty-one gallons of paint over the bus garage.

Not all protests were as hapless. In one of the more immediately successful outbreaks of direct action this summer, five thousand Teddy Boys from all over Britain marched on the BBC to demand more rock'n'roll on the airwaves. They promptly got their wish, with Stuart Colman's Saturday afternoon rock'n'roll show starting on Radio 1.

At 2am on 23 May, at the junction of London's Haymarket and Jermyn Street, a tall young chef called James Smyth was kicked to death by a gang of youths. Plenty of people drove by as it was happening. None of the cars stopped. The Rolling Stones were throwing a party at Sotheby's just yards away.

Police inquiries revealed that Smyth had been drinking in Louise's on Wardour Street, a lesbian club that had become popular with the arty crowd who milled around a new band called the Sex Pistols. His assailants had been at the Sundown Club, a big disco on the nearby Charing Cross Road. Out on the street, after the club, they were shouting football chants and stealing sweets from the late-night stall on Shaftesbury Avenue.

That's when they saw James Smyth. He was very tall (6ft5in) and was wearing clogs, and that was enough for them, ten in number, to surround him, insult him, chase him, kick him and finally stab him in the heart with a flick knife. The police arrived moments later and a

passer-by attempted to give Smyth the kiss of life, but it was too late. There was a protracted investigation and eventually ten youths were arrested and charged. None of them was convicted of murder – only assault and 'causing an affray'. They received sentences of between three and four years. The only reference point the press could find for such a senseless killing was the violent dystopia portrayed in the film (and original novel) *A Clockwork Orange*. The movie's teenage hooligans, the *droogs*, were alive and well on the streets of Soho.

SPORT

Boxing

The British heavyweight Richard Dunn fought Muhammad Ali in Munich. Dunn, the underdog's underdog, was still working as a scaffolder in Bradford at the time. Ali won in five rounds, knocking Dunn down five times along the way, once with what he called his 'accupunch', which he claimed to have learnt from Bruce Lee. Later Dunn said: 'The showbiz stuff got on my nerves, but I enjoyed Ali himself. He were a great fella; a fabulous man. When the cameras weren't there, he were just an ordinary guy. I liked him.'[11]

Euro 1976

Football fans rioted in Cardiff after Wales lost to Yugoslavia in the second leg of the quarter-final of the European Championship. Needing to win by three goals, they could only draw 1–1 in a match dominated by controversial refereeing decisions made by the East German Rudi Glockner. The fans blamed him and anyone else at hand as they invaded the pitch after the match. A policeman was bayoneted in the neck by a corner flag intended for Mr Glockner, and Wales were banned from playing international matches in Cardiff for four years. No surprise to people like me who had attended the infamous Cardiff City v Manchester United match of the 1974–75 season – one of the high-water marks of ugly football hooliganism, with Cardiff fans singing about the Munich plane crash and the Mancs responding with mocking chants about the Aberfan disaster.

FA Cup Final

Second division Southampton beat First Division Manchester United 1–0 in a major upset. They were gifted the winning goal by United's ageing goalie Alex Stepney. The match was later immortalised in a cod-folk ballad performed by Birmingham's Jasper Carrott, one of the new breed of folk singers turned comedians. The song neatly captures the trials of trying to watch live sport on temperamental seventies televisions – 'me vertical hold went up the spout, me contrast knob fell off.'

Cricket

The West Indies team arrived in the UK. They started playing a series of warm-up matches. The press latched on to the ferocity of their fast-bowling attack. There was much debate as to who England should select to counter this threat – promising youngsters or gnarled veterans.

SOMETHING ROTTEN IN THE STATE OF YORKSHIRE

There was a grubbiness to the seventies and it was everywhere. It was both literal – the bus stations, the dole offices, the football stadiums, the public conveniences – and spiritual. And nowhere was that more clearly evident than in matters of sex.

Somewhere there was a world in which beautiful people had beautiful sex with each other under a golden sun. Somewhere lithe young hippies were having free love. But the nearest the people who didn't live in Chelsea or Marbella or San Francisco got to free love in 1976 was the tawdry variety featured on Page 3 of *The Sun* and to be found in the dirty mags on the top shelf of every newsagent. Sex in Britain in 1976 was a big and dirty business.

If there's an image that sums up the tone of seventies Britain, it's the torn-out pages of *Fiesta* or *Knave* that seemed to proliferate wherever there was a scrubby patch of undergrowth on the edge of a playing field or next to a layby.

I first became aware of it, this grubby underworld, when I was twelve and my friend Steve and I would go into Cardiff centre searching for Marvel comics. They were hard to find back then; not really distributed in the UK. But if you walked down the seediest street in Cardiff's generally pretty seedy city centre, there were dark little bookshops that had comics in the window, and if you ventured inside, there would be a rack of American comics alongside the copies of *Commando* and *Wild West Stories*.

All these shops had mysterious rooms beyond the counter, mostly

Stefan Kiszko and his mother, Charlotte Kiszko.
Victims of a truly shameful miscarriage of justice.

hidden from view by a beaded curtain. And while we were choosing between *Daredevil* and *Spiderman*, shabby men would come in and pass through the curtain and we would glimpse magazines there. The man on the till would always give us a funny look as we bought our comics, as if he was somehow surprised that that was all we wanted.

A little while later I noticed a story in the local paper. One of the shops we'd bought comics from was in the news. The proprietor had been busted for selling pornography. Apparently this particular emporium had a secret basement where he kept the hard stuff. I was horrified and fascinated. What sins lay right beneath our noses?

Too many to countenance, was the answer, and some of them much worse than we could have imagined.

In the summer of 1976, two misogynist murderers were at loose in Yorkshire, one obsessed with prostitutes, the other with pornography. Both should have been caught at the time, but neither was. And by a malign coincidence, the same senior detective was responsible for both botched investigations. The story of Superintendent Dick Holland's inglorious double failure speaks volumes about the changing attitudinal fault lines in Britain in the mid-seventies.

This summer was different from the off. The second weekend in May 1976 was blazing hot from Friday to Monday. It was a weekend made for partying, and one of those revellers was a young Black woman from Leeds called Marcella Claxton.

Leeds in the seventies was in flux. A redbrick Victorian city with a busy city centre full of soot-blackened buildings alongside the sixties Merrion shopping centre. Leeds had grand plans to be 'The Motorway City of The Seventies', and ran one of these motorways right up to

the edge of the city centre. There were ring roads everywhere as the planners assumed that the car would always be king.

That Saturday night, 8 May, Marcella was out late at a party in the city's Black stronghold, Chapeltown, the once prosperous, now rundown suburb to the north of the ring road. Walking home drunk at four in the morning, she was stopped by a man in a white car who offered her a lift, taking her for a prostitute.

She wasn't a prostitute – but inebriated and heat-blasted, she took the lift anyway. The man didn't take her home. Instead, he drove into a nearby park, a place called Soldier's Field. Marcella Claxton staggered out of the car to go for a pee. The driver, a 30-year-old man with black hair and a black beard, got out of the car too. He was carrying a hammer, which he used to rain down a series of blows on Claxton's head.

He stood over her then. Somehow, she wasn't dead yet. He was about to finish her off when he had an attack of something like conscience, as he later told the police:

> I don't know what it was this time, but I just couldn't go through with it, I could not bring myself to hit her again for some reason or another and I just let her walk away, possibly to tell the nearest policeman or passer-by what had happened . . . I went back to the car in a stupefied state of mind, I just had a feeling of morbid depression, I didn't care whether she told anybody or not, and I drove back home.

Marcella Claxton somehow made it to a nearby phone box, where she called an ambulance. As she waited, crouched down in the phone box, she saw the white car return and drive around looking for her. Fortunately, he didn't see her, and in due course an ambulance arrived. She was taken to hospital, where it took 52 stitches to close the wound

in her head. She needed brain surgery too and would never fully recover. But she was able to give the police a description of both the man – black hair and beard, Yorkshire accent – and the car – white with red upholstery.

The man who'd attacked her was, of course, Peter Sutcliffe, soon to be known as the Yorkshire Ripper, who'd started his campaign of misogynist violence the year before. He'd bludgeoned and stabbed three women, leaving them grievously injured, before killing for the first time in October 1975, his victim a woman called Wilma McCann. He'd killed again in January 1976, this time Emily Jackson, a 42-year-old woman who had been coerced by her husband into sex work. Marcella Claxton was almost next. Over the following five years he would kill eleven more and bring fear to the lives of women in Yorkshire and beyond.

He could have been caught in that May of 1976, or even earlier, but he was grimly lucky in the calibre of the detectives charged with his pursuit. Superintendent Dick Holland had already investigated an earlier victim of Sutcliffe's, Olive Smelt, who had also survived an encounter with his hammer, just about. It was a hot August evening in 1975, and Olive had been to the pub, where she had been accosted by a bloke with a black beard who called her a prostitute. She told him she was nothing of the sort and gave him what for.

Walking home later, though, she saw the same man again, and this time he had a hammer in his hand. He used it to hit her over the head twice. She fell to the ground and the man pulled out a knife. He was ready to kill her when a car came along, catching them in the headlights. He ran off and she was rushed to hospital, terribly injured by the blows to the head. Like Marcella Claxton, she offered the police a good description and was very clear that her assailant was a Yorkshireman.

Dick Holland, however, failed even to realise that the two women

had been assaulted by the same man, despite all the obvious similarities. Neither did he connect either crime with the two murders Sutcliffe had now committed. In the case of Marcella Claxton, his investigation was particularly half-hearted. Holland and his colleagues sat on their hands and referred to Claxton among themselves in vilely racist terms (she was referred to as 'just this side of a gorilla'). She, meanwhile, lost the baby she'd been pregnant with, and was left with terrible headaches and profound depression.

Holland and his colleagues weren't much more concerned with the women Sutcliffe had murdered. They were written off as prostitutes who, in essence, deserved what they got. That attitude would only change a year later, in the summer of 1977, following the murder of a sixteen-year-old girl called Jayne MacDonald. She was obviously a 'good girl' and the police and press belatedly accepted that there was a monster on the loose, the 'Yorkshire Ripper'.

A dedicated squad was set up to find this Ripper and Dick Holland was made second in command. However, his – and his colleagues' – inability to recognise the importance of the evidence of Marcella Claxton and Olive Smelt, meant the investigation was disastrously flawed, allowing Sutcliffe to kill again and again before his final capture. It's little wonder that trust in the police, once a given, was starting to fray at the seams.

The second Yorkshire murderer driving around looking for prey, a little later that summer, was a man called Ron Castree. In subsequent years, he would become one of those men that ran a comics and dirty mags business. First a market stall, then a shop. His son Nick's memoir, *Did You Never Suspect?*, describes how Castree brought the mags home to show his wife and kids, telling his wife he was showing her what

she was lacking, telling the kids, three boys, what women were really all about.

Before that though, back in this hot summer of '76 when he was in his early twenties, Ron Castree was a taxi driver around Rochdale, a struggling former mill town nestled in beautiful countryside ten miles or so north-east of Manchester. He was the sort of taxi driver who was always trying it on with women unfortunate enough to be sat in his sticky plastic backseat. And it wasn't only grown women that interested him.

On 3 July 1976, a baking Saturday afternoon in the absolute heart of the heatwave, Castree was driving around in his taxi when he spotted a nine-year-old girl, tiny and with learning difficulties, on the Turf Hill Estate. He snatched her up, stuck her in the cab and drove off to a derelict house near by. There, he sexually assaulted her, before the girl managed to kick him in the legs, break free and run home.

She told her mother that a man had done things to her, and her mother called the police, who took them out looking for any sign of her assailant. As luck would have it, there he was, Ron Castree, still driving around in his red taxi. The little girl identified him and Castree was arrested and charged with indecent assault.

However, and this is hard to believe, the police didn't send this up to the Crown Court to be prosecuted as a serious crime – but allowed it to be dealt with in summary fashion by the magistrate's court. On 12 July, just nine days after the assault, Castree went to the court, admitted his guilt and was fined £25 on each of the two charges – a punishment one might have thought more appropriate to a speeding fine than to a sexual assault on a child.

We now know that the previous October, Ron Castree had abducted another little girl from that same estate. Her name was Lesley Molseed. She was eleven years old but looked younger, being only four feet tall

and three stone in weight. Castree had picked her up in his taxi and drove her to nearby Rishworth Moor, where he sexually assaulted her and then stabbed her to death, before ejaculating on her body.

The investigation had been led by Dick Holland, then based at Halifax. He'd soon found a likely suspect – not Ron Castree, but a young man called Stefan Kiszko.

Stefan Kiszko was twenty-three years old, a clerk in the tax office. He was tall and very overweight, around twenty stone. He had a knock-kneed walk and a funny face. He lived with his mother, Charlotte, to whom he was devoted, and he was what might charitably be called 'a figure of fun' to local kids.

And it was local kids who brought him to the attention of the police. A few days before Lesley Molseed's murder, there had been allegations that a man had flashed at schoolgirls. Two of the girls came forward and pointed the finger at the local weirdo loner, Kiszko. The police questioned him and he denied it.

But then they discovered there was something odd about Kiszko's sexuality. He had recently been diagnosed with hypogonadism, a condition which meant his testes didn't function properly and didn't produce sperm. As a result, he was now getting testosterone injections. These had had the effect of giving him a new interest in sex, the main expression of which was a cache of magazines that he kept hidden in his car. The police started to wonder, then, if Kiszko might not just be a possible flasher, but could also have abducted Lesley Molseed.

They took him in for questioning again, on 21 December 1975. He was accused of being both a flasher and a murderer. Kiszko protested that he was neither of those things, but the longer he stayed in the police station the more anxious he became, desperate to get back home to his mother and the Christmas preparations. This is how he later explained what happened:

Holland was very aggressive and threatening in his manner. He kept poking me in the shoulder and kept saying, 'I'll get the fucking truth out of you.' I remember being very intimidated by what Holland had done and said to me and I thought I would get beaten up unless I made admissions.[12]

So eventually he gave in and started to give Dick Holland and his team what they wanted – hoping that, if he just went along with things, they would let him go, and then later he could take it all back as the tissue of falsehoods it was. After thirty hours in custody, he signed a confession which had been written down by Holland himself. It contained a couple of details that should only have been known to the murderer – unless, that is, the police officers had introduced them into the interrogation, or Holland had simply written them in to the confession . . .

Once the confession was signed, Kiszko was finally given access to a solicitor. The first thing he did was to tell the solicitor that he wanted to take back his confession. So, three hours later, he produced a second statement, denying everything he had previously admitted to.

Kiszko, who was assessed by a psychiatrist as having the maturity of a 12-year-old, assumed that that would be the end of things. What he did not realise was the potency of a confession – even one that had since been taken back – in a prosecution case.

As far as the lead detective, Dick Holland, was concerned, he had his confession. And the motivation of sorts; the notion that the testosterone shots might have had a Jekyll and Hyde effect on Kiszko. The police added in some extremely circumstantial evidence: some fibres on Lesley's body, which were broadly similar to those found in Kiszko's car; and a minute amount of blood on a knife belonging to Kiszko, though it was impossible to know who, or what, the blood came from.

And so, Stefan Kiszko was charged with murder and held in prison on remand.

His trial began at Leeds Crown Court on 7 July 1976, just four days after Ron Castree had been arrested for abducting another little girl. In a fairer world with better police, Stefan Kiszko's trial would have been halted the minute Castree was arrested. Someone would have made the connection between the taxi driver abducting and assaulting one little girl from the Turf Hill estate, and the man in a car who'd abducted Lesley Molseed from the same estate nine months earlier.

But the better, fairer world was not the one the West Yorkshire police inhabited. Dick Holland had his murderer, and he had no interest in reconsidering anything.

The jury were presented with this awkward giant of a man, the testimony of the girls who said he'd flashed at them, and the bits and bobs of circumstantial evidence. What the police prosecution leant hard on, though, was the matter of the testosterone shots.

Unfortunately they were helped enormously by a supposed defence witness, a psychiatrist called Dr Michael Tarsh, who had examined Kiszko shortly after the trial began. His appearance on the witness stand was absolutely disastrous for the defence case. Here's how the court reporter summed up his evidence:

> Lesley Molseed, the Rochdale schoolgirl stabbed to death on Moorland in October, probably 'signed her own death warrant' with a childish slip of the tongue, a psychiatrist said at Leeds Crown Court yesterday. Dr Michael Tarsh, a consultant psychiatrist called for the defence, said Lesley probably triggered off the stabbing with a taunt such as, 'you dirty old man,' or 'you ought to be locked up.'
>
> The doctor said that if the accused man was the killer he would not have been responsible for his actions. He said Stefan Kiszko, a

civil servant, had an emotional age of 12 but had been boosted physically and sexually with sex hormone injections and treatment for anaemia . . . According to Dr Tarsh, the treatment had made him uncontrollable and he would have been suffering from diminished responsibility at the time. He said that, as a result of the treatment, coupled with his emotional instability, Mr Kiszko would have been liable to pick up children. He added: 'he would not know how to approach a 17-year-old girl. He would not know how to go about intercourse.'

This clearly convinced the jury that the apparently mild-mannered Kiszko was only one testosterone shot away from turning into a beast, and he was duly convicted of murder.

Stefan Kiszko would spend the next sixteen years in prison, where he was reviled and regularly beaten up for being a child-murderer. His mental health, never strong, declined terribly as he retreated into schizophrenia.

His story might have ended there had it not been for the unrelenting efforts of his mother, Charlotte, a Slovenian émigrée who'd spent her working life in the cotton mills. She was always convinced of her son's innocence – and after fruitlessly contacting the likes of her local MP Cyril Smith (himself, as it later turned out, a paedophile), she finally got help, in 1987, from the campaigning group Justice, and a solicitor named Campbell Malone. He told me how he became involved, introduced by a friend and fellow solicitor, John Pickering, who had helped Charlotte Kiszko and her sister receive some compensation for the lung disease they had contracted while working in the mills. Charlotte Kiszko made a big impression on Malone:

She was lovely, very feisty. She was small and indomitable, very hospitable. Once I started working with her, she came to the office the first time, but every other time I went to her home. Charlotte and her sister Alfreda would be there, both wearing identical overalls, and within minutes there'd be plates of homemade jam tarts.

She was very driven. She didn't like the press! They all had Stefan down as a monster. She didn't like anybody who'd been hostile to Stefan. She'd tried to get help from Cyril Smith, but he was very unsympathetic. Back then few people had any idea of just how appalling he [Smith] was.

That was the thing about Charlotte. It wasn't just a mother's love. She knew he didn't do it, because he was with her at the time. She would grab hold of me by her arm and say, 'Please, please Mr Malone. Get Stefan home.'

Campbell Malone fought hard to do just that, but the efforts to get a new trial took years and meanwhile Stefan Kiszko himself was deteriorating. Malone remembers their first meeting:

When we sat down together, he just came out with a torrent of made-up words. It was all nonsense. He was clearly ill. When that settled down, he was a very gentle person. He was painted as simple, but he wasn't. He was not dumb by any means. He had quite a mischievous sense of humour, but he was suffering from full blown schizophrenia, very damaged. I've acted for all sorts of people, and some were genuinely scary. I never felt a moment of anxiety with Stefan. He was not creepy in any way. It's a cliché but he was a gentle giant.

After fifteen long years the case was finally referred back to the Yorkshire police for re-examination in 1991. Campbell Malone recalls that 'It fell

in the lap of a very capable policeman called Trevor Wilkinson, who approached it as he would any other murder case.'

He began by looking to see what forensic evidence had become available. First, he looked for DNA, but all of Lesley's clothing had, quite wrongly, been destroyed. However, he next looked at the forensic laboratory notes, which Malone had been asking to see for years, but had been blocked at every stage. Wilkinson soon spotted something odd:

> Trevor saw that there was a discrepancy between the findings with relation to the semen samples found on the body and the samples taken from Stefan by this police surgeon, Dr Tiernan. Tiernan had recognised the condition Stefan was suffering from, hypogonadism, and asked him to produce a semen sample.

This was an explosive discovery. Kiszko's hypogonadism meant he couldn't produce sperm. The sample of his semen that the police had taken confirmed that. The semen sample found on Lesley's body *did* contain sperm – therefore Stefan Kiszko could not have been the killer. Detective Superintendent Dick Holland later swore blind that he had never been given this information, but if that was so, it could only be because he deliberately avoided seeing it. Nevertheless, Wilkinson decided to double check the finding:

> Trevor approached me and said, 'Would Stefan give a sample? It could either clear him or incriminate him.' I explained this to Stefan and he was happy to cooperate. With some difficulty he provided a sample and I remember I got a call from Trevor to say that it didn't match. That afternoon I went to see Charlotte and things accelerated very quickly from there.

Following this revelation Stefan Kiszko was moved to a hospital in Prestwich. The retrial itself was now a formality. And to cap it all, the four girls who had claimed Kiszko had flashed them in one of his imagined testosterone rages confessed that they had made it up. 'At the time it was funny,' one of them said. Malone remembers the day the appeal verdict was delivered:

> I was there the day they gave judgement. Stefan wasn't there, he couldn't face it. I knew that we were going to win. But the judgement itself was very mealy-mouthed. It was almost as if they were saying that it was Stefan's own stupid fault he got himself convicted. There was no apology, no criticism of the police. But I can remember the wave of emotion. I nearly broke down at that point. It was a physical thing rising up in me.

Charlotte was overcome with joy at the news. However, it was another month or so before Stefan was well enough to be discharged from hospital:

> Charlotte found it very difficult to accept that there was a problem. She couldn't understand why he couldn't come home straightaway. She couldn't accept that he was damaged, would never be able to hold a job down.
> [The years in prison had broken Stefan Kiszko.]
> Stefan found it very difficult to cope with any attention. He was OK at home with his mum and aunty Freda and their regular trips to the garden centre. But if people were nice he couldn't bear it.

When Malone introduced Stefan to two psychiatrists who were working on the psychology of false confessions, they spent the day with

him – and afterwards he was physically sick from the stress of reliving his dreadful experience. Soon his health went into a terminal decline, culminating in a fatal heart attack less than two years after his release:

> He came out in spring. His first Christmas he was very poorly, and he died just before the next Christmas. By then Charlotte had realised how fragile he was. She was devastated. My wife Judith and I went round. She clung to Judith and just sobbed. She said she was glad he went first, he couldn't have coped without her.

Charlotte herself died soon afterwards. She had battled her own ill health long enough to see her boy released but now there was no need to keep on.

It would be a full fourteen years after Stefan Kiszko's release before Lesley Molseed's killer was finally caught. Ronald Castree had been arrested again, in 1978, for abducting a seven-year-old boy. He'd stripped the boy naked, and who knows what would have happened next if the kid hadn't screamed his head off and a passer-by intervened. Once again, though, the case went no further than the magistrate's court and Castree got off with another fine – £50 this time.

He then kept clear of the law until 2006, when he assaulted a prostitute. She reported him and he was obliged to give a DNA sample. That case never made it to court, but the DNA sample was entered into the system anyway, and showed up as a perfect match for Lesley Molseed's murderer. Castree was convicted of the murder in 2007 and sentenced to life imprisonment with a minimum term of 30 years.

Dick Holland had received a promotion in recognition of his work in the Lesley Molseed case. Interviewed when Stefan Kiszko was proved

innocent, he commented: 'My conscience is clear. Whilst I feel sorrow for Mr Kiszko, I did an honest, professional job. I did not stitch him up.'

Campbell Malone is rather less impressed by Holland: 'I knew of his reputation. He was an old-fashioned thief-taker – somebody who was promoted way above his abilities. Even after Stefan was cleared, he always maintained he was right.'

With a final terrible irony, Malone discovered that there was one person who had spotted the link between Ronald Castree and the murder of Lesley Molseed at the time. And that was Stefan Kiszko himself.

After Stefan and Charlotte had both died, Malone and his wife Judith were given the onerous task of clearing out their belongings. 'We spent a day in tears going through the letters – every letter he sent to her and copies of all the letters she wrote to him.'

Along with the letters there was a collection of newspaper cuttings that Stefan had made, dealing with crimes in the area. Malone didn't understand their significance at the time but 'looking back, I realised they related to Castree. He'd spotted him then.'

So there it is: Stefan Kiszko would have made a better detective than the late Dick Holland ever was. But this was a world where the substance of a man's character mattered rather less than whether his face fitted in. Holland was the type of man who slotted perfectly into the police culture of the time. He and his colleagues repeatedly failed to arrest the ostensibly regular bloke Peter Sutcliffe, while railroading Kiszko, the big clumsy oddball, with impunity. He destroyed Kiszko's life – and his mother's too – without so much as a second thought.

FILMS

May was a thoroughly dispiriting month for the film world. The only major releases of any note were Richard Lester's reflective *Robin and Marian*, with Sean Connery and Audrey Hepburn returning to Sherwood Forest twenty years after their original adventures, and Jack Gold's First World War drama *Aces High*, an adaptation of R C Sheriff's *Journey's End* with the *Clockwork Orange* star Malcolm McDowell. More highlights (and lowlights) to tempt cinemagoers that May included the following.

The Tenderness of the Wolves
A belated British release for this Fassbinder production, which offered a much darker reflection on the First World War and its aftermath. It's a morally challenging take on the story of the real-life serial killer Fritz Haarman, who sold his victims' bodies for meat in the starving Germany of the post-war years.

Black Emanuelle
This was a lot more successful at the box office, as it managed to combine two big seventies movie trends: making blaxploitation versions of mainstream hits and calling every softcore movie with a French-ish girl in it 'something Emanuelle' (or variants of that name). This one was set in Nairobi and features the Eurasian Laure Gemser being raped at a 'tribal ceremony'.

The Sky Riders

In this movie 'vastly improbable lefty revolutionaries' kidnap Susannah York, with Charles Aznavour playing a Greek cop.

Trial By Combat

A comedy thriller which *The Guardian* deemed 'unspeakably inept', featuring Donald Pleasance as a fascist who dresses as King Arthur and invites rapists to trial by jousting. One thing that is only going to get clearer as the summer moves along is that rape is a very big theme in the movies.

Double Bills

Alongside the new films, though, the cinemas also showed any number of old movies. This was before the advent of home videos, so picture houses regularly recycled movies from previous years, often in double bills. As a result, in early May in London you could see *Don't Look Now* paired with *The Devil Rides Out*, *Shampoo* playing alongside *Confessions of a Pop Performer* – and a Pasolini double bill of *The Decameron* and *The Canterbury Tales* clearly marketed as sexploitation. And softcore movies with ludicrous titles took up about a third of the city's screens. By way of a contrast, not one but two London cinemas were showing *Woodstock*, the film of the festival that had been the previous decade's notional high point for peace and love.

MUSIC

While British politics was still struggling to get away from the shadow of the war, British pop was trying to escape the shadow of the Beatles. In March, EMI had re-released all twenty-two original Beatles singles. In May, Paul McCartney's Wings, the biggest British band of the moment, released their new album, *Wings at the Speed of Sound*. Other major chart albums were also from sixties survivors – Led Zeppelin's *Presence* and the Rolling Stones' *Black and Blue* – though neither of them could match the success of the four Swedes who had taken over the Beatles' mantle as purveyors of universally palatable pop tunes. Abba's *Greatest Hits* reached number one in early May and would stay there till July.

When it came to live music, both Bowie and the Stones were on tour. But they were familiar fare, at least for the music press. Its journalists were eager for something new and exciting. So the arrival of the far less famous Patti Smith, for a one-off show at London's Roundhouse, received almost as much attention.

All the Patti Smith coverage did at least pay homage to the potential of a woman to shake up the boys' club of rock'n'roll. But elsewhere sexism was omnipresent. Take just one May issue of the music magazine *Sounds* and it included all these:

A photoshoot of a band called Strapps manhandling a barely clad woman in the back of a taxi.

A picture of Chris De Burgh, of all people, standing next to a topless model to promote his new single, 'Patricia The Stripper'.

The John Peel column showing a snap of Radio 1's coolest DJ with a topless woman reclining in his lap.

NEW ALBUMS

Move away from the top of the charts and there was a plethora of fine new releases from artists in a whole range of genres. Here's a sample:

Gil Scott-Heron & Brian Jackson – *From South Carolina to South Africa*

South Africa would be much in the news this summer, as its people fought against the apartheid regime. The radical American jazz-funk poet Gil Scott-Heron sent a message of solidarity across the Atlantic. The lead single from the album, 'Johannesburg', offered a rallying cry for the resistance: 'What's the word? Johannesburg!'

Ramones – *Ramones*

One of the most influential albums ever. The Ramones – four leather-jacketed New Yorkers pretending to be brothers – provided the template for what we would soon be calling punk rock. The album consisted of fourteen breakneck rock'n'roll songs with simple chords, cartoonish lyrics and extraordinary energy. All over in 29 minutes.

AC/DC – *High Voltage*

Were AC/DC punk rock too? The music press wasn't sure yet. No matter – these bumptious hard-rocking Aussies toured Britain relentlessly throughout the summer, and their high-energy live show

found them an eager audience of straight-ahead rock fans. Like the Ramones they would go on to sell a billion T-shirts off the back of taking rock'n'roll back to basics.

Steely Dan – *The Royal Scam*

Serious rock fans lapped up *The Royal Scam*. Its lyrical cynicism and super-sophisticated jazz-funk rock, played by the finest session men money could buy, seemed to have been beamed in from another planet to most rock music. The characteristically misanthropic 'Haitian Divorce' was an unlikely hit single.

Thin Lizzy – *Jailbreak*

Not since Status Quo had a new band so completely captured the all-important 'lads in denim jackets' demographic. The irresistible hit single 'The Boys Are Back in Town' led the way. The mixed-race Irishman Phil Lynott was one of the great frontmen of his day, his voice as distinctive as the band's twin guitar lines.

Bob Marley & the Wailers – *Rastaman Vibration*

The fact that this underwhelming album was Marley's biggest chart success yet reflected his rising popularity, rather than its intrinsic merits. It includes 'War', a setting of a Haile Selassie speech demanding freedom for Angola, Mozambique and South Africa. By the time the album was actually released, both Angola and Mozambique had indeed become independent.

June Tabor & Maddy Prior – *Silly Sisters*

The British folk scene had never been healthier than in the mid-seventies. Every town had its own folk club, which gave an array of talented musicians ample places to play. June Tabor was a new voice

and a big favourite of John Peel. Here she teamed up with Steeleye Span's Maddy Prior to make a very fine traditional folk record, which the record company, Charisma, in its wisdom, packaged to look like a pop disco album.

LIVE SHOWS

The live music circuit was in rude health in 1976. At the top end there were festival and stadium gigs for the biggest acts like the Who or Elton John. Then there were the concert halls, mostly big old cinemas like the Cardiff Capitol or the Birmingham Odeon, where the next layer of major acts played – American newcomers Kiss and Nils Lofgren were big attractions this month. Below that there were civic venues, places like Silverman Hall in the Lancashire mill town of Nelson, where, on 16 May, you could have seen some cutting-edge British jazz from the Mike Westbrook big band. Then there were the pubs which hosted any number of good time R&B combos, plus up-and-coming new names like Joe Strummer's 101ers, who would be tearing up the Red Cow, Hammersmith, on 12 May for just 50p. And not forgetting the folk clubs where, on 18 May alone, you could see, just for instance, the utterly marvellous folk harmony group the Watersons at the Blundell Arms, Southport, or the Teesside all-round entertainer Vin Garbutt at the Royal Hotel in Par, Cornwall.

The whole country was well served with quality live music, but it was still the case that the biggest shows were largely concentrated in London. Here are a few of the month's most notable live events:

The Rolling Stones played six shows at Earl's Court. The night of the first gig, the after-party was held at the Cockney Pride Tavern beneath Piccadilly Circus, presumably to show they were still men of the

people. The next night, Ahmet Ertegun, their American record label boss, threw them a party around the corner at Sotheby's, with Princess Margaret and Caroline Kennedy in attendance, and Bianca Jagger holding court in the Ladies. The unfortunate James Smyth's murder took place just yards away.

Patti Smith played her first British gig at the Roundhouse. The New York poet turned rock'n'roller's first album *Horses* had been a huge critical hit. Almost everyone who would be involved in the punk scene must have bought a copy. I played it incessantly. And all the hipsters turned out to see her play live. 'She could be a figurehead for the decade,' said the press.

British Festival of Country and Western Music at Wembley Arena. Country music's popularity in Britain was often underestimated. Thirty thousand people came to Wembley for this annual jamboree. It was a reminder that Britain was still an agricultural nation and many people in farming villages had a real affinity with the music of rural America. Headliners were the music's two rival queens: the traditionalist Tammy Wynette and the thoroughly modern Dolly Parton, whose 'Jolene' was currently in the charts. The *Sunday Times* critic pointed out how much Dolly's stage wig resembled that of Louis Quatorze.

The Sex Pistols at the 100 Club – the beginning of a London club residency which would change the face of British music. Previously this determinedly outrageous new band had mostly played gigs in art schools, but now they had a weekly show at one of London's leading rock clubs, the 100 Club on Oxford Street.

BOOKS

The Bookseller magazine published a list of the ten bestselling paperbacks of the month, as provided by one of Britain's largest publishing consortiums, the Granada group. There's a couple of spy stories and a *Coronation Street* novelisation, a book of horoscopes and a collection of slimming recipes, but there are also no less than three books that focus on women exploring their sexuality. They're quite a trio – *Fear of Flying* by Erica Jong, *Flying* by Kate Millett and *The Further Experiences of Emmanuelle*, by Emmanuelle Arsan – and quite a study in contrasts.

Fear of Flying was a publishing sensation that has sold over twenty million copies – the pioneering story of a young woman called Isadora Wing, attempting to foreground her own sexual needs and wants in a man's world. This was positively revolutionary at the time and joyfully upended centuries of patriarchal thinking. Not that Jong herself had found it easy to write: 'It was terrible. I wrote *Fear of Flying* in a constant state of tremor. I was so scared my hands and feet kept getting cold. I kept thinking, "What are you doing, what are you putting on the page, you nut, you can't publish this." '[13]

Famously, it's the novel that invented the elusive concept of the 'zipless fuck' – 'zipless because when you come together zippers fell away like rose petals, underwear blew off in one breath like dandelion fluff'[14] – the dream of sex without awkwardness or consequences. It's also the most conventional novel of the three; a smart and funny riposte to the likes of John Updike, in whose work it's always the man who's the sexual adventurer.

Kate Millett's *Flying* is a Kerouac-like account of her first year as a feminist celebrity, following the publication of her hugely influential thesis *Sexual Politics*. It's bang up to date, set in a world that has been changed by the upheavals of the sixties and early seventies. *Spare Rib*'s reviewer was delighted to find a book with such a joyful portrayal of lesbian sex:

> *Flying* is a consciously innovatory book in its descriptions of women making love to women which is erotic and yet simple and unsensational. Millett is not concerned with argument; therefore she has nothing to prove. And so lesbian sexuality can take its place in her autobiography, naturally; a celebration of its own rightness. 'Rejoicing in our bodies' women's beauty . . . looking down on the gold of her head between my thighs while the white sky brings its first light through the ivy's green in the windows.'[15]

Despite this, the book sees Millett struggling to uphold her identity as a bisexual – caught between the demands of heterosexual monogamy and the revolutionary feminist imperative to take on an exclusively lesbian identity.

It was a conflict that was starting to cause deep divisions within feminism as a whole. Just a few weeks earlier, the Women's Liberation Movement Conference in Newcastle, attended by 1,500 women, had collapsed into chaos over the issue. Jill Nicholls from *Spare Rib* told me what happened:

> I remember being at the plenary session and it was very unpleasant, the beginning of the end really. There seemed to be hundreds of people in the hall shouting – they were feminist separatist lesbians. Revolutionary feminism was very aggressive to people who were heterosexual – there

was a pamphlet called *Sleeping with the Enemy*. That was the sort of thing that was going on.

Erica Jong had clearly seen this coming. When *Spare Rib* suggested that lesbians might find her book offensive, as her heroine has a bad same-sex experience with a manipulative feminist, she had this to say:

> I was really doing a send-up of that period in the Women's Movement in the United States when everyone said, 'If you don't try it, whether you like it or not, you're not a good feminist.' I think that's absurd and an insult to people who are inclined to be gay, or seriously gay.[16]

Fear of Flying and *Flying* were both books aimed at women trying to figure out their own sexuality. *The Further Experiences of Emmanuelle*, by contrast, was aimed at men who were all in favour of women exploring their sexuality as long as that meant they would be up for having all kinds of sex with any kind of man whenever he wanted it. To that extent the eponymous Emmanuelle was perfect, a beautiful and submissive Eurasian who would always try her best to deliver a zipless fuck.

'Emmanuelle' was a seventies phenomenon – the very definition of the 'erotic' at the time – all beautiful French people making photogenic love in equally photogenic Thailand locations; lots of soft focus and rattan chairs.

The 1974 film had been a gigantic box office success. It could still be seen in plenty of cinemas in 1976, along with any number of spin-offs. The film was actually based on a 1959 novel credited to 'Emmanuelle Arsan', which was soon reissued as a tie-in paperback and became a similarly enormous hit. *The Further Experiences of Emmanuelle* was the inevitable follow-up. For both books and film, the USP was that

they were the acceptable face of smut. They were translated from the French! And the dirty bits were interspersed with interminable swathes of cod-philosophising – what could be classier?

The author, 'Emmanuelle Arsan', was purportedly the pseudonym of a French-Thai woman called Marayat Rollet-Andriane, though there was a growing suspicion that her husband might have had more than a little to do with the writing. The message that came over loud and clear was that women might have been struggling to figure out what they desired from sex, but men were still very easily pleased.

Welcome to the *Rock Follies* – Charlotte Cornwell,
Julie Covington and Rula Lenska.

ROCK FOLLIES

During the last week of the Easter holidays, just a few days before the summer revealed itself with the first burst of hot weather, I had gone out and bought the brand-new soundtrack album to a TV show called *Rock Follies*.

Rock Follies had been the hit TV drama series of spring 1976. It could hardly have been a more unlikely one. It had no stars. Its lead characters were played by three more or less unknown women. It was set in the music business, a notoriously difficult world to get right. But there was an audience out there of kids like me who yearned to know more about the world of rock'n'roll. And while it seemed unlikely that a prime-time drama on ITV would deliver the goods, I was prepared to give it a try. It wasn't like there was a whole lot of choice.

In 1976 there were just three TV channels – broadly ITV for the working class, BBC1 for the middle class and BBC2 for the more intellectually inclined – and, for most of the country, just three music stations – Radio 1 for pop, Radio 2 for light music and Radio 3 for classical.

If, like me, you were obsessed with pop music, especially the fancier sort you heard on John Peel's late-night show on Radio 1, there was precious little to savour on TV. There was *Top of the Pops*, the weekly show with acts performing their latest hits, of course, but I thought most of the music in the charts was rubbish. And there was *The Old Grey Whistle Test*, but that just featured stuff student hippies liked. Beyond that there was just an ocean of appalling 'light entertainment'

75

music. The worst offenders were the bewildering nostalgia shows my grandmother would watch – *The Black and White Minstrel Show* and *The Good Old Days* – all set in some diabolical imaginary past full of blokes in blackface, women with parasols and chirpy cockneys doing the Lambeth Walk.

More watchable were the talent shows – *Opportunity Knocks* and the brasher, newer alternative, *New Faces*. I mostly couldn't stand the acts they had on, but I watched anyway, hoping – always hoping – that something good might turn up.

Opportunity Knocks offered its twenty million viewers a chance to see acts from across the spectrum of music hall entertainment, all introduced by the oleaginous Hughie Green, an Englishman with an odd Canadian accent who seemed to delight in his obvious contempt for the acts, covered up by the most transparently bogus praise, all summed up by his catchphrase: 'And I mean that most sincerely, folks.'

The acts themselves were mostly awful, some of them strictly amateur hour, like a man whose talent was banging a tea tray on his head in time with the music. Now and again a true star-in-the-making would emerge, or at least a hit record, normally lachrymose fluff like Neil Reid's 'Mother of Mine'. Rock music barely got a look in. About as close as it got was a group called Paper Lace, all velvet suits and moustaches, straight off the cabaret circuit, who won for weeks on end and followed up with a huge debut hit, the sentimental war ballad 'Billy, Don't Be a Hero'.

New Faces was a bit different. It eschewed the rank amateurs who would show up on *Opportunity Knocks*. Instead, it gave a chance to acts who were already working the clubs. There were more singers and comedians and less out-and-out novelty acts, and a panel of judges taken from the entertainment industry.

And what a panel it was. One of the regulars was the benevolent

Arthur Askey, a small dapper fellow in a bookie's suit and big glasses, who had fought in the First World War. Alongside good cop Askey were two bad cops, both music industry heavyweights. There was Mickie Most, whose record label RAK had scored big in the pop charts for the last few years with Mud, Suzi Quatro, Smokie et al. And there was Tony Hatch, songwriter and producer, probably best known for his run of hits (co-written with Jackie Trent) with Petula Clark – 'Downtown', 'I Know a Place', etc. – and writing the theme to *Crossroads*. But *New Faces* had made him a star in his own right, by dint of his extraordinary rudeness. If he thought an act stank, he told them so. And, in a Britain accustomed to deference and politeness at all times, at least on the telly, this was quite something.

New Faces was still full of dross that no self-respecting fifteen-year-old rock fan wanted to listen to, but it did at least have one foot in the modern world. What both shows reflected was a working-class entertainment tradition, now declining into obsolescence, people auditioning to appear at the end-of-the-pier shows that were closing down by the month.

Which, as it happens, was precisely the starting point for *Rock Follies*. It began in a showbusiness world that was dying on its feet.

Written by a gay New Yorker called Howard Schuman, whose scant previous TV work included a wilfully avant-garde meditation on the death of sixties idealism, *Rock Follies* reflected his roots in fringe theatre rather than conventional TV drama. Everything was shot on studio sets. The actors mostly had stage rather than film or TV backgrounds. There was nothing about it that suggested a hit. Nor had the team behind it expected it to be one. As Howard Schuman told me:

We had made a decision that it would all be shot in the studio, which was not popular at the time, but I love video and I love the studio because it was hyper theatrical, not realistic. My work was always charged with surrealism and music and fantasy. Nobody thought we were doing anything except maybe fringe television. We were pretty sure it would be shown late at night.

But then the executive producer Verity Lambert – the guiding light behind so much TV drama over the next few decades from *Minder* to *Widows* – decided to put it out at the peak time of 9pm. And so a mass audience found themselves plunged into an eye-opening world that would have been familiar only to fringe theatregoers.

It was a remarkable show – effortlessly, if accidentally, channelling the zeitgeist. Schuman certainly denies any intention of writing a state-of-the-nation piece, but somehow it's all there, all the elements that would come to the fore over the sweltering summer of '76. This is a Britain that's running out of steam, in need of something new but with no clue as to where to find it. The lefties are going round in self-regarding circles, the free love merchants are making soft-porn movies, the music business is chasing after nothing more than novelty, and the outside news is all bad, from the IRA to the climate crisis. And it's broilingly hot. The show's three heroines are set on finding their way out of this morass, but there'll be any number of selfish men that they have to get past first.

The series begins with these three struggling performers auditioning for parts in an obviously doomed revival of a pre-war musical called *Broadway Annie*.

There's Anna, played by Charlotte Cornwell. She's a serious actress seeing her dreams crumble as she pushes thirty, still clinging to her memories of the time she played Desdemona – no matter that it was in

rep in Nottingham. It's a career arc not a million miles from Cornwell's own experience as a jobbing serious actress. She's the most true-to-life of the three characters, which is perhaps why she's also the one who made the least impression on the viewers, lacking the cartoon energy of the other two.

There's Q, a statuesque woman who very much wishes she was living in the 1920s, and dresses accordingly. Q is played by Rula Lenska, daughter of a Polish countess, whose few screen credits at the time were in British sex comedies, most recently *Confessions of a Pop Performer*. She was, by common consent, the sexy one.

And then there's Dee –a one-time rock singer, now earning a crust as a magician's assistant, and the immediately striking thing about her is the short hair. It's really short, like Jean Seberg in *A Bout De Souffle*. It makes her look so much cooler than everyone else in the show, making her immediately the one to keep an eye on. She's played by Julie Covington, and once again her backstory isn't far from her character's. Covington had made an album in the early seventies and been part of the original cast of fringe theatre's great success story, *The Rocky Horror Show. Rock Follies* made her a genuine star and she would soon have a huge hit with 'Don't Cry For Me Argentina'. But the limelight didn't suit her and before long she would return to the theatre and then retire completely.

Broadway Annie is a complete debacle that grounds the viewer in a showbusiness world that looks more like the fifties than the seventies. That's a useful reminder that Britain in the seventies was, in large part, little changed from the fifties, especially in the kinds of provincial towns where a bargain basement musical might get put on.

As the show collapses, the three women need to find new jobs. But meanwhile they have started to enjoy singing together. Maybe they should give up on the theatre in favour of music, and try their luck as a

girl group, a three-piece combo in the tradition of the Supremes et al? And so they do. Howard Schuman explains why he decided on a girl group as the focus for the series:

> I knew three always seemed to be this magic number when it came to women in pop and rock, but there's another element too. Britain was not quite in a depression, but on the brink of a depression, and so I started thinking of great Hollywood musical movies made during the previous depression. Particularly *The Gold Diggers of 1933*, which was about three feisty women in show business, fighting for survival. I thought, there's going to be echoes of this – so it really needs to be three women.

But while the three women are indeed trying to make ends meet in an economically straitened Britain, the primary struggle they face is in their relationships. All three are portrayed as straight – though Schuman reports that Covington's winsome crop made her an immediate lesbian icon – and their boyfriends are quite a bunch.

Serious Anna has even more serious Jack, a man mostly portrayed lying in bed, reading books about the upcoming climate catastrophe. Jack's a very recognisable type – a moustachioed lefty English teacher. He's also an obviously depressed failed writer who embraces left-wing causes so as to have something other than himself to blame for his failures. He sucks the life out of Anna and then criticises her for her lifelessness.

Dee has Spike, sort of. He's another lefty, but an activist who lives with Dee in a commune in Camden. He's dedicated to overthrowing the capitalist patriarchal system. Unfortunately for Dee he mostly expresses this revolutionary fervour by sleeping with other members of the commune while she's away on tour. Again, he's a recognisable

type to anyone used to spending time with leftist activists, but rather less familiar to mainstream TV viewers.

Q's boyfriend Tubes is rather less recognisable as a type. He's a surfboard designer, supposedly from Las Vegas, and spends the first few episodes under a sun bed wearing dark glasses. Presumably waiting for his creator to figure out what to do with him.

They're quite the selection, then, these guys, as Schuman recognises: 'The most negative reactions I've got were from my straight male friends who said, "Why did you have to make the men so awful?" '

Schuman's very reasonable, if downbeat, answer is that he was simply drawing from life:

Going back to my university days, most of my really close friends were women, and the sexual component was removed because I knew I was gay. At that point, I was out. And to me, my close women friends were so extraordinary in their intelligence, so dynamic in their political commitment – and yet they were all with men who, in my opinion, were not worthy of them. Not terrible guys, but not worthy of them. And there would be a controlling element to the relationships.

And as I talked to them, there was one strand that seemed to be true for all of them. Their mothers were all Depression-era mothers. Themselves very talented, very interesting, but they couldn't really follow their natural bent because they either had to work, or they had to be at home, looking after the children. And instead of being proud of their daughters, they would, unconsciously or consciously, chip away at them. And so there was an insecurity in the women I knew, who I thought were so amazing. This made them vulnerable to men, who would (not in the most horrible abusive ways, but in other ways) control the relationship.

And when I came to London, I found a lot of the same thing. So that was part of it. I was conceiving of these men who would in some ways be controlling and bring women down. So when they went on to the road, which I knew would be halfway through, there would be liberation from their relationships, their particular men.

It's true that the three women – now a girl group called, with blunt irony, The Little Ladies – do find some liberation in pursuing their dream, but *Rock Follies* is no wish-fulfilment fable. As the series progresses, their every escape route seems to lead to a dead end. There's always a man with a plan for them, and the plans are always terrible.

The first man with a plan is the piano player from the musical. He's a nice guy, but the best he can come up with is to send the group off on the pub rock circuit, only for them to find that it's not the gateway to anything but more of the same, an endless trudge through the backroom bars. It also requires the audience to accept the fact that, while the Little Ladies appear on stage with a backing band of serious musos, these three guys never appear in the storylines – they just magically appear on stage now and again.

It doesn't really matter, however, because, as Schuman said, this isn't meant to be strictly realistic. Nevertheless, *Rock Follies* is shot through with moments of grimy authenticity. So there's a scene where the group are introduced to a possible manager. He's basically a gross caricature of a showbiz shark, too ludicrous to be credible, except that when he sticks his actual tongue down the actual throats of the three women to seal the deal, we also know that this is real. That tongue is real. The Little Ladies are giving us the uncensored version of what it was to be a female entertainer in 1976.

They are broke and exhausted. And the weather isn't helping. In another bit of weird prescience, it's already a long hot summer in *Rock*

Follies world. 'It's too hot, must be a hundred today, my fingernails are melting,' says Q.

Dee sits around trying to re-ingratiate herself with the commune by reading something called *The Death of Capitalism*. Anna's doleful Jack, meanwhile, is reading *Farewell Earth: 20 ways the world will end by 2000*.

As for their would-be manager, the man with the probing tongue – he decides to dump them before even coming up with a plan. At least he's honest about it: 'We're not looking for real women, we're looking for cartoons of women . . . We're looking for hysteria – like the Whip Sisters [presumably a riff on the real-life act The Sadista Sisters]. All through their set they keep whipping the audience!'

And so their struggle goes on: systematically the show lays bare the whole range of unappealing options for female performers in the mid-seventies. Q, it turns out, has eked out a living in the past appearing in ludicrous soft-porn movies for a cheery shyster called Chas Speed. Chas has a brainwave. He'll make them the stars of a softcore film – 'A musical with tits,' as he puts it. Chas runs with the idea. It'll be a meta musical, an exploitative film about exploitation – 'The theme is how disgusting life is . . . One way or another everyone works for the pornographers.' It's almost exactly the pitch that Malcolm McLaren would use for *The Great Rock'n'Roll Swindle* a couple of years later.

Would they be up for it? Reluctantly they would, but not when Chas decides they need to make it hardcore. None of them is prepared to go that far for their art. They've tried grit, they've tried sex, what's left? Glamour is what.

There's always another man with a plan lurking in the offing, and up pops one last manager, a young Anglo Greek entrepreneur called Stavros. And unlike Chas Speed, he doesn't want to rub the audience's nose in the filthiness of everything. He wants sophistication: Frocks

from Biba, London's style mecca, and nightclubs, not jeans and pub backrooms. The Little Ladies do as they're told.

But once again the man with a plan turns out not to have a clue. The time of Glam was just as much past as the time of defiantly un-Glam pub rock. Biba itself will have closed down by the time the series was broadcast. Britain was ready for something new, but without much clue as to what that might be.

The challenge for Schuman, both as the writer of the series and as a keen observer of his times, was to come up with a suggestion as to what this new thing would look like.

The answer he came up with was nostalgia. In this time of uncertainty, he figured Britain might start looking back in longing, back to the time when the country had come together like never before or since: 'The nation's finest hour', a.k.a. the Blitz. But by now *Rock Follies* viewers could confidently predict that nostalgia would be no more of a golden ticket for the Little Ladies than pub rock or sex or glamour. They get to perform a strange haunting lament, 'Glenn Miller Is Missing', and then the series ends with a literal blackout, as a bomb goes off and blows the club to smithereens. An ending that was both absurdly over the top and grimly plausible, given the IRA's mainland bombing campaign.

For Schuman it gave a neat circularity to the Little Ladies' journey. At the end they were no distance from where they were at the beginning, appearing in *Broadway Annie*, and the mid-seventies were far too close to the Depression Years for comfort, as Schuman explains: '*Broadway Annie* was about the uses of nostalgia to try and distract everyone from economic crisis and frustration. About saying life now is so shitty and we're so divided and we wish we were happy.'

The Little Ladies survive the explosion, physically at least. They vow to carry on but have no idea how. Each has fallen out with her

boyfriend. Dee's boyfriend Spike doesn't have anywhere to live either, as it turns out that the commune was actually owned by one of its number. And when push comes to shove, it's the guy with the capital who gets his way.

And that's the end of the most entertainingly bleak state-of-the-nation rock musical series we're ever likely to see.

Except it wasn't the end. Ironically, even as the series ended with a literal bang, with the Little Ladies further from success than ever, the soundtrack album was released into the real world and, thanks to people like me, it went straight to number one in the album charts, right at the start of the summer of 1976. The reasons why were simple: the series had hit a nerve and the songs themselves were always much better than they needed to be, or that you would expect from a TV drama.

The songs actually got better and better as the series wore on. The composer, Roxy Music's Andy Mackay, had only been employed late in the day and he was working alongside Schuman, writing songs for the next episode while they were filming the current one. The porn world episode produced a song called 'Hot Neon' which was the most contemporary sounding number yet, like Euro disco. The designers too had risen to the challenge, making each song into what was effectively a stand-alone pop video, at a time when pop videos were almost unheard of. 'Hot Neon' is all flashing Soho signs, a forerunner of Soft Cell's *Non-Stop Erotic Cabaret*, and the Little Ladies' outfits have them looking like prototypes for Kate Bush and Toyah Wilcox, both about to launch their own careers. There's very likely a musical influence too (not to mention the fact that Julie Covington was a friend of Kate Bush's older brother).

85

The uptown glamour episode had perhaps the best song of all – a shimmering electro-ballad called 'Biba Nova' – a nod to the soon-to-vanish fashion wonderland that was the Biba department store in Kensington. Howard Schuman elucidates: '"Biba Nova" is in the strand of *Rock Follies* which is about the death of the sixties. It's a political void . . . a rock void. It's at the moment of the big sleep of political idealism.'

There's a rock critic character who appears from time to time in the series and amplifies this notion. He's initially intrigued by the Little Ladies, but finally decides they're not the authentic rock group he'd hoped they'd become, but just a bunch of commercial sell-outs. He's right, of course, but then that's the point – these women had no option but to sell out. They were in a world that seemed to systematically deny female artists any autonomy.

What Howard Schuman didn't anticipate was that *Rock Follies*, in both its fashion choices and its nihilism, would be just one of the precursors of the movement that would see the music world awake from its big sleep. Because the *Rock Follies* trio actually were a success. They had a number one album. And they had starred in six hours of prime-time TV.

Thus it was no coincidence that the musical revolution they unknowingly heralded – punk rock – had so many women involved in it. As Debsey Wykes from the wonderful post-punk trio Dolly Mixture explained it to me:

As a mid teenager in 1976 I was blown away by the existence of *Rock Follies*. The fact that there was a drama about a pop group was amazing enough but then the pop group being three women was pure, utter indulgence for someone like me. The group didn't play instruments (if only, that would probably have sparked a revolution!) but they were

the main focus of the show and it was all pinned around them. The characters were all so individual and you instantly had that 'which is my favourite' pop reaction. The show fed into the general feeling of wanting to be in a band but it took punk to enable us to do that.

'It's the buzz, cock!' ran the headline to a *Time Out* feature on the show. We would soon find out just what the buzz was.

June

THE WEATHER

This was the month when the long hot summer really got going. It was pleasantly sunny and dry for the first few weeks, with the talk of drought starting to intensify. Then, from 22 June onwards, the temperature went up above 30 degrees and refused to come down below that level for nearly three weeks. It was the most sustained heatwave in living memory.

Newspapers started running endless pics of sunbathing girls alongside silly heat-related stories. Few sillier than this one in the *Daily Mirror*: 'BBC disk jockeys have come up with their own answer to the water shortage . . . bottling their dirty bath water. DJ Tony Blackburn told Radio 1 listeners yesterday: "If you have plants that are dying, write in and we'll send you a bottle." '

Before long though, the heatwave started to generate plenty of real, if often somewhat surreal, stories for the press to cover.

In Dover, a lorry carrying a cargo of kippers broke down, its refrigeration unit with it. According to the police, it was repaired just in time by the AA and the town was saved from 'a fate worse than death'.

Ted Moult, 'the celebrity farmer and strawberry grower', welcomed a bumper crop of strawberries, ten days ahead of normal and just in time for Wimbledon. And Derby's ice cream manufacturers had broken all sales records, according to their spokesperson, Mr Gino Franco.

There was an upsurge in sales of deodorant on Piccadilly, where a salesgirl, asked by the newspaper if the heat was making the customers

bad-tempered, commented, 'God yes, but then most people are crabby most of the time.'

Otherwise, there was some confusion as to whether the heatwave was also causing a crime wave. Crime was down generally in Lincolnshire, though there were plenty of fights, a well-attested heatwave symptom. Burglaries, however, were up in Bristol, where people were warned not to leave their windows open.

Hot weather is always conducive to an upsurge in workplace unrest. There was any number of sudden industrial flare-ups. In Bristol the draymen from the Courage brewery went out on strike, causing a beer drought. Also briefly on strike were the staff at the House of Commons bar, protesting at being forced to wear jackets and ties. Despite the Commons' general policy of resisting strike demands, when it came to their own bar the MPs capitulated after 15 minutes.

After a week of constant high temperatures, West Yorkshire police warned that scantily clad girls could be a 'major distraction' for motorists. The *Daily Mirror* was concerned that students having sex in the hayfields near Exeter University might be causing damage. Local farmer Edward Baxter explained that 'When I tell them to go, they give me a lot of cheek. They say the land shouldn't be private anyway. I don't think students like that are worthy of their grants.'

The *Liverpool Daily Post* offered the terrifying headline, 'Heatwave Shock as Babies Burn', going on to quote a doctor as saying that leaving toddlers out in the heat 'is like pouring boiling water on them'.

Random acts of barely motivated violence, of which Britain already had no shortage, did seem to be exacerbated by the hot weather. In York, two youths were charged with 'using two drunks like footballs', killing one of them. In London, a runaway 15-year-old, who had been sleeping rough, stabbed a stranger, then had his lawyer attempt to blame the crime on a viewing of *The Man Who Fell To Earth*. 'Horror

as a boy copies Bowie film,' went the headline. A baffled Nicolas Roeg, the film's director, pointed out that Bowie's character in the film is not actually violent.

A Salford solicitor, defending his client against charges that he had beaten his wife after she refused his demands for sex, came up with an excuse that reflected much contemporary thinking: 'It is my experience,' he said, 'that there are a lot of women in this town who do not think they are properly loved unless their husbands treat them unkindly.'

Finally, the *Birmingham Evening Mail* reported four swimming-related deaths: an eight-year-old girl drowned in the River Severn despite there being a hundred people in the vicinity, as she was caught in an underwater whirlpool; a man in his forties drowned in the River Wye; and two brothers met their deaths in a disused quarry.

THE HEADLINES

The heatwave arrived as a valuable distraction from the substance of the news. For if there was any doubt that Britain was an imperial power now living in much reduced circumstances, the two big stories of early June had swept it away.

First there was the inglorious resolution to the so-called 'Cod War'. Iceland was determined that no British trawlers should operate within 200 miles of its coastline, while Britain wanted unrestricted access. A compromise of sorts was agreed on 1 June, allowing a reduced number of British trawlers to fish in Icelandic waters for the next six months, before the 200-mile limit came into operation. The British press were in no doubt this was a defeat: 'Yes we've had our chips,' said the *Daily Mirror*. And it was true to say that this change of limit led to the loss of many jobs in the British fishing industry.

Next up was an even more serious threat to the economy. Britain had been lumbered with high inflation since the disastrous Tory budget of 1972. That had led to the Tories losing the subsequent election, but left Labour with a huge problem. The inflation rate had peaked at a terrifying 25 per cent during 1975, but was still running at an alarming 15 per cent in 1976. The pound was collapsing on the foreign currency markets and, quite simply, Britain was running out of money.

The Chancellor, Denis Healey, took the only remaining option and went in search of a loan. A collection of central banks, most of them American, came through and offered Britain what was, in effect, an overdraft facility to the tune of £3 billion. This eased the pound's slide

in the short term but would turn out to be no more than a temporary fix, while the very act of going to the central banks was generally felt to be a national humiliation. One that would be magnified in September, when Healey famously had to go 'cap in hand' to the IMF for a new loan of $3.9 billion.

While at least the Cod War had come to a close, there was absolutely no sign of Northern Ireland's civil war coming to any sort of ending. The month was dotted with terrible stories. On the first weekend there were ten people killed and another thirty-eight injured in the ever-escalating series of tit-for-tat attacks. In earlier years the paramilitary organisations, the Catholic IRA and the two Loyalist Protestant groups, the UDA and the especially brutal UVF (Ulster Volunteer Force), had generally only targeted known activists on the opposing side, but increasingly it seemed that anyone of the other religion was now fair game, especially as far as the UDA and UVF were concerned. In May they had threatened to start killing indiscriminately, and now they were following through on their threat.

This latest round of violence culminated in Loyalist gunmen entering one of Belfast's few mixed drinking establishments, the Chlorane, asking the clientele to identify themselves as Catholic or Protestant, and then just opening up with automatic weapons, without even a pretence of seeking out 'legitimate' IRA targets. And, in fact, despite their clumsy precautions, two of the five people killed were Protestants. The object clearly was to terrorise the population into taking sides. And, sure enough, this atrocity inspired a further series of pub killings across the month, while the Chlorane itself was blown up ten days after the murders. The IRA and UDA/UVF were most certainly delivering on their promises of a long, hot summer of terror.

SOUTHALL YOUTH MOVEMENT

For teenage boys growing up in the seventies, violence was almost inescapable. You were constantly on the lookout for trouble. Wrong haircut, wrong football team, wrong shoes, anything would do. But that constant sense of threat was magnified hugely if you really did stand out from the pack – if you were Black or Asian or gay.

Four years earlier *A Clockwork Orange* had evoked a dystopia in which teenage gangs beat people up for sport. By now that looked far too much like everyday reality. Stanley Kubrick had removed his film from the cinemas in horror at what it had spawned. Out on the streets there was a vicious hierarchy in which the bullies – the skinheads, the football hooligans et al. – reigned supreme, and those that chose to turn the other cheek were likely to get it slashed by a Stanley knife.

Those perceived as weak became prey. There were names for the way they were preyed on – names like 'queer-bashing' and 'Paki-bashing'. It was the Asian community who suffered the very worst of it. At least four young Asian men were murdered on the street in the summer of 1976. Two of them, students Dinesh Choudhry and Ribhi Alhadidi, had been stabbed to death outside their hall of residence in East London by a drunk sixteen-year-old showing off in front of his older mates. That was at the end of May. The feeling in the Asian community was that such outrages could not be allowed to carry on. Typical was the response of Syed Annisuddin, chairman of the League of Overseas Pakistanis:

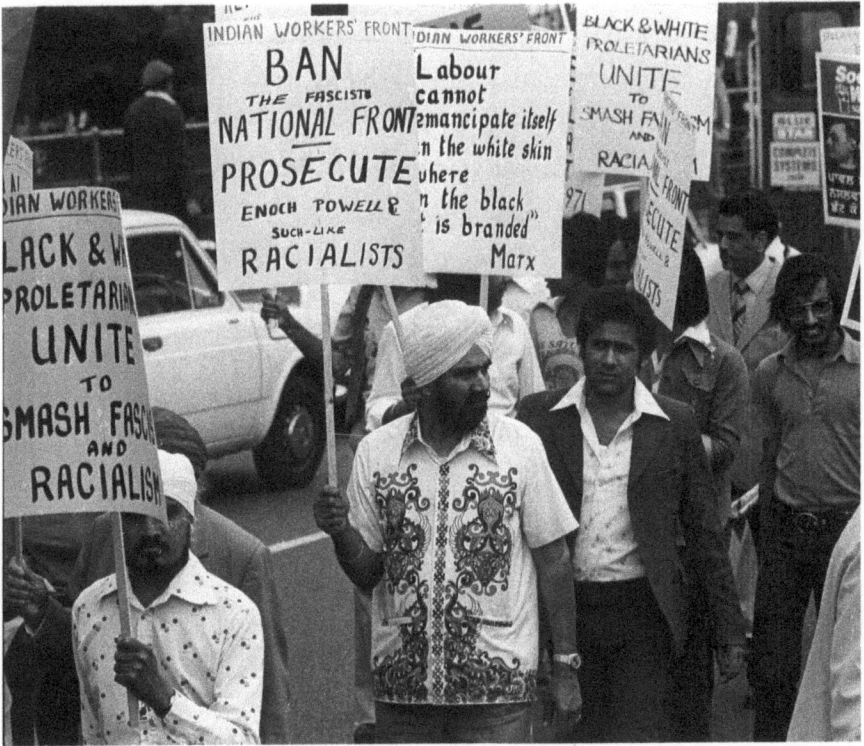

Southall in revolt: 'Black & White Proletarians Unite.'

This latest incident will make more of our people feel they should join hands and fight. I have always been a very moderate person and always felt there should be no demonstration or confrontation. But I'm beginning to think that immigrants will have to start doing something to support the anti-Fascist groups who are challenging the National Front.[1]

The catalyst for change came two weeks later on 4 June, with the third killing of the summer – that of Gurdip Singh Chaggar. Ironically, though, this was not the textbook example of racist violence that it might appear, but something messier, as life so often is.

Five lads went to the Soul City Disco at Southall Football Club that balmy Friday evening at the beginning of June. They called themselves the Soul Guys – four white, one mixed race, all between sixteen and eighteen years old. They came from far West London: Southall, Northolt, Hanwell, Acton. Some had connections to a children's home in Southall called Mill Hall. Pat was a painter and decorator. His old schoolmate Julian was an apprentice gas fitter. The mixed-race lad, Darren, worked on an assembly line. Jody was the youngest. He was the one who brought the knives along from Mill Hall. Bob was the other one. You couldn't miss Bob with his tricolour hair – bright red on top, a blonde triangle below, and then a darker red at the sides – his yellow paper jacket and his drainpipe jeans. He'd done a photo shoot for a magazine the week before. He was a Mill Hall boy, had lived in children's homes all his young life. Now they'd moved him to a hostel in Kensington, but he still came out west to socialise.

Bob wasn't the only flashy dresser. They all favoured eye-catching colours: their drainpipes were purple or lavender, their shirts sported

the wildest colours they could find. Overall they looked a bit Bowie, a bit *Clockwork Orange*. Their girlfriends dressed to impress as well – jockey caps, stilettoes, drainpipes and bright baggy mohair jumpers. You couldn't miss the Soul Guys and girls in their King's Road finery.

That night they danced till nearly eleven. The big tunes were perfect for a sweaty summer's evening: Miami's 'Kill That Roach', a slice of laidback but insistent funk, Rose Royce's irresistible party anthem 'Car Wash', and most of all Lalo Schifrin's relentless, pounding version of the *Jaws* theme, as ominous as it was funky.

The Soul Guys had been on the lookout for trouble. The Hanwell mob were rumoured to be coming down, but they never showed. Still Jody had his two knives. If there was going to be aggro, they were ready.

After the disco, which was out on Western Road, they headed into the middle of Southall, the five guys and their girls and some more of the clubbers. It was a warm evening after a few colder days and there were plenty of people out and about. They stopped for chips, then headed up King Street towards Green Street and their buses home. There were a lot of Asian lads hanging out on King Street. It had two cinemas showing Asian films and a pub on the corner, the Victory, where Asian people liked to drink. The Soul Guys carried on past the pub till they came to a café-cum-restaurant called the Pakeeza. There were more young Asians in there, drinking tea and talking. One of the Soul Guys banged on the window.

He probably thought nothing of it, just like aiming a kick at any Asian kid who got in your way in the playground. It was just the law of the jungle, letting everyone know that the top boys were around. Respect on the streets for teenagers was based on a complex interplay between a distinctive look and a capacity for violence. The hard boys saw Asians as too meek and mild. That's why giving them grief was a regular thing.

He'd doubtless done that sort of thing any number of times. But not on an early summer night on a busy street full of Asian youths who'd had just about enough of being picked on, who were starting to think that their parents didn't know what they were talking about when they told them to turn the other cheek. So one bang on a café window and everything went to hell. Minutes later a kid called Gurdip Singh Chaggar, Raju to his friends, would be left draped over the metal railings on the other side of the road, bleeding from the hilt-deep stab wound in his back.

Southall is a London suburb, about ten miles west of the city centre. It grew up around the old stagecoach road to Oxford and expanded in the Victorian era with the arrival of the Grand Junction Canal, which made it a convenient place to build factories, ranging from bricks to chemicals to margarine. Factories meant jobs and waves of newcomers came to Southall. In the 1920s it was Welsh people escaping poverty. After the war, it was Asian people who were the latest to arrive. Topographically it's a pretty typical suburb. There are two main roads with the town centre laid out around their crossing point. In 1976 there were still several cinemas, plus pubs, cafés and shops, as well as a church left over from the days when it was just a little village.

Indian people, largely Punjabi Sikhs, started coming to Southall in the 1950s. The initial driver was the proximity of Woolf's rubber factory. Woolf's general manager had served with Sikhs during the war and was an enthusiastic recruiter. Then came the announcement that Heathrow Airport was to be built near by, with the promise of large numbers of new jobs. In 1954 a man called Pritam Singh Sangha opened one of Britain's first Indian corner shops in Southall. By 1960 there were at least a thousand Punjabis living there; by 1976 the figure

was probably closer to 30,000, out of an overall population of 60,000 or so. And when it came to school-age residents, two-thirds of the local kids were non-white.

This posed a real question for schools. Was it OK for an area of London to have a majority immigrant intake? Would white parents accept their children being in a minority, or would they move their kids elsewhere? The authorities thought they knew the answer to this. It was agreed that no school should have more than 40 per cent immigrant children. They decided to keep schools in Southall (and ten other local authority areas from Luton to Huddersfield) predominantly white by bussing local Asian kids out to schools in the surrounding areas. This policy, which was enacted under a Labour government in 1964, had a liberal gloss to it. English language teaching would be provided for the children at the new schools. And the whole experience would ideally help them to integrate.

This policy may have reassured white residents that their children would not feel in some way outnumbered, but it had very much the reverse effect on Southall's Asian kids. Instead of going to a school with the people who lived near them – and shared similar experiences, language etc. – they would be sent to schools anywhere from Hanwell to Acton, where they would be one of only a handful of non-white kids and, more likely than not, subjected to relentless bullying.

This was an unacknowledged forerunner of the bussing policies that were famously put in place in the USA in the post-Civil Rights era, to make sure that schools were integrated whether white parents wanted them to be or not. A key difference is that, in the States, white kids were bussed into Black areas as well as vice versa. In Southall (along with eleven other places in England, from Bristol to Leicester to Huddersfield) it was all one-way. Asian kids were bussed out. And the suggestion that it was all about helping kids gain English language skills was given the

lie by the fact that Southall's small Afro-Caribbean population also saw their kids being bussed out of the area, despite the fact that English was their first language.

The *New York Times* sent a reporter to Southall in 1972 to observe this English bussing phenomenon. They painted a reasonably rosy picture. The kids are picked up in a nice coach, the girls sing 'I'd Like To Buy The World a Coke', the boys sing the Chelsea song 'Blue Is The Colour', as they make the journey into what a little girl refers to as 'English Language Country'.

Unfortunately, not all experiences of English Language Country were particularly rosy. The documentary film *Young Rebels: The Story of the Southall Youth Movement* offers a moving picture of what it was like growing up in Southall at that time, including the following testimonies. One Southall boy, Balraj Purewal, recalled that he and his friends were forever being given 'lines', endlessly having to write out the words 'I must not speak Punjabi in class'. Worse than that, though, was his experience of being completely ostracised by his teammates when he tried to join the school football team. No one would pass to him.

The bullying many of them experienced was merciless, but the advice from home, as Avtar Dosanjh remembered, was to keep their heads down: 'Our parents told us, "Don't answer back," but we were getting to a stage where we were being physically abused every day going to school.'

Jagdish Bangar was sent to school in Acton. He put up with endless abuse till one day he was knocked down in the playground and was encouraged to fight back. 'There was this Jamaican boy, Terry, he said, "C'mon, Bangar, get up, man," and we started getting in a fracas. Then he ran off, and I thought, "Oh, that's nice!" But he came back with a load of Black people and we had such a big scuffle.'

The violence wasn't confined to the school yard either. Gangs of

white – and some Afro-Caribbean – youth, particularly but by no means exclusively skinheads, would set out of an evening to go 'Paki-bashing'. This was in addition to the long-established tradition of going 'queer-bashing', the language of each appearing to legitimise the violent street cruises as a form of sport. And turning the other cheek didn't dissuade them. It just emboldened the gangs. These meek and mild Asians appeared to be the simplest of prey. If they were going to be resisted effectively, a new approach was obviously needed.

Jagdish Bangar elaborated: 'I remember some Sikh boy, skinheads collared him and they scarred him up, you know, scarred him with a Stanley blade – put NF on his back, and that was when I was thinking we need to stop this. That could be me, the clock was ticking.'

Jaswant Hunjan picked up the story: 'We formed a gang. Skinheads would go, "We're going Paki Bashing," so we'd go, "We're going Skinhead Bashing." At night they'd come in cars, swear at us and look for someone on their own and beat them up. There was quite a few of us, we'd stand round corners with bottles and bricks and when we'd see them coming . . .'[2]

So that's how things were in the summer of '76, on a steamy June night when a bunch of white and Black kids came banging on the windows of the Pakeeza café.

There were two cinemas within a few yards of the Pakeeza. There was the Century where two teenage boys, Javan Soba and Surinder Barij, had been to see a film that evening, and there was the Dominion, which was now owned by the IWA, the Indian Workers' Association.

The IWA was Southall's leading community outfit, well-organised and, thanks to their profitable cinema business, well-funded. They were mentioned in the local paper that day, responding to Enoch Powell's

latest piece of provocation. In the House of Commons he had said, clearly referring to Southall and places like it: 'There are now places where, by day, let alone by night, many ordinary citizens are unwilling or afraid to go abroad.' Furthermore, 'nothing could prevent the injection of explosives and firearms' into such communities. The IWA called for the government to release the actual figures on immigration to demonstrate that Powell's fearmongering was not just racist but unfounded.

By the time the Soul Guys came sauntering down the green, full of chips and bravado, the cinemas had also chucked out and there were people hanging out on the streets outside. Others were outside the pub and more still inside the Pakeeza.

Javan Soba and Surinder Barij had gone to the Pakeeza after their film finished. Which film it was isn't recorded. Maybe it was the year's big Bollywood hit, the horror movie *Nagin* (loosely based on Truffaut's *The Bride Wore Black*) or perhaps *Charas*, a thriller set during Idi Amin's eviction of Uganda's Asian population – the event that had led to an immediate surge in Indian immigration to Britain and fuelled Powell's malevolent fantasies.

In the Pakeeza, they were drinking tea and eating samosas with a few of their mates, among them a boy they called Raju. He was another Sikh, full name Gurdip Singh Chaggar. Raju's family had arrived in Southall four years earlier from Tanzania – not Uganda, but still an increasingly unsympathetic place for South Asians. Javan and Surinder were sixteen and seventeen, Raju was eighteen. He'd spent the day at Southall Technical College where he was studying engineering, then gone home for tea with his parents. He was a jolly, chubby-cheeked boy, a keen hockey player. But his parents weren't pleased with him, because three weeks before he'd decided to ditch his turban and get his hair cut, in a bid to fit in better in English Language Country.

There were others too in the Pakeeza, Indian boys in varying degrees of adjustment to their lives in West London. And when the Soul Guys banged on the window and made them jump, a bunch of them, including Raju, went outside to see what was happening on this hot and humid night.

They saw the Soul Guys and their girls, now accompanied by a few more stragglers from the disco, shouted, 'Watch it,' and started towards them. The Soul Guys and their mates, not expecting this reaction, ran off up Green Street, apart from one of the stragglers, a kid called Sean, who couldn't keep up because of his asthma – so by the time he got as far as the Century cinema, the Asian boys caught up with him and gave him a kicking.

The Soul Guys weren't having that. They regrouped outside the British Legion. Jody took his knives out, gave one to Bob, ready for action. They charged back down the street and there was a short and brutal fracas outside the Victory. Kicks and punches were exchanged, but the Soul Guys had the knives. Between them, Jody Hill and Bob Hackman stabbed one Indian boy, Gurcharan Mahal, who worked in the Pakeeza, in the neck – and another, Rashpal Bilu, in the arm. But Raju – Gurdip Singh Chaggar – got by far the worst of it. He was stabbed three times in the back and once in the chest, the knife going in all the way up to the hilt. Bob Hackman's 14-year-old girlfriend, Michelle, said it was Bob who stabbed Chaggar: 'He hesitated for a moment then stabbed him in the back.'

This shocking act of violence brought the fight to an end. The Soul Guys and their girls ran back towards the British Legion and jumped on a 120 bus. In court a witness claimed that the boys were whooping with adrenaline as they led the way upstairs and someone called out, 'Nice one, Bob.' By the same account Bob Hackman looked in the mirror, did his best to wipe the blood off his face, and took off his paper

jacket – now bloodstained as well – folded it up and put it in his pocket, then showed off the bloody knife to the girls, and asked them if they'd like to lick it.

They changed buses at Hanwell Broadway, and Hackman saw another Soul City boy, Tony Dujon, there. He showed Dujon the bloody jacket and told him to read the papers next morning. Hackman had a yen for publicity – he and his girlfriend were very proud of the fact that he'd recently posed for a fashion magazine. After that he dumped the incriminating knife and jacket in the bin.

Next day Bob and Michelle would go shopping for clothes on the King's Road, home of *The Rocky Horror Show*, Don Letts's Acme Attractions and Malcolm McLaren and Vivienne Westwood's Sex boutique. Did Hackman visit Sex? Quite possibly. Bob would have fitted right in with McLaren's gang of street urchins. More than likely, given their particular taste in clothes, they'd have gone to Don Letts' store, the fashion shop of choice for London's soul boys and girls.

After Bob Hackman stabbed him in the chest, Raju fell back on the metal railing separating the pavement from the street outside the Victory. A young engineer called Davinder Kallah had just come out of another pub, the Featherstone, and was walking towards the Victory in the immediate aftermath of the fight. He saw Chaggar sprawled over the railing and in obvious distress. Another young engineer who had been caught up in the fight, Yashpal Kalsi, quickly borrowed his girlfriend's car. Together the two boys bundled Chaggar into the motor and drove him to the nearest hospital, the West Middlesex in Isleworth. As Kalsi later recalled: 'Raju kept gasping for breath, but he did not say anything. He was sitting up in the back of the car and took his shoes off

by himself. I thought he was going to be all right even though there was blood coming from his wound all the time.'[3]

Raju wasn't all right. The stab wound to his chest had pierced his lung. He died soon after arriving at the hospital. His blood was still pooled on the pavement outside the Victory.

Word of Raju's death slowly made its way back to Southall. A few of the lads who'd been involved in the earlier fight went out looking for revenge. A white boy called Brian, who hadn't been involved in the earlier violence, was the unlucky recipient of a kicking, and ended up getting stitches at Hillingdon Hospital.[4]

Raju's parents, however, didn't realise that their son had died until the following morning, when news of the murder started to really spread though the community. Soon it was on the local and national TV and radio news. They announced that Gurdip Singh Chaggar had been murdered in a 'racially motivated incident'.

It was another warm going-on hot day, the temperature nudging up towards 25 degrees, and young people started congregating around the site of Raju's murder. One of them, Suresh Grover, remembers being horrified to see Chaggar's blood still there on the pavement, and on the railings, congealed in the heat. As the day wore on, and the temperature climbed towards 30 degrees, the youths got angrier. They started shouting at white motorists as they passed by, throwing bottles at windscreens. When the crowd reached three hundred or so, the police stepped in to disperse them.

But the anger of the community was only increasing, and the next day, Sunday, it would explode. As Dosanjh remembered, 'The word got through Southall, they've started killing people now.' And Tejinder Singh added, 'We felt like we'd got to do something.'[5]

Again they gathered around the green. The weather was climbing up towards 30 degrees. At the murder site someone painted the slogan, 'This racist murder will be avenged. We'll get you, racist scum.' There was a public meeting in the Dominion cinema that afternoon. Over five hundred people attended. It was horribly hot, sweaty and crowded, there was no air-conditioning. The mood was angry and unruly. There were loud arguments, even fights, over what to do. The old guard, as ever, preached caution and forbearance. The youngsters wanted action. When the meeting broke up in mid-afternoon the atmosphere was fractious. As one Shan Chaudhary put it: 'The elders wanted jaw jaw, we wanted war war.'

Anger started to boil over. Passing drivers received more abuse. Then a Jaguar with two white men in it slowed down. The passenger waved a pickaxe handle out of the window and shouted 'Black bastards'. That was the cue for violence to break out. The Jag got a thorough stoning.

Other cars were surrounded and given the same treatment. One had a young couple with a baby in it. The guy got out to remonstrate and was knocked down and beaten, before one of the local elders, Vishnu Sharma, stepped in to halt the attack. A young woman driving a tiny Hillman Imp just sat there petrified and unable to move, so a policeman jumped into her car, pushed her into the back seat and drove off. But it wasn't only white people who caught the ire of the youths. The Liberty cinema, another Indian-owned place showing Bollywood movies, got its windows smashed, apparently for staying open rather than closing as a mark of respect to Chaggar.

There was only a small police presence at first – Southall was hardly a known trouble spot – but the police who were there arrested two young Asian men for public order offences. This provoked the crowd further. They set off towards the police station to demand the release of their comrades.

More cars got their windows smashed along the way, and the impromptu march swelled in numbers. When they arrived at the police station, they were three hundred strong and began to lay siege. The police put up a barricade and made urgent calls for reinforcements, which duly arrived. But the marchers weren't to be dissuaded. The siege of Southall police station lasted three hours.

Balraj Purewal was there and saw that the police were initially completely unprepared for this level of anger. However they soon came up with an effective strategy. They called in the familiar community leaders and persuaded them to talk to the two men they had in the cells:

> They went into the police station and talked to the guys who were arrested. 'You'll get a record, what will your family think? You go outside and you tell people you haven't been charged.' [6]

Purewal went on to explain that this turned out to be a lie, just a tactic to disperse the crowd: 'The elders sold us down the drain. Actually these people were going to be charged.' But that was for later. In the moment it felt like a huge win. The two lads who'd been released were carried away from the police station on the crowd's shoulders. The youth of Southall had flexed their muscles and it seemed they had found they had real power. Fighting back, not turning the other cheek, produced results.

There were some further outbreaks of violence that night. People were out on the streets again, escaping the heat indoors. Two white boys were attacked near the murder site. One was stabbed in the hand, the other hit over the head with an iron bar. But there was a feeling of satisfaction among some of the community. Not only had their two boys been released, but the police had arrested five boys for the murder.

Next day, however, the *Daily Mirror* would call the events of Sunday, 'A Rampage of Vengeance'. The National Front, meanwhile, tried to claim that these events showed that Enoch Powell was right, that mass immigration could lead to nothing but trouble – as ever ignoring the fact that any trouble wasn't being stirred up by immigrants but a reaction to the continual abuse that was visited upon them.

The police had immediately realised the seriousness of this case, with its political implications. A senior policeman, Detective Chief Superintendent Jim Sewell, was placed in charge within hours of the news. That same night he made the first arrest – Jody Hill, the 16-year-old who'd brought the knives. Hill was well known around Southall and speedily identified. In turn he gave up the rest of the Soul Guys. By Sunday afternoon all five of them were under arrest at Southall police station. They didn't put up a fight. Bob Hackman told the cops that he'd dumped his bloodstained jacket and the knife in a bin in Hanwell. However, the police were unable to trace the items.

DCS Sewell quickly put out a statement that in his view this was not a racial incident – a view most likely based on the fact that Darren, one of the five lads he'd arrested, was mixed-race:

> The whole affair has been carried away on a wave of mass hysteria and a lot of nonsense talk about racial undertones. When this whole story is told, as it certainly will be, it will be plainly shown that this killing had nothing to do with racialism. This is another murder, no different to any other of its type, committed anywhere else in London[7].

This would still be the message when the case came to court a year later. By then ten young men were facing charges. Not only the five Soul Guys were on trial, but also five young Asians who'd been subsequently

arrested for their alleged parts in the fight. They had clearly been arrested in order to bolster Sewell's assertion that this wasn't a racist murder but a gang fight. None of the ten denied they'd been present when the fight was going on. The important question was the extent of their involvement. Jody Hill and Bob Hackman were the only two charged with murder – and they were both blaming each other for striking the fatal blow.

When the trial began, the first thing that struck the court was the outlandish fashion sense of the Soul Guys' girlfriends, who had turned up in force. According to the court reporter: 'Their get-ups and hair-dos brought comments from the judge, questions from barristers and the occasional giggle from the jury box.'[8] One girl sported bright pink hair and another, Bob Hackman's now ex-girlfriend, 15-year-old Michelle, was sporting 'a black leather jacket, tight jeans and a loose low-hanging belt'. These were fashions that the world was soon going to be seeing a lot more of, as in the intervening year soul style morphed into punk style.

There was no great drama to the trial. Several of the accused who had been charged with affray were discharged. A couple of others pleaded guilty to minor charges. Which left Hackman and Hill. With neither of them prepared to take the whole blame, they both agreed to plead guilty to manslaughter midway through the trial. Before they were sentenced, their barristers were at pains to deny any racial motivation. Jody's mother had told the local paper that 'he is not a racialist, he has lots of coloured friends'. His barrister, Mr Blofeld, said that Hill was a likeable young man 'who needs to grow up a little' and 'is in no way influenced by racial prejudice'[9].

Similarly Bob Hackman's lawyer said that, 'There was no wish on Hackman's part to hurt a coloured boy. There was no anti-Black or racial prejudice. Many of his friends at the time were coloured.'

Then he made the point that Hackman had no family, had grown up in children's homes and hostels.

The director of the last hostel he'd been living in, in Kensington, testified that 'Black boys at the hostel regard him as a Soul Brother.' And she likely knew whereof she spoke as this director, whose name was misspelled in the press as 'Rhanny O'Brien', was actually Rhaune Laslett O'Brien, the woman largely responsible for starting the Notting Hill Carnival in the mid-sixties.

The judge, Neil Lawson, clearly took all of this at face value. 'I am quite satisfied that neither of you was activated by feeling of racial prejudice,' he said, and sentenced them each to four years in prison[10]. Four years for taking a life. It was hardly a signal to the people of Southall that British justice truly cared about them.

As for the question of racism, the sorry truth is that it is of course quite possible to be racist towards one group and not another. Clearly Jody Hill and Bob Hackman had Black friends. Equally clearly they felt that Asian kids were fair game to be attacked and abused. Some of their Black friends felt the same. The world of teenagers in the Britain of 1976 had many intricate hierarchies.

The young people of Southall were well aware of what they were up against. The killing of Gurdip Singh Chaggar had been the most brutal of wake-up calls. The Saturday after the murder, 12 June, there had been the biggest protest march Southall had ever seen. Around five thousand people made up a mile-long procession through the area. Banners at the front, where the trade unions and the IWA led the way, proclaimed, 'Together For Peace and Justice', 'We Mourn In Peace' and 'Black and White Unite'. One all too literally proclaimed that 'The Heart Bleeds at Racists'. Further back in the march, though, where the

young militants were, the banners said, 'Enoch Powell Murderer' and pointedly asked, 'We mourn in peace for how long?'

The march itself passed off without incident. At the rally that followed, a young Sikh, Harpal Singh Gil, received wild applause when he told the crowd, 'We've had enough of our leaders kow-towing to the British with folded hands and our parents following them like dumb sheep.'

On the same day, in another heavily Asian London neighbourhood, East Ham, there was an anti-immigration march organised by the far-right National Democratic Party. Its leader, John Kingsley Read, a well-known racist demagogue of the time who had just won a seat on Blackburn town council, made a speech from the back of a lorry – one that made it very clear what the people of Southall were up against. This is how he began: 'I have been told that I cannot refer to coloured immigrants. So you will forgive me if I refer to n------s, wogs and coons. As for the murder of one Asian youth in Southall last weekend. That was terribly unfortunate. One down, a million to go.'[11]

In Southall the youth took this as a sign they needed urgently to organise. Some of the young men – it was almost all men at this time – who had been radicalised by the murder of Gurdip Singh Chaggar decided to form their own organisation. This would be a militant alternative to the IWA.

The Southall Youth Movement's position was that its members no longer felt grateful just to be allowed into Britain. Instead, they demanded the same rights as any other British citizens – and would become one of the groups that would reshape racial politics in Britain.

As one of its leading lights, Suresh Grover, succinctly put it: 'I think it's a seminal moment in race relations in this country. It's the first time a community led by young people sent a very clear message that they're not willing to tolerate racist murders and violence.'[12]

Grover was right. The Southall Youth Movement would soon be joined by other Asian Youth movements, as anti-Asian racism was only getting worse. The 1980 murder of Akhtar Ali Baig in East London inspired the Newham Youth Movement, while others started up right across the UK, from Luton and Watford in the south, Coventry, Leicester and Birmingham in the midlands, to Bradford, Sheffield and Manchester in the north. In 1979 Southall also produced the first British Asian feminist anti-racist movement, the Southall Black Sisters. One thing was very clear: a new generation of British Asians were determined to fight back against the racists.

THE INSIDE PAGES

The month's domestic news was dominated by two high-profile court cases, both revolving around kidnapping.

On 28 September 1975 three Black militants had attempted to rob a Knightsbridge restaurant. Everything had gone wrong and they'd ended up barricading themselves into the basement, with the restaurant staff taken as hostages. Whether or not there was really any revolutionary intent in the original robbery plan, the three men now announced that this was a political act and demanded a plane to take them to the West Indies. After a six-day siege the robbers gave up, let the hostages go unharmed, and handed themselves over to the police.

The subsequent trial, starting on 8 June, offered them a chance to further their claims that their actions were a legitimate reaction to British racism. Their leader, Franklin Davies, refused to acknowledge the legitimacy of the court. 'We've stopped pleading,' he said, 'we've been pleading for five hundred years. This isn't a trial – it's a lynching party.'

This didn't stop them receiving lengthy prison sentences. The trial, however, coming as it did on the heels of the Southall uprising, helped shine a spotlight on race relations. The *Daily Mirror* ran a front-page story on 'The Broken Dream of Black Britain' on 10 June.

The Black Panther Trial began in Oxford on 14 June. The case had transfixed the public for over a year. A career villain called Donald Neilson

became known as the Black Panther because he carried out a series of post office robberies while wearing a black balaclava (not because he had any connection to the Black American revolutionaries). At the beginning of 1975, he had embarked on his biggest undertaking yet – kidnapping a midlands heiress, 17-year-old Lesley Whittle, and imprisoning her in a reservoir drainage shaft, while demanding £50,000 for her release.

He was eventually captured and brought to trial. But, not for the only time this summer, it became clear that the police had thoroughly botched things up. There had been a leak to the press, a fumbled ransom delivery and an inept search of the reservoir where Lesley was imprisoned. A combination of police incompetence and Neilson's ruthlessness led to Lesley Whittle dying a terrible death in the drainage shaft, where she'd been held naked and freezing on a narrow ledge. Neilson was found guilty of Whittle's murder and given a full-life sentence, which he duly served.

After the trial, it became clear that Neilson had been given a thorough beating by the police following his arrest, but in this instance there wasn't too much sympathy available for the victim.

Neither was there much sympathy for the six victims featuring in another trial this month. Fourteen prison officers had been charged with beating up the six Irishmen who had been convicted, the previous year, of the 1974 Birmingham pub bombings. Years later the Irishmen would be freed on appeal, and the case would be seen as one of Britain's greatest miscarriages of justice. In 1976, however, the jury clearly felt that while it was quite obvious that the men had indeed been beaten up in prison, it was no more than they deserved and acquitted the prison officers.

A controversial verdict came in an Old Bailey case in which a judge, Neil McKinnon, freed two men in their mid-twenties who'd been

arrested for having sex with 15-year-old girls at the boarding school where they were decorating a flat. According to the judge the case was 'an attempt to protect fully mature young women against their own natural inclinations'.

Future Labour luminary Patricia Hewitt, who was then head of the National Council for Civil Liberties, agreed with the judge, calling for the age of consent to be reduced to fourteen and was quoted in the *Daily Mirror* on 23 June as saying, 'it's ridiculous to expect the law to stop girls having sex.' The *Mirror* was delighted to be able to illustrate the story with a topless picture of the judge's daughter Kathy, a 'glamour model'.

WORLD NEWS

THE YOBS OF WAR

Britain had such an excess of violence in 1976 that it was able to export some of it. The front-page story on 11 June was the opening of the trial in Luanda, Angola, of a Londoner named Costas Georgiou. He came from a Greek Cypriot family and called himself 'Colonel Callan'. He was charged with committing war crimes while serving as a mercenary leader for the anti-communist rebels in the newly independent country.

It was a story that reverberated easily around Britain. The idea of being a mercenary had wide appeal among teenage boys and young men. We had all grown up in the shadow of the Second World War, which had come to an end a mere sixteen years before I was born.

The war was still everywhere in the culture in 1976. It was in the playground, where we acted out Brits against the Germans/Nazis. It was always on TV, from *Colditz* to *Dad's Army*. Films such as *The Great Escape*, *The Dambusters* and *Where Eagles Dare* were shown over and over. It's hardly surprising that young men wished they too could be heroes.

The obvious option was to join the army. Many of my fellow pupils came from military families, and some of them went on to join up as soon as they left school. But the only armed conflict on offer for army recruits, that in Northern Ireland, hardly fitted the romantic ideal of war.

So the mercenary recruiters operating at that time had plenty of willing volunteers. One boy I knew at home in South Wales headed out

to Rhodesia to lay his life on the line for white privilege and didn't come back. Aged only eighteen, he died thousands of miles from home – shot, I heard it said, by his own side because he was such a liability.

Had he been a few years older he could easily have been one of those who went out to Angola to fight with Colonel Callan. When the first survivors of this ill-fated crusade returned to London there was a picture of these generic lads on the front of the *Daily Mirror*, aptly captioned, 'The Yobs of War'. One of them, David, was the 17-year-old son of a milkman. He was only two years older than me.

Bizarrely this ill-fated mission had begun in the fun-loving surrounds of Camberley's finest new discotheque, Ragamuffins. Ragamuffins was a classic suburban disco of the time: a big town-centre upstairs space freshly done up to prime mid-seventies spec. Saturday night fever Surrey style, DJs with lots of chat and conga lines to 'Love Train'. One of these personality DJs was a man called Oliver Plunkett, a soul specialist who DJed at Rags on a Thursday, then took his mobile disco out at the weekends.

His real name was Chris Dempster and he was older and tougher than he looked. Ex-army, he'd fought the Mau Mau uprising in Kenya and tried to join the SAS, but failed the training after attacking another soldier with a rifle butt. After a stint fighting for Israel in the Six Day War he'd come back to Surrey and attempted to settle down and get a regular job.

It may not have been completely helpful that he had the words 'Death Before Employment' tattooed on his arm, but nevertheless he had stints as a plumber, a panel-beater and a salesman, before realising that he could put his love of American soul music to good use. And so Oliver Plunkett was born (the name borrowed from a 17-century Catholic martyr).

His DJing career had a good run but it wasn't enough to overcome Dempster's need for excitement. Playing records in the background, while Radio 1's David Hamilton or Emperor Rosko brought their star power to Camberley, wasn't ever going to measure up to the life-or-death thrills of warfare.

He had a mate called Dave Tomkins who was a safecracker and explosives expert.[13] They'd first bonded when they worked together on a casual job digging a ditch. Tomkins decided that digging was too much like hard work so he came up with an alternative: 'I knew it would be faster to blast out a ditch than to dig one, so I made an explosive mixture from garden weedkiller and sugar. The explosion blew the ditch – and the street's drainage system.'

That was the end of that job, but Dave Tomkins knew Dempster was a kindred spirit and they started to look for work in the mercenary world. He kept this in mind when he met another Camberley resident and sometime frequenter of Ragamuffins, 'Major' John Banks.

John Banks was an extraordinary character, the Arthur Daley of the mercenary world. He was short, but fit and wiry and full of talk. Another army kid, he joined up himself aged seventeen in 1962. He obviously showed a lot of promise, as he was able to join the 2nd Battalion of the Parachute Regiment– the 2 PARA of legend. He served in assorted hotspots and was wounded a couple of times in Aden, before being sent back to England to work as an unarmed combat instructor. There, he was discharged in unhappy circumstances after being arrested driving a Jaguar he hadn't paid for, while disqualified from driving.

For the next few years he was, if you accept his own account, a sought-after mercenary running missions for the CIA in Kurdistan and North Vietnam. Some cynical associates suggest this was surprising, as they were pretty sure he was working as a cab driver in Camberley at the time.

He really did have connections, though, and it was Banks who arranged for a posse of British mercenaries to go out to Angola, including Dempster and Tomkins, early in 1976.

Their mission had been brief and disastrous. As the trial progressed the awful details came out. Some 115 British mercenaries had been recruited to go and fight in Angola, which was caught up in civil war, having gained independence from Portugal. The Marxist MPLA were clearly set to be the victors, but the CIA were covertly backing a group of anti-communists called the FNLA, based in the north of the country. That was who the Brits went to fight for.

They were a ragtag bunch with few experienced fighting men. 'Colonel Callan', who had been discharged from the British Army for robbing a post office while serving in Northern Ireland, became their leader, essentially because he was a ludicrously brave psychopath.

His fellow mercenary, Chris Dempster, summed up his alarming power over his fellow mercenaries: 'You see everybody's got their little photo-fit of what they are and then suddenly you get out into the blackest of Africa and you've been a roughie-toughie soldier all your life, and you meet a 24-year-old Greek Cypriot waving a gun at you and you look at yourself and you realise that you're not going to do anything about it.'

It was estimated that Callan murdered around three hundred Angolans over a few months. He killed some of his own soldiers too, simply because he wanted to see whether his guns could blow a man's head off. Then, as the operation collapsed around them, some of the British mercenaries tried to escape to safety in nearby Zaire – away from the conflict and also away from Callan. Callan rounded up eighteen of them and had them massacred. The details were horrifying.

Thirteen of the mercenaries, including Callan, were eventually captured by the MPLA and put on trial in the Angolan capital, Luanda. Callan and three others were sentenced to death by firing squad. The others were given prison sentences and eventually returned to Britain. At the time of their recruitment, not one of the jailed Britons had had the faintest clue where in the world Angola was. As one of them, Michael Smart, put it: 'Actually to tell the truth I don't really know why I came here. I just wanted to get away from England.'

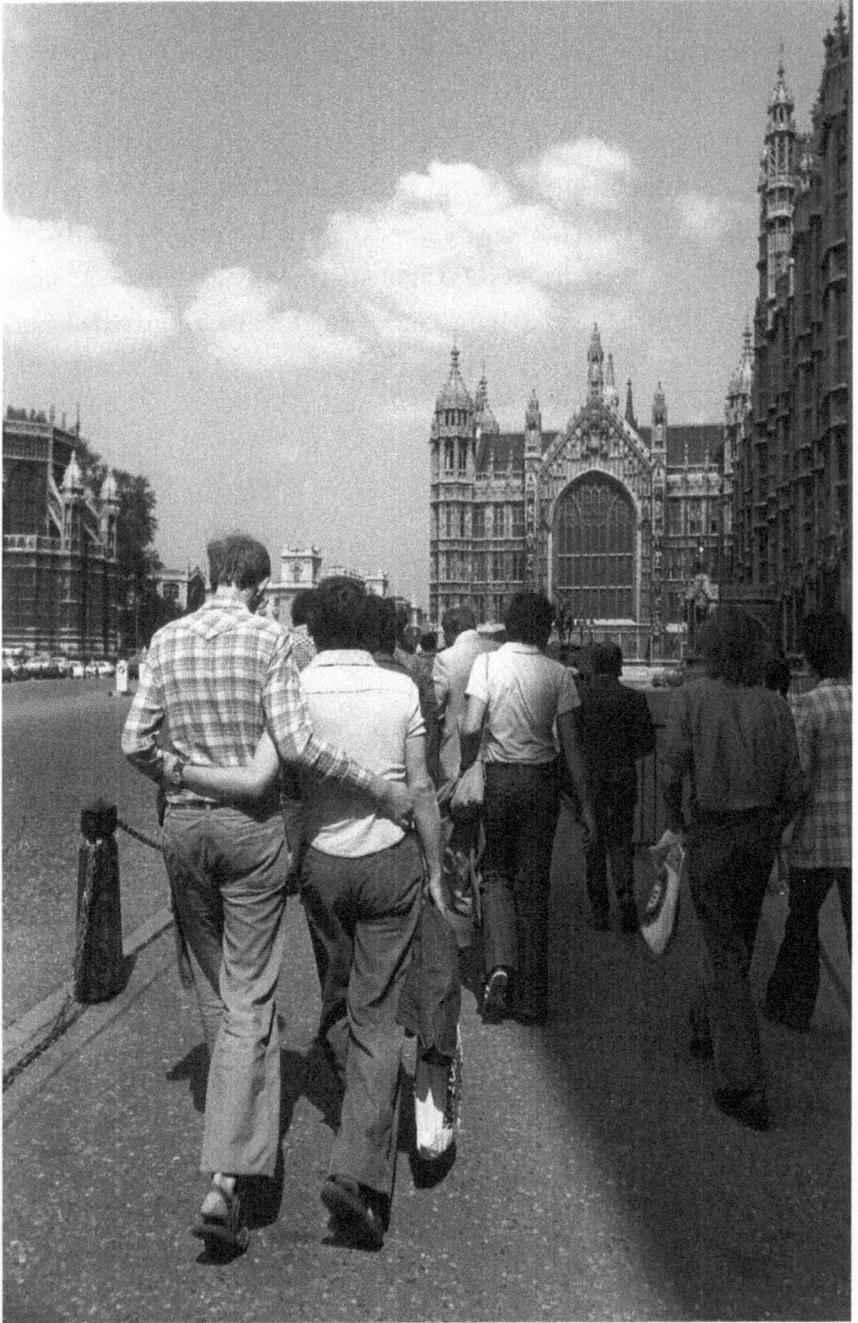

Gay Pride Week 1976 – 'Sing if you're happy that way.'

SING IF YOU'RE GLAD TO BE GAY

It was hard to imagine anyone singing that they were glad to be gay when I was at school. In an all-boys boarding school, homophobia was a basic linguistic currency. Anyone who annoyed you in any way was a 'poof' or a 'bender'. Anyone who was actually suspected of being gay was bullied unmercifully. And it was an actual phobia. People were frightened of gayness. They were frightened of it in other people but, most of all, they were frightened of it in themselves.

Some of the fears were rational – word went round about particular teachers who were thought to have designs on the boys. You would do well to avoid ever being alone with them. But most of it was anxiety about our own sexuality. All of us going through adolescence, locked up together in sweaty dormitories, starved of contact with girls and women. Most of the boys got by, like me, on a diet of third-hand copies of *Club International* or *Knave*. Some though, generally the ones who were loudest in their homophobia, had sex with each other, on the principle that what happened in the rowing club stayed in the rowing club. They weren't *like that*.

And it was boys like those, I suspect, who were the ones who would be first to lead the queer-bashing expeditions that disfigured gay life in seventies Britain. If you couldn't admit your desire to fuck someone, might not fucking them up be the next best thing? Especially in a culture in which you were more than likely to get away with it. Everyone knew that gays would be unlikely to go to the police for fear of public exposure.

That was just how things were, only, as with so much else in the summer of '76, it turned out we had reached the boiling point and the erstwhile victims decided they weren't putting up with it any longer.

Late in the summer, as Britain became ever more sunburnt, the new paper *Gay Weekly* ran the headline 'Gay is Angry'. And it was no wonder. Enough was enough. It wasn't one single incident that made gay people angry in the summer of 1976, it was one thing after another. There was the police harassment, of course, everywhere gay people congregated. There was the constant threat of police entrapment too. And then there was the violence: in the streets, in the cottages, in the parks, down the towpaths. In all the places where gay men had been forced to go to find a connection, there was always the threat of queer-bashing.

For far too long, this had been the status quo, the price you paid for being gay. To be treated with contempt and disgust if you were lucky, and to be beaten within an inch of your life if you weren't.

Nevertheless, many things had improved for gay men over the last decade. Homosexuality was no longer illegal for men over twenty-one. There were gay newspapers and magazines. *Gay News* had been started in 1972 by members of the Gay Liberation Front and now it was joined by *Gay Weekly* – 'Gweek' to its readers – as well as a more artsy publication called *After Lunch*, edited by David Seligman.

Gay News ran ads for restaurants and hotels that were gay friendly, mostly in London or Brighton, but also dotted around the UK. There were gay pubs in every major town or city and, in London's Earl's Court, a readily identifiable gay neighbourhood with a panoply of pubs, bars

and restaurants. There had been gay discos in London for a little while, but now they were getting bigger than ever, with the opening of Bangs on a Monday night at the Sundown Club on the Charing Cross Road, a place with a capacity of a thousand.

Even a year earlier, in the summer of 1975, the prevailing mood was of optimism. A new world was emerging in which being gay was something you could happily embrace. The main gay organisation of the time was the CHE – the Campaign for Homosexual Equality – whose annual conference was a key date in the calendar. That summer it was held in Sheffield City Hall – a far more impressive and official setting than ever before. Over a thousand people attended, among them a young musician called Tom Robinson.

Tom Robinson had come to London in the early seventies, from a therapeutic community in Kent for troubled young people, looking to make his way in the music business and to discover whether there really was such a thing as a gay scene. His music business ambitions had paid off, up to a point. He joined a three-piece acoustic harmony group called Café Society, very loosely in the Crosby, Stills & Nash mould, and they had been signed to Konk Records, helmed by the Kinks' Ray Davies. However, the other two band members were both straight and so was Café Society's music. As Tom Robinson told me, it was an increasingly awkward balancing act: 'With Café Society, I was constantly treading on eggshells, trying not to upset the other guys in the back by making too much noise about being out and gay and them getting, as they put it, "tarred with the same brush"!'

The truth was that moving to London had made his gayness ever more central to his life and his politics:

Finding the gay scene in Earl's Court and then finding *Gay News* being sold there. and then finding all this other stuff, was like being a kid in the candy store. It was unbelievable, not just because I got a lot of sex suddenly, but also I got a lot of interesting things to get my teeth into – that it was OK to be gay, that David Bowie was soundtracking this for us. There was a new way of life beckoning. It was fucking extraordinary.

He started to find a balance in his life by moonlighting as a solo act at gay events. People liked what he did and, come the 1975 conference, one of the organisers suggested that he might write a song, some sort of gay anthem that people could sing at rallies and demos, and which they could press up as a single to raise funds. Tom was happy to take up the challenge, to write a song that would be called 'Good To Be Gay', which would celebrate the new generation of gay men we had come to know in London. To write the lyrics he harked back to his first ventures into London's gay scene:

Leading into the writing of 'Good To Be Gay' I was going to a south London, GLF-organised, Gay Ball at Surrey Halls in Stockwell, a council-owned building. I saw it advertised in the back of *Gay News*, put it in my diary and waited for months for it to come up. Finally, on the night, I put on what I imagined were my most attractive clothes and got on the tube. I went to Stockwell and then, as I got up to the building, my heart sank. There was a gang of youths loitering outside. I thought, fuck, I'm gonna get beaten up here. And then I saw they all had GLF badges on. And it was unbelievable. It was like this is my tribe! These weren't the piss elegant queens of Earl's Court. These weren't the rent boys of Earl's Court either. These were just normal lads and lasses, you know?

Just ordinary looking people – some of whom looked like they could have been the people who would have attacked you – and they were welcoming you in. And then it was just like a retread of all the school dances that I'd been to in my youth, where everybody sat around the outside of the dancefloor. There were kind of ramshackle turntables and makeshift speakers. Just playing everybody's favourite records.

But then, when the next record started, we all got up and went to ask somebody to dance. And the boys danced with the boys. And the girls danced with the girls. And it was like, 'Oh my god. That's why you dance. You have to fancy the other person. It makes sense now!' I'd thought dancing was something like rugby, that you had to do because you were at school. It made no sense until I actually saw a man I fancied on the other side of the hall and said, 'Do you want to dance?' and he said, 'All right.'

The finished song was simple and upbeat, both musically and lyrically, gently encouraging people to come out of the closet: *'People won't mind if you're honest and gay / You might even find they prefer you that way.'* Didn't everyone accept that it was good to be gay?

A year later, though, Robinson was unable to maintain this sunny optimism. On the one hand there were good things happening – new gay papers, bigger and better clubs – but on the other there was a rising tide of police harassment and savage queer-bashing assaults that always seemed to go unpunished.

As far as police harassment went, the regular flashpoint was in Earl's Court, the heart of the London gay scene. The most popular spot was the Coleherne pub, so popular that it was said it was Bass Charrington's most profitable public house in the UK at the time. This

pub was an absolute institution; as the *Gay News* illustrator Tony Reeves remembers, 'sooner or later you'd see every gay man in the country', and it was a particular favourite with the leather crowd. That summer it was busier than ever, with crowds of men on the pavement outside. The police evidently saw this as a provocation, and continually made trouble. Tom Robinson elaborates:

> They also started raiding the gay pubs in Earl's Court – coming in mobhanded in vans and arresting people for just standing on the pavement – 'causing an obstruction'. Denis Lemon, the editor of *Gay News*, tried to photograph them doing it and they immediately took the camera off him and said, 'Have you got a receipt for this, sir?' He said no, and they arrested him under the sus laws on suspicion of having stolen it.
>
> Outrageous shit was going on. There were Surrey bankers dressed up in leather getting handcuffed and kicked in the backs of Black Marias, who'd then plead guilty to causing an affray so as not to cause a fuss and get their face in their local paper back home. Running in a gay man on trumped-up charges was apparently known as a 'soft' arrest – they could be pretty sure of a conviction and no trouble afterwards.

But, this being the summer of '76, there came a point where the gay men of the Coleherne decided they'd had enough. Inevitably matters came to a head on 26 June at the absolute peak of the heatwave as the temperature hit an unforgiving 35 degrees. *Gay News* illustrator Tony Reeves recalled what happened:

> We had a polite British Stonewall [the New York gay club that was famously the flashpoint for anti-police riots in 1969] there. It was the

middle of summer and hot and the police were coming around every night and telling people to fuck off and pushing them out of the way. It really started to get to us. Even the most conservative people in the Coleherne were starting to get a little pissed off with it. There were also plain clothes police about, two guys in T-shirts and jeans, and they tried to arrest someone in the street outside the Coleherne. Nobody knew what was going on, they just thought it was queer-bashing or something, so they surrounded them. Then they produced a badge and said, 'Police making an arrest'. And everybody piled out of the Coleherne and just surrounded these guys. They were totally outnumbered, there was an almighty noise in the road. The uniformed police turned up, the locals were getting pissed off and started chucking buckets of water over the police. The police were still outnumbered. I'd never seen them back down before but after a couple of hours they did. They just drove off in their police vans. Everybody started spontaneously dancing in the middle of the road. We couldn't believe the police had backed down. I thought this is going to be a turning point. But it wasn't, it was just a one-off, a night when everybody's tempers flared.[14]

One-off or not, notice had been served that the time of 'soft arrests' was coming to an end. You could no longer rely on a gay man accepting a bogus conviction. Elsewhere, however, there were still all manner of perils.

Queer-bashing was as popular as ever. Nowhere more so than on Hampstead Heath. Again, as with the police arrests, the victims traditionally didn't dare report what had happened for fear of being outed.

Tom Robinson's friend David Seligman, however, was already very firmly out when he had gone up to Hampstead Heath on the evening of 9 May. He'd been one of the founders of *Gay News* and the Gay

Switchboard helpline. And he was just about to put out the first issue of his own magazine, *After Lunch*.

As he told *Gay News*, a few days after the event, he'd been up on the Heath that particularly dark night, 'doing what everyone goes there to do'[15]. Walking back to the main road afterwards, he was approaching the car park at the big Heath pub, Jack Straw's Castle, when a man came out of the darkness and asked if he had a cigarette. No sooner had he said he didn't, than two or three more men loomed up and started to give him an almighty kicking, leaving him lying on the ground, unconscious and beat up to hell.

Fortunately, another gay man found him lying there a half-hour or so later. He called an ambulance, which eventually arrived. However, the paramedics weren't prepared to come on to the Heath, so the unknown gay man carried David up to the road and promptly left the scene. David was taken to the Royal Free Hospital, where he spent six days recovering from a broken nose and severely bruised eyes, lucky in fact not to have lost an eye. The advice he gave a *Gay News* reporter was not to go to the Heath – 'too dangerous'.

But it wasn't just while cruising that gay people were under threat. As the gay community became more visible, setting up community centres and so forth, so it became easier for homophobes to find their targets. The North London Gay Community Centre in Finsbury Park came under repeated attack, culminating in the events of 5 August, when a gang of youths besieged the premises. They threw bottles and bricks, then found some scaffolding poles to use as battering rams in an attempt to smash the doors in. The police made a token appearance then disappeared, leaving the youths to try again, fortunately without success. Tony Deane for the collective summed up the situation neatly: 'We were expecting hostility, but it was quite frightening at the time.

Immediately you bring gayness out into the open, it brings out the hostility as well.'[16]

A week later there was similar trouble outside the offices of the courageously named East London Faggots in Stepney. A mob of 30 or so people attacked it with bricks and bottles. One member of the Faggots collective was knocked unconscious. Afterwards they observed, in concord with their North London comrades, that there was something different about this wave of violence. They all believed it to be organised. Both groups pointed the finger at the Far Right.

They were right to do so. The National Front had become increasingly vocal in its homophobia. By 1976 the NF was struggling to maintain the level of popularity it had reached at the turn of the seventies. Its one big issue had always been anti-immigration, but public concern about this had died down a little, so they needed a new campaign to gain public support. And one fringe of the Gay Liberation movement had given them the perfect opportunity.

Adults with a sexual interest in children had recently rebranded themselves with the academic-sounding name 'paedophiles'. First the Paedophile Action Movement and then the Paedophile Information Exchange (PIE) had worked hard in recent years to be accepted as just another liberation movement. And, as almost all of these organisations' few hundred members were men attracted to boys, the Gay Movement was where they strove to find a foothold. And, at least at first, they had some success.

The Southampton conference for the very respectable Campaign for Homosexual Equality in May 1976 produced a newsletter for delegates called *The Daily Gay*. And it included a quite extraordinary apologia-cum-manifesto from the PIE's 23-year-old chair Keith Hose. There's a

particularly disturbing section, in which Hose addresses the one issue on which they had received limited support across the left – the lowering of the age of consent. The National Council for Civil Liberties, to which PIE had affiliated itself, was ready to campaign for the age of consent to be reduced to 14 across the board, as in Holland, and then going further still by arguing for 'special provision for situations where the partners are close in age, *or where consent of a child over 10 can be proved*'.[17] Even this wasn't enough for Hose, however:

> We suggested abolition of the age of consent from the criminal law because we believe that it is ridiculous for the law to say that below 16 or below 21 people are incapable of giving consent. They are certainly capable of giving consent but whether this can be communicated to other people is another matter. Therefore we suggested that the criterion should be communication of consent and since we are talking of simple verbal terms of whether someone likes something or wants something, we suggested that below the age of four, a child could not communicate. Although this may not be true in every case.
>
> We recommended, therefore, that adults should be prohibited, under *civil* law from having relationships with children under four and, in the case of children over three and under ten, a similar civil injunction could also be made if there was a complaint made by those close to the child.

And just in case you were wondering what he meant by 'relationships', Hose was asked this very question by Polly Toynbee in *The Guardian* the following year and he explained airily that 'almost all children are far more capable of anal and vaginal intercourse than they are given credit for.'

Obviously the vast majority of the gay movement wanted nothing to do with the PIE, if they'd even heard of it, but pro-paedophile pieces continued to run in the gay press through 1976. All of which offered the tabloid press a series of field days. In the summer of '75 *The People* had run an exposé of the PIE that had provoked an immediate increase in homophobic hate crimes. And while it's easy to point at the hypocrisy of the tabloids – take for example the lascivious coverage given to Jodie Foster's appearance as a child prostitute in the late summer's big film *Taxi Driver* – there's no doubt that the PIE were friends that Gay Liberation needed to – and soon would – get rid of.

So between the police and the teenage queer-bashers and the Far Right storm troopers, these were perilous times to be an out gay man. *Gay Week* responded by publishing a series of illustrated self-defence tutorials, written by James Saxon. He notes that 'For the Gay person, the risk of violence is often magnified if he cruises secluded and often dangerous areas such as heaths, towpaths and certain cottages'[18]. So gay men needed to be prepared for the worst, as in a scenario when they've taken someone home only to find that 'instead of the nude young male you expected, you are confronted by a deadly young animal armed with a knife'.

What followed was a handy, but in itself quite terrifying, guide to fighting off knife-wielding trade. It's possible, even likely, that this advice might actually have saved lives.

Over the course of these increasingly humid and tense months, Tom Robinson came to a realisation that his polite 'Good To Be Gay' song was increasingly out of step with the mood on the streets. If his music and songs were to have any impact at all, a gentle three-part harmony

over acoustic guitars was not the way to go. He recalls his moment of musical awakening. It was at a poorly attended gig at the Penthouse in Scarborough.

At the end of the night, playing to this quite sparse crowd, the DJ came on – 'Ladies and gentlemen, that were Café Society. Next week, we've got a band coming from London. I don't know anything about them except they're meant to be the worst band in the world and they're called The Sex Pistols' – and you just knew it was going to be rammed. Of course you're gonna go.

And on that basis I went and looked in the back of my *NME* and saw that the Sex Pistols were playing at the 100 Club and I went to see them. They hadn't written a lot of their songs at that point. Most of their set was covers that they deliberately massacred. And particularly I remember 'Whatcha Gonna Do About It'. It's usually a chirpy song but the way Lydon sang it was, '*I want you to know that I hate you baby / Want you to know I don't care'*. And of course the chorus then – '*Whatcha gonna do about it*' – turned it completely into a Sex Pistols song.

The audience was about fifty per cent punks, some of whom were in the same sort of get-up as the Pistols, and fifty per cent ordinary rock fans – flared jeans and nice jumpers and shirts and stuff, just come to check it out. It was brilliant, although I didn't think so at the time.

I'd grown up with this idea that you have to please the audience and be nice to them and tune your guitars before you start playing and show up on time. None of these things happened. They show up half an hour late, they don't tune up. And the first thing that Lydon says to the audience is, 'Who's going to buy me a drink?' It was contrary to everything that I'd ever thought that showbiz was about.

It was absolutely clear watching that evening that whatever the next big thing was, it wasn't an acoustic harmony trio. That was really a turning point for me to leave my old band and form a new band of my own. Also, it gave me the confidence to sing as a lead vocalist, though I didn't have a very good voice. I thought that doesn't matter. If this bloke Johnny Rotten could do that, then I can do something. And I need to be doing something real, something truthful – and something that has resonance for me and for the audience.

It was another show that summer that helped Tom to realise that the real and resonant things he had to talk about were the realities of being gay in this climate of violent homophobia:

What really kicked it home was encountering a New York theatre group called the Hot Peaches. They were staying at a squat in Hampstead, and they were performing a play called *The Divas Of Sheridan Square*. Which was an account of the Stonewall Riot, based on first-hand testimony and experience.

I was approached through a friend of a friend who said, 'There's this theatre group, they need a guitarist. Do you want to come and do it?' And I looked at the advance publicity and I thought, 'Oh, really? Drag queens? Platform boots?' I was so snobby. I really was up myself at the time with this attitude of 'I'm a proper musician and what's this tacky nonsense going to be about?' And I could not have been more wrong. It was mind-blowing. In terms of gender, in terms of gender identity. It wasn't [traditional old fashioned Drag pub] the Black Cap in Camden Town.

Once I came and rehearsed with them and saw what the songs were like, well, the level of humble pie I had to eat! They were quality fucking songs, some great poems, fantastic script and real talent

among this really diverse troupe of people. The key thing is that at Stonewall it was these drag queens who had actually fought for our liberation, who built the platform. The platform from which their more respectable gay sisters and brothers were then denouncing them for 'making us look bad'. I still tear up thinking about the injustice of that. And they sold out night after night after night. People had never seen anything fucking like it. It was really liberating, fired me right up.

I realised we needed to be angry. The cops are not your friends. They were not in 1969 and they were not in 1976. And you've got to call it like it is. That summer, when we were facing all that shit in the Coleherne, you'd go to CHE discos and people were wearing yellow 'glad to be gay' badges. And then taking the badges off as they went out into the street. Not that glad then!

So when Tom Robinson was invited to play at the Pride rally in Hyde Park that August, he decided that the sunny optimism of 'Good To Be Gay' no longer cut it. Instead, he took the badge slogan and deliberately subverted it.

When I had the chance to play at Pride in the Park, I wanted to deliver a self-righteous rebuke to my fellow sisters and brothers about the fact that we were not angry, we were not fighting the cops in the streets. We were nothing like what Hot Peaches were describing. And so my song was very, very sarcastic. *Come on then! Sing if you're glad to be fucking gay, you bastards.*

He sang this confrontational new song four nights running at Pride week shows, then it became the centrepiece of his first solo show, skilfully billed as 'Robinson Cruising', in which he was joined by

Jimmy Centrola of the Hot Peaches and played another new song, 'The Long Hot Summer', that explicitly linked the Stonewall with what was happening at the Coleherne.

There was also a cover of Rod Stewart's recent gay-themed hit 'The Killing of Georgie'. It's a song that sounds a little patronising these days, but in its time, as Tom remembers, it was genuinely radical: 'For someone of Rod Stewart's stature to go, "*Georgie Boy was gay, I guess, nothing more / Nothing less the kindest guy I ever knew*" was like a ringing fucking endorsement. When we had had so many years of snarky anti-gay stuff. It was great that it got into the charts.'

Eighteen months later, 'Glad To Be Gay' would be an actual hit for the Tom Robinson Band. At their gigs their mostly straight fans would happily sing along to the very singalong chorus. And some of them would also take note of the verses that deftly summarised the indignities that gay people had been subjected to in that summer of '76, whether it be the police, at the Coleherne, '*Raiding our pubs for no reason at all / Lining the customers up by the wall*', the slanders in the tabloids, '*Read how disgusting we are in the press*', or the thugs who'd come for David Seligman, '*Queer-bashers caught him, kicked in his teeth / He was only hospitalised for a week*'. The backing is too jaunty to be called 'punk', but the undisguised bitterness and anger in Robinson's voice gave it a real cutting edge.

'Glad To Be Gay' announced that gay people were no longer prepared to suffer in silence or hide in the shadows. It was time to stand tall, out and proud.

TELEVISION

SHOW OF THE MONTH: *THE FOSTERS*

A brand-new sitcom had debuted on ITV in the Friday night 8.30pm slot: *The Fosters* was the first ever all-Black British TV show. Michael Grade, the new deputy controller of LWT, had seen an American show called *Good Times* and decided to buy the rights to make a British version.

Good Times was a groundbreaking show, a sitcom centred around a two-parent Black family in the Chicago projects, struggling to make ends meet. It was devised and written by Black Americans and offered real grit and social comment alongside the usual sitcom stuff, silly catchphrases and so forth.

Ideally Grade should have found a Black British writer to adapt the series, but rather than risk hiring new talent, the job was given to white sitcom veteran Jon Watkins, who had worked on *Bless This House* and *Love Thy Neighbour* among other things. This inevitably diluted the authenticity of the scripts. Nevertheless, Grade assembled a fine collection of Black British acting talent for the series, including Norman Beaton, Carmen Munro and Sharon Rosita, plus guest appearances from the likes of Rudolph Walker and Linda Lewis. The most ambitious piece of casting involved hiring a 17-year-old comic who had been a hit on the *New Faces* talent show the year before, but had no acting experience at all – Lenny Henry.

In his autobiography, Henry points to the show's central problem: they just didn't *sound* like a real family. He was from Dudley in the West Midlands, the two parents, Beaton and Munro, were from Guyana,

Lawrie Mark, who played the kid brother, was a cockney: 'We all spoke and behaved differently, there wasn't a coherent family dynamic, but this was the mid-seventies, and although some advances had been made in getting people of colour on to our screens, the executives in charge had no real experience of casting Black and brown people.'[19]

Akua Rugg, writing in *Race Today*, lamented that 'the programme lacks the courage of its producers' apparent conviction that Britain is a fully multi-racial, multi-cultural society' while allowing that '[it] is saved from total disaster by the authority and authenticity the adult figures bring to their roles.'

The Fosters was far from perfect then, but it did at least attempt to show a Black British family getting on with their lives and dealing with the same everyday problems/ridiculous sitcom situations as any other family. It ran for two seasons, finishing in 1977. Forgotten now, it stands as a reminder that, for all the racism of the time, there were already efforts being made to present positive images of the new Britons, and not in some marginal late-night slot, but right in the middle of prime time.

It would be another six years before the next Black British sitcom came along: the Black Theatre Co-operative's *No Problem!* on the new TV station, Channel 4. And another six years after that before the arrival of another sitcom, also based in Peckham, and also featuring Norman Beaton and Carmen Munro as patriarch and matriarch. This time, by becoming a genuine commercial hit featuring a largely Black cast, *Desmond's* finally managed to achieve what *The Fosters* had first attempted in 1976.

MUSIC

The music press spent a lot of the month of June fretting that rock was going to hell in a handbasket. *Melody Maker* was worried about violence at gigs – in particular the two big outdoor shows the Who had played in London and Glasgow. It may not have helped that the shows were billed as 'The Who Put The Boot In', nor that their principal support act was the Sensational Alex Harvey Band, the violence of whose stage act was all too reflective of their following – they were certainly the preferred band of all the would-be hooligans at my school. The crowd's mood may not have been helped by the fact that the London show at Charlton Athletic's Valley ground was measured as the loudest ever – 120 decibels at 50 metres.

The paper ran a big interview with the head of security for the gigs, Gerry Horgan, who reflected on the changes since the Who's previous show at the Valley two years earlier:

It's all changed. The first Charlton concert was rough. The conditions were very bad. The audience were pissed off. It was hot, there was nothing to drink and it was murder to get around through the crowd. But they weren't nasty. They weren't taking it out on each other.

This time, you could see the difference. There were guys kicking the shit out of each other. I mean there was violence in that crowd that I haven't seen in England for a long, long time. It was a sickening sight. Twenty or thirty guys fighting in the middle of this huge crowd. Loads of people were getting hurt. At one point we were just taking them

over the top: chicks who'd been crushed, passed out, had their heads cut open. This was going on all the time. Eight or nine stretchers were going back and forth continually.

I don't know how we're going to work around it. We've got a violent generation on our hands. We've got a long hard summer in front of us.[20]

While *Melody Maker* worried about safety, the *NME*'s Mick Farren saw the Who shows as evidence of an existential crisis, a sign that rock had drifted too far from its roots. So he wrote a manifesto for change, portentously titled, 'The Titanic Sails at Dawn':

It may be difficult in the current economic climate, and it may be a question of taking rock back to street level and starting all over again. This is the only way out, if we are not going to look forward to an endless series of Charlton and Earls Court style gigs, and constant reruns of things from the past, be they Glenn Miller revivals or Bowie's stab at neo-fascism. Putting the Beatles back together isn't going to be the salvation of rock'n'roll. Four kids playing to their own contemporaries in a cellar might.[21]

Mick Farren wasn't the only one wondering whether rock'n'roll was taking a wrong turning. The playwright David Hare had a West End drama exploring just that question: *Teeth'n'Smiles* featured a young Helen Mirren as rock singer Maggie, and the Joe Meek protégé Heinz playing a washed-up rocker. Whatever happened to the acid dream, the play wondered, like a highbrow version of *Rock Follies*. The answer seemed no more likely to be found in a West End theatre than at Earls Court. Farren's cellars were a more likely bet.

LIVE SHOWS

Tom Waits, the Los Angeles beatnik singer-songwriter, had yet to make any impression on Britain, so his record company flew him into town to give some entertaining interviews to the press, slagging off everyone who'd covered one of his songs – from Bette Midler to the Eagles – and play London's premier jazz club, Ronnie Scott's, backed by a be-bop trio. Or as *Melody Maker* put it, 'Over-praised nouveau-beat poet-cum-singer starts two-week residency.'

Genesis played five nights at the Hammersmith Odeon, keen to demonstrate that there was life after their flamboyant frontman Peter Gabriel had left the band. Their formerly unassuming drummer Phil Collins stepped up to the mic.

The West Coast Rock Show at Ninian Park, Cardiff, was the summer's most ill-fated festival. First ticket sales were extremely slow. Then the headline act, Steve Stills, pulled out, as did Little Feat. Their unlikely replacement was Bob Marley and the Wailers. Tickets still didn't sell and, when the day dawned, it turned out to be the one really wet day of the entire summer. By the time Bob Marley came on there were only a few hundred people left in a stadium that could hold 40,000 or more. The Wailers were pretty good, by all accounts, but as Wales's finest rock critic, Allan Jones, pointed out, 'Woodstock this was not . . . A hopelessly drab day with one of the most incongruous and motley selections of acts ever assembled for such an event.'[22]

POP: THE SLIK STORY

Slik were going to be huge. Cute boy bands that appealed to early and pre-teen girls had dominated the charts for years. Stars included the Osmonds, the Jackson Five and, above all, the Bay City Rollers, with their attendant Rollermania. But even the biggest teenybop groups have a limited shelf life, as their fans quickly grow out of them. So, as the Rollers' chart fortunes started to decline, it was time for the next group to come along.

Slik were perfect – like the Rollers they were Scottish, and they had the same pro songwriting team, Bill Martin and Phil Coulter. They also had a charismatic lead singer in the shape of Jim 'Midge' Ure and their own fresh image. Where the Rollers had gone big on tartan, Slik went for retro American baseball styling – already fashionable thanks to the success of the film *American Graffiti*. And, just to differentiate themselves a bit, they were a proper band who had been treading the boards for a few years under their previous name, Salvation – and could actually play their instruments.

Their first single, 'Boogiest Band in Town', didn't make much of an impression on the charts. However, the second one, a ballad called 'Forever and Ever', went straight to number one, knocking Abba and 'Mamma Mia' off their perch. It had a portentous intro with a church bell tolling, before kicking into a singalong swayer reminiscent of the Rollers' 'Bye Bye Baby'.

When their follow-up single, 'Requiem', came out in May, everyone was expecting another big hit. It had a similar ominous intro – this time with a monastic choir in the background – before bouncing into a mid-tempo pop number, somewhere between the Beatles and 10cc. Surely it would head straight up the charts?

Except it didn't. 'Requiem' spent the month of June crawling its

way up to number 24, then dropping back down again. So what went wrong? Part of it was the song itself. Catchy enough but burdened with depressing lyrics and a bizarre choice of key word for the chorus: '*Nothing is for ever / This is a req- oh what a req-uiem*'.

Never mind – there was still the album and the tour, but neither took off. In July the Scottish *Daily Record* ran a story on the band with the headline: 'Slik and the strange story of the missing fans'. The newspaper revealed that the group had sold out their shows in Glasgow and Edinburgh, but played to a half-empty theatre in Aberdeen, and had to give away eight hundred tickets in Dundee.

There was one more single, the fashionably named 'The Kid's a Punk'. Musically, though, it had nothing to do with punk. It was just a bouncy pop-rock number with another weirdly downbeat lyric – '*He's a bum, where'd he come from nobody knows / Yeah the kid's a punk*'. This one didn't trouble the charts àt all. And that was that. Slik had gone from nowhere to the top of the charts and back again in less than a year. 'The thinking man's teenybop band', the *Birmingham Evening Mail* had called them, and there was the problem – the thinking man wasn't really in need of a teenybop band.

The lack of lasting success probably wasn't Slik's fault – the overly doomy lyrics notwithstanding. No other boy band came along to claim their short-lived crown. In fact there wouldn't be another really popular manufactured British boy band till the emergence of Bros, over a decade later. In which light, the title of their second and final hit is all too appropriate. Slik's short, strange career was indeed a requiem for a generation of teenybopper idols and their songwriting svengalis.

Slik might have been finished, but their lead singer and guitarist certainly wasn't. Midge Ure had already turned down the chance to be in an early version of the Sex Pistols, but in late 1977 he would form a band

called Rich Kids with ex-Pistol Glen Matlock, and then joined Ultravox, with whom he finally achieved lasting success. His most successful composition, however, was Band Aid's 'Do They Know It's Christmas?', co-written with Bob Geldof. Listen to that song's intro with its tolling bell, and it sounds exactly like Slik's greatest hit, 'Forever and Ever'.

SPORT

TENNIS

Britain's pre-war supremacy as a tennis power had long been on the wane by the summer of 1976. The only serious contender in recent years had been the queenly Virginia Wade, who would finally win Wimbledon in the Silver Jubilee year of 1977 – but this year she had a new rival, 20-year-old Sue Barker. Barker shot to the fore by beating the Czech player Renáta Tomanová in the final of the French Open on 13 June. It wasn't the most illustrious victory, as many of the sport's top women boycotted the tournament in favour of the World Team Tennis in the US – a high-paying breakaway league that gave equal status to male and female players. Nevertheless, a Grand Slam win is still a rare achievement.

Following her French success, Barker was a hot tip for the Wimbledon title. The tournament coincided with the peak of the heatwave: 2,700 spectators were treated for sunstroke and dehydration across the fortnight. By the second week the famous grass was parched and brown, and Barker was safely through to the quarter-finals. But that was as far as she got. On 28 June she lost in three sets to the Czech teenager Martina Navratilova, who had recently defected to live in the US. As Martina recalled, it was a match in which the line judges appeared to be distinctly biased in favour of the British player:

The line calls began going against me . . . 'I wonder if you called it that way because she's British,' I shouted. After I [won] the match in the

third set, I had to answer questions about whether I thought the British officials were prejudiced against me. I had never thought so before, and I have never thought so again, but in that distempered summer of 1976 I was sure the entire world was against me.[23]

Navratilova herself was defeated by Chris Evert in the semi-final, another hotly contested three-set affair. In the other semi-final Virginia Wade was easily beaten by Evonne Goolagong Cawley, setting up a final between two old rivals at the beginning of July.

The men's singles, meanwhile, saw the holder and favourite, the Black American Arthur Ashe, knocked out in the fourth round by the dashing New York playboy Vitas Gerulaitis, who lost in turn to the dashing Swedish playboy Björn Borg. Borg would go on to meet the Wimbledon idol Ilie Nastase in the final.

CRICKET

At international level the West Indies were locked in battle with England. Meanwhile, in County Championship cricket the dominant figure was Gloucestershire's Zaheer Abbas from Pakistan, the county's one allotted overseas player. Over the season he would score an extraordinary 2,554 runs at an average of over 75. His peak came in mid-June when he faced Surrey at the Oval and scored 216 in the first innings then 156 in the second, both times without getting out. Earlier in the season he had come to my school to practise in the nets. I went to watch and was utterly astonished to see the speed at which the ball came off the bat of this slightly built, bespectacled man – an absolute miracle of timing and skill.

HORSE RACING

Derby Day was 2 June. Horse racing was a very big deal in Britain in the seventies, largely because it was a staple of afternoon TV. It was compulsory viewing everywhere from your local bookies to Buckingham Palace. I would watch it regularly with my grandmother. The Derby and, even more so, the Grand National were major national events, attracting huge TV audiences and encouraging millions of Britons to make twice yearly visits to the betting shop. The Derby was the front-page story in the *Daily Mirror*, with a feature on the odds-on favourite, Wollow, to be ridden by the star Italian jockey, Gianfranco Dettori. The next day, though, the front page was devoted to the actual winner, Empery, ridden by the most famous jockey of them all, Lester Piggott.

IT'S THE REAL THING

Hot nights followed on hot days, and the natural inclination of the young people of Britain was to go out and dance. I was not the kind of 15-year-old to try and sneak into some happening nightspot, so the only discos I had any experience of were the mobile ones that kids I knew would hire for their parties. These all followed the same formula: chart hits with a soul or disco feel for the girls, who would spend most of the evening dancing with each other, then a few rock classics to get the boys on the floor, 'All Right Now' or 'Jumpin' Jack Flash'. At the end there would be a slow one – maybe 'If You Leave Me Now' by Chicago – to give the braver boys a chance to grab a girl and rub their sweaty rugby shirt all over them, and finally a mass singalong to 'Hi Ho Silver Lining'.

But out in the grown-up world there was an array of nightlife options available for these hot summer nights. Take Manchester, for instance, the effective capital city of northern England, and its satellite towns. On the unexpectedly baking weekend of 4 June there was a cornucopia of choice.

At the Cat's Whiskers in Oldham you could see Radio 1's Johnnie Walker 'and his fabulous roadshow'; the Placemate on Whitworth Street offered 'immediate admission for smart people'. This had once been the home of the original Northern Soul club, the Twisted Wheel, but now its seven bars and dance floors were mostly devoted to chart sounds. You could experience 'the new dance scene' at the Bees Knees, an old cinema in Oldham with a dance floor that lit up in squares, just like something off the telly. Or you could 'Meet new friends' at

Straight out of Liverpool 8 – ain't nothing like The Real Thing.

Rafters, 'exclusively for divorcees, widows and separated persons'. 'It's a summer place,' trumpeted the Sands in the Arndale Centre, in timely fashion. The Church Inn in Wythenshawe promised, intriguingly, a 'Dread Soul Disco'; the Casino Club in Wigan, the new home of Northern Soul, offered a rock night with Mr Big, while Glad Rags in Stockport had a straightforward offering of four bars and cheap drinks.

If you wanted something different there was a steel band in the Robin Hood and a ceilidh in St Bernadettes, while Pat Ely & the Rocky Tops were at the Carousel along with the 'Miss Carousel' Contests.

A lot of places offered a live act alongside the disco. Soul trio the Flirtations were at Fagins, while comedy combo the Grumbleweeds were at the Talk of the North. Tony Christie was at the Golden Garter, showing you the way to Amarillo. Blighty's offered a definite blast from the past with Frankie Laine (of 'Rawhide' fame). One low-key listing, however, offered a little bit of mystery: the Willows in Salford was advertising a group called the Chants, billed as 'direct from USA'.

The Chants were not from the USA at all. They were a group of Black lads from Liverpool. And most of the time they were known by another name, the Real Thing. And that week the Real Thing had just entered the charts with their new single, 'You To Me Are Everything', which would propel them to stardom. No longer would they need to pick up extra gigs by moonlighting as 'The Chants'.

Because, if you had to pick one record to sum up the sound of the heatwave, blaring out from radios and jukeboxes and disco sound systems all across the nation on these sweltering days and nights, it might very well be 'You To Me Are Everything', which – after a month spent gradually climbing the charts – at the beginning of July became the first record by a Black British group to make it all the way to number one.

This was the epitome of British pop-soul, a sound that blended Black American influences with British pop melody and appealed to pretty

much everybody. All seven dance floors at the Placemate would have been happy to shake a tailfeather to this sound on those nights when sweat and pheromones mixed with the pervasive scents of Brut and Charlie. It was a sound full of optimism, largely performed by acts who were unequivocally both Black and British: acts like the Real Thing.

The Real Thing were led by two brothers, Chris and Eddie Amoo, children of a Ghanaian sailor. Eddie, older by eight years, had started his music career in the early sixties, as part of a doo-wop group called the Chants, whose first appearances at the Cavern Club saw them backed by the Beatles. Despite this auspicious start, the Chants never made it out of the club circuit. They were hampered, Eddie felt, by the lack of a truly dynamic lead vocalist. By the early seventies, though, younger brother Chris had developed into just that singer. Together the brothers formed the Real Thing, along with Dave Smith and Ray Lake (while keeping the Chants name going on the side).

Their big break came when their manager got them a slot on British TV's leading talent show, *Opportunity Knocks*. The show had featured a few Black acts over the years, from ska band the Marvels, as far back as 1965, through steel bands, crooners and the folk singer Johnny Silvo. And like them, the Real Thing offered a rare blast of quality among the show's usual dross when they appeared in January 1972. Chris Amoo remembers what happened:

> It was more *Britain's Got Talent* than *X Factor* because a yodeller beat us. It was wonderful because we were on television, man. We were walking down in Liverpool City Centre and everyone recognised us. That's how big the show was. We were no longer doing little clubs but playing all over the country for quite good money. *Opportunity*

Knocks changed everything for us, as we could now sustain ourselves professionally.[24]

Nevertheless it took them another four years, until the spring of 1976, to record a hit single. They'd been making a living playing gigs, singing backup for the actor turned pop star David Essex, and recording advertising jingles for Essex's producer Jeff Wayne. They released a couple of gritty, socially conscious soul tunes but the public didn't take to them. David Essex gave them a song which didn't do much either. Then they got offered a tune by a couple of jobbing songwriters called Ken Gold and Mick Denne, who'd brought it straight to the Real Thing's manager, convinced it would be a perfect fit.

Some of the group thought it was too pop, but Chris Amoo knew a hit when he heard one, and agreed to record it. In the studio Gold had to stop Chris from trying to make it more soulful: 'I said: "Honestly, Chris, I'd just like to hear you sing the melody exactly as it was written." And that's what we did. If you can write a melody that gets into someone's head after just one play, then you have something people can sing.'[25]

As the record climbed the charts, the Real Thing came down to London to record their first album to capitalise on their success – and while there, they talked to Robin Katz of *Sounds*. Chris Amoo made it very clear to her that they had worked hard for this success and intended to make the most of it:

> We have ditched the identical costumes and dance steps and singing everyone else's hits . . . We discovered the hard way that being someone else's second-best isn't worth it. You can either play cabaret and pay the rent or be yourself and starve till you make it. For the last two years we've been hungry. But we've got a hit we're proud of.

Even then, in the middle of all the excitement, Chris was clear that the success of the Real Thing wasn't just significant for them, but for Black Britons generally, and especially those from Liverpool, as he told Katz:

> We're the first Black act from Liverpool to make it. We want to show the kids back home they don't just have to be like American groups if you're Black and talented . . . We're working on a concert show about our source of inspiration, Liverpool 8. That area's seen us struggle for a long time. People used to come up to us and say, 'Why don't you pack it in and get a factory job?' But now I go into a disco like the Time Piece and guys come up to congratulate us, girls put our record on and dance.[26]

The 'concert show' Chris Amoo alludes to was something the group had been working on for a while. They had an ambition to make a British answer to Marvin Gaye's *What's Going On* or Curtis Mayfield's *Superfly*, a concept album telling the truth about the world they'd grown up in. That was really where their hearts were, but now they had a huge hit with a feelgood disco song. Eddie Amoo recalls his mixed feelings: 'I saw the whole thing as a big digression, but David Essex took me aside and said: "Too late, mate, they're not going to let you stop now." And hey, who doesn't want to be number one if you come from Liverpool 8?'[27]

The Real Thing had another big hit with a Ken Gold song, 'Can't Get By Without You', at the end of the summer and they recorded a first album that was, in Chris Amoo's words, 'light, with a nice overall mood'.

But their record company was now prepared to let them express themselves fully and the following year they put out a beautifully packaged album called *4 From 8* which featured a three-song Liverpool suite, including the lovely Mayfield-like ballad 'Children of the Ghetto'.

It was their big statement, their bid to be recognised as serious Scouse soul brothers.

Sadly, though, the album bombed despite some positive press coverage. The band have tended to blame their record company for this in recent interviews, but the sorry truth was that times were changing fast, and Marvin and Curtis were no longer the forces they had been either. Conscious soul was giving way to D-I-S-C-O – ghetto fabulous trumped ghetto realism when it came to sales.

Disco was a complex phenomenon, rooted in Black American music, in funk and soul, but by the summer of '76 it was far from exclusive to the US. The simple, driving 4/4 disco beat proved to be both universally popular and infinitely adaptable. You could take almost any kind of music, from anywhere in the world, add the disco beat, and get people dancing. Giorgio Moroder was redefining the form from his studio in Munich, with his electronic beats and his expat diva Donna Summer. And in Britain the leading disco producer was a man known simply as Biddu.

Biddu Appaiah, a doctor's son who had grown up in Bangalore, was one of two young Indian men to have a big influence on British pop in the seventies without anyone at the time seeming to notice or acknowledge they were Indian: Freddie Mercury's Indian-ness was somehow hidden in plain sight; while in Biddu's case it was because he was a writer and producer rather than a frontman.

Biddu had had some success in Calcutta and Bombay with his teenage band, the Trojans, before coming to London in the late sixties, determined to make it in the music business. It was an epic journey – travelling by boat to Basra in Iraq, then hitchhiking across the Middle East to Beirut, flying to Paris, and from there by train and boat to London. Fortunately the city didn't disappoint him:

London was better than I had imagined. I took to it like a vampire to blood. I was totally seduced by the city. I marvelled at the roads, the clean pavements, the wonderfully ornate Victorian street lamps that hung like inverted tulips . . . a plethora of shops and stores with all kinds of tempting goodies within . . . In time I noticed the amount of foreigners who had made London their home and realised what an incredibly cosmopolitan city it was.[28]

It took him some time to break into the music business. He worked as a chef in a burger bar called Yankee Doodle, while knocking on doors in Tin Pan Alley. Typical was his phone call to the Walker Brothers' manager Maurice King:

'I have come from India with a great song for Scott Walker. You will love it.'

'Don't be daft,' his voice boomed, 'nobody comes from bloody India with a song for Scott.' With that the phone line went dead.[29]

Finally, he secured a deal to make a single for EMI, produced by a young Tony Visconti, but it did nothing, so he decided to concentrate on writing and producing. One of his most unlikely collaborations was with the Black Panther activist Farrukh Dhondy. Together they co-wrote a song called 'Sunny Road Walk of Fear', sadly lost to history.

Gradually, though, Biddu discovered that his real strength was in production, and the music he connected with most was Motown-influenced pop-soul. And as disco gathered popularity he was ready to make his move. He started producing minor hits for the likes of Jimmy James and the Vagabonds, before a singer he was working with, a Jamaican called Carl Douglas, brought him some lyrics inspired by the martial arts craze that was sweeping Britain in the early seventies.

And so 'Kung Fu Fighting' was born. Biddu produced and arranged it but was going to use it as a B-side, until the record company persuaded him to make it the A-side.

It was of course a huge hit, selling over 10 million copies worldwide, which was quite something for a song about an oriental martial art, sung by a Jamaican Englishman, produced by an Indian expat, and performed by a team of white British session musicians, and all dashed off as an afterthought one afternoon.

The homemade-ness of the product is really brought home by the *Top of the Pops* appearance. It features Carl Douglas in extremely unconvincing martial arts kit, with a headband failing to cover up his incipient baldness, plus Biddu himself, along with another of his acts, Lee Vanderbilt, dressed in black silk outfits, pretending to do the backing vocals. Douglas's career tailed off quickly, but Biddu was only just getting going.

The very epitome of British seventies pop disco, naff and obvious but outrageously catchy, 'I Love To Love (But My Baby Loves To Dance)' by Tina Charles was his next big hit. Tina was just 22, but already an experienced session singer – you could have heard her and her friend Linda Lewis doing the backing vocals on the previous year's big hit 'Make Me Smile (Come Up and See Me)' by Steve Harley and Cockney Rebel.

At the time of recording, 'I Love To Love' was just another day in the studio for Tina: 'I can remember having flu and I went in the studio and I must admit it didn't take us very long to do and I didn't think anything of it, got back in the car, drove home with this awful flu. And the next thing I know everyone's telling me it's going to be number one.'[30]

Which makes it all the more remarkable that she turned in the vocal performance she did, hitting higher and higher notes as the song built to a climax. Biddu remembers how it came about:

Tina came in and did a great vocal. Then I asked her to sing the lyrics towards the end of the song an octave up. 'You're joking,' she said, 'I don't think I can do it and if I could I'll shatter the glass between the studio and the control room.' 'You can do it,' I said, encouragingly. She sang the ending a whole octave up. It took the song to a stratospheric level. 'This is a number one,' I said to anyone who would listen.[31]

One of those who listened was Tina Charles's boyfriend, a session musician called Trevor Horn. For him it was the turning point which set him on course to be perhaps the most successful record producer of the 1980s:

Back then I was very much Tina Charles' boyfriend. I wasn't a producer or anything . . . When Biddu played it I told her, 'That's a really good song.' But what was more important, she came home with the backing track. That was the first time in my life that I'd ever heard a backing track . . . I was trying to produce records and I wasn't doing very well with it . . . Listening to the backing track for 'I Love to Love' was a really educative thing for me. It was so simple, it was cold, it was clear. Nobody played anything that they shouldn't play.[32]

Tina Charles and Trevor Horn were living in a small flat in Streatham at the time and, as Tina recalls, unprepared for sudden stardom: 'We only had this tiny little flat, no vases, there were flowers arriving at the door, it was like a florist, and I was putting all the flowers in the bath, in milk bottles. It did change my life. And Trevor, who was a bass player, became my MD [music director]. He was talented.'[33]

Looking back, Tina recalls that being known as an accomplished singer was sometimes a mixed blessing. Particularly when it came to

appearing on *Top of the Pops*. The Musicians Union had ensured that the BBC employed a live band to back artists on the show:

> I was unfortunate because I was the one who had to sing live, because of the union. There had to be one person to sing live every week to use the band. Everyone else mimed and, because I could sing, they said you have to sing live every week.
>
> They stuck me up in the gantry one week and I hate heights, but in those days you didn't complain because a) you're a woman and b) you didn't want to get told off by the record company. I nearly passed out looking down. It was awful but I kept smiling. I'm wearing a really weird multicoloured jumper. Where did I get that from? I had no clue at that age.[34]

The jumper, available to view on YouTube, is quite something. But while Tina is indeed smiling gamely through her terror, there's something very likeable about the fact that she's doing so while wearing a comfy sweater and not the kind of rote 'sexy' outfits that disco divas of the time were generally expected to wear.

Indeed, the world of UK disco could hardly contrast more starkly with all the stories of Studio 54 excess in Manhattan. After 'I Love To Love' did go to number one, the teetotal Biddu hosted a celebration drinks do for which he provided one whole bottle of champagne. 'We each had a thimbleful!' Tina Charles remembers.[35] It may be relevant that, according to Trevor Horn, 'Tina could drink more than most men that I know. And when she'd had a few drinks, she could cause more trouble than anybody I ever knew.'[36]

'I Love To Love' lasted three weeks at number one in the spring. So did the Real Thing's 'You To Me Are Everything' in the summer. And now the pop disco floodgates were open. The hot weather was perfect

for easy-going dance tunes. Elton John was next. Seven years earlier he'd been duetting with the 15-year-old Tina Charles. This time he was accompanied by another session pro, Kiki Dee, for 'Don't Go Breaking My Heart'. Number one for the month of August. And at the very end of summer the Swedes decided to try their hand at disco too, and Abba's 'Dancing Queen' was number one through September.

Collectively these records formed the popular soundtrack of the long hot summer of '76, upbeat and optimistic, a much-needed contrast to all the darker stuff in the news. It was the sound that came out of transistor radios in the parks and on the beaches, and was played in rotation in the discos that had sprung up on every suburban high street. And it wasn't the artists' fault if some of those discos were happy to have their punters dancing to Black music, but not to have Black people on the dance floor.

In the years to come both Tina Charles and the Real Thing would carry on making music, following hard-working blue-collar musical careers. The Real Thing have belatedly been recognised for their socially conscious songs: 'Children of the Ghetto' is something of a modern standard. Tina Charles remains underrated – perhaps one of the finest singers Britain has produced, but a talent overshadowed by the one big hit.

Biddu had some good years ahead. He was responsible for the disco-heavy soundtracks to Joan Collins' two big hit movies, *The Stud* and *The Bitch*, in the late seventies. And when disco's popularity ran its course in the UK, he cannily switched his attention elsewhere and decided to bring disco back home to India. He found a Wembley teenager with a great voice named Nazia Hassan and recorded a song called 'Disco Deewane' which was a huge hit and ushered the Indian music business into a new era. The interchange between colonised and coloniser was becoming ever faster and more complex.

July

THE WEATHER

The full-on heatwave that had begun towards the end of June carried on through the first week of July. The temperature across most of England and Wales was consistently above 30 degrees until 8 July, when it dipped down to average in the low 20s for the rest of the month.

However, there was still precious little rain to alleviate the drought. Even the Local Government Minister John Silkin, who had previously ruled out any question of a national drought, was starting to change his tune. He now told MPs that 'it would be irresponsible not to recognise that over the late summer and autumn we may in some places have to tackle a series of local water emergencies.' And so, on 3 July, the government announced that it would bring in emergency drought legislation, with hosepipe bans and potential water rationing to come.

Evidence that the drought really was serious came four days later when the Queen announced that she had ordered an end to the use of sprinklers on the Buckingham Palace lawns.

The *Daily Mirror* was concerned that the sustained heatwave was having an impact on the nation's love lives. According to psychologist Maurice Yaffe, the heat was affecting men's ability to perform: 'They still feel sexually aroused but don't feel inclined to initiate any activity because using energy in this weather is uncomfortable.' He predicted a fall in the birthrate nine months later, while also noting that this state of affairs was unfortunate for women who 'feel more sexy in a heatwave'.

Possible evidence for this theory surfaced in Glasgow. Overall temperatures in Scotland in the summer of '76 were rather lower than in the southern parts of the UK, and on 9 July there was heavy rain and flooding in Glasgow. But a few days earlier the thermometers had hit 29.5 degrees, and a young Frenchwoman called Michelle caused a sensation by going topless in the city's George Square. The local press reckoned she was Scotland's 'first female streaker', while the sun-struck magistrate who sentenced her for committing a breach of the peace commented that 'It's not quite as good as the Folies Bergère.'

Clearly some men were managing to shake off their sexual lethargy, as the National Farmers Union was complaining about people accidentally setting fires while having sex outdoors. 'It is no coincidence,' said their spokesman, 'that there are many blazes in the early hours in areas where midnight courting couples park their cars.'

The continued heat of early July had one particularly memorable side effect – the plague of ladybirds. Scientists have conflicting theories as to the exact cause, but one way or another it is estimated nearly 24 billion of the insects were to be found in Britain this month, mostly around England's southern and eastern coasts.

There had been, to cut a complex story short, a surfeit of aphids for them to eat in the early summer and a shortage thereafter. This meant that huge numbers of ladybirds built up in their feeding grounds near the coast, but as their food ran out they lacked the energy to move on. Surprisingly, well-fed ladybirds can fly at altitudes of over 1,000 metres for distances of up to 75 miles. Starving, however, they were stuck.

In badly affected areas, like the Isle of Sheppey, the ground was literally carpeted with the creatures. You couldn't walk along a pavement without crushing them. Ruislip Lido, on the edge of London,

was smothered too, making for a deeply unpleasant swim. There were even reports of starving ladybirds biting people, perhaps in a desperate attempt to drink their sweat.

On the other hand, things could have been worse. Adders were reported to be swarming in South Hams, Devon, but thankfully nowhere else.

THE HEADLINES

The headlines were dominated by the government's continued struggle to get the economy back on track, following the embarrassment of the central bank bailout. Unemployment remained stubbornly high at 1.3 million, the highest figure since the war. It wasn't an obvious time to bring in swingeing cuts, but the terms of the bailout left the government with no choice. So Chancellor Denis Healey announced £2 billion worth of public spending cuts and tax rises. It was a package that threw the Labour left into disarray, with many threatening to vote against it. That raised the question of whether the Tory party, now under the stewardship of Margaret Thatcher, would support the cuts, of which they broadly approved, or use the vote as a chance to defeat the government. In the end the cuts did go through.

In the wake of this, there was a tricky test for the government in the shape of the Thurrock by-election. Thurrock, in the London docklands, was historically the safest of Labour seats. At the last election they had had a majority of 19,000. It was also exactly the kind of area in which the National Front believed they would find support. In the event the NF finished fourth with a little over three thousand votes, much less than had been feared. Labour hung on to the seat with a massively reduced majority. The happiest party leader was Mrs Thatcher, said by the *Daily Mirror* to be 'cock'a'hoop' at the big increase in the Tory vote.

THE INSIDE PAGES

On 4 July four primary school girls, Brownies, died of carbon monoxide poisoning as they slept in a dormitory at a council-run outdoor pursuits centre in Derbyshire. At the inquest the deaths were put down to a badly installed boiler. The caretaker said he was aware of fumes leaking throughout the centre, but had not raised the issue because it was not his job to do so.

On 17 July the papers reported the case of a 15-year-old girl who had been taken into care after being sexually abused by her father, then sent back to live with him again, whereupon he immediately started abusing her again. The social worker responsible for the decision defended it on the grounds that the girl had been playing truant from school and seeing her boyfriend.

On the 29th the *Telegraph* ran a story about a man called Seamus Higgs from Luton being fined £100 for having sex with two underage girls, headlined 'Landlord Fell For Teenage Temptresses' – and went on to describe how the two girls, aged fourteen and fifteen, had let themselves into Higgs's house, where he'd found them lying naked on his bed when he came in from the pub. The judge showed what he thought of the girls by insisting that their names should not be kept secret. With casual viciousness the *Telegraph* duly published both names.

The papers – and society at large, come to that – found themselves continually confused by such stories of sexually active teenage girls, constantly flip-flopping between portraying them as victims and as 'sluts'.

The strangest case of the month was the arrest of a 'cold-eyed knife

girl'. Nineteen-year-old Susan Blake had stabbed three different women in public toilets in Reading and was arrested after a phone call from her bank manager father, who had found his daughter's collection of press cuttings about her crimes. She was sent to Broadmoor for an indefinite period. *The Guardian*'s story quoted various psychiatrists who all said they had never heard the like.

'A 20-year-old member of a gang which kidnapped a 19-year-old Greek Cypriot girl by mistake, kissed her hand, gave her a pound and put a bullet in her handbag as a souvenir when he released her.'

'The body of the Russian ship's captain, who disappeared 11 days ago, was found in the River Tyne yesterday, with a weight similar to a clock's pendulum tied to it.'

Both these sentences come from brief news stories that ran in the *Telegraph* with no further explanation, leaving the reader to imagine what on earth might have been going on in each case.

WORLD NEWS

Far and away the biggest story of the month – one that even cut through to dozy teenagers like me – was what became famous as 'The Raid on Entebbe'. An Air France flight from Tel Aviv to Paris, with 248 passengers on board, was hijacked on the runway when it stopped for refuelling in Athens. At this stage there were four hijackers: two Palestinians and two German radicals. They directed the pilot to fly to Libya, where Colonel Gaddafi was happy to let them land, and then on to Entebbe Airport in Uganda. Uganda's leader, the military dictator Idi Amin, positively welcomed the hijackers.

Idi Amin was a major player in the political landscape in the mid-seventies. He had seized power in 1971 and attracted further international attention in 1972, when he enacted his 'economic war'. This involved appropriating the property of the Ugandan Indians, the 80,000 or so immigrants from India who'd been encouraged by the British to effectively dominate the country's business culture. Soon Amin went further and ordered the 60,000 Indians who did not possess Ugandan passports to leave the country. Since then 30,000 of them had arrived in Britain, the so-called 'Ugandan Asians'.

All this had had disastrous effects on the Ugandan economy, but Amin appeared unbothered. He enriched himself and used his secret police to quash all dissent with the utmost brutality. Estimates of the number of people killed under his regime vary between 100,000 and 500,000.

Despite this, Amin had somehow established himself in the British

popular imagination as a figure of fun. This was down to his eccentric use of English idioms and ridiculous affectations, for instance giving himself the title of 'His Excellency, President for Life, Field Marshal Al Hadji, Doctor Idi Amin Dada, VC, DSO, MC, CBE, Lord of All the Beasts of the Earth and Fishes of the Seas and Conqueror of the British Empire in Africa in General and Uganda in Particular'. The humorist Alan Coren had a satirical column in *Punch* magazine purporting to be Amin's private diaries (apparently a copy was found on Amin's bedside table following his eventual overthrow).

Gradually though, this perception of the clownish buffoon had started to change as stories of his regime's brutality began to emerge. His support of the Entebbe hijackers inevitably hardened that view.

Amin personally welcomed the hijackers and deployed over one hundred soldiers to assist them. The hijackers then set out their terms to Israel. They wanted the release of forty Palestinian prisoners in Israel and thirteen held elsewhere. Over the next couple of days the Israeli passengers were separated out from the rest. The 148 non-Israelis were released and flown to Paris on a chartered plane, while the remaining 94 passengers plus a dozen crew members were kept as hostages.

The Israeli government were divided as to what to do. Prime Minister Yitzhak Rabin was minded to give in to the demands, while the defence minister, Shimon Peres, was against capitulating, on the grounds that it would only provoke further such events. In the end Peres won out and the Israelis planned a rescue attempt.

They put the plan into action on the night of 4 July. One hundred Israeli commandos flew out, stopping off in Kenya to refuel. Under cover of night, they landed at Entebbe and, acting on intelligence given to them by the freed passengers, found their way to the airport terminal where the hostages were being held. They swiftly killed the hijackers and released almost all the hostages, though three of them died in the

crossfire. However, as they began loading hostages into a support plane, a firefight opened up with Ugandan soldiers. This resulted in forty-five Ugandan deaths, and one Israeli. That Israeli was Yonatan Netanyahu, the older brother of the future Israeli prime minister.

The rescue was essentially a triumph, the stuff of war films – *Where Eagles Dare* in real life. And sure enough there would soon be a movie made – *Victory In Entebbe*, with Richard Dreyfuss as Netanyahu.

Idi Amin, meanwhile, was unsurprisingly furious. He decided to take his anger out on Kenya, as they had allowed the Israelis to refuel. He duly ordered the killing of hundreds of Kenyans living in Uganda, and caused thousands more to flee the country.

PARKLIFE: GOTTA MEET SOME BIRDS

London has a remarkable number of public green spaces, ranging from the great parks in the centre to rediscovered river valleys and canal paths. There are Victorian cemeteries and post-war recreation grounds, hidden jewels and sprawling commons, but nowhere is there a place to rival Hampstead Heath.

Hampstead Heath is a special place at any time, this huge wild expanse amid the North London hills. It was first singled out as a unique space by Ethelred the Unready in 986 when he gave the land to the Abbot of Westminster. It's been publicly owned since 1871 when the Hampstead Heath Act was passed to protect it in perpetuity. There are woods, bridleways, a stately home to the north and a strange little hamlet called the Vale of Health to the west. There are nearly 800 acres of hills, valleys and lakes. It's big enough to get comprehensively lost in. From Parliament Hill in the south there's an extraordinary view looking over London. Parliament Hill is also home to a large swimming lido. Around the edges of the Heath are highwayman's pubs, emigré's chess cafés, some of the most beautiful housing in London and some of the bleakest.

The Heath is too big to belong to any one group or tribe. You don't have to live in Hampstead or Highgate to use it. There are plenty of popular activities – sports or dog walking or swimming or sunbathing or clandestine assignations – but you don't have to take part. You can just wander about, or sit and watch the world go by. In winter, to be sure, dog walkers and fitness fanatics may dominate, but come summer the Heath is full of all kinds of people.

There were over a thousand kids in the Parliament
Hill Lido at the height of the summer: one of them died there.

Never more so that during the broiling summer of 1976. Londoners of all descriptions used the Heath to sunbathe or swim, heat up or cool down. As well as the lido, the Heath features three bathing ponds to the south and east: One for men and women, one for men only and one for women only. The latter two have been enduringly popular with gay people, the men's pond particularly so. A meeting there could lead to a dalliance in the nearby woods. Come darkness, when the ponds closed to the public, the action for gay men moved to the north-west of the Heath, not far from the large clapboard public house, Jack Straw's Castle.

For teenagers that summer, Hampstead Heath was a complicated territory with plenty of potential joys and hazards. You needed your own mental map, something like the one at the beginning of *The Lord of the Rings*, to tell you which group had dominion over which lands – where there were friendly hippies throwing frisbees, and where you had to watch out for rivalrous crews, from Kilburn or Kentish Town, Belsize Park or Highgate.

Hampstead itself had become a fulcrum of the North London teenage world in the past couple of years. Crews would all meet there, riding up on their mopeds and scooters to the old garage where you could hang around, have a cup of coffee, find out where there was a party going on, and the bad boys could chat up the Hampstead girls.

Hampstead girls were a big draw. Girls with money and nice houses. And Hampstead parents weren't like Kentish Town parents or Kilburn parents. They didn't just turn a blind eye to what their kids were up to; they gave every impression of not caring. They were too busy finding themselves.

It was a precocious world. Everyone was doing too much too young: sex at thirteen, drugs at fourteen. Dope, lines of speed, even lines of heroin. No one seemed to know what the rules were. Teenagers hung out all over the Heath. There were trees where they might meet their friends,

the viaduct where there could be a bonfire late at night, and bushes where reckless girls might let themselves be spirited away. There were hippies smoking dope at the Arches. At the lido there were rough kids from the estates, the Aldenham mob, the best-looking, coolest, hardest boys.

Of course, it being 1976, there were fights everywhere, punch-ups at gigs in the Town Hall or in the Hollybush pub. Boys got stabbed, girls got gang-banged on the Heath. No one talked to the police, even when things got out of hand, as they often did. At the lido everyone had been chucked in at the deep end, to see if they sank or swam.

The Parliament Hill Lido lies at the southern foot of Hampstead Heath. It was built in 1938 as part of a wider programme to encourage fitness and cleanliness among the working classes. This was not a development that attracted unanimous approval from the smart side of the Heath. A letter published in the local paper, the *Hampstead & Highgate Express* (aka the *Ham & High*), in July 1938, complained that 'sun-bathing attracts a large number of young people of both sexes, many undesirable, who come, not to swim, but who think it "the thing" to show as much of their nude bodies as they dare, in all sorts of postures.'

That was certainly the case in the summer of '76. By 8 July the temperature had been in the high 80s or low 90s for a fortnight. It was sweltering. And though it was still term time and 8 July was a Thursday, the lido was absolutely rammed with teenagers, bunking off from school or job. One of them was 14-year-old Andrew Anthony, from one of the nearby estates. He told me that the lido was the only place to cool off during these weeks of relentless heat. With his mates he wouldn't bother with the enormous queue. Instead they'd clamber over the wall, navigating the barbed wire top. Once inside, he remembers it as a thrilling place to be:

It felt liberating – wild anarchic fun. You could wear cut-down jeans instead of swimming trunks. It was difficult to find somewhere to lie straight out. In the shallow end it was all people standing up. All the way until you started to get out of your depth, it was just packed with people. In the deep end you have the diving boards, people diving in all directions. It was completely anarchic, run and dive, push people in. There was always a chance you [were] going to land on top of someone. Like so many things in the seventies, it was dangerous but a lot more fun. It was exhilarating, the stuff that you did. It was just the sort of lawless fun you're not allowed to have any more as a young person.

The lido they were crammed into, along with a thousand or maybe even two thousand other people, is a functional but elegant brick outdoor swimming pool complex. Changing rooms along the south side, a café to the north. The pool itself is huge – 60 by 27 metres, only 75 centimetres deep at the shallow end but 2 metres at the deep end. The deep end, back then, featured a diving stage with two boards, a low one and a high one. Off to one side is a series of broad steps officially designated as a sunbathing area. This was traditionally where the tough guys hung out. Boxers Corner, as it used to be known, was now held by the most renowned of the local crews, the Aldenham mob, sometimes known as the Aldenham Glamour Boys. John Lockwood was a local teenager who frequented the lido over the summer. He told me what it was like:

It was absolutely packed, every inch was covered in towels, and they would not limit numbers, so it would be heaving in there. We'd all been going there since we were kids, and there was a lot of violence. There was a couple of youth clubs – the Thanet Youth Club and the

Aldenham Club on Highgate Road – and they were the boys, they were fucking hard little guys. They would all have a place where they'd go. The Aldenham lot, they would sit on the steps at the deep end. They'd just pick people up, chuck them in.

I remember two blokes walking in one day and they hadn't got changed, they were walking round the pool in their motorcycle gear. They were in their thirties, hairy bikers, and these kids just chucked them in. I remember sitting there thinking that's mad, all their gear – leathers, everything. These blokes who thought they were hard, they couldn't believe it. These kids going, 'What are you doing walking around like that, giving it some, in you go.' They were quite fearless.

They had a fight once in Highgate Road with the North Bank [football hooligan] crew from Arsenal. They came down to take on the Aldenham. The Aldenham were outnumbered about ten to one. They were unusual, though, because normally you have only one or two tough kids in a crew, but the Aldenham had about fifteen. They were quite hard. And quite cool, in their own way.

Andrew Anthony likewise remembers that for all the lido's anarchic fun, you had to be careful not to get on the wrong side of the older, tougher boys: 'It was a bit like going into a heavy pub, you had to make sure you didn't tread on the wrong person.'

Unlike most teenage gangs of the seventies, there's quite a lot known about the Aldenham Glamour Boys, thanks to the subsequent celebrity of some of their number. Chris Foreman explained how they came together: 'What happened was, there was us little bunch, who used to go out shoplifting, and doing sort of vandalism. We used to walk through Parliament Hill, up to the top of Kite Hill, and set fire to rubbish bins, like you do.'[1]

One night they were doing just that when they ran into another local gang, from Kiln Place in Gospel Oak. They all got chased by the police and ended up joining forces and starting to go to the Aldenham Boys' Club. And then one of them said for a laugh, 'Oh, we're the Aldenham Glamour Boys,' and the name stuck.

Another of the Glamour Boys, Carl Smyth, later told the press their style evolved out of the skinhead culture they liked, both the clothes, the boots and braces, and the music, Motown and ska.

The Aldenham Glamour Boys certainly had a bit of outlaw charisma around them. Younger kids looked up to them. Among them, one teenager who called himself Suggs. He was aware of all the little gangs around his patch of north-west London, but it was the Glamour Boys that he later said he was really drawn to: 'When I met them, because I was a bit younger, they seemed so cool. It was just before punk and everyone was dressed like Kevin Keegan or Status Quo, but I saw these blokes who were into wearing old clothes. They just seemed more interested in style than the average person.'[2]

He remembered them listening to glam rock and sporting their Dr Martens boots in a range of unlikely colours: 'They looked like a packet of Smarties coming down the road, but you wouldn't say that to their faces.'[3]

Certainly not. As Andrew Anthony says, the Aldenham mob and their youth club were not to be trifled with: 'It was a place you'd cross the road when you walked past, so you didn't bump into anyone coming out of it.'

So that was the way the lido was on 8 July 1976, when the temperature topped 30 degrees yet again. It was a teenage Wonderland, but one that was at boiling point, a place where you had to tread carefully,

lest you attract the attention of the tough kids, the playground bullies relocated to the poolside. In the lido, just as on the streets outside, you needed to keep your wits about you. But not everyone is blessed with quick wits.

One teenager who made it to the lido that day was the 15-year-old Enrico Sidoli. A local boy, Enrico had decided to take the day off school to enjoy the broiling sun. Plenty of kids had the same idea; after all this was a time when the school leaving age had been raised from 15 to 16 only four years earlier, and most kids would leave school as soon as they could.

Enrico went to the pool in the morning, then came back at lunchtime with his older sister Catharina and her two young children, Lulu and Anna. It could get brutally hot in the walled environs of the lido, with precious little shade to cool off in, while the pool itself was liable to be insanely full, so Catharina had suggested they go to the park instead, where there was a paddling pool her girls would be happy with. But Enrico was insistent: 'I've gotta meet some birds,' he told her. In reply she told him, 'If I don't come with you and something happens, Mum will never forgive me.'[4]

There were, as it happens, reasons to worry about Enrico. He had learning difficulties and went to a special school. He couldn't read or write. A childhood neck injury meant his head was inclined to lean to one side. As a result, other kids called him Noddy. That wasn't the only abuse he got from his peers. He tended to talk away all the time as if he was the radio DJ he dreamed of becoming. In a world where the smart thing to do was to keep your head down, and your mouth shut, unless you were quite sure you were hard enough, this was unfortunate. It meant the bullies noticed him, and there were plenty of them. His mother, Louisa, would tell the *Daily Telegraph* that 'On one occasion, a group of boys wrote filthy words over Enrico's face

and body. He did not fight back because I told him to walk away from any trouble like that.'[5]

Yet this treatment clearly failed to crush his spirit. On the way to the lido he stole an old butcher's bike just for the hell of it – 'he was terrible for nicking bikes'[6] his sister recalled – and now he was on his mission to meet some 'birds'.

Once they were inside, Catharina briefly left Enrico to look after her kids. When she returned, Enrico had vanished. Catharina tried to spot him, but it was hopeless. They were at the shallow end, and there were sixty chaotic metres of jam-packed pool in front of her. The noise and the heat were overwhelming – you couldn't hear yourself think, let alone pick out a particular voice. Then came an announcement over the loudspeakers: someone had been pulled out of the deep end. Catharina immediately feared the worst.

And with reason. It was Enrico. Michael Pearce, a 28-year-old lifeguard, saw someone lying at the bottom of the pool:

> I ran over with another lifeguard and dived in. The boy was just lying there and was motionless. I pulled him to the surface . . . checked for pulse, heartbeat and breathing and there was no sign of life. Two nurses who were swimming came over to help. I gave mouth to mouth resuscitation with the help of one of the nurses, while the other helped my lifeguard colleague by pumping his chest.

At first Pearce thought their efforts were pointless, but then there was an apparent miracle:

> It was after about twenty minutes that we realised he was coming back to life. He started to breathe on his own and there was a faint heartbeat. By then the ambulance came and took him to hospital.[7]

Sadly, it was a false reprieve. As with Gurdip Chaggar in Southall a month before, this return to consciousness was only temporary. Enrico's family were able to see him in hospital that afternoon and he was able to speak to the police, but then he suffered two huge heart attacks and went into a coma from which he would never return.

He died eleven days later on 19 July.

The story made an immediate impact, locally. London's leading newspaper, the *Evening Standard*, covered it the following day. The police officer in charge, Chief Supt Rex Lewis, was adamant that this was not an accident but a deliberate attack:

> We know there was some shouting and argy-bargy between the victim and his attackers shortly before he was beaten up and thrown in the pool. It seems to have been a savage attempt to murder him. It may not have started that way, but it is certainly how it ended up.[8]

The reporters spoke to Enrico's father, Antonio, who commented: 'His mother and I are heartbroken that such a tragic thing could happen before such a crowd.' This was the line that gave the case such resonance. How could such a thing have happened in broad daylight? What kind of place was this Parliament Hill Lido? The *Evening Standard* offered a powerful hint with the last line of their story, which noted that one of the nurses had had her purse stolen while she'd been desperately trying to resuscitate Enrico, losing £3.

The national news coverage didn't really start in earnest until Enrico's death on 19 July. A *Daily Telegraph* story the following day identified the key elements of the case. Enrico, according to the police, had been beaten up, then held underwater by two youths, who stood

on his shoulders to prevent him getting up. A third boy may have been involved and may have tried in vain to help Enrico before running off. So far, so appalling, but surely it should be easy enough for the police to identify the killers, acting in plain sight as they did, in front of some thousand-odd people. But apparently not. The police, it was said, were being met with 'a wall of silence'.

This wasn't exactly true. The problem was that the many names being bandied about didn't appear to be the right ones. One policeman mentioned they were investigating a suspect with 'an English Cypriot name'. Another said they were looking for two or three of 'the local yobs who are known as the Kentish Town Cowboys'.

That might've sounded like a promising lead to the outside world, but not to the locals, none of whom had ever heard of these Cowboys. And so it would carry on over the next few months. Endless speculation and no substance. At one point the police did arrest a 16-year-old boy, but he too had learning disabilities, and his so-called confession was so unconvincing that the case against him was eventually dropped.

There would be a TV documentary on the case a year later which provoked more handwringing and no new evidence. The world had moved on but the Sidoli family, mired in grief and hopelessness, could not. They were evicted from their Kentish Town flat for non-payment of rent. Louisa had a stroke – brought on, she believed, by the stress of it all. Every now and again over the subsequent decades, Enrico's sisters would launch another fruitless appeal for new evidence. No murderer was or ever would be found. The case lived on as an embodiment of what a broken Britain we were living in in the summer of 1976 – a place where a backward kid could be murdered for a laugh, in broad daylight, in full view of crowds of people, and no one would care. A

place where we were all too frightened to stand up for what was right. A place where bullies ruled unchecked.

As for the kids who frequented the lido, all of whom had inadvertently been cast as suspects or callous onlookers, there was a variety of responses. Andrew Anthony, fourteen at the time, remembers a simple fascination: 'It added lasting intrigue to the summer – wondering who did it. There was a thrilling element to it.' John Lockwood, on the other hand, is keen to reject the notion that this case somehow besmirched the whole community:

> The Enrico Sidoli thing – some people say he got killed, some people say he had a fall. To this day nobody knows really. There were a million theories. I think the worst thing that probably happened is someone pushed him in. If you walked along the side of the pool someone would push you in. They didn't ask if you could swim. The pool would have been so busy, so noisy you'd never have known – and it was deep. There were diving boards, people bombing. The lifeguards couldn't do much, it was too unruly, too busy. But I've been going there since I was in a pram and that's the only person to have died in the lido. Sixty-five years and only one death, that's not a bad record.

However, another local teenager from those days who I spoke to, Mick Joyce, is happy to go along with the wall of silence idea: 'The main thing that was going around at the time was, "Nobody grasses." Who done it? Fuck knows. But a lot of people knew. And the main thing was, "No one grasses." '

And no one has grassed. How many people were in a position to grass is impossible to know. In super crowded, frenetic environments like the

lido, it's very hard to know what's going on in front of your nose. Too many people shouting and bombing off the diving boards and generally horsing around to notice if one little bit of the chaos is malign. You'd have to be looking. And there were plenty of boys around who you wouldn't want to be caught staring at. So out of the fourteen hundred, or two thousand, or however many people who were there at 2.30pm on one of the hottest days of the hottest summers, it's likely that only a handful could have known with any certainty who had drowned Enrico Sidoli, and even fewer who could say for sure whether it was an accident, or horseplay that got a bit out of hand, or something more sinister and deliberate.

I remember the case from the time. It fascinated me. At fifteen I was the same age as Enrico Sidoli. And I was aware of the laws of the streets: you had to keep your eyes open and try to make yourself as invisible as possible. Not like poor Noddy. The fact that no one grassed didn't surprise me at all. There was plenty of stuff that went on in my school that you knew was wrong, but you wouldn't dream of speaking up about it. In the summer of '76, that was not the way the world worked. The long arm of history might incline to justice, but the short arm of teenage life never did.

A coda to the story. From out of the assorted teenage hard nuts who ruled the roost in the lido and its surrounding streets came a band who would do as much as anyone to promote a sense of unthreatening camaraderie among the young boys of the next decade: that band was called Madness.

Madness took their roots as a gang of teenage Herberts with the strong street look of the Aldenham Glamour Boys, and translated them into something fun and friendly, even something – to use a

much-abused word – inclusive. There were seven of them, playing irresistibly upbeat British ska and clowning about like mad in their videos. Naughty but nice. Anyone could be in the Madness gang, anyone could be a Nutty Boy. It's hard not to think that Enrico Sidoli would have loved them.

MUSIC

THE CHARTS

The hot weather was definitely having an effect on the charts – like much of Britain's sun-blasted population, they were upbeat but slow-moving. Elton John and Kiki Dee's inescapable duet 'Don't Go Breaking My Heart' quickly made its way to number one, replacing the light-operatic holiday sounds of Demis Roussos – and stayed there for what seemed like a very long while. Such was the lack of exciting new music that the singles chart was spotted with oldies like the Beatles' 'Back in The USSR' and the Shangri-Las' 'Leader of The Pack'. The real highlights were the smattering of soul tunes: Candi Staton's immortal 'Young Hearts Run Free' and Dorothy Moore's deep soul ballad 'Misty Blue' outclassing everything around them.

The album charts were much the same, except the proportion of oldies was even greater – Greatest Hits collections were everywhere. Rod Stewart started the month at number one, having finally toppled Abba, but after a couple of weeks he was replaced by the Beach Boys' *20 Golden Hits*, which remained at the top of the charts for the rest of the long hot summer. Fun fun fun. Further confirmation that Britain was in holiday mood was the appearance of two Greek acts in the top ten: not only the be-kaftaned Demis Roussos, but also the famously bespectacled Nana Mouskouri.

Not all the music that was popular showed up in the charts, however. The disco hits that made it into the top 40 were only the commercial tip of the iceberg. The charts were based on sales in so-called 'chart return'

shops. This supposedly representative sample of British record shops would submit their weekly sales figures from which the chart positions would be calculated. The list of chart return shops was supposedly secret but well-known within the industry. It was a system open to manipulation by the big companies, who could send people round to buy multiple copies of titles they were especially keen to see in the charts.

The chart return shops were always ones that catered to a general audience and sold a bit of everything. But Black music – soul, disco and reggae – was largely sold in specialist shops whose sales weren't included. So it was possible for reggae records, in particular, to sell substantial numbers but never come anywhere near the official charts.

Which was why *Black Music* magazine had its own chart, taken from a selection of London reggae specialists. In this chart Bob Marley languished well behind the likes of Jah Woosh and Junior Byles, while the big number one from L.A.B. was a dread version of the nursery rhyme London's Burning, remodelled as 'Babylon Burning'. A similarly apocalyptic mood was conjured up by the month's biggest new release, Junior Murvin's 'Police and Thieves' – a song inspired by the daily struggle in Jamaica, but soon to find a specifically British resonance.

Reggae music was starting to be associated with riot and rebellion. There was trouble at the Bob Marley and the Wailers show at the Hammersmith Odeon, so the Rank Organisation refused to allow the next big reggae show scheduled – featuring U Roy and Mighty Diamonds – from taking place in their venues. There was immediate outrage in the music press, and the Lyceum stepped in to put on the show, but it demonstrated how nervous many commercial venues were about hosting Black audiences.

THE RADIO 1 ROADSHOW

Radio 1 was the nation's only pop music station (give or take Radio Luxembourg which was beamed in from the continent and played chart sounds from 7pm every evening). It had up to twenty million listeners a week, with the most popular shows listened to by more than ten million people, making it the world's most listened-to radio station at the time. Beginning at Easter, then running through the summer holidays, the Radio 1 Roadshow saw the station touring the British coastline, all the way from Ayr to St Ives, and broadcasting live from a different seaside town every weekday morning for 90 minutes.

Radio 1's DJs, who mostly doubled as presenters of the TV chart show *Top of the Pops*, were major stars. They were omnipresent – on our portable radios at home, on the car stereo, or blaring out from shops and building sites alike. Even today, almost five decades later, I can remember the daily line-up of 1976's DJs.

Back then the nation's teenagers woke up to the sound of Noel Edmonds, an amiable, lightly bearded cove, presenting the breakfast show. Then, once we were safely in school, on came Tony Blackburn. Blackburn looked like a *Thunderbirds* puppet with plastic hair and was supposedly the 'Housewives' Favourite'. Right-thinking rock fans like me utterly disdained him, only realising years later that he actually had pretty good taste in soul music. At lunchtime there was Johnnie Walker, who had long hair and bad skin and made it very clear that he resented having to play records by the Bay City Rollers, with their bubble-gum pop for early teenage girls, rather than the Grateful Dead. The afternoon was given to David Hamilton, who sounded as if he'd sooner be listening to the Carpenters than either of those. Teatime there was Dave Lee Travis, who had a rather more

generous beard and the air of a time-seasoned mobile DJ – jokey and affable enough on the surface but could doubtless handle himself if anything kicked off.

Radio 1 went off air then, at 6pm, so the young folk could get on with their homework, and only came back at 11pm for an hour's broadcast from the station's one properly hip DJ, John Peel, who was allowed to play as many Grateful Dead records as he liked.

The station's live events were hugely popular. The year before, May 1975, there had been a memorable 'fun day' at Mallory Park racing circuit, involving such attractions as a Dave Lee Travis 'dragster demonstration', and an in-person appearance by the Bay City Rollers that led to some of their fans having to be rescued from a lake by the BBC Sub-Aqua club. John Peel, who was there, recalled that: 'While all of this was going on, Tony Blackburn was speeding backwards and forwards on the lagoon in a speedboat, driven by a Womble. And I just thought, "If I live to be 200 years old, I am never going to experience anything like this again in my life." '[9]

For the summer roadshows, the station's most personable DJs – the insufficiently perky John Peel and Johnnie Walker firmly excluded – would take a week each of the round Britain tour. Emperor Rosko, an extrovert American with a weekly show, got Lancashire and North Wales; Noel Edmonds got the surfing beaches of Cornwall; Ed 'Stewpot' Stewart, who presented the weekend show for younger kids, did West and South Wales; Dave Lee Travis put in a double stint, covering both Yorkshire and Dorset.

The format would be the same each time: a bit of audience participation, Radio 1 merchandise giveaways and the odd special guest, plus some prize competitions – always including one in which a punter had to guess how far they'd driven to arrive in Margate or Aberystwyth. Radio 1 staffer Tony Miles, known as 'Smiley Miley' – and the man

whose caravan housed the first edition of the Roadshow – would then provide the right answer.

There's a promotional film that gives a flavour of the festivities. The roadshow was housed in a showman's caravan that opened up into a small stage. A montage shows stagehands in Radio 1 T-shirts putting it all together while one of the newer DJs, Paul Burnett, sits on a folding chair having a pint and a fag.

The video cuts to Noel Edmonds, perhaps the biggest star of the lot at the time, waking up in his camper van. We watch as he gets up, showers, and cooks himself a fry-up, before putting on motorcycle leathers. Then he mounts his motorbike to drive down to the beach at Newquay, where thousands of holidaying pop fans have gathered, covering the beach and the surrounding hillsides. It's a glorious August day, the girls are all in bikinis, the boys all bare-chested, the apotheosis of that Bristol park in early summer.

Noel does a quick change and emerges on to the little stage, dressed in white flares, white shirt, platform shoes and sunglasses. 'I won't take my glasses off,' he tells the crowd, 'I had a very nasty accident with a gin and tonic last night.' Back then DJs were not expected to be clean-living role models. Even so, Edmonds embarks on a little sermon, explaining the roadshow's mission: 'We go round the country, helping people to like each other, helping people to feel closer to each other. We go coast to coast, no aggravation, no nasty thoughts, just clear, clean, pure thoughts, hoping that we have no problems at all at any point . . . No physical violence at all . . .'

Just as the audience is starting to wonder why he's protesting so much, a fight appears to break out between various Radio 1 staff, which then leads to a further pretend fight between Edmonds and his producer. Cue general hilarity. This was a time when the very idea that a mass gathering might not involve a punch-up was objectively hilarious.

And so the roadshow rolled on. Ed Stewart is in a very sunny, and similarly mobbed, Tenby, where he is able to whip the crowd into a frenzy by introducing the recent number one chart toppers, the Wurzels. They come on stage, do their yokel shtick, and then dance and gurn along as the sound system blasts out their immortal 'The Combine Harvester'.

Dave Lee Travis wasn't so lucky with the weather. Whitby, at the very end of July, was evidently windy and less than baking, judging by the number of jumpers worn by the crowd around the harbour. Travis manages to smoke a cigar while broadcasting and looks very happy to retreat to the pub after his stint, leaving the crowd listening to Candi Staton's 'Young Hearts Run Free'. The sound of summer '76 right there.

IN OTHER MUSIC NEWS

Sounds had a spread on 'The A–Z of Punk' – basically a list of US bands from the sixties who released short, sharp singles. In the same week Eddie and the Hot Rods released their *Live At The Marquee* EP, four breakneck covers of some of those songs – arguably the first British punk record. It certainly seemed like it when I bought my copy.

Bob Marley complained to the *London Evening News* that they failed to get their facts straight: 'You wrote that I had seven children by four women. That's not true – I have nine children by seven girls – everybody know that!'

The NME was very excited by the launch of a new Marvel comic, the first one that seemed to acknowledge the existence of the counterculture – step forward *Howard the Duck*.

A new ITV music show launched, called *So It Goes*. It was broadcast from Manchester and not available everywhere, so I couldn't watch it in Wales. The first show featured Clive James monologuing and Kevin Ayers and Frankie Miller playing live. In the *NME* Mick Farren was not impressed by the presenter, local journalist Tony Wilson: 'Let's face it, he sits on his stool in his stupid wet-look PVC jacket, trying to decide if he wants to be Lenny Bruce or Jonathan Miller.'

AC/DC finished the 'Lock Up Your Daughters' tour, their first full UK jaunt, with a gig at the Lyceum. In true 1976 style the audience were encouraged to show up in 'school uniform'. The lucky winner of the 'Schoolgirl We'd Most Like To' award received her prize from the reliably lecherous John Peel.

Confessions of a Driving Instructor: It's a man's, man's, man's world.

CONFESSIONS OF THE BRITISH FILM INDUSTRY

On a broiling Sunday afternoon in July, there was precious little for a bunch of 15-year-old boys cloistered in a Bristol boarding school to do, other than go to the movies. This particular Sunday we decided to have a go at getting into an X film, with its promise of nudity and who knew what else. None of us looked remotely 18, but the rumour around the school was that the Studio cinema in Broadmead was easy to get into.

The Studio had four screens, so it was just a question of which movie we wanted to see, which boiled down to which one we reckoned would have the most nudity in it. On that basis we decided to go for a lip-smacking double bill of *Confessions of a Pop Performer* and *Linda Lovelace For President* – because Linda Lovelace was famous for being in an actual pornographic film, *Deep Throat*.

This film, however, turned out to be a lame satire on American politics with very little nudity, though Linda Lovelace was quite charming. Mickey Dolenz from the Monkees appeared in the film, which somehow seemed even stranger than all those old stagers from the British comedy world appearing in the *Confessions* film, which we didn't see much of anyway, because we had to get back to school in time for 6 o'clock curfew.

Mostly though it was a lesson learned. Don't bother going to any of these films hoping to see something genuinely erotic. All you would get was some girl with her bosoms out, if you were lucky, and some daft

bloke running about with his trousers round his ankles – basically just seaside postcards brought to life.

The great British sex comedy boom would only last for a couple of years. But right then, in the summer of 1976, it was still doing good business and if there was one actor who had caught the British zeitgeist, full of sexual insecurity and thwarted ambition, then it was undoubtedly the cheeky chappy star of the *Confessions* films, Robin Askwith.

The *Confessions* phenomenon had begun with a book called *Confessions of a Window Cleaner*. The author, Christopher Wood, was an advertising executive who'd written a couple of literary novels with no great success. Towards the end of a lunch with his editor he had a bright idea:

> Why not do a series of stories about the sexual adventures of a bloke in a number of different jobs? What I meant was everybody knows somebody who has the sort of job where women are always supposed to be making passes at him, inviting him in for cups of tea and asking him to mend the lids of their vanity cases.[10]

The editor ran with it and Wood went away and wrote *Confessions of a Window Cleaner*. It purported to be written by its hero, Timothy Lea, and offered a broad mix of smut and comedy. It was an immediate hit and Wood went on to write eighteen more Timothy Lea books, ranging all the way from *Confessions of a Driving Instructor* to *Confessions of a Long Distance Lorry Driver* via *Confessions of a Milkman* and *Confessions of an Ice Cream Man*.

Timothy starts out as a hopeless sexual novice, but before long is being propositioned by every woman he meets. It's mostly too obviously

a ridiculous adolescent sex fantasy to be truly offensive – unlike Wood's other *Confessions* series which featured Timothy Lea's female counterpart, Rosie Dixon, wherein Rosie is continually groped and flashed at by almost every man she meets and there are regular scenes in which she is subjected to rape or attempted rape.

Put the two series together and you end up with a grim vision of a Britain in which every man, no matter how unattractive, is convinced that all women are secretly desperate to be groped, and every woman has to go through life continually fending off the resulting unwanted sexual advances. A vision, in fact, that was uncomfortably close to reality.

By 1976, when the *Sunday Mirror* came to interview him, Christopher Wood had sold three million copies of his *Confessions* books, knocking a new one out every month and living in style in the south of France. His wife Jane was resolutely unimpressed by Wood's lecherous alter ego: 'He's exactly the sort of man I hate most,' she told the reporter. 'He's shallow, he treats women like objects, he's so sexually obsessed he becomes boring.'

Wood himself offered an intriguingly downbeat sidelight on the character:

> He has no friends, he has no real interests. Even the women who take him to bed exploit him. Perhaps he is reassuring to people in a strange way. I mean he is by no stretch of the imagination a superhero; he has all the normal sexual frailties and fears. He just happens to be a bit luckier, that's all.[11]

So that was the Timothy Lea of the paperbacks that were on sale in every WH Smiths and railway bookstall in the land. A film producer, Greg Smith, fresh from making the *Dad's Army* spin-off movie, picked up a copy of *Window Cleaner* on London Bridge Station – and by

the time he arrived in Eastbourne he was sure it had the makings of a successful film. He bought the rights, signed up the veteran Val Guest to direct, and had Christopher Wood himself write the script.

The next step was the trickier one: to find the right actor to play Timothy Lea, someone with just the right balance of glamour and gormlessness. This wasn't too easy. The first few actors they approached – among them Dennis Waterman, Richard Beckinsale and Nicky Henson – all turned it down on the grounds that it was rubbish and would be bad for their careers. And so their attention turned to a young actor called Robin Askwith.

Askwith was twenty-three years old but already had an extensive array of screen credits. He'd appeared in Lindsay Anderson's *If* while still a teenager, and then had managed the unusual feat of simultaneously working with Pier Paolo Pasolini, in *The Canterbury Tales*, and Sid James, in the sitcom *Bless This House*. He was currently appearing in a prime-time comedy drama called *Beryl's Lot*, where he played a hapless young love object called Fred. He looked just right: longish hair and lips like Jagger, and he had already shown that he didn't mind taking his clothes off in the interest of art or laughs, in films like *Horror Hospital* and *Cool It Carol*.

The script was duly sent to his agent, Hazel Malone. Askwith wasn't keen initially – he'd been hoping that *Beryl's Lot* would be a stepping stone to classier jobs, not more *Horror Hospitals*, but Malone pointed out that work was work and Askwith caved in and went for the audition. He turned up sleep-deprived and hungover, and it turned out that the reason for the producer's interest wasn't *Beryl's Lot* but a Kit Kat ad in which Askwith had played a window cleaner. He won the part by suggesting that the sex scenes themselves needed to be funny. He was duly offered a contract for six *Confessions* films, with the money increasing each time, albeit from a low base.

Askwith took the deal, but he was still trepidatious about the part he was taking on, with the challenges of not only appearing in numerous sex scenes, always surrounded by any number of onlookers, but also having to make them funny.

Nevertheless, it turned out he was absolutely the man for the job – the perfect mix of glam and gormless. And, as he told me, the key thing was that he didn't play Timothy as a macho man, but more a wimp who got lucky. Over and over again.

> I was just trying to be as gentlemanly as possible – and pathetic with women, which I was, to show that men have no idea what they're doing. And trying to get some comedy out of it. Whereas I think if somebody more aggressive, more testosterone-charged [played the role] . . . I don't mean I wasn't testosterone-charged, but I was frightened of women.

Columbia were more than happy with the finished product so the next job was selling it. The sex scenes made sure it received an X certificate, so it obviously couldn't get the breadth of audience a *Carry On* film could – but on the other hand it served to let the punters know they'd see a lot more than just Barbara Windsor's bra. The film would launch all over the country at the end of August. To stimulate enthusiasm, Askwith went off on a tour of TV and radio chat shows. With his co-star Linda Hayden and the producer Greg Smith, they even visited factories in each city to drum up trade – emphasising the point that this was deliberately blue-collar entertainment.

In an indication of things to come, the opening night showing, at the end of August, 1974, was a big hit with the audience, but the press night rather less so. The critics mostly hated it, though the *Sunday Telegraph* did at least have some praise for Askwith and the supporting cast of comedy professionals: 'Robin Askwith plays him with disarming and

engagingly clumsy innocence . . . and from time to time one or two good actors turn up, such as John Le Mesurier, Bill Maynard and Dandy Nichols: but they don't turn up enough.' The *Sunday Mirror*, however, was brutal:

> Only the British could make sex seem as crude and unattractive as it does in *Confessions of a Window Cleaner*, a crass and clumsy comedy which makes the Carry-Ons look like works of art . . . For all its full frontals and saucy talk this lamentable bit of British rubbish is half a century out of date in its outlook and attitudes.[12]

The great British public, however, took no notice. *Window Cleaner* was the big cinema hit of the year. It spent ten weeks at number one in the box office charts, a first for a British film. Robin Askwith had been half-expecting the film to be a one-off, but now it was clear that there would be sequel after sequel. *Confessions of a Driving Instructor* was due to be filmed next, but there was a last-minute change of plan. The producers decided to set the second film in the world of Glam Rock – though this was a world that was fast falling out of fashion. They called it *Confessions of a Pop Performer*, a film that even the generally buoyant Askwith can find no fondness for.

The movie didn't do as well as its predecessor, but still well enough to ensure that a third instalment was filmed in the spring of 1976. This time they went back to comedy basics with *Confessions of a Driving Instructor*. Askwith was the lead again, supported by an array of starlets and some old reliable comedy troupers, while Tony Booth reprised his role as Timothy's brother-in-law.

Robin Askwith told me of his high hopes for *Driving Instructor* after the slight misfire that was *Pop Performer*:

I was looking forward to it because the second one [*Pop Performer*], I just didn't enjoy making. Even the focus puller one day said, 'You're not your usual jolly self.' And I wasn't, because I was working fucking hard to make scenes funny. But I was looking forward to this one because I knew I was going to do some great stuff with Irene Handl, and my friends George Layton and Windsor Davis.

His first job was to get in shape. Not so simple at a time when fitness wasn't a popular leisure activity:

I had to go and get fit for these films, as I would have to run around with no clothes on. It was quite difficult, back then, as there were no real gyms or anything, apart from Dave Prowse's one in Kensington. I did a lot of swimming, two miles a day at Swiss Cottage pool.

Filming began in mid-February, 1976, at Elstree Studios. They began with the indoor scenes before moving outdoors in March to shoot the various alfresco sex scenes. Christopher South, from the *Cambridge Evening News*, went to see the team in action:

The fair-haired young man with a mouth full of strong white teeth has lunged lustfully at the girl in the passenger seat of his battered Triumph Herald. Now they are motionless. His right leg is sticking out of her window. Her right leg is on his dashboard. Various items of their clothing lie scattered about the car. A crowd has gathered but they ignore the couple in the car. They are staring at the wing mirrors which are revolving rapidly like mad radar scanners . . .

'Oi!' shouts the young man in the car, petulantly. 'Oi!'

No one responds. 'Oi!' he yells again. 'Where's me tea, then?'

Still they ignore him. His wing mirrors have stopped revolving, but the crowd has a new attraction. A kindly, white-haired old gent is fixing explosive charges under the young man's hubcaps.

'Tea . . .' gasps Robin Askwith (for it is he) faintly. 'Please . . .'

At last his plea is heard. Someone sets off up the road to where a trestle table stands in the gutter, laden with urns and corned beef sandwiches. Mr Askwith gets his tea, but no sympathy. With olde worlde courtesy he shares a plastic beaker with the girl as they remain locked together in attitudes of extreme sensuality.

'What's the girl's name?' I ask an onlooker. 'Sally something,' he says.

Poor Sally Something, she has a bruised shoulder from the rough-and-tumble of being seduced for the umpteenth time in the past hour. She rubs it feebly with icicle fingers. No one sympathises with Sally Something. Starlets are disposable. She suffers alone in passionless proximity to Mr Askwith, waiting for permission to move again . . .

Making this sort of film is particularly unpleasant when you're on location, shooting outdoor summery scenes in the middle of March. That is why poor Sally's fingers are like ice. She's wearing a thin blouse and a wicked wind is whistling across the roadside verge on the edge of suburban Kings Langley.

Cast and crew would probably get thoroughly fed up if director Norman Cohen wasn't such a funny little fellow. He hides his quick wits behind a bearded face that looks as if he had just woken up from a night in a hedge . . .

He has kept everyone cheerful while the hubcaps were being made ready. Now he gives the order for the cameras to roll again. Robin and Sally Adez (by now I have discovered that is her full name) go into action. More clothes fly out of the car.

Crouching at the back an effects man pumps the bumper. 'More rocking, much more rocking,' bellows Mr Cohen.

As the simulated sex session gets underway, Mr Cohen shouts 'wiper blades!' An effects man twenty feet from the car presses a button on a small control panel. The car's wiper blades whirl violently and fly off.

Then, as further buttons are pressed, the headlights flash, part of the bonnet flies off, the hubcaps explode and fly off, the passenger door flies off depositing Robin and Sally on the grass where they are rained on by the windscreen washer.[13]

Another spectacularly uncomfortable scene involved Timothy having sex in a bunker on the golf course and the ball landing in his bum crack. The lady golfer responsible then decides to take her shot anyway. It was an idea full of potential pitfalls and, to make matters worse, Askwith had only himself to blame:

As always, I was asked for any ideas. So the shagging on the golf course was my idea, not thinking of course, that it'd be shot in February and I would be naked. And then there was the question of who's going to take the shot, the golf ball coming out of my arse. It was actually a stuntman called Rocky Taylor in women's clothes. He chipped out of my crack very, very nicely.

Which pretty much gives you the whole *Confessions* phenomenon in one handy image. The film was released four months later in July. *The Guardian*'s John Cunningham decided to make sense of the series appeal and talked to the director, Norman Cohen (who had replaced Val Guest). 'Light sex, nudity and comedy' were the keystones, he said, adding that, 'We don't cheat the audiences. Other films tend to fade out when a couple come together. We go beyond the fade . . .'[14]

That sums it up pretty well, though Cohen goes on to point out that they were still well aware of their limits, both in terms of the law – 'the censor doesn't allow thrusting and we don't linger on private parts' – and their desired audience – 'we're definitely not making porn movies and we don't attract the dirty raincoat brigade.'

As for the charge that the films are ludicrously sexist, Cohen takes it on the chin: 'Our films are male chauvinist oriented. If I was a woman, I'd be terribly insulted.' Well, quite. But Cunningham then makes the point that, 'The sex scenes are made acceptable because of the humour, because Timothy Lea . . . is anchored in his family, and because all the coupling is mercifully guilt free.'

The *Sunday Mirror* decided to find out where Timothy Lea stopped and Robin Askwith started. Just how much of a Lothario was the actor? Not that much, it turns out. Or at least not while working:

> Bathed in enough wattage to floodlight Wembley stadium, Robin Askwith is lying on a bedroom floor with a young lady in red ringlets. It's rehearsal time at Shepperton film studios. But Mr Askwith's mind is not entirely on his work. The lady with the red ringlets is scratching his bare chest and has a look on her face that suggests she's going to do something extremely pleasant to him. But Robin just turns to a mate who appears on the dark side of the camera. 'What won the 3.30 at Goodwood? Oh no! That's another of your bloody tips gone up the spout.'

Askwith politely explained to the *Mirror* reporter, Colin Wills, that simulated sex really is a very different matter to the thing itself. There are lines to be remembered, precise movements to be followed, none of which is conducive to actual lust.

Wills is fascinated, however, to discover that while Askwith's

co-stars may be fellow professionals, more than able to repress any genuinely amorous inclinations, there were plenty of film fans out there who were definitely interested in getting all flirty with him: 'They've seen you performing on the screen and they reckon you must be a bit of all right. They walk up to you and they come right out with it.'

Which is enough for Wills to come to the conclusion that, 'There must be something in the character he plays that unleashes the deepest, most secret feminine fantasies. Perhaps it's the fact that he's the sort of guy who really might knock on the door any day of the week and see if you have any jobs that want doing.'

Timothy Lea may have been an ultimately hapless character, but the young man who played him on screen was now a bona fide star. So much of a star that he was soon given the ultimate honour of the times, an invitation to participate in the annual celebrity edition of *It's a Knockout*.

It's a Knockout was an enormously popular TV show from the late sixties to the early eighties. Presented by the voluble Stuart Hall (later to be convicted for indecently assaulting numerous young girls) and self-parodying northerner Eddie Waring, it involved teams of contestants competing at ridiculous outdoor games – typically navigating an obstacle course carrying a bucket of water while being blasted by water cannons operated by the opposing team.

The annual celebrity version followed similar lines, but with more elaborate fancy dress and a bunch of more-or-less recognisable faces. Notionally the competition was between the cricketing charity the Lord's Taverners, and the celebrities, but the two line-ups were pretty much interchangeable.

The 1976 edition took place in the sunburnt surrounds of Crystal

Palace Athletic Stadium and attracted a huge crowd. The celebrities were mostly TV stalwarts, ubiquitous names of the time like Judith Chalmers and Anita Harris, Richard Stilgoe and Shaw Taylor. There was Mick McManus from the world of wrestling and Bernard Cribbins from the world of *Carry On*. Robin Askwith was one of a group of younger actors, alongside his friends Richard O'Sullivan and George Layton, and he thoroughly enjoyed himself:

> They're huge fun and the audience really got sort of involved with us all dressing up as rabbits, carrying carrots around, falling over each other or whatever . . . I don't know what we talked about – football, rugby, cricket. And then we wandered out and behaved like fucking idiots. Making a lot of money for charity.

Such was the life of a celebrity in the sultry summer of '76. It was a smaller world then, and Askwith was right in the middle of it. He had a flat in Maida Vale and everyone who was anyone seemed to visit:

> Most people of that era – footballers, rock stars – passed through that flat. I would meet footballers through charity football matches. I played with a lot of them, at testimonial and benefit matches. I supported Queens Park Rangers and became very friendly with Stan Bowles, and then we married two sisters. I got to know Dave Webb and Johnny Hollins [Chelsea players], a lot of footballers. And then the rock stars were down the road at Abbey Road. I played in charity cricket matches with Mick Jagger, Peter O'Toole, Bill Wyman, of course, he was always there. I played a charity tennis match with John McEnroe, Peter Fleming and Trevor Eve – Trevor took it very seriously!

Askwith's world was a scene fuelled by alcohol rather than drugs:

Yeah, we didn't party as much as people said, though we did like to drink. But my little crowd – I mean, we were naughty, you know, there was girlfriends and bits and pieces, but we were pretty careful cos we had to play in front of a camera. There was no swagger, you know? You just kept working. I was making silly films . . .

And so he continued to do for a while. After *Confessions of A Driving Instructor*, he signed on to spend the remainder of the roasting summer by the seaside making the silliest of the lot. An Egyptian-American film director called Frank Agrama had a project called *Queen Kong*, a musical sex comedy reworking of the classic story, with the sexes reversed. The idea was probably inspired by the recent success of a Flash Gordon parody called *Flesh Gordon*. Robin Askwith, in the Fay Wray role, would be playing opposite a 60-foot female gorilla, to be constructed by Ridley Scott's people. What could possibly go wrong? As Robin Askwith remembers, practically everything:

It's one of the worst films ever made. Ridley Scott's company hadn't been paid, so the 60-foot gorilla wasn't quite ready and it fell to pieces. But by then, I was enjoying myself so much. I mean, it was just craziness. I was worried about it being seen, it was a ten-minute joke stretched to an hour and a half. But I was paid an extraordinary amount of money. And I bought a boat, I bought a cruiser and paid a lot of fucking tax.

In an echo of *Rock Follies*, Askwith's human co-star was Rula Lenska, making a film every bit as ridiculous as anything dreamed up by the Follies' sexploitation director Chas Speed. Though one benefit of filming in this blistering summer was that their chosen location of Newhaven in Sussex did a much better job of impersonating a parched tropical island than anyone could have predicted.

From *Queen Kong* Askwith headed straight back to Shepperton to finish up his enjoyably surreal summer by filming *Stand Up, Virgin Soldiers*, a sex comedy based on Leslie Thomas's novel about a bunch of young men doing their National Service in Singapore. Norman Cohen was the director once again and many of the *Confessions* team reappeared as well, this time in period costume. John Le Mesurier wasn't too challenged by moving from *Dad's Army* to the regular one. And Askwith got to have sex scenes with both a young Pamela Stephenson and Fiesta Mei Ling in the role of local prostitute Juicy Lucy. There wasn't the budget to actually go to Singapore, of course . . .

Straight after that came the final *Confessions* film, 1977's *Confessions from a Holiday Camp*, and then this particular train hit the buffers. Lame comedies with added tits and bums were no longer raking in the money. A brief vogue for straight ahead softcore porn lasted another year or so – truly dreadful films financed by dirty mag supremos Paul Raymond and David Sullivan.

An unedifying era in the history of British cinema was coming to a close, and with it Robin Askwith's time in the limelight. He has carried on working though, all the way from Lindsay Anderson's *Britannia Hospital* to *Coronation Street*. As we finished talking, I asked him if he'd been aware of the burgeoning punk phenomenon in the summer of '76. He said he had been, because he used to eat at a place called Osteria 430, which was in the same building as McLaren and Westwood's Sex, but in the lotus-eating summer of his stardom he didn't pay them much mind: 'I wasn't very angry. Those were angry people. I'd been angry in the sixties. I wasn't angry any more, I was having a great time!'

TELEVISION

On televisions up and down the country, half of which were now in colour, sport was to the fore, with the Wimbledon finals, the West Indies Test matches and then the Olympics – which took up much of BBC1 for the second half of the month. And there were plenty of episodes of that surprise hit of the early colour TV era, *Pot Black Snooker*.

The oddest TV sporting offering was *The War of the Worlds*, a screening of a bout in which Muhammad Ali took on Japanese wrestler Antonio Inoki. The fight was in Tokyo's Budokan arena, and Ali approached the ring shouting, 'There will be no Pearl Harbor! Muhammad Ali has returned! There will be no Pearl Harbor!' Due to some poorly conceived rules and restrictions, Inoki spent almost the entire fight lying on the floor kicking Ali in the legs, while the crowd got increasingly angry. It was scored as a draw. Overall it was possibly an even less genuine competition than *It's A Celebrity Knockout*.

BBC1 and ITV both ran summer specials, but neither of them offered more than the most routine end-of-the-pier entertainment. ITV offered the jaded *Summer Night Out* at the Batley Variety Club with the lovably misanthropic comedian Les Dawson or the ventriloquist Rod Hull and his Emu – while *Seaside Special*, on the BBC, at least moved to a different seaside town each week and offered the equally over-familiar likes of magician Paul Daniels and crooner Sacha Distel, though the Three Degrees lent a bit of American star power when the show visited an unusually heat-blasted Scarborough for a Bicentennial edition on 4 July, celebrating two hundred years of American independence.

There was a good deal of Bicentennial programming that weekend, little of it very exciting. John Wayne, Alistair Cooke and Leonard Bernstein were all present and correct. Meanwhile prime-time US TV drama appeared to be playing out the battle of the sexes. There was *The Bionic Woman* and *Policewoman*, a pretty formidable duo, competing for viewers with their rather less tangible opposition in the shape of *The Invisible Man* and *The X Y Y Man*. Did this signify a coming crisis of masculinity?

Light entertainment, meanwhile, had rarely been lighter. Vera Lynn, the singer whose fame still rested on her wartime rendition of 'We'll Meet Again', had her own variety show with maudlin singing duo Peters & Lee and the 'comedy' pianist Victor Borge. If you wanted something a bit more up-to-the-minute you could switch to ITV where Bruce Forsyth, whose career only went back to the early 1950s, presented *Bring on the Girls* with Lena Zavaroni, Twiggy, Honor Blackman and, once again, the Three Degrees.

Panel shows were popular too: anything from *Whodunnit* to *Call My Bluff*. Most of them seemed to feature the supposedly charming eccentric, Dr Magnus Pyke, a TV scientist.

Despite all of the light entertainment, there was still space for considerable quirkiness around the schedules. There was an oddly bleak, movie-length comedy drama called *Machinegunner* about a Bristol rent collector played by Leonard Rossiter, now approaching the peak of his fame as a comic actor. The femme fatale who ensnares him was played by Nina Baden-Semper, Britain's best known Black actress thanks to her role in *Love Thy Neighbour*.

Offbeat documentaries included the poet laureate, John Betjeman, on the Rev Francis Kilvert, and a study of the American choreographer Twyla Tharp. James Burke, the genuinely charming and very popular

TV scientist, teamed up with celebrity astronomer Carl Sagan for *Is Anybody There: The Search For Life In Outer Space*.

The BBC's flagship *Omnibus* documentary strand offered *Beyond A Boundary*, in which the great, but then almost completely unknown, West Indian historian and cricket writer C L R James offered a personal meditation of sport, colonialism and the West Indies. It was shown, appropriately enough, the night before the first day of the Third Test match.

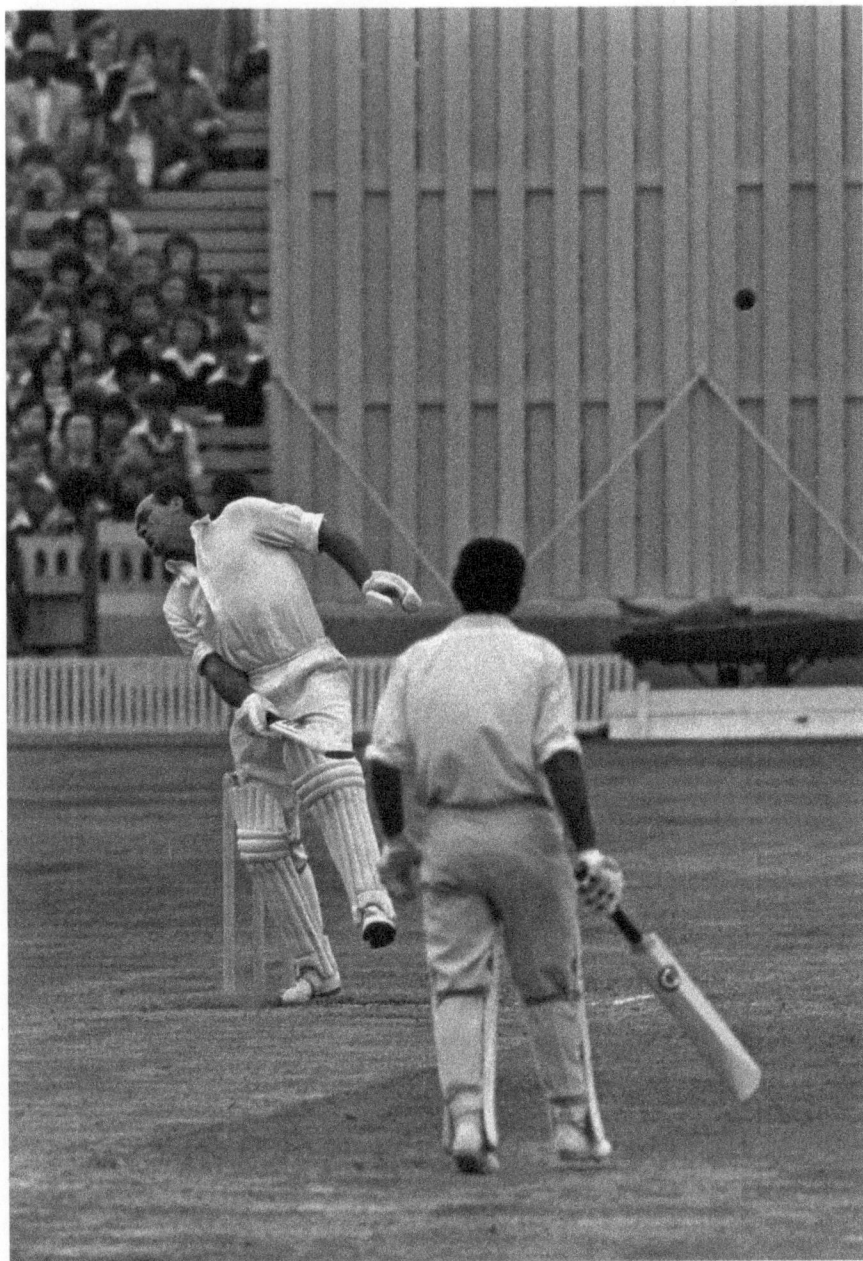

Brian Close narrowly avoids having his block
knocked off by a Michael Holding bouncer.

WAR MINUS THE SHOOTING

'War minus the shooting' said George Orwell of international sport, in an essay written immediately after the Second World War. He didn't live to see the final hour of the third day of the Third Test between England and the West Indies on 10 July 1976, or he might have revised the part about 'minus the shooting'.

Cricket is the most ambiguous of sports, simultaneously profoundly democratic and deeply conservative. The game itself requires both individual excellence and the imperative to work as a team. It emerged from rural England, and was administered by the patricians of the MCC, but flourished across the British Empire, in Barbados as in Australia, in India as in South Africa. In 1963, C L R James, the Trinidadian historian and revolutionary, had published *Beyond a Boundary*, his game-changing analysis of the way the colonised had taken the colonisers' sport and made it their own, and now the basis for a BBC documentary.

What James made clear was that for the West Indies, cricket was not simply a game but an expression of national, and indeed racial, pride. The history of cricket in the West Indies was also a history of the West Indian peoples and their struggle for independence and respect over the past century. And all the more so in the post-war years during which the various West Indian nations had indeed achieved independence from Britain, and so many West Indians had come to help Britain rebuild after the war and were now making lives here. So the arrival of a West Indies cricket team every four years or

so was always eagerly awaited, both as a great sporting contest and a chance for the immigrant population to show pride in their roots and culture.

At fifteen I had no more than the dimmest inkling of any of this, but like many of my contemporaries, I was a West Indies fan. They were to cricket as Brazil was to football: glamorous and exciting, devastating in attack but vulnerable in defence. And until recently they had had, as their captain, the greatest cricketer in history, Garry Sobers. He was the Pelé of the summer game. Eight years earlier he'd come to play against my home team, Glamorgan, and he'd hit six sixes in an over for the first time ever. He had been an absolutely heroic figure, the public face of the newly independent countries that made up the West Indies. This latest tour would make new heroes, some predictable, some rather less so.

The West Indies cricket tour was unquestionably the sporting event of the summer. And it lasted the whole summer as they toured the country, playing against all the county teams as well as the games against England. The team arrived at the beginning of May, warmed up against the Duchess of Norfolk's Invitation XI at Arundel, as such were the times, and finished up some four months later with another charity match, against T N Pearce's XI at Scarborough on 5 September. Along the way they played a grand total of thirty-four games, including the main event, the series of five Test matches, and changed cricket for ever.

Sobers had still been the captain the last time the West Indies toured in 1973. They had beaten England 2–0 in a three-match series. The final Test match at the Oval had seen them give England an absolute hammering with centuries from Sobers and my particular favourite, Rohan Kanhai. That was the last time we in the UK had seen the West

Indies in action as a team. In those days you could only follow overseas games on the radio – there was no Sky Sports beaming games in from all over the world.

In the summer of '76, however, I would see quite a few of the West Indies players in action, as many of them were also playing for English county sides. Every Sunday the BBC would show a live 40-overs county match from the John Player league – this being an era in which county cricket was considered prime-time entertainment (and tobacco companies perfectly acceptable sponsors). In fact there was proportionately more live cricket on TV than there was football (where the most we could watch was highlights on *Match of the Day* and *The Big Match* – and where the only games shown in full were internationals and the FA Cup final).

I was aware, though, that the West Indies had had a bumpy ride in the last few years. Sobers had retired, soon followed by Kanhai. Just in the last year they'd gone to Australia and been badly beaten over the winter of 1975/6, losing the six-match series 5–1. This provoked much soul-searching. What had gone so wrong?

The new captain Clive Lloyd identified two things: One was the devastating fast bowling of the Australian pair Dennis Lillee and Jeff Thomson, who had left the West Indies batsmen with multiple broken bones. The West Indies needed to fight fire with fire. They already had two genuine fast bowlers, in Andy Roberts and the newcomer Michael Holding, but Lloyd wanted more. He had a vision of an all-out pace attack that would never let up in intensity.

This linked to the second area of perceived weakness. The West Indies had a tendency to believe their own press, determined to live up to the hype as the Calypso cricketers, the great entertainers. And so, when they were under pressure, instead of digging in, they went for flamboyant attack instead. And time and again this approach had

failed. Lloyd, for all his amiably bespectacled exterior, was a tough cricketer and now he demanded that his team play the game hard and play to win, not just to entertain.

He started to put these plans into action in the spring of 1976, when India came to tour the Caribbean. He selected three genuinely fast bowlers, Roberts, Holding and the erratic but extremely hostile Wayne Daniel. The final Test in Kingston, Jamaica, ended with the Indians not so much losing as surrendering, after having several players hospitalised by the West Indian bowling. This was cricketing carnage on a level never seen before.

Lloyd wasn't minded to back down though. The lesson he took was that intimidating bowling works. 'No team enjoys the sight of opponents being injured and taken to hospital,' he said, before adding, 'If you can't play quick bowling you shouldn't be in the game at international level.'

For the England tour, then, there was no doubt that Lloyd was going to stick to a winning formula. Roberts, Holding and the wild new boy Daniel would all be part of the Test team, backed up by the experienced, if slightly slower, Vanburn Holder. This would be the most full-on pace attack ever seen in Test cricket.

No one could say that England weren't warned. They knew they would be facing an ordeal by pace. The question was what to do about it. The press was full of stories about the fearsome West Indies bowlers, particularly the handsome and deadly Michael Holding. And there was much debate as to who England should select as their opening batsmen to stand up to them. The best opener was undoubtedly the phlegmatic Yorkshireman, Geoffrey Boycott. But Boycott had fallen out decisively with the England setup after expressing his contempt for the previous captain, Mike Denness, a man he would describe in his autobiography as 'the worst England captain I have played under.'[15]

He declined the offer to rejoin the fold, saying he preferred to concentrate on captaining Yorkshire. This did nothing to help his growing reputation as a thoroughly self-interested player who cared little for his England teammates. Next best was Dennis Amiss, but Amiss was thought to have one weakness in his game and that, unfortunately, was against extreme pace. Two years later he would be one of the first cricketers to wear a protective helmet. So it was decided that he should play for the MCC against the West Indies as a kind of Test trial.

Holding had taken a few matches to warm up, but by the time he arrived at Lord's for the MCC match he was ready to rumble. And there was Dennis Amiss waiting with his bat. Holding started his run-up from way back at the boundary's edge, then went in as fast and smooth as you like. His first ball was short. Amiss ducked to get out of the way, but it wasn't as short as he had thought and, instead of ducking under it, he ducked into it. And so the rock-hard cricket ball smacked into Amiss's skull just below his left ear. He collapsed, blood dripping from a cut to his head that would need four stitches. England had their fears confirmed. This summer's Test series would be war by any other name, and there would be no shortage of flying missiles.

So what did the England selectors do to combat this terrifying new threat? In essence, they called up Dad's Army. John Edrich was brought back into the team to open the batting, shortly before his 39th birthday. The 34-year-old David Steele was retained in the middle order. He had become a cult hero the previous summer – a John Major-like figure with grey hair and glasses, he was memorably caricatured by the *Sun*'s Clive Taylor as 'the bank clerk who went to war' – for his fearlessness in taking on the Australian fast bowling. Steele obviously had guts. The same went for the real surprise selection, Brian Close. The trouble was that with Close, it seemed likely that guts was all he had.

Close was a big tough Yorkshireman who was nothing if not battle hardened. But he was 45 years old, bald-headed and long past his peak. His first appearance for England had been as a teenage prodigy as far back as 1949, just four years after the war.

The only new cap in the team was himself a veteran of county cricket, the 34-year-old Middlesex opener, Mike Brearley. The youngest players were the two fast-medium bowlers Chris Old and Mike Hendrick, both 27.

The first Test started in Nottingham on 3 June. Two significant things happened before that. First Michael Holding came down with glandular fever and was ruled out of the game. Then the England captain, Tony Greig, gave what may well be the most incendiary pre-match interview in cricket history.

Tony Greig was a six-foot-seven white South African who was able to play for England on account of his father being Scottish. While this was within the laws, it was still hard for many people to swallow. Here was an obviously South African bloke – the product of a cricket culture that denied access to Black people and had therefore been ostracised from world sport – gaily playing Test cricket anyway. He was a decent all-rounder whose boundless self-confidence allowed him to consistently punch above his weight. This same self-confidence was reliably on display whenever he talked to the media.

Here's what he said when he was asked how he saw the series going: 'You must remember that the West Indians, these guys, if they get on top they are magnificent cricketers. But if they're down, they grovel, and I intend, with the help of Closey and a few others, to make them grovel.'

The West Indies teams watched this in their hotel with a mixture of bewilderment and fury. Did this white South African really say he was going to make them grovel? If Greig had been trying to gee up his opponents, he could hardly have done a better job.

Years later Greig tried to explain himself. He naturally denied any racist intent, and it's true to say that there is little in his subsequent career to suggest that he was any kind of active racist. He said he was just making the point that in Australia the West Indies had fallen apart once they were down in the series. He was really only echoing Lloyd's own concerns about his team. He added that, of course, he shouldn't have used the word grovel – but it was a live TV interview and sometimes you say the wrong thing.

Back then, though, in the summer of '76, the West Indies team – and alongside them the entire West Indian population of the UK – just knew they wanted to ram these words down that South African bastard's throat. But this was easier said than done.

The weather in Nottingham on 3 June was that of a more typical English summer, pleasant rather than baking, and the outfield grass was still a healthy shade of green. The West Indies played well though. Their new star batsman, the princely Antiguan Viv Richards, scored an imperious double century without feeling the need to take off his sweater, and Wayne Daniel took some first-innings wickets, but England's old guard held the line. David Steele managed a century in the first innings, and in the second innings, when they needed to bat out time to secure a draw, John Edrich and Brian Close did exactly that.

The second Test at Lord's was even closer. The West Indies were still not at full strength: Richards had also come down with glandular fever and was a big loss. Holding returned, but Daniel was surprisingly left out in favour of Bernard Julien, not as fast but a better batsman. It was a relatively slow-scoring game, marred as a contest by the fact that the rain made one of its rare appearances that summer. Had it not rained, England might well have won, but the sun came back with a vengeance

on the final day and the West Indies managed to hold on for a draw. In a sign that the 'grovel' remark was not forgotten, a frustrated Holding bowled a beamer at Greig, nearly taking his head off.

Beamers are fast balls that don't bounce but head straight at the batsmen above waist height. They should never be bowled deliberately and, these days, a bowler receives a warning after the first one, and will automatically be taken out of the attack after a second one. Generally they are bowled accidentally by overexcited youngsters, or when the ball is particularly slippery and hard to hold. Bowling a beamer deliberately is beyond the pale. There's a real risk of injury to the batsman for two reasons: first, the batsman habitually has his eyes on where he expects the ball to land, so it's hard to pick up this unexpected direction of travel, and secondly, they give the batsman even less time to react than normal.

Holding was a young and occasionally wayward fast bowler, so the odd beamer was forgiven. But bowling one at Tony Greig, the man who'd said he would make the West Indies grovel, did seem to be a rather fortuitous coincidence.

Over the years, West Indian fast bowlers had intermittently been seen as over-aggressive. Some of this reputation was doubtless racial stereotyping, but some of it was down to Roy Gilchrist. Gilchrist, who played for the West Indies in the later fifties and early sixties, was a ferocious fast bowler with an uncontrollable temper. If a batsman annoyed him or simply defied him, he would frequently resort to bowling beamers or, equally lethally, deliberately running an extra pace down the wicket before letting go with a bouncer (a delivery designed to bounce up towards the batsman's head). His Test career ended mid-match on a tour of India, when his (white) captain, Gerry Alexander, ordered him to stop bowling beamers at a batsman called Swaranjit Singh whom Gilchrist disliked. Gilchrist simply refused and

bowled another beamer. He was sent home on the next plane – though not before, according to one account, pulling a knife on Alexander. Gilchrist summed up his bowling philosophy like this: 'I have a reputation for hitting batsmen. That comes from being the kind of fellow who really wants to get batsmen out; and that is what every bowler should do – hate the other guy on the field. It is the only way to see them off.'[16]

So, while Michael Holding would insist he never bowled a beamer deliberately, it's probably not unreasonable to suspect that when any of the West Indies bowlers saw Tony Greig walk out to bat, they felt a little of Roy Gilchrist's fury. Especially as this England team, this bunch of journeymen and old soldiers, had so far failed to crumble in the face of the West Indies bowling.

Two matches down, three to go and the score was still nil–nil. Maybe England had a chance of winning the series after all. If that optimism extended to the players themselves, it was swiftly squashed when they arrived at the Old Trafford ground in Manchester. As Pat Pocock, the England spinner, remembered: 'When I looked at the wicket on the first morning, I sensed that the optimism was hopelessly misplaced. It was green and nasty with sinister bare patches; worse, it was an undulating wicket, making the bounce dangerously unpredictable.'[17]

In short everything was set up for a potential replay of the Jamaica match, with batsmen as liable to be hospitalised as bowled. So how were England going to repel the inevitable onslaught? By bringing Dad's Army to the front was the answer. The two opening batsmen from the previous Test were dropped – Barry Wood because of injury and Mike Brearley, rather harshly, on grounds of form. Instead, the two openers would be the veteran John Edrich and the old man Brian Close, who hadn't opened the innings for 20 years. Close remembered how he received the news:

'Look,' I said, 'I haven't done that job regularly since 1957. You've got a chap in the side who is opening regularly for Kent.'

'Ah,' said the captain. 'We think Bob Woolmer is going to be on the international scene for a long time. We don't want him killed off.'

He said it with the smile that charms the televiewers but the point was still the same. I was now expendable.[18]

That's the way Close saw it, and it's hard to disagree. He had been moved up to open against a terrifying fast-bowling attack on a substandard pitch because, if he failed, as he was almost bound to, he would make a convenient scapegoat when it came to looking around for someone to drop. He had to succeed against overwhelming odds, or his Test career was over.

The West Indies won the toss and batted first. England's new opening bowler, the medium-fast Mike Selvey, had an outstanding start. He dismissed Roy Fredericks, Viv Richards and Alvin Kallicharran for next to nothing. The opener Gordon Greenidge played brilliantly for a century, but no one else could stay in on this horribly difficult pitch. The West Indies were all out for 211, normally a sub-par effort but, on this pitch and with their bowling attack, they weren't too unhappy.

And they were right. Brian Close went out to open the batting and spent half an hour defending stoutly before a ball from Wayne Daniel beat him for pace. And that was the start of a procession. As Holding warmed up he became every bit as hard to face as his reputation had suggested. He bowled fast and aggressively, plenty of bouncers with no let-up for the lesser batsmen – the spin bowler Derek Underwood receiving a particularly lethal one. Pat Pocock, the other spinner in the team, was unlucky enough to face Holding as he reached absolute peak performance. He recalled that when he made it back to the stands

afterwards, veteran watchers of the game told him that they reckoned Holding was bowling faster than anyone had ever done before, 'and I readily accepted that judgement'.

Included in the spell were two beamers, which Pocock explained with commendable neutrality:

> I [could not] claim to have seen many of the balls that Michael Holding bowled to me that evening. I was at least grateful that the two deliveries which were potentially the most lethal were the ones I had chanced to see most clearly; two beamers which slipped from his hand, whistled past my shoulder and smacked into the gloves of the distant wicketkeeper. For the rest it was largely a matter of hope and trepidation and I survived until close of play through the powers of luck and prayer.[19]

Pocock was out first thing the following day. Only David Steele made it into double figures and England were bowled out for just 71. The West Indies batted again and this time the England bowlers were unable to keep them in check. Greenidge made his second century of the match and Richards his first. They declared just after teatime on Saturday, having made 411 runs for the loss of 5 wickets. England were put into bat. They had to score 552 to win. To put this into context, it's a task that has never been achieved in the history of Test cricket, to score that many runs in the fourth innings. The only question was whether they could at least put up a fight, or even, by some miracle, hold out for a draw.

There were eighty minutes left in the day's play and they were indelible. Pat Pocock reckoned that 'those eighty minutes were the most appalling and unforgettable that I ever saw during all my years in first-class cricket.'

It was ten past five. The day was punishingly hot and muggy. Being

a Saturday, there were a lot of West Indian supporters in the crowd and they kept up a percussive accompaniment throughout the day. The drumming got louder than ever as Edrich and Close walked out to open the batting. In Kingston against India the crowd had chanted, 'Kill him, kill him.' The Old Trafford crowd didn't say that part out loud, but the drumming conveyed it effectively enough. One can only imagine the effect on the bowlers' adrenalin as they ran in.

The noise was relentless. Out on the pitch Brian Close would walk away from his wicket, waiting till the crowd quietened down before he was prepared to face the next ball. In the England dressing room the next batsman due in, David Steele, was so affected by the heat and the noise that he came down with a migraine and had to ask Bob Woolmer to get ready to go in in his place.

The first ball from Andy Roberts to John Edrich was short. And so were the vast majority of those that followed. No beamers, but constant short bowling aiming to hit the batsmen rather than the wickets, and almost impossible to play on a pitch with unreliable bounce.

Roberts used the bouncer relatively judiciously and Edrich was mostly able to defend against them by conventional means. At the other end, though, there was mayhem. Holding was bowling at a phenomenal pace at the 45-year-old Close. And Holding gave every impression that he was trying to kill Close, not bowl him out. Again and again, as much as four times an over, he bowled either bumpers that got up to chest height or bouncers that went head high. Close was less bothered by the bouncers – generally you could play them by swaying out of the way. Though there is a famous clip of Close just barely getting his head out of the way of one that would surely have done him serious damage had it hit. The next day he would tell the *Daily Mirror*: 'Michael Holding is the fastest bowler in the world. The ball is reaching us in under half a second, that's not much time to avoid a bouncer.'

The bumpers, the balls coming through at chest height, were another matter. They weren't really high enough to duck under, so that was an extremely risky option. And if you defended them with your bat, there was a high risk of an edge to the slip fielder or a lobbed catch to a fielder standing close in. For most people those were the only two options. But for Brian Close there was another one: Just let the ball hit you.

Again and again the ball cannoned into him at ninety miles an hour and Close simply acted as if nothing had happened. And this despite the fact that he had none of the protection modern day cricketers wear. No helmet, no chest pads, no arm guards, just a small towel folded up as a makeshift thigh pad. He did at least have a plastic box to protect his genitals, but one of Holding's deliveries hit it so hard that it broke. Twice Holding hit Close with body blows so powerful that he did finally flinch – once when hit in the thigh, and once when hit in the chest. You could see his knees wobble for a moment before he straightened up once again, doing his best to look unbothered.

His fellow cricketers watching from the stand knew what he was going through, though. Pat Pocock was due to come out to bat as the so-called nightwatchman, if Close or Edrich got out close to the end of play:

Close was one of the strongest men, both physically and mentally, who ever played the game, a man who carried courage to the borders of insanity, yet there were times when his knees buckled and he almost fell. The English players sat in silence in the dressing room; some were unable to watch . . . To see Close in the middle, straight-backed and knowing that every delivery was bowled with the intention of damaging him was an experience which nobody at Old Trafford on that July evening will ever forget.[20]

Amazingly, Pocock claimed he was keen to get out there and take Close's place: 'I was more pumped up than I have ever been . . . I heard myself muttering: "Come off, Closey, you've had enough. Come off now, Closey. Let me get out there." '[21]

There was even one member of the West Indian team who was finding this passage of play hard to bear. Viv Richards played his county cricket for Somerset, and his captain there was none other than Brian Close. Fielding close in and watching the battering the old man was taking, he finally cracked and, whispering so his teammates didn't hear, asked, 'Are you all right, cappy? Are you all right?' Close, inevitably, gave him a volley of abuse in reply. No one would ever be able to accuse Brian Close of being frit.

Such was the carnage that the England team and the radio and TV commentators kept expecting the umpires to step in. There were rules against intimidatory play. But again and again they let the West Indies, Holding and Daniel particularly, bowl two or three short balls an over. Finally, when Holding bowled four in an over for the second time in a row, the senior umpire, Bill Alley, stepped in and gave him a warning. Afterwards, Close claimed he was disappointed by this ruling as bouncers were never going to get him out. The risk of actual death didn't seem to cross his mind.

And he was right. At the end of this brutal 80 minutes Close and Edrich had survived the onslaught of short-pitched bowling and its accompanying soundtrack with their wickets intact. Aged 45 and 39 they had endured; they had literally taken everything the West Indies could throw at them. The score was a paltry 21 for no wicket. Ten of those were 'no balls'. As for the other 11, John Edrich had scored 10 and the heroic Close just one. As they arrived back at the dressing room Edrich asked him the obvious question, 'All that for one! Closey, was it worth it?'

It was a hell of a question. England's position was hopeless. There

was no way they were going to bat out two full days against that West Indies attack. And Close already sensed that the England selectors were preparing to drop him. When he took his shirt off back in the dressing room, Pocock observed that 'the bruises were already starting to overlap across his chest and ribs, and in places there were small clusters of livid bumps, as if somebody had forced handfuls of marbles beneath his skin.' The physio told him he should go to hospital for an x-ray. Close of course was having none of it. 'Nay, lad. Just give us a Scotch.'

And so the sun went down on a day's cricket and more besides.

For the next two days – there was no play on the Sunday – the British newspapers were full of outrage. In Monday's *Daily Mirror*, Peter Laker said that English batsmen faced 'maiming or death' if these tactics continued. He put the blame on the captain, Clive Lloyd, who, 'has given dumb sanction to a murderous, senseless and cowardly attack'.

Brian Close told the same paper that he felt like he was on the wrong end of a coconut shy and should have been receiving blood money. He even admitted that he had let on to the umpire, Bill Alley, that he was in a lot of pain and struggling to run.

For his part, Clive Lloyd refused to condemn his bowlers' tactics as being against the spirit of cricket: 'You can't tell your fast bowlers to bowl half-volleys . . .' he said. As for the potential consequences of his refusal to rein his bowlers in, he seemed alarmingly insouciant when he agreed that batsmen were bound to get hit and 'you hope there'll not be a fatal accident.'

Lloyd seemed happy to accept the risk of death as just another part of the game, commenting that if a ball from Gary Gilmour in Australia had hit him on the temple instead of the chin, then he could be dead

himself. As for the man most likely to have had a fatal accident, Lloyd simply said, 'Close has a style of his own – a forward lunge. That way he is going to be hit. But he always takes the blow.'

What Lloyd did accept was that his bowlers had been ineffective. They got 'carried away', he said. And, clearly, he conveyed this message to the bowlers, for when play resumed on Monday morning they regained their focus on taking wickets, not just bombarding the batsmen.

Close and Edrich battled on for a while, managing one of the hardest-fought 50-run partnerships in Test history, before John Edrich was bowled for 24 by Wayne Daniel. Then Michael Holding finally took aim at the stumps and clean-bowled Close for 20, and after that it was all over. No other batsman managed to equal even those meagre scores. England were all out for 126. West Indies had won by the gigantic margin of 425 runs. The fast-bowling barrage had worked.

It continued to work for the rest of the summer. West Indies won both the remaining Test matches, narrowly in Leeds then comprehensively at the Oval, South London, in front of a huge crowd of triumphant West Indian fans. There they were in their pomp – thrilling batting matched by awe-inspiring bowling. The new kings of cricket were starting a reign that would last nearly twenty years.

Watching the footage of Holding v Close now, I'm seeing so much else – Rorke's Drift, Custer's Last Stand, the plucky old white man locked in a hopeless defence against the youthful violence of the oppressed. At fifteen I just wanted blood. I too was roaring on Michael Holding. Now, in my sixties, it's Close I feel for. I can only imagine how much nerve you would have needed to face that bowling at 45.

I haven't changed my mind that this was the triumph of the colonised

coming back to beard the colonisers in their lair and best them at their own game. But getting older does make it easier to hold two conflicting opinions at the same time. Because if I'm going to romanticise tearaway fast bowlers as spearheads of revolution, why not also romanticise Brian Close and John Edrich as avatars of pluck?

Close and Edrich were not officer-class cricketers, they were yeomen of the common people. Close himself had barely missed the war – his call-up to the army came in 1948, just three years later. His brand of quixotic heroism had little place in the modern world, but it's hard not to look back now and concur with Pat Pocock's verdict on Close's performance, on that day when cricket's balance of power shifted once and for all: 'He didn't have the technique to play Test cricket at that stage; he just had the most guts of anyone who had ever walked on a sports field.'

Or another teammate, Mike Selvey: 'I can't speak too highly of Closey that night. Everybody, myself included, used to regard him as a bit of a joke, a caricature. He was mad, I don't mean in a derogatory way. But what we saw was an extremely brave man. He went up massively in my esteem, as did Edrich.'[22]

'He stood there, no teeth, no hair and a big grin,' David Steele said. 'He loved it. He bloody loved it.' As his teammates looked on in disbelief, Close added: 'You should see the state of the ball . . . there's no shine on it. It's all on me.'[23]

SPORT

WIMBLEDON FINALS

Wimbledon was one of the biggest TV sporting events in the seventies. Two whole weeks of televised live sporting action. Only the Olympics and the World Cup had a comparable amount of TV coverage. In this media environment, the leading tennis players became genuine stars. This year's finals featured my two favourite tennis players of the time – Ilie Nastase in the men's game and Evonne Goolagong Cawley in the women's, both of them great talents who were approaching the twilight of their careers. I very much wanted them to win.

Ilie Nastase was the Romanian bad boy of tennis, a surprising product of the Soviet bloc – he was dark and long haired and looked more like a continental film star than a normal tennis player. But he had never won Wimbledon. In 1972 he had lost in five dramatic sets against a really straight looking American called Stan Smith. This time he was in great form – he hadn't dropped a set on the way to the final – but he was up against the new wonder kid, a Swedish player with even longer hair, who had just turned twenty and went by the name of Björn Borg. Borg was both the first player to become a pin-up in my sister's *Jackie* magazine and incredibly good at tennis. I feared the worst and, sure enough, Borg won the men's final easily in straight sets, the younger man performing much better in the blistering heat.

The women's title followed a similar pattern. Evonne Goolagong, who was now playing under her married name Evonne Cawley, had been a star for a few years now and was wildly different from the other

players. She was an indigenous Australian – or 'Aborigine' as people said back then – and you could just sense that she'd had to struggle harder than the other women to get where she had.

In fact, not that I knew it at the time, she really did have a hell of a backstory, growing up in an indigenous family at a time when they were plagued by literal child catchers. Many indigenous children were forcibly taken into care, the so-called 'stolen children'. As Cawley remembered, 'Every time a shiny car would come down the road, my mum used to say, "You better run and hide, the welfare man's going to take you away." So I remember hiding very nervously under the bed, 'cause I didn't want to get taken away.'[24]

Instead, she fell into the hands of an abusive tennis coach who took her to live with his family in Sydney, but did set her on the path to win multiple Grand Slams and to briefly become number one in the world. Chris Evert, by contrast, was a clean-cut all-American blonde with a neat, efficient game to match. I didn't take to her at all at the time. The game swung this way and that, but Evert prevailed in the end. Cawley's nerves were visibly preying on her, which made her all too relatable.

THE MONTREAL OLYMPICS

The Olympics had historically done their best to disassociate themselves from politics, infamously so in the case of the Berlin Olympiad of 1936, which found itself instead hijacked by Hitler's Nazi propaganda. In the 1972 Olympics, however, politics had well and truly made its presence felt. Eight Palestinian terrorists, calling themselves Black September, had invaded the Olympic Village, killed two members of the Israeli team and taken nine more hostage. A botched rescue attempt by the West German authorities resulted in the deaths of all the hostages and

five of the terrorists. The other three were sent for trial, but released to Libya after Palestinian allies hijacked a Lufthansa plane.

After that, the idea that politics and sport could be kept apart was laughable. Across the sporting world the big issue of the time was the participation of apartheid-era South Africa in international competition. The International Olympic Committee had been quick to ban South Africa, following the UN resolution against apartheid in 1962, and it had not been allowed to compete since then.

Most sports had gradually followed suit, though some, like cricket, had to be dragged kicking and screaming into a ban. Rugby union, however, remained an outlier and, in June 1976, New Zealand sent their All Blacks over to South Africa. Outraged by this, African campaigners demanded that the IOC ban New Zealand from the Montreal Olympic Games. They refused and twenty-nine countries, including almost all of Africa, boycotted the Games as a result.

This boycott, combined with organisational chaos and a stadium that was barely finished on time, didn't bode well for the success of the tournament. The track events were particularly badly hit by the African boycott, which may help to explain why the biggest star at Montreal was not a gold medallist from track or field, but a teenage gymnast.

The 1972 Olympics had featured a 16-year-old Soviet gymnast called Olga Korbut, who gave the world the 'Korbut Flip' and won three gold medals. But in 1976 she was thoroughly overshadowed by the 14-year-old Nadia Comăneci, who became the first athlete to be awarded a perfect 10 out of 10 for a routine – something previously thought unfeasible. Comăneci managed seven of these perfect 10s on the way to winning three gold medals, plus one silver and one bronze.

I was fascinated by Nadia Comăneci. Another Romanian, the only one I knew of apart from Ilie Nastase. She was exactly six months younger than me, yet had this extraordinary ability. And not just that, she had the

poise, even the arrogance, of an actual grown-up woman. I'm not sure if I had a crush on her, but I couldn't take my eyes off her. And, even then, I wondered what that must be like – achieving perfection at fourteen. Where did you go from there? For Comăneci the immediate answer was back to Romania, where she was named a Hero of Socialist Labour.

Elsewhere, the big stars of the track were the Finn Lasse Virén who won gold in both 5,000 and 10,000 metres, just as he had done four years earlier, and Alberto Juantorena of Cuba, who became the first man to win both the 400 and 800 metres at the same Games.

Fidel Castro's Cuba was starting to make quite an impact in the Olympics. They had won three golds in Munich, and they doubled their tally in Montreal. The nation's great sporting hero was the heavyweight boxer Teofilio Stevenson. He'd won gold in Munich and did so again in Montreal.

After the Games he was offered $5 million to leave Cuba, turn professional and fight Muhammad Ali. Stevenson declined all offers, saying, 'I will not trade the Cuban people for all the dollars in the world.' It was a stance that firmly established him as a beacon of integrity and idealism in a sport not noted for either.

It was a vintage year for boxing – US gold medallists included both Sugar Ray Leonard and Leon Spinks – but the question of just how successful Stevenson might have been, had he turned professional, continues to fascinate boxing fans.

Elsewhere the East German team won an extraordinary number of medals – forty Gold, twenty-five Silver and twenty-five Bronze, and finished second in the overall medal table. Unfortunately, 'extraordinary' was the word. For, as was much suspected at the time and later confirmed, that success was predicated on a regime of systematic doping. If Cuba offered an inspiring vision of sport under communism, East Germany gave an insight into all that was worst in the Soviet version.

Joan Armatrading: 'I wish people would just listen
to the songs and leave me alone!'

JOAN ARMATRADING: WILL YOU LISTEN?

The seventies were not a good time to be a female singer-songwriter in the British music business. Very few of them got record deals. And those that did, including talented artists like Lesley Duncan and Bridget St John, made precious little headway. By 1976 the two best-known were probably Elkie Brooks and Lynsey De Paul, both of whom had to put up with crassly sexist marketing, as exemplified by their latest album covers – Brooks naked apart from a feather boa, De Paul unbuttoning her jacket to reveal her bra beneath – that did nothing to suggest that the labels had any confidence in their talent. For Black women it was the same only more so. Apart from the previous generation's ineffable Shirley Bassey, Linda Lewis was the only Black British woman with any real success at the time and her latest album cover had her lying naked on a bed with a cigarillo in her hand. It was clear that, as far as most of the industry was concerned, female musicians should be judged on their sex appeal, not their talent. *Rock Follies* had made that point on prime-time TV.

So it was quite a surprise when a full-page advert appeared in the music press towards the end of July. On the bottom half of the page, there was a dramatic close-up of the artist's face, coming out of a black background. On the top half was a paragraph of impassioned advertising copy:

> *Joan Armatrading* is one of the most original albums of 76.
> But will you listen?

She writes songs like she's lived them. She plays guitar like
she was born to it. Some people will compare her with Joni
Mitchell, Van Morrison and even Cleo Laine.
Meanwhile, the lady who recorded it is quietly going spare
because the person they're all talking about sure as hell isn't her.
She's not the next anybody.
She's just a brave black lady who won't accept compromise.
So what do you do?
Especially if you like the album as much as the guy who's
writing this ad does. Forget the hard, hard sell.
Forget all the commercial, 'you've-never-heard-it-
like-this-before' crap.
Joan Armatrading.
She deserves a lot more.
But will you listen?

The album was simply titled *Joan Armatrading* and the campaign
worked. I, for one, bought a copy. The reviews were ecstatic and, come
the end of the year, *Sounds* magazine would vote it the best of '76,
ahead of Joni Mitchell's *Hejira* and Bob Dylan's *Desire*. The standout
single, 'Love and Affection', made the top ten. It was the perfect
accompaniment to the last days of summer, a record made for humid
late nights. The album spent months in the chart. By the end of the year
Joan Armatrading was able to sell out the Hammersmith Odeon. It
turned out that we were more than happy to listen.

So why was the copywriter so worried? Well, maybe because
this artist was breaking all the rules. She absolutely wasn't going to
play sexy. And gay, working-class, female Black Brummie singer-
songwriters had never troubled the charts before. Looking back now it
seems remarkable, and actually cheering, that the music-loving public

were prepared to welcome such an act so enthusiastically. Some of the credit goes to her record company for not trying to mould her, but most of it was down to Joan Armatrading herself: an artist who refused to let any of those different identities define her, who was absolutely committed to being her unique self, whatever anyone said.

Very few journalists have ever got close to the extremely private Joan Armatrading. One who did was Marion Fudger. She was writing for the feminist monthly *Spare Rib* in 1974, when she first saw Joan Armatrading play live, and told me how instantly struck she was by her talent:

> It was just her and her guitar on stage (at Ronnie Scott's I think). I'd never seen nor heard an Ovation guitar before and I'd never seen anyone like her before. Here was this woman who had everything . . . an amazing voice, an excellent guitarist and pianist and her songs were immediately great. Which is a hell of a lot for one person! I was knocked sideways! I wanted to do all I could to help her get recognised. I was working at *Spare Rib* and writing the music section and focusing only on what women were doing musically. The music press was very sexist at the time!

Fudger arranged to interview her for the magazine and gradually they became friends:

> I got to know her quite well, which was no mean achievement as she was pretty shy and didn't want to be interviewed by anybody. Our birthdays are one day apart, we're both Sagittarius. She had a good sense of humour. We did things together. At one point she needed accommodation and I managed to find her somewhere with a guitarist

friend. I just thought she was such an overwhelmingly talented person and very likeable as well. I remember one time I was round her place and she played 'Dry Land' on her grand piano just for me. I'll never forget that . . .

The rapport between the two women is evident from the *Spare Rib* interview, which came out in May 1974. At the time Joan Armatrading had only released one album, her debut *Whatever's For Us*, which had come out in November 1972 and received warm reviews but hadn't sold at all. The record company commented that, 'though the media reaction was almost unprecedented for a new artist, it sold abysmally'.

Joan was phlegmatic about her lack of success to date:

What I thought I'd do was some office cleaning and work for about three hours a day, but I couldn't get it to quite work out because I'd start playing and by the time I'd finished it was time to go to bed. I keep thinking 'well I'll do it tomorrow'. Then I went on the dole for a while, and that paid the rent.

She was twenty-four years old at the time. She was born in St Kitts but came to Britain when she was eight, following her parents and older siblings who had come over four years earlier. She rarely talked about her background, but pressed by another female music writer, Caroline Coon, in *Melody Maker*, she opened up a little.

I had a weird childhood, and that's probably been the strongest influence on my character. But I can't tell you about it because it's not very nice. There isn't a nice way of explaining it . . . It's to do with my parents. My father . . . I was on my own a lot.

She goes on to tell Coon that she remembered little about her early years living with her grandmother in St Kitts, though the experience of travelling on her own to England, looked after by an air stewardess, stuck with her. And then there was the shock of being reunited with parents she barely remembered:

> I didn't know my father. And my mother, well, I couldn't remember her at all. Couldn't remember my brothers either, they'd all grown up, hadn't they! We were very poor. And they still are. I had a letter from my mum a couple of days back asking for some money to get them food.

A few years later, talking to Paul Gambaccini during her first return visit to St Kitts, she emphasised her sense of having grown up English, rather than West Indian:

> I think I grew up feeling English because my parents were not, to me, the typical West Indians. First of all, whether by design or accident, they didn't go to a Black community, they didn't get to Birmingham and move into Handsworth . . . They were proud of where they were from, but they were very aware they were in England, which was giving them a better way of life and that sort of thing.[25]

After school, she told Caroline Coon, she went to work as a comptometer (a souped-up adding machine) operator in an office, but by then she was already starting to make music: 'I used to take my guitar to work and play in the breaks . . . But the boss in charge of my section didn't like it and she told me she was going to give me the sack. So I left.'[26]

She sang a little in local clubs with a male friend before attending an open audition to appear in a travelling production of the rock musical

Hair in 1969. The actor and TV presenter Floella Benjamin, who was already one of the cast, remembers:

> In Birmingham, a young Black singer with a beautiful Afro made everyone sit up right away. Her voice was extraordinary – rich and deep – and she ticked all the boxes . . . and she got the job. Joan was very, very shy and when she came and joined the touring company, I thought I'd better take her under my wing.[27]

They stayed in the same digs for a while and discovered that they were in fact cousins. They remained friendly, but the key relationship Joan made while on tour with *Hair* was with another Black woman her own age, Pam Nestor from Jamaica. The *Hair* touring production kept on going for the best part of two years and the two women started writing songs together.

Then they came down to London, found places to live in Notting Hill and continued writing, hundreds of songs. Joan wrote the music and Pam most of the lyrics, which they both sang. They quickly secured a publishing deal, then a record deal with the independent Cube label. Elton John's producer, Gus Dudgeon, took charge. A new manager, Mike Stone, was appointed and it soon became clear that, in the eyes of the industry, there was far more interest in Joan as a solo act, as opposed to Joan and Pam as a duo. Joan's was the only name on the front of the record when it came out. Pam did have her picture on the back, sitting next to Joan, and her lyrics printed on the inner sleeve, but it was increasingly clear that her days were numbered.

This was initially tricky as, while Joan was obviously the better singer and songwriter, Pam was the extrovert to Joan's introvert. In the few interviews they gave, Pam did almost all the talking. *The Guardian*, unsurprisingly, wanted to raise the question of race and Pam made it clear that it was something they wanted to rise above:

I wouldn't write about black and white, though. I don't think that's important . . . There are plenty of other black songwriters writing non-black music. There's all these black kids now growing up who will do what they want to do. They might like soul and reggae but they don't want to have to stay with that. If we get accepted into this thing I think it's going to break for a lot of black people. I think there's a lot of blacks not venturing out because they're scared to have a look.[28]

A year later though, in the summer of 1974, when Joan played at a *Spare Rib* benefit in the Marquee Club, Pam was out of the picture. The gig was arranged by Marion Fudger, which had required some careful negotiation with Joan on her part:

The interview I did with her for *Spare Rib* was a real coup, but I think she never felt comfortable about being seen as a Feminist as such. She was reticent about the idea of being some sort of figurehead. She didn't want to explain her lyrics, she didn't want to be told how to look or present herself. She loved her music, she worked with the best musicians and producers and if people didn't like that – then tough!

Joan appeared at the show as a duo with another young songwriter, a white girl from Southampton called Jaki Whitren. Whitren was a teenage prodigy who had just made her first album for CBS at the age of 19. Like Joan she was a fine singer-songwriter and also a really good guitar player – their work had obvious kinship. Joan had suggested they collaborate and went to stay with Jaki for a week to work up the set, but that was the end of it. Jaki turned out to be a true hippie who decided she wanted nothing more to do with the music business.

Joan did want to stay in the music business, but was determined

that she was going to do it on her own terms, starting with the way she dressed, as she told Marion Fudger:

You know it's such an effort not to go on stage in this cardigan, I live in it and that jacket you saw me in. I've had so much bother with my managers over that jacket. I had another manager before this one and they try and say, 'Well I think maybe you should wear a dress or something.' But it's no good saying that, because I won't do it, I couldn't, I don't wear dresses. They say, 'Well at least look a bit smarter.' Well, I have this other jacket that's a bit smarter, but I feel horrible in it. But they're no bother now, because they've made up their minds that that's how I'm going to be and that's how I want it, so they just have to take it.

I did some photos once and I had this argument with this guy about taking off my jacket. I like being well covered, I don't see the point in doing all that anyway, people don't think any more of you. You don't have to let them make you do anything you don't want to do. I don't think it helps us, all these sweet singers with their little dresses. I suppose they think that's the way they've got to sing. Men have said, 'Look, you've got to sing pretty because you're made that way' . . . There are lots of women about with voices that aren't pretty, but they seem so used to dressing up and things, they're frightened to change or something.

Joni Mitchell's new album is lovely, funky too, I mean she sings pretty but it's not pretty. I'd never be bored by her or Maggie Bell and what about Jaki Whitren? I really like her voice, she plays nice guitar as well. I guess black women don't sing so sweet because they haven't been brainwashed so much into thinking they've got to be weak – the opposite, they've got to be strong, so they just get on with it.[29]

Joan was determined to get on with it, but the question was how. London's feminist scene might have seemed the obvious fit for her. As

the fine photographer and music writer Val Wilmer remembered: 'Joan Armatrading was the idol of nearly all the women I got to know in the seventies.' But she was no more at ease at a feminist discussion group than in the rock'n'roll world. Wilmer remembers her coming to one such gathering: 'Joan Armatrading turned up, but she spent the entire proceedings standing by the window staring out on to Holloway Road.'[30]

Joan Armatrading was the least likely of music business hot properties. She didn't smoke or drink, didn't eat meat and emphatically preferred her own company. And while she has never been inclined to discuss her sexuality (though she did announce her civil partnership with Maggie Butler in 2011), those who knew her at the time always assumed her to be a lesbian.

On the face of it, then, it's surprising that she should have been able to make her way in the music business in Britain in the mid-seventies. And yet that's just what happened. She was able to find a record label that was prepared to take her just as she was and simply do everything they could, first to develop her talent and then to market it.

That label was A&M. Originally a US label, started by the musician Herb Alpert with Jerry Moss, it had become enormously successful by the early seventies, thanks in part to the huge global popularity of the Carpenters. In 1972 they decided to set up in the UK with the successful music publisher Derek Green at the helm. A&M had already put out Joan's first album, *Whatever's For Us*, in the US – now they would be her UK record label as well. Derek Green told me how it came about: 'Joan was signed by David Platts at Essex Music for the first album. That album got a lot of really great press. But it didn't sell. I didn't get into it, I thought the songs were there, but it didn't have the drama that she had.'

The first album she made for A&M, 1975's *Back To The Night*,

was something of a near miss. Joan didn't like the production by Pete Gage and found the whole experience very difficult, but also a genuine learning experience:

> Doing that album I was really miserable, I thought it was a load of rubbish, a waste of time. Then when I finished it, I couldn't wait to do the next one. I suddenly realised that this was my career and I was going to make the best of it.

Derek Green had much the same opinion:

> The album was already set up before I got involved. She had broken up [her writing partnership] with Pam Nestor and it was going to be produced by Pete Gage. When the record came in I knew it wasn't quite . . . it wasn't going to do her any harm, but it wasn't going to make her either – but I backed it as best we could, with the future in mind.

Many record labels might have bailed out when confronted with an unhappy artist and another album that didn't sell, but Derek Green simply accepted it as a further challenge. He decided that they should get Glyn Johns – one of the very best producers, who had worked with everyone from the Beatles to the Stones via the Eagles – to helm the next album:

> Glyn Johns was a very good friend. I called Glyn and I said I've got this most alternative kind of artist. She is absolutely fabulous, she writes great songs, but she's really different. She's not an easy sell from my point of view, but boy she's got what it takes. I'm absolutely committed to her, I'll put absolutely everything into it. He said, 'Well, I'm always interested if you've got that much commitment.'

Johns was persuaded to come and see Joan play live at a small club in Washington DC. He recalled what happened in his autobiography:

> I remember it was a very small stage with a very large band crammed onto it. The singer was painfully shy, barely lifting her head from her chest to look at the audience, and mumbling incoherently in between songs. The sound was not at all good and she was overpowered by the band. So I said it was not for me and returned home to England the next day.[31]

Derek Green wouldn't take no for an answer:

> I just couldn't give up. I said to Glyn, 'I don't know what you were on, but you missed something. Just do one thing' – now I'm really calling in a favour – 'I'll ask Joan into the office. She's quite difficult on a personal level, but I will ask her to come in with her guitar, you can hear her play.' And that's exactly what happened. Glyn came in and fell hook, line and sinker. That moment of magic happened right there and then.

Glyn Johns concurred:

> I got it within the first few bars. By the time she had finished I could not believe how I could have misjudged the extraordinary talent that was sitting opposite me. Not only did she have the most wonderful voice, but the songs and her delivery of them were so original, and she was one of the best rhythm guitarists I have ever heard.[32]

The enthusiasm was reciprocated by Joan who was, by her standards, fulsome in her praise for him:

Before we met, everybody kept mentioning all the famous people he has produced. But he came up and said hello, just like a normal bloke. He gave me a limp handshake and I thought, 'Oh, I like him.' He had on sporty clothes and a hat which really suited him, and he looked really nice.

When we did the album he kept saying 'you can really play that guitar'. And I believed him. So I thought, 'Oh, all right then. I'll do this album for Glyn.' Not just for him, but I made a special effort to try to do it really well; because he seemed to believe that I could do it. I played the guitar better than on any other album, and better than I've ever played on stage, that was purely because of Glyn saying, 'You're good, Joan. Get on and do it.'[33]

Things moved fast from that first meeting. Johns booked Olympic Studios and assembled a crack team of session musicians: Dave Markee on bass; Dave Mattacks, Kenney Jones, and Henry Spinetti on drums; Jerry Donahue, electric guitar; and Tim Hinkley on piano. It wasn't the easiest of sessions as Joan was still very shy and directed all her comments to Johns rather than the individual musicians. When it came to recording a song called 'Love and Affection', Johns knew he had a potential hit, with 'Joan brilliantly coming up with the idea to use the bass voice for the first line of the chorus on what was already a fabulous track. What a song and what a vocal performance.'[34]

Afterwards all concerned were sure they had made something remarkable. It's an extraordinarily strong set of songs – especially side one, which has a five-song suite exploring the vicissitudes of love from a variety of angles. Impeccably accompanied by the session musicians, the music is always led by Joan Armatrading herself; her extraordinary voice, subtly rhythmic guitar-playing and artful song-constructions that pretty much define the phrase 'deceptively simple'.

A special record then, but still not an easy sell. Derek Green was thrilled with the album, its vindication of his belief in her talent. And he prided himself on his promotional abilities, but he recognised that breaking Joan Armatrading to the public at large would be a very particular challenge. Not so much, in his view, because she was Black and female, but because the music was so singular, and resistant to easy categorisation:

> Now it was my game. I decided for the first time I'm actually going to call in an outside marketing business. I'd never done it for any other artist – but I thought, this is such a challenge, I've got a great artist and a great piece of music – so I called a company called Cream and they came up with one of those presentations. Cost us a few thousand, of which almost none of it was even a starting position. Except one thing – they had the front album image and they had come up with, 'The most original artist of 1976'. I latched on to this and that was it.

Now he had his lead advertising line, Green went to work. And again he decided to go beyond his usual promotional strategies:

> At the time advertising music on buses was very unusual – it wasn't a big enough business to justify the spend, that was the theory. What I liked about it was if you chose routes that went past Broadcasting House, and I got the right poster on the side of the bus, they're going to think she's an important artist. More important than just the *NME* liking her.
> So we had on one corner of the back of the bus her picture, and on the other corner 'The most original artist of 1976'. It gave a sense of her importance to broadcast and to retail. 'Love and Affection' came out as a single and we had enough access to get her on TV, *The Old Grey Whistle Test.*

'And that's the story of Joan's marketing campaign', says Green, before adding with a laugh, 'miserable cow though she was!' It was certainly the case that burgeoning success hadn't made Joan Armatrading any easier with the business of self-promotion. Green again:

> There was an American radio and press interview cum club tour. I'd taken her myself which is not usual for the MD. Black radio in America was completely uninterested, so we were going to FM stations. I'd take Joan along and after a few of these I had to take her aside, 'These are going so badly, Joan, you got to learn small talk, it's how we get on, how we interact, it leads to things.'

It wasn't just strangers she was shy of though, as Green remembers:

> When I saw her my natural instinct would be to go, 'Oh hello, Joan' and go to give her a peck. She'd be like, 'Whoah'. It was horrible. And yet she always had this wonderful smile, she could light a room up on stage. I just wished she could give one of those smiles to a DJ or a journalist, just be agreeable!

Glyn Johns also went above and beyond for this most farouche of artists:

> I became very protective of Joan – so when she appeared a few weeks later at Hammersmith Odeon in London and then at the Lincoln Center in New York to promote the record, I went along to take care of the sound in the auditorium, just to make sure she would be represented in the best light possible after my experience of seeing her in Washington. All she needed in order for her extraordinary talent to be recognised was a really good band and a sound that did her justice.

The Hammersmith Odeon show came in September at the very end of the summer. This was the big London gig of the time, the place where you would see the likes of Genesis or Thin Lizzy. And remarkably, only a little over a month after the album was released, the concert sold out in advance – a remarkable feat for an artist who had only ever headlined small clubs before this. It was a triumphant proof of the success of A&M's marketing campaign. For, as Derek Green observes, 'If you could get people to listen, they were persuaded.'

I was persuaded. At the tail end of summer I played the album a lot, late at night, gleaning what knowledge I could of adult life and love from these emotional but complex songs. 'Down to Zero' was my favourite, despite being the most confusing of them all, with its switch-backing between tough and tender, male and female perspectives. It was the single after 'Love and Affection'. John Peel made it his single of the week. His show then was a mix of established legends, Dylan and Joni et al., plus latter-day hippies, pub rockers, folkies and oddballs like Ivor Cutler. But it would only be a matter of weeks before he was playing the first UK punk single, 'New Rose' by the Damned, and everything would change. I don't remember him ever playing another Joan Armatrading record.

I'm sure Joan didn't mind. She never wanted to be cool or controversial. We know little about her, other than that she likes studying history and breeding horses. Oh, and that she loves reading comics. And even that innocent pleasure is craftily deployed by her to deflect any questions about social or political matters, as when she told *Spare Rib*, self-deprecatingly, back in 1976: 'I have got very important opinions on *Sparky*. Every week I go out and buy the *Judy*, the *Mandy*, the *Sparky*, the *Beano*, *Whoopee*, *Bunty*, *Whizzer and Chips*, and

Sparky is the best, and that's the truth. That's it. That's my intellect. I read comics.'

But no matter, she has found a loyal mainstream audience who have been quite happy to accept her privacy and to support her to keep on making music on her own terms for half a century.

'I wish people would just listen to the songs and leave me alone,'[35] she told Marion Fudger at the end of the summer of '76. Somehow, despite living through an era in which her multiple identities – Black, female, gay, working class – have become increasingly central, that's exactly what has happened.

Elsewhere in Britain that summer, Black people were asserting their place in Britain through riot and rebellion. Women were striking and demonstrating. Gay people were battling the police. Joan Armatrading asserted her place in Britain by simply getting on with her music. Radical women would have loved her to identify as one of their own, but, as the lesbian feminist photographer and writer Pam Isherwood pointed out to me, it didn't really matter: 'We know very little about her as a person, so we project on to her everything we want her to be. She was this massive lesbian icon without having to be a lesbian icon.' So popular was she in that world that, as Isherwood points out with a laugh, 'Finding a Joan Armatrading album in a feminist house was like finding milk in a fridge.'

And the fact that she was able to find such success, at such a time, is a valuable reminder that while racism, sexism and homophobia were all rife, there were plenty of people who were happy to leave those things behind and embrace an artist who, in her work and her presence, embodied a new and hopeful Britain.

August

THE WEATHER

There had been dire warnings of drought since the spring, and now they were proving all too prescient. At the beginning of August, the *Daily Telegraph* took stock of the situation in the countryside. Wetlands and peat bogs and all their dependent wildlife were at risk of extinction. Forest fires were a particular problem: three thousand acres of forest had been destroyed since April, with the Peak District very badly hit. The trees most at risk, though, were those planted in suburban streets, which depended on regular watering. Rivers were starting to dry up and teams from the Environment Agency were sent to gather fish from the dry rivers and transport them to local lakes before they died.

On the other hand, the hot weather had been good news for butterflies and basking sharks, which were found in numbers off the south coast. Marine biologist Dr Roger Mitchell bumped into one: 'I was swimming off Lundy recently and grabbed a basking shark by its tail. It pulled me along for about 20 feet.'[1] It's worth noting that basking sharks don't have teeth.

The government had already brought in drought legislation, allowing for rationing. Now it was going to have to be put into practice. South-east Wales was one of the first places in the firing line. By 9 August the Talybont reservoir was empty and the situation was chronic. Daily water rationing was brought in from 6pm to 7am the next morning.

In some areas the water was cut off completely and standpipes were brought in instead. These were outdoor taps installed by the Water

Board. Locals would queue up to fill buckets with water. Sales of plastic buckets immediately multiplied.

Only Scotland remained immune to the threat of drought. Reservoirs were full, and there was some debate as to whether sending water to England would be politically unpopular or not.

Meanwhile the campaign against waste was stepping up. There were stories in the papers of people being arrested and fined for watering their gardens, and lots of letters from people protesting at egregious watering taking place on golf courses or bowling greens. There was also plenty of correspondence from hardy British folk suggesting how best to save water. A classic of the genre came from Evelyn Dainty of Sherborne writing in to the *Bristol Evening Post*. Here are a few of her tips:

1) Wash in a pint of water – or rub oneself with a damp cloth moistened with any skin lotion or eau-de-cologne.
2) Shake down the dew from trees for washing the face.
3) Eat everything raw that can possibly be eaten raw.
4) Eggs, well beaten, can be added to nourishing drinks.

The Guardian sent a reporter to hard-hit Guernsey, where he interviewed the hotelier Ronnie Ronalde, formerly a music hall star known as the world's greatest whistler and birdsong imitator (his rendition of 'Bird Song at Eventide' featured in the TV drama series *The Singing Detective* some years later), who told him that his three children had done their bit by not having had a bath in a month.

Children in general were rather less worried by the drought than their parents, enjoying the many curious changes it was wreaking to their surroundings. Donna Howells recalled that 'I was eight years old and remember the latest craze was collecting the melted paint from double yellow lines. My ball of paint was the size of a football. I was

very proud of it.' Similarly, Dean Merchant: 'Every corner where we lived had all our mates' names inscribed in tarmac. It was that hot the tarmac actually melted; we loved it.'[2]

The tabloids inevitably helped out with the national effort to save water by showing illustrative photos of naked models sharing a shower. But despite all this, in the following weeks the rationing was expanded to seventeen hours a day in the worst affected areas – water was only available from 7am to 2pm.

By 22 August, the drought had led to forest fires raging across the south of England. One of the biggest was in Ringwood, on the edge of the New Forest, and it came dangerously close to an old people's home. One wheelchair-bound resident said, 'It was terrifying, the sky got blacker and blacker, and we could smell the smoke . . . I thought we were all going to die.' Cars driving up the nearby M3 motorway were overheating and breaking down to such an extent that the hard shoulder was starting to look like a parking lot.

Two days later the government decided it was time to appoint a Minister for Drought. The Minister for Sport, Denis Howell, was given the job. He advised the populace to halve their water use and launched his battle cry: 'Let the Flowers Die!' As if by magic, the following day London had its first trace of rainfall in a month. And come the weekend, which was also the August bank holiday, there was widespread rainfall across the country, which helped see off the fires, though there was still a long way to go to refill the reservoirs.

THE HEADLINES

Aside from the drought the month's news headlines were dominated by two stories that had been percolating all summer and were now coming to the boil: the Northern Ireland Troubles and the South African riots.

The Northern Ireland Troubles would see 3,500 people die across the seventies. The worst year, by far, was 1972, when 480 people died. But 1976 was the second worst, with 297 deaths. The threatened long hot summer of violence had turned into a grim reality. The pattern of tit-for-tat killings was acquiring a ghastly familiarity. It would take something peculiarly awful to make the embattled communities say enough is enough.

That something peculiarly awful arrived on 10 August. An IRA man, Danny Lennon, was driving across Belfast with an Armalite rifle in his car. He may or may not have used it to fire on a British Army patrol, but the patrol certainly chased him across the city, firing as they went. One shot killed Lennon, and his car veered out of control on to the pavement where a Catholic woman called Anne Maguire was pushing her baby in a pram, her three other young children alongside. The car killed three of the kids and left Maguire herself in a coma.

As was becoming conventional, the immediate response was for all sides to blame each other for the tragedy. However, Anne Maguire's sister Mairead Corrigan wasn't having it: 'Please stop the violence, people can't take any more, it's just too much . . . I blame the Provisional IRA, I blame all men of violence. People who say they're Christians,

yet they can't practice what God said – love one another and forgive and forget.'[3]

The children's deaths had been witnessed by a Protestant woman called Betty Williams. She circulated a petition to stop the violence among her own community. When she organised a small march a couple of days later, Mairead Corrigan joined it. Afterwards the two women resolved to join forces to campaign across the sectarian lines for an end to the killings.

Their efforts bore immediate fruit. On Saturday 14 August, 10,000 people, both Protestant and Catholic, joined them on a march to the graveyards where the children were buried. Two weeks later they went a step further and organised a march to start on the Shankill Road, the absolute heart of the Protestant community. Betty Williams received death threats for letting her community down. Mairead Corrigan got similar disapproval from the IRA, but they went ahead and this time 35,000 people turned out to say that enough really was enough.

By now their efforts were receiving international publicity. The British media, in particular, was desperate for a ray of hope in what seemed like an endless sequence of nightmarish news from Northern Ireland. Within a few months 'the Peace Women', as they were now known, were nominated for the Nobel Peace Prize, which they won the following year.

There was no obvious immediate effect – instead, another round of killings took place through the remainder of August and the British Army stirred the pot by shooting dead a 12-year-old Catholic schoolgirl on her way to church on the day of the first big march. The Peace Women as a mass movement died down after the first rush of publicity – with the two women at its centre eventually falling out.

It would be easy to be cynical, but even a cursory glance at the figures shows the Peace Women marches did have a real effect. It would

be another twenty years till the Good Friday Agreement, but thanks, at least in part, to the marches, the paramilitaries were no longer able to assume the unqualified support of their communities. The next year, 1977, there would be just 110 killings, and never again would they pass the 200 mark. Between them, these two ordinary Belfast women had succeeded in changing the course of their contested country's history.

WORLD NEWS

The big overseas news story of the month was the return of violence to South Africa. It had begun in June when the schoolchildren of Soweto, the huge township that housed Johannesburg's Black population in brutal squalor, started to demonstrate against a new law that mandated the use of Afrikaans as the primary teaching language in Black schools across the country. Afrikaans at this point was clearly seen as the language of the oppressors, the white Boers (despite a fascinating history as a Creole language whose first written publications used Arabic script). To add injury to insult, it was little spoken in Soweto, where Zulu was the general first language and English the more common second language.

On 16 June the school kids took to the street. Thousands of them marched towards Orlando Stadium, where they planned to have a rally, while the police blocked their way repeatedly. Finally, as they approached Orlando High School, the police threw a teargas canister. The protesters were coughing and choking, but carried on advancing. The police responded by opening fire, and these were not warning shots: The white police took deliberate aim at the Black schoolchildren. The first to die was a 13-year-old boy called Hector Pietersen, whose picture would appear in newspapers across the world. Still the children refused to back down – many of them girls, and some as young as ten years old. Collectively, they did their best to fight back, hurling stones and whatever else they could find at the gunmen.

As a journalist covering the march commented: 'What frightened

me more than anything was the attitude of the children. Many seemed oblivious to the danger. They continued running towards the police, dodging and ducking, despite the fact that they were armed and continued shooting.[4]

Estimates of how many died in this massacre and the subsequent rioting vary from two dozen to two hundred. Unsurprisingly there were further days of rioting in response to what had happened.

A government crackdown followed and many real or suspected student leaders were arrested. One of them, Mohetle Mohapi, a former leader of the South African Students Organisation, was found dead in his cell, having supposedly hung himself. It was the 23rd death of a Black man in police custody in recent times.

At the beginning of August, Soweto reacted by announcing a stayaway policy – not a strike, as such, but an appeal to all Black workers to simply stay off work on certain days. This had some success and provoked the government into extending their crackdown on activists, with more arrests following. In response the people rioted again – in Soweto, in Durban and, for the first time, in Cape Town. Dozens more Black Africans died across the month. Probably seven hundred or so across the summer. The world looked on in horror. This student revolt – so much braver and more meaningful than most such – might not have achieved its purpose of ending Afrikaans education, but it had alerted people across the globe to the uncompromising brutality of the apartheid regime. With hindsight, it can be seen to have marked the beginning of the end.

The faces of radical teaching: Brian Haddow (third from left),
Terry Ellis (fourth from left) and David Austin (centre).

TEACHER – LEAVE THOSE KIDS ALONE!

Education was a highly contested subject in the seventies. The headline news was that state schools were changing fast from the old two-tier system of grammar schools and secondary moderns to the unified comprehensive schools. But the debate as to what a modern and truly democratic education should look like was being played out in schools up and down the land, secondary schools and primary schools alike.

A new generation of teachers had grown up in the ferment of the sixties, infused with progressive ideas. They wanted to do away with the rote learning and corporal punishment of their own childhoods and were in search of something utopian. Up till now such ideas had been confined to the private sector, where schools like Summerhill and Dartington had been experimenting with new ways of teaching for decades, while state schools had stayed resolutely authoritarian – but the old order was breaking down.

In many schools, lines started to be drawn between those who wanted profound change and those who believed in a more or less traditional approach. And in the summer of 1976 this debate came to a head, all thanks to a tiny primary school in Islington, North London, called William Tyndale.

In July and August of 1976 the newspapers were full of stories about this one small school, due to the publication of the Auld Report, following a public inquiry, led by barrister Robin Auld, into the running of the

school. Over the preceding three years, William Tyndale had become a battleground between radical and traditional teachers. A whistleblower had gone to the press, claiming that the school had descended into *Lord of the Flies*-style anarchy, with kids left to run riot. The right-wing newspapers had been happy to print scare stories and opinion pieces railing against all this trendy nonsense. Parents were taking their children out of the school and the staff were up in arms at the interference with their work. Everyone was waiting for the Auld Report to finally reveal the truth about what had happened.

There was so much interest in the report that it was even published as a book by the Inner London Education Authority (ILEA). They claimed its sales largely paid for the £55,000 cost of the inquiry, which seems unlikely. Nevertheless, as judicial inquiries go, it was a riveting read.

William Tyndale, built in 1916, was typical of the schools of its time. A slightly forbidding three-storey structure – each floor with a long corridor, flanked by classrooms. It was set close to the shops and pubs of Upper Street, behind the Town Hall and next to a small housing estate.

Islington now is an extremely wealthy and fashionable suburb, just a mile or so north of the City – a byword for bourgeois liberal values. Tony Blair famously lived there before he was prime minister, just yards away from William Tyndale (and, coincidentally, the short-life housing flat I was living in through the mid-eighties). In the seventies, though, things were different, almost unbelievably so. In 1971 the UK census showed that Islington was the second worst place to live in Britain, above only Glasgow – the key measures considered being overcrowded housing, unemployment and lack of private baths or toilets.

William Tyndale school's intake was mostly working-class children, some of them from extremely poor families, but with an increasing

number coming from the middle-class families who were pioneering the gentrification of the area. It was divided into an Infant School for 4–7 year olds and a Junior School for 7–11 year olds – and it was in the Junior School that the trouble erupted. The Infant School, throughout this time, continued to do well under the direction of its headmistress, Mrs Hart.

Through the early seventies, the Junior School headmaster had been the appropriately named Alan Head. He left in the summer of 1973, after five years in which the school had acquired a good local reputation. His approach was modern, even gently progressive, but not alarmingly so. Despite this, it took the school a little while to find a new headteacher. The deputy head, Mrs Irene Chowles, stood in for the next term, but didn't relish the job and was happy enough when Terry Ellis took over as headmaster in January 1974.

Ellis, then in his mid-thirties, was definitely on the progressive wing of the profession – you could tell by his longish hair and raffish sideburns. The school inspector at his previous job provided him with this somewhat barbed reference: 'Mr Ellis is a likeable enthusiastic teacher always willing to experiment. He maintained constant interest among the pupils in a somewhat chaotic environment.'

This should perhaps have given a warning as to what was to come. The principal agent of chaos was the new deputy head, Brian Haddow. Aged 28, blond curly hair and beard, NHS specs, Haddow was the previous headmaster's final hire. Despite having only just arrived at the school and very newly qualified, he was made deputy head for the simple reason that he was the only man on the teaching staff at that point – and that was qualification enough.

Haddow was a big personality, abuzz with radical new ideas on teaching. He was against the rigidity of the traditional classroom and in favour of an open plan environment in which the children would be able to follow their particular interests – to which a team of teachers

would respond. And he didn't just see such strategies as a matter of achieving better exam results, but as a building block in a profound reimagining of society.

An experienced headmaster like Alan Head might well have kept Brian Haddow's ideas in check, but Terry Ellis was a less battle-hardened and more ideologically sympathetic leader, so Haddow was soon given permission to reconfigure his class – Year 4, the ten and eleven-year-olds – after the February 1974 half term.

Rather than simply being sat down and taught a lesson, with Haddow's changes in place, the kids could now choose between around 20 different activities. Some of these were the traditional subjects, others were crafts, such as woodwork and needlecraft – but there were also options like dancing, tie-dye and table tennis on offer. And once they had chosen their activity, the kids weren't confined to the classroom either. Table tennis, for instance, took place out in the corridor. This is how Haddow explained it to the inquiry in 1976:

> With the children I decided on a range of 20 activities to be set up for them. They had the choice to move freely to the one they wished to do. I expanded these activities from the classroom into the hall outside. Where necessary I would intervene and give direction to the children's learning.
>
> Each day we would meet in the classroom, I would say what I was able to provide for that day, talk about what they wanted to do, give them a general discussion on how this would affect the rest of the school (e.g. keeping the noise level low). I had a timetable on the wall of fixtures, which I provided every day, e.g. TV programmes, games, visits. It was a partial opting-in system for the children.

The effect on the rest of the Junior School can easily be imagined. The big kids appeared to be allowed to do what they liked, and the teachers

responsible for the younger kids found it harder to carry on in their usual way. To make matters worse, the other teachers had not been consulted or even notified about this change to the teaching of Year 4.

However, Haddow himself was pleased with the results. As the inquiry notes, he 'saw the new system as being of particular benefit to the socially deprived and emotionally disturbed children – in that, according to him, they were able to develop far greater self-sufficiency in this freer atmosphere'. Haddow observed that the new system didn't really affect the more academic children, who continued to work as before. He did admit that there was a middle group who were just taking the easy option of watching TV programmes or playing table tennis. He felt this was just a stage though, and they would soon want to broaden their outlooks.

That was Haddow's opinion. Outside observers had contrasting views of this experiment. One of the school 'managers' (what we would now call governors), Elizabeth Hoodless, observed that: 'He was an extremely talented teacher who had developed very innovative methods in the class room.' On the other hand, the part-time remedial English teacher Mrs Dolly Walker thoroughly disapproved of Haddow's approach and made her feelings very clear. However, Terry Ellis and most of the other teachers were caught up with Haddow's passionate desire to find new and better ways of teaching deprived children. The use of free options started to spread to other classes in the summer term – though a couple of teachers stuck to their usual regimes.

All of that, though, was the adult view of the situation – as expressed through the inquiry. What the Auld Report lacked was any real sense of what the kids themselves made of this new regime. One of those children was Stephen Spooner. The child of Barbadian parents, he is now a primary school headteacher himself, and he gave me a very positive view of his time at William Tyndale. Here's his take on Terry

Ellis: 'The guitar playing headteacher! I used to love his assemblies. He used to play his guitar really fast and get us all singing. He wore this beige jacket and brown trousers. He was a great headteacher. He was really fair.'

Spooner's big inspiration, however, was Brian Haddow:

Brian Haddow with his big beard was my childhood hero. We used to get on really well. He was also our football coach – he couldn't play himself but he was really encouraging. I used to play football at quite a good standard. I played for Islington, London and Bournemouth youth team for a bit. One day I came into school and Mr Haddow said, 'How was your weekend?' And I said, 'I played football Saturday, Sunday I went to church.'

He turned to me and said, 'You don't believe in all that rubbish, do you?' That was the first time anyone has said anything like that to me. Coming from a Caribbean background, my parents were religious – not over the top but they did force us to go to church. So first I thought, what's he talking about? Then we had a conversation about walking on water and all the things Jesus was supposed to have done. It wasn't so much that he was trying to persuade me not to be a believer, but it was the first time I'd learnt to question anything. He wasn't teaching us to be bad or ungodly. He was just saying to me – you need to think about things and not just accept what people say. It had such a profound effect on everything I did afterwards.

As for the much-maligned options system, Spooner says it was actually well worked out and successful:

What I recall was that you did your work in the morning: Maths, English and maybe a bit of Science. So the deal was, you did all your

work, you kept up to scratch, and the afternoon was your choice, you could do whatever activity you wished to. But if you didn't do your Maths and your English, you would be in the hall sitting there for the whole of lunchtime, the whole of the afternoon, catching up. That was a democratic process where the majority of children knuckled down because they wanted a free afternoon. What more motivation did you need as a kid? I had visions of grandeur of being a pop star, so five or six of us made a band and we used to just go and do rehearsals in the afternoon and sing our songs in assembly to the rest of the children.

As far as discipline went, however, Spooner's memories do rather explain the concerns of some teachers and parents:

It was almost like a free school in every sense of the word. I remember being able to leave the school building, go down to the Canonbury bookshop, which was a few doors away from the school, and – this is terrible – nick those rubbers that smelt of strawberry and so forth. I'm sure the owner knew we were nicking these rubbers because everyone wanted one. But this was at lunchtime in a primary school. It wouldn't be heard of now, that you could go out of the school at lunchtime and then return! And even when we returned, I remember climbing up on the power station within the school. We'd climb up the pipe and sit on the roof and smoke. The teachers knew we were up there, but they turned a blind eye to it.

However, even at the time, he was aware that not all the teachers saw eye to eye about the way the school was being run:

I remember the distaste between some of the teachers and their opposites – the two factions in the school. I remember Mr Ellis and

Mr Haddow having these huge arguments with their colleagues. As children we didn't know what was going on, we thought it was quite funny.

The grown-ups, of course, didn't find it funny at all. Matters started to come to a head when Mrs Walker wrote a critique, summing up what she felt was wrong with the way the school was being run, and delivered it to a staff meeting in May, 1974. Dolly Walker was in her mid-forties, a little older than the other teachers. A bright and serious person, she had previously written a biography of the playwright Christopher Marlowe, and had taught for some years at the private and exclusive Dulwich Preparatory School. Here's an extract from her jeremiad on the failings of William Tyndale:

> The school is suffering from a malaise. The atmosphere is demoralising for both teachers and children, as well as cleaners, helpers, caretaker staff and visiting parents.
>
> This state of affairs has arisen and grown progressively worse as a result of certain blindly-held half-baked theories regarding education and children.
>
> My contention is that free activities methods are being seriously abused in this school. You have substituted a 'free for all' atmosphere of total self-indulgence, self-pleasing, do what you want for the moment. Chaos and anarchy are in possession. Discipline is frowned on as 'old-fashioned'. Children are being seduced to behave in ways which are detrimental to them, both in their progress in learning anything and in producing antisocial behaviour. They are growing up ignorant, selfish, rude (to the extent that even those manners they learn at home are being eroded), lazy, effete. In order to get them to do any work or make any effort you have to bribe them, cajole, persuade, threaten and spend

endless time because of the unreasonableness and immaturity in which they are locked, so that the drain on adult energy and morale is out of all proportion to what is achieved.[5]

She clearly loathed both Terry Ellis – 'The biggest buck-passer I've ever seen' – and Brian Haddow – '[he] talks of Children's Rights. What about the right to a decent education?'

If she had kept her complaints to the staffroom, it might have been possible to work out some kind of compromise, but instead she started to broadcast her feelings far and wide. She talked to the parents, filling them with apprehension. And then she talked to a friend of hers called Dr Rhodes Boyson.

Rhodes Boyson was a remarkable figure: fifty years old and bald with big mutton chop sideburns, he looked like a Dickensian schoolteacher and acted the part with relish. He came from a working-class Methodist family in Lancashire and kept his accent loud and proud. He was just old enough to have served in the war, in the Royal Navy. In the summer of 1974, he was the newly elected Tory MP for Brent North. He was also the head of Highbury Grove Comprehensive School, close to William Tyndale. He was no fan of the comprehensive system, however. One reason he gave for opposing it was because he had figured out that it would lead to selection by postcode, with raised house prices around popular schools determining their intake. History certainly proved him right on that.

In his seven years at Highbury Grove, Boyson had made the school a striking success story, with demand from parents far outstripping the places available. He hadn't achieved that success through progressive teaching, though, but the reverse: times tables and spelling tests and corporal punishment. He would soon become an education spokesman for the Tory opposition, now led by a kindred spirit in Margaret

Thatcher. As a firm believer that what working-class children needed was discipline not freedom, he was a natural ally for Dolly Walker. He dismissed Ellis, Haddow and co. as left-wing 'head-bangers'.

Dolly Walker was successful in her efforts to alert parents to the changes at William Tyndale and many of them expressed their concerns. They demanded a meeting with the staff to discuss what was going on. This took place on 9 July. Terry Ellis put forward a bland statement of the five aims of the school. None of these was controversial – the children should learn to read, write, understand Maths, think for themselves and 'live together in school harmony'. What he didn't get to address was how these aims were going to be delivered by the new teaching approach. This was because Dolly Walker had placed a copy of her latest attack on the teachers on all the parents' chairs. Some of those parents, egged on by Mrs Walker, laid into the staff, who then walked out in protest. It was, in short, a fiasco, and when term restarted in the autumn the school roll had dropped from 230 pupils at the start of the previous year to 155.

Ellis and Haddow were not to be deterred. Ellis blamed the fall on 'working-class fascists' and 'middle-class trendies out for their own children' – those people who paid lip service to progressive ideas but then ran away when the going got tough. Their focus was on kids like Stephen Spooner who were thriving under the new regime.

There was one particular case that perhaps summed up the strengths and weaknesses of the new regime at William Tyndale. That was of a boy referred to in reporting as 'Homer Eliot' (not his real name). He was a bright boy, but still completely illiterate at age ten. Here is an account of his behaviour at the start of the new school year:

The sound of glass being smashed on the playground, a young voice wildly chanting, 'Black is power, White is flour'. A boy of West Indian parentage, whom we shall call Homer Eliot, the terror of William

Tyndale, was at it again. Up on the roof of the lavatories, which abut onto the main school building, dancing, screaming, he hurls down the milk bottles and refused to budge. Eventually he allowed himself to be persuaded by Mr Haddow – often the only person he would allow himself to be persuaded by – and came down. But the violence and the abuse continued. In the end, Mr Haddow and Mr Austin together had to frogmarch him, while he screamed racial insults at them, all the way up Upper Street to his home and the thrashing his teachers knew he would get from his father.[6]

The standard response to such behaviour was to get the child sent to a special school for what were referred to as 'the educationally subnormal'. As progressive teachers like Ellis and Haddow, plus new recruit David Austin (an interesting character who had a sideline writing and drawing a cartoon strip set in Ancient Rome for *Private Eye*) knew, this was all too often the fate of Black children. Indeed radical Black teacher Bernard Coard had written a short book on the subject three years earlier – *How the West Indian Child Is Made Educationally Sub-normal in the British School System*. So they weren't prepared to consign Homer Eliot to that fate. Instead a multi-agency meeting was convened and, on Austin's initiative, they persuaded the ILEA to finance the purchase of instruments for a school steel band, knowing that Eliot would be keen to take part.

They won the day and the William Tyndale steel band was formed. Twenty-five children became involved over the next year, and they performed at County Hall and at a successful summer carnival at the school in 1975. It provided a positive outlet for several of the school's most troubled pupils and, as Haddow et al. had hoped, they began to become better behaved and more receptive to learning. Progress was actually being made.

However, as far as many parents and most of the school managers were concerned, this was an isolated success. They were worried about the school's plans for the next year. It had been decided that the first and fourth years would be taught in a more-or-less conventional way, while years two and three would experience Brian Haddow's team teaching. They would choose from a menu of options and a team of teachers would move from group to group helping them where needed.

Alongside this the school was to break down many of the traditional barriers between staff and children. The kids would be allowed to use the staffroom and even staff toilets as they wished. Formalities would be done away with. Teachers would be addressed by their first names. The keenest apostles of the new approach would no longer take their coffee breaks in the staffroom but out in the playground, chatting to the kids.

All of this may have made sense in theory, but as the Auld Report makes clear, it was the implementation that sometimes let it down. This group of teachers had little or no experience of cooperative teaching and Haddow, while a teaching natural, was not a good organiser.

Typical of the gap between aspiration and actuality was the fate of the library. It was decided the room that housed the library should be turned into a parents' room – a place where parents could come and chat to the staff about what was going on in an informal setting – while the books would come out into the halls and classrooms, where they would be more freely accessible.

In practice the parents' room never really got off the ground. It was a bleak, bare space that neither parents nor teachers wanted to visit, and it soon turned into a repository for general junk. Meanwhile the books were just left lying around the place in random piles, unread and undervalued.

As the year wore on, though, the radical teachers were broadly pleased with the way things were going. Dolly Walker left at Christmas '74 and went back to teach at Dulwich Prep, so there was less internal disruption. The school carnival went well and the exodus of children had slowed down. Given time, they felt sure, everyone would see the benefits of new ways. Certainly that chimes with Stephen Spooner's experience.

However, the school managers were less convinced. Successive visits failed to alleviate their fears. The state of the library particularly concerned them. One of the managers, Aelfthryth Gittings, was also a parent and she withdrew her son partway through the year, saying he was bored and frustrated by the lack of decent reading matter, as well as being bullied. When they tried to raise their concerns about the school with the ILEA, they received little response.

So, in April 1975, they started up a petition. It began, 'We the undersigned are concerned at the deteriorating quality of education . . . and call upon the ILEA to take urgent steps to reestablish public confidence.'

Auld's Report pointed out that this was a thoroughly unhelpful move. It led to any number of rumours flying around – many of them following on from Mrs Walker's allegations that the teachers were a nest of revolutionary communists. But the teachers' response, led by Brian Haddow, didn't help matters either. He doubled down on the need for the school to take a truly radical course. The teachers then banned the managers from visiting the school, citing the existence of the petition as evidence of bad faith. In July, just before the end of term, the ILEA finally stepped into the row and announced they would commission an inquiry into the school.

The inquiry, with its team of inspectors, was due to begin proceedings as the next term started in September 1975. But the teachers made a last stand. They went out on strike against what they saw as unjustified

intrusion into the running of the school. They even set up their own rival school in a church near by. That lasted two weeks before they agreed to return to work and the inquiry finally went ahead. Meanwhile the press were taking an extraordinary degree of interest in this tiny school. There was blanket coverage of the strike across the broadsheets, which only intensified in October, when the inspectors published an interim report, criticising the lack of formal learning and achievement among the pupils.

London's *Evening Standard* blazed the story across its front page: 'Rebel school is slammed: pupils can't read or do sums'. And where the news journalists led, the opinion columnists soon followed. Rhodes Boyson published a think piece in the *Daily Telegraph* excoriating the teachers as 'the destructive pied pipers of our times'. More thoughtful but also more damning for the teachers, as it came from a voice of the left, was Jill Tweedie's piece in *The Guardian*. She talked to a couple of working-class parents, a fireman and a school assistant, and took down their views on what was happening. They pointed out that middle-class parents, whose kids were growing up with money and motivation and books at home, could afford to indulge this experiment. But working-class kids from difficult homes were always going to prefer playing Ludo or table tennis to reading a book. As the fireman put it:

To me, these kids badly need what I got at my school. Stability, discipline and the 3 Rs, the basic tools to do the job. You don't have freedom before you have those tools. And the teacher should be a dominant figure. They've got to have control or the kids won't respect them.

We know what it's like to do without, so we want our kids to better themselves. *They* never had to do without. Their kids sit down and read because their parents do and they want to. Working class kids must be *made* to. My father was killed in the war, my stepfather was in the fire

brigade and we all went into it. But my father's brother was properly educated and his two sons, my cousins, one is a doctor and one is a solicitor. That's how you change things, not talking politics.[7]

It's a damning verdict – all the more so because these were parents who had stuck with the school thus far. And it would be echoed over and over when the Auld Report finally came out in the summer of '76. Conservative critics, led by Boyson, seized on the example of William Tyndale as a stick with which to beat the whole notion of progressive education.

In reality, though, the Auld Report was not simply the kind of establishment demonising of progressive teaching that the Tyndale staff had feared. In fact, as *The Guardian*'s education correspondent John Fairhall had it, 'headmaster, teachers, managers, inspectors and the Inner London Education Authority are all blamed in the William Tyndale Junior School inquiry report for the failure of the school.' And indeed, there is just as much criticism of Dolly Walker and the managers for inflaming passions, as there is of Ellis and Haddow for their erratically executed policies. Neither was Robin Auld the out-of-touch mandarin that opponents of the inquiry cast him as, but a publican's son who had failed the 11-plus, gone to a technical college and from there won a scholarship to study law. He very much had a dog in the fight to improve the quality of state education.

Nevertheless, the ILEA decided to put all the blame on the teachers and announced that Terry Ellis, Brian Haddow and four others would be suspended on full pay before facing a disciplinary hearing. Ellis and Haddow took to the left-wing press, who whipped up support for their cause. They rushed out a book, *William Tyndale: the Teachers' Story* – and a sympathetic playwright had a supportive play, *Sir is Winning* by Shane Connaughton, commissioned by the National Theatre. But

it wasn't enough to save the 'Tyndale Six'. They were duly sacked by the ILEA in September and a month later, in the dour aftermath of the long, hot summer, the Labour prime minister, Jim Callaghan, made a speech decrying what he said were the excesses of progressive education. In this speech, made at Ruskin College, he went on to say, 'It is not my intention to become enmeshed in such problems as whether there should be a basic curriculum with universal standards – although I am inclined to think there should be.'

Dolly Walker might not have won her battle in the staffroom, but along with her ally Rhodes Boyson she'd set in motion a sea change in educational policy. No longer would headteachers be masters of their own domain. Guidance would come from above. The emergence of a national curriculum was only a matter of time. It was not only in the world of music that long-haired hippie idealism was suddenly hitting the buffers.

Dolly Walker, herself, devoted much of her remaining time to her own quixotic crusade – attempting to prove that Christopher Marlowe was the author of Shakespeare's plays.

David Austin, the man behind William Tyndale's successful steel band initiative, quit teaching that summer, but went on to have a very successful career as a cartoonist, most notably for *The Guardian*.

As for Stephen Spooner though, the boy who was a pupil at William Tyndale and went on to be a headteacher himself, he has nothing but good words to say about the experience: 'I think it was one of the best schools I've ever attended or even seen. I've kept in contact with some old school friends and they've all come out really well, got decent jobs. I loved William Tyndale, loved it to bits.'

Which makes it all the sadder that state schools have since been prevented from even experimenting with new ways of teaching, instead forced into the one-size-fits-all straitjacket of contemporary state education.

SPORT

MOTORBIKIN'

Growing up as a teenage boy in the mid-seventies you couldn't help but know a bit about motorbikes even if, like me, you had no interest in them at all. They were the number one topic of conversation at my school – way ahead of music or football. There were endless debates about which bike people would want to get when they turned seventeen. Some went for the flashy American Harley-Davidson, others for the classic British Nortons and suchlike. The one thing everyone seemed to agree about was that the Japanese Kawasaki bikes were for losers. Everyone's older brother had a bike, often in a state of disassembly in the front garden.

The entry point to motorbike culture for lots of kids was an American called Evel Knievel, one of the big stars of the time. Knievel was basically Elvis as a motorcycle stunt rider. His showstopping stunt was jumping huge distances over ever-increasing numbers of cars and trucks. In May 1975, he'd come to Wembley Stadium amid great fanfare to jump over thirteen London buses. It was shown on TV the next day, and to mass horror and excitement he clipped the final bus and came off his bike on the down ramp, the bike then careering into him on the ground. His body suffered a fractured pelvis and a broken hand, but his legend didn't suffer a bit.

The other big biker hero of the moment was Barry Sheene, the glamour boy of British motorcycle racing. A chirpy cockney with long hair, he fitted nicely into the pantheon of sexy male seventies

sports pin-ups, alongside the likes of George Best and Stan Bowles in football and James Hunt in Grand Prix racing. Like Knievel he'd had a bad accident in 1975, smashing up his leg in a crash in Florida, but in 1976 he came back to racing and won the world title for the first time.

So far so wholesome, if dangerous, but there was another side to the motorcycle world. That was the world of the outlaw biker: Hells Angels and their myriad wannabes. The Hells Angel was the ultimate macho fantasy figure of the time. *Easy Rider* was still showing on endless cinema double bills. Steppenwolf's 'Born to be Wild' was on the jukebox of every pub where bikers congregated. If you believed you were hard enough, and had a good enough bike, you could be part of the ultimate gang. Not just one of a bunch of football supporters having a bit of a barney on a Saturday afternoon, but a member of a posse, each with their own silver machine, roaring into town and taking immediate possession.

The poet and novelist Joolz Denby was twenty-one years old in the summer of '76, married to a member of the Satan's Slaves motorcycle club. She explained to me the appeal of the outlaw biker lifestyle:

> I did like motorcycles, I liked the whole thing. I liked the bikes themselves. I liked the mechanics of it. I liked the clothes, I liked the idea of tearing around not in a car and, you know, just generally hanging out. The sense of outlaw-ness was very real. You were absolute kings in the street. I was like a little princess. I mean somebody dared raise a hand to me once and they hunted him right through Bradford. We were kings and queens.

One of the many objections to the Hells Angel phenomenon was the frequent use of Nazi imagery. Denby doesn't excuse it,

but does offer some context, suggesting it was little different to Vivienne Westwood using it in the clothes she designed to *épater les bourgeois*:

> Nazi memorabilia was knocking around. It didn't signify you being a Nazi. It was just shock value, because straight people hated it. There was a lot of baiting of straight Society, just for kicks. I was trying to be a jeweller and I used to make like little disc earrings. And they used to go, 'Can you do a swastika?' And I'd go, 'Yeah, yeah'. So I would do a reverse swastika because they couldn't tell the difference. And I'd charge quite a lot of money for it. They weren't dedicated Nazis by any means.

The two worlds of biker culture collided with a vengeance in August at the John Player Grand Prix, which took place on the Silverstone Race circuit, just outside the small Northamptonshire village of the same name. Getting on for 100,000 regular bike fans went there to cheer on Barry Sheene and were doubtless disappointed when his engine failed while he was in the lead, and he had to retire from the race. Meanwhile the campsite was dominated by Hells Angels. Two rival chapters went to war on the Saturday evening.

A Silverstone official said, 'A lot of them were well tanked up. There was only a few of them fighting to start with. But then everyone came running out of their tents and joined in. It was bloody murder, but there was nothing we could do to stop it.'

As the battle raged, the big disco tent was set on fire along with the portable toilets, a hotdog stand and assorted cars and caravans. The police turned up and tried to subdue the rioters with batons and staves but were driven back by an onslaught of missiles. They asked the fire brigade to turn their fire hoses on the rioters, but they

refused to get involved. The fire chief said: 'We couldn't just turn up like the cavalry. It's not our job. We are here to save lives and put out fires, not to attack the public – however badly they behave. We knew the crowd would have smashed up the fire engine if we had got involved. They did it last year.'

BREEZIN': THE SUMMER OF SOUL BOYS

Mainstream teenage fashion was at a low ebb at the start of the summer of '76. Doubly so if you were a boy. Everybody I knew wore flared jeans. Not extravagantly flared, for the most part, just enough to be thoroughly shapeless. You could combine them with denim shirts, waistcoats and jackets if you wanted, but in this heat a T-shirt was plenty.

You could buy your jeans and T-shirts at one of the many high street chains – Jean Junction, Jean Machine or Jean Genie. I bought mine at Gentle Folk jeans in Cardiff. Any individuality was confined to the choice of T-shirts. If you wanted something a bit different in the way of a T-shirt, you could get them mail order from a company called Permaprints, who had full-page ads in all the music papers every week.

Each ad featured about fifty different T-shirt designs. Here are some of the highlights from the range available in May. There was a range of rock bands – Led Zeppelin, Roxy Music, Santana, two different Status Quo designs and a David Bowie T-shirt no self-respecting Bowie fan would have gone anywhere near. I had the Genesis T-shirt, a relatively tasteful item, with an art nouveau-ish drawing of a girl's face and the name of the band underneath.

There were shirts featuring all-purpose icons – Beethoven, Elvis, Marilyn, James Dean, Lenin, the Marx brothers. And then there were the comedy T-shirts. Some of these were text based – 'Work is the curse of the drinking classes', 'Butlitz holiday camp escape committee', or the one I bought: 'Join the army/travel to exotic distant lands/meet exotic unusual people/and kill them'. Plenty of them went for straightforward

Margate, 1976: Black and white unite and party.

sexism and/or sexual innuendo. If you wanted a cartoon of two pigs having sex with the words 'Makin' Bacon' emblazoned above them, you were in luck. Likewise a picture of an animated nut and screw with the legend, 'Smile if you've screwed today'.

By our T-shirts did you know us. Looking back, it's easy to see we were a generation just waiting for a fashion of our own. That wasn't true of everyone, though. Rock fans like me may have been lost in a denim hall of mirrors, but soul and disco aficionados were finding their own distinctive looks. The one I used to see around on the streets was boys in Oxford bags paired with jumpers that had a collar and short sleeves. The collar and the end of the sleeves were in contrasting colours, and the front of the shirt had three stars on it. This was a look originally associated with Northern Soul clubs, but it had made its way out into suburban discos and football terraces throughout the land.

That look was commonplace. But for those in the know – which certainly didn't include me – there was a whole new scene that had come out of the disco explosion of the early seventies, a scene in which fashion and music were equally crucial. That was the world of the soul boys and soul girls.

The writer and broadcaster Robert Elms was one of those teenage soul boys. He told me that for him the summer of '76 was a perfect coming together – right sounds, right clothes, right weather:

> People were all going bleach blond, dyeing it or it happening naturally because of the sun. So suddenly that summer had a different feel to what England had been like in the mid-seventies.
>
> There were little things that became quite normal later. It was the first time I ever remember drinking beer from a bottle because it was

cooler that way. I seem to remember that for the first time a lot of restaurants put tables outside, which was really un-English. We didn't do alfresco eating back then, but all of a sudden, walking through Soho there were tables out on the street. It changed the whole way that England felt. People had been on holiday in Greece or Spain and suddenly they were doing it at home. An awful lot of people didn't go to work; they just found ways to be off, and in the park and take their clothes off, or go cruising down the King's Road.

I think because it was hot all the time, you could almost convince yourself that you were either Californian or Italian. England was very hidebound, quite sort of tense and the seventies was a very politically difficult time, but for the period of that summer it was too hot to get wound up by stuff like that. So everyone just took music outside, music was playing in the streets. It was a bit like those films you see of New York – not the fire hydrants, because we don't have them, but that sort of style. Everybody was going to parks or lidos. So everything loosened up for this one long, wonderful summer. And it was a long, wonderful summer if you were seventeen. Everything became kind of cool.

It was a teenage time. I don't remember there being anyone older than twenty in the world. The whole world was based around clothes and music – that was all you had. And you didn't aspire to anything else. You just wanted the right clothes and the right music.

He has a very clear memory of what the right clothes were:

At the start of that summer, on a typical Saturday afternoon, I'd have been walking down the King's Road, which was sort of the catwalk. I'd be wearing a pair of pink pegs. Pegs were pleated trousers, wide at the top and narrow at the bottom. Plastic sandals. White socks with the sandals. Or white socks with other shoes. White socks were really

important. They were like a kind of badge, sort of white towelling. Then probably something like an American bowling shirt. Or maybe a Hawaiian shirt. The looks were very, very bright. Or I might have been wearing a cap sleeve T-shirt of the kind Bryan Ferry had. If you look at what Bryan Ferry was wearing, much more than what Bowie was wearing, you'll see the soul boy look.

There was a kind of a fifties thing going on. I can't remember what year that film *American Graffiti* came out but there was an element of that. And there was the classic car thing – we used to go and watch the cars parading up and down King's Road.

I also had this GI look, which I used to go out to wear in clubs, with jungle greens, a tie tucked in and a forage cap. That was all bought at Laurence Corner army surplus store, which was a real hangout.

The clothes were a mixture of some quite high-end stuff, bought in places like Acme Attractions, or it was bought in Wembley Market and it was really cheap knock-off gear. I was a working-class kid, I had a job in a record shop and what money I got I spent on clothes. My hair was cut in a wedge, asymmetric, almost like a bowl cut.

And the right music was very definitely soul:

It was a soul summer because the music suited the vibe, the temperature and everything else. And the music was like that too – 'Breezin' by George Benson was one of the big records of that summer, 'Lowdown' by Boz Scaggs. Alessi Brothers' 'Oh Lori'. That was the feel of it – slightly Californian and slightly European.

The soul scene was indeed just perfect for a long hot summer. It was all about fashion, dancing and music – and its highlights were the

bank holiday weekend trips to the seaside towns of Bournemouth and Margate. It was an aspirational subculture, and the principal aspiration was to have a good time.

Discos had proliferated on every high street during the seventies, but by 1976 they were far from all the same. Most were everyday places where working-class boys and girls went to dance to the Real Thing or Tina Charles, while getting on with the serious business of looking for someone to cop off with. Closing-time fights were an optional extra. But there were also those places that catered for a more discriminating clientele.

Britain had always had clubs playing the very best in Black American soul music, since the time of the mods a decade or more before. In the north of England, the sixties soul style still reigned supreme (hence the term, Northern Soul), but across the south the demand was for the latest sounds. This meant Philadelphia soul, post-James Brown funk and particularly the new strain of music which fused jazz and funk. That summer these were the sounds of the progressive London dance floors. As Elms remembers, 'There was a club on every night. It was the Lyceum on a Monday night. Global Village on a Tuesday or Wednesday, Sombreros on a Thursday, Crackers on a Friday.'

Crackers, a disco on Wardour Street in Soho, was the absolute heart of the soul boy scene. It was the place with the best music, courtesy of resident DJ Mark Roman. He was the man who is widely credited with reintroducing serious soul and jazz to London's West End in the early seventies, after years in which clubs had done their best to dissuade Black people from coming in. As he told *Soul Survivors*: 'I came into London not knowing that it wasn't OK to play so-called black music and I blew the doors off the place.' His residency at Crackers was a great success. Up to a thousand

people crammed in to hear Roman play the latest sounds on Tuesday evenings and Friday afternoons. It may not have been the hard-drinking crowd that club owners traditionally wanted to attract, but it made up for that in sheer numbers.

Favourite tunes ranged from jazz-funk – Donald Byrd's 'Change (Makes You Wanna Hustle)', Lonnie Liston Smith's 'Expansions' or Eddie Harris' 'Is It In' – to out and out funk like Maceo and The Macks's 'Across The Tracks' or the J.A.L.N. Band's 'Street Dance'. The music selection attracted absolutely the best dancers. Particularly popular were the Friday sessions that ran between midday and three in the afternoon, and pulled in a mix of workers taking an extended lunch break and school kids bunking off to hear the new music and see the best dancers.

These were mostly young Black Londoners like Horace Carter, Clive Clarke and Trevor Shakes. The one noted white dancer was a redhead called Tommy Mac. Each had their own distinct style and patent moves. There would be regular dance-offs between the stars of the scene. Robert Elms described the action in his book *The Way We Wore*:

> When these boys were on the floor, a circle would form to give them an amphitheatre in which to perform. They would then pull out moves and steps with a wickedly competitive edge, legs flying like lasers, some new twist or turn eliciting spontaneous applause from the closely watching circle. Unlike northern soul, with its dervish spins and flailing kicks, its wild amphetamine abandon, the southern style was tight and precise: feet made rapid tap movements, knees were bent, hips sashayed, shoulders rolled, heads bobbed. The whole effect was somewhere between boxing and bopping. And if you couldn't cut it, you didn't go anywhere near the floor.[8]

Cleveland Anderson was one of the dancers and recently recalled the status they had:

> Back in those days the dancers were every bit as important as the DJ and the music he was playing. They were stars. People actually came to see the dancers, like Clive Clarke, who won the Disco Dancing championships . . . The girls would go there and they would just stand there watching these guys dancing with naked chests.[9]

The naked chests were not just a come-on to the girls, though, but a result of the fact that Crackers was literally boiling that summer. There would be sweat dripping from the ceiling and walls, queues of boys waiting to drink from the taps in the bathroom, before the management turned the water off to make them pay for soft drinks instead.

Apart from the music, what marked Crackers out from the regular discos was the mix of the clientele. Most obviously it was racially mixed at a time when most West End clubs would be overtly hostile to Black boys wanting to come in. The future DJ and broadcaster Norman Jay MBE remembered that 'At Crackers we never had that. We felt this was home, this was our place. We belonged; we were wanted.'[10]

It was also a place where gay people were welcomed. There was an overt sexual fluidity in popular dances like the Bump. Robert Elms elaborates:

> No one cared. You went to Crackers and there were boys dancing with boys. It was the first flowering of a kind of multicultural scene. If you went to straight clubs back then, there would almost always be a punch-up. That was what kids went out and did on the Friday night – they got pissed up and they had a punch-up. That didn't happen at these soul clubs because they were mixed gay and straight, mixed Black and

white. They were much more tolerant places. That was another part
of the appeal – if you looked a bit weird, you found a kind of solace in
numbers.

Alongside this sexual fluidity came an ever more extreme approach to
dressing up:

> The soul boy scene was the working-class style of London. And so every
> night, in the centre of town, you could go to clubs where you would
> see all these kids and you'd see the new style. Someone would turn up
> and they dyed their hair red or blue, or they're wearing dungarees with
> nothing underneath them. Throughout that summer, almost by the
> week, the styles were getting weirder and weirder and the music was
> getting pushed further and further out, it was jazzier and harder and
> faster.

The singer Andy Polaris offered a similar memory: 'That was when you
started meeting all the freaky dressers. A lot of people always forget
that you used to have to wear a suit and tie to get in before punk and all
the rest of that started.'[11]

These hardcore soul boys were an increasingly visible tribe. They
were not always welcomed as such. 'Soul boy' was originally just a
derisive putdown directed by Black youth who were into reggae to their
fellows who preferred soul, as Elms remembers: 'They were seen as
somehow effete, slightly treacherous – you know, your parents are from
Jamaica, why are you dancing to this rather than to reggae? So the term
"soul boy" was a term of insult from the hard kind of rasta reggae kids.'
Cleveland Anderson put it rather more brutally: 'They [reggae boys]
used to think the soul boys were queers.'

Gay or straight, like so many of British youth cultures up to this

point, it was a male-dominated scene. Especially on the dance floor where the men were solo peacocks, while girls tended to dance together in formation, doing the Bus Stop or the Slide to tunes like El Coco's 'Let's Get It Together'. Style-wise there was a strong forties/fifties element in the girls' fashions. Biba styles. Cinched waists with big belts, long skirts, floral prints, plenty of blusher and flicked-up hair, perfectly soundtracked by Dr Buzzard's retro-funk 'Cherchez La Femme'. There was even a *Rock Follies* influence, as the show's wartime nostalgia episode inspired a brief fashion for the military look.

As well as being male-dominated, the soul boy world was an unapologetically elitist one. It was important to be one of the best dancers – and if you couldn't manage that, then you should have the best clothes and the best music. Again it harked back to the mod culture of the previous decade, right down to using the expression 'He's a Face' to refer to the top boys in the scene.

Sourcing the best music was simple enough if you were part of the Crackers crowd. You just had to be fast on your feet, as Robert Elms remembers:

> There was a shop called Contempo. I would go to Crackers on a Friday afternoon. Bunk off school for the dance session and then run over the road to Hanway Street, get in the Contempo queue and try and buy whatever was the latest record that they'd been playing. I remember buying 'Always There' by Ronnie Laws on Blue Note. It was the first time I'd ever bought an import – really expensive. The guys in the shop were the two coolest Black kids in London and if you didn't know what you wanted, if you didn't know the right name, they wouldn't say!

For the best, most fashion-forward clothes you needed to head to the King's Road. This was home to London's two hippest boutiques. Famously there was Malcolm McLaren and Vivienne Westwood's Sex at the very end of the street. This was both intimidating and punishingly expensive. But its rubber T-shirts were soon to be seen on many a soul boy chest – a particularly perverse choice given the heat on the streets and on the dance floors. The other place to get in with the in-crowd was a place called Acme Attractions in the basement of the Antiquarius antique market.

This was run by a spectacularly chic young couple. There was Don Letts, a tall Black guy from Brixton, with his hair in rasta-style dreads. And there was Jeannette Lee, another South Londoner, a white teenager with an impeccable fringe. Both of them liked to wear sunglasses indoors, as if they weren't scarily cool enough already.

They had met on the soul scene the year before, as Jeannette Lee (whose subsequent career took her from a stint in John Lydon's Public Image Limited to be the co-owner and director of Rough Trade Records) recalled:

> I used to go dancing at the Lyceum on a Monday night . . . this particular night this irritating guy came up to me. I was sitting on the stage and he walked towards me with make-up on his eyes, earrings in his ears, wearing a plastic mac and winklepickers . . . I was desperately trying to give him a wide berth but he kept talking to me. I really liked his plastic granny mac and eventually I cracked and asked where he got it and he told me he sold them and if I was to come to such and such a place he'd have one that would fit me.[12]

She didn't get her granny mac, but a job and a boyfriend instead. Letts and Lee weren't designers, so Acme Attractions didn't sell original

creations like Sex. Instead they sourced clothes from here and there, particularly 'dead stock' left over from the sixties and found in warehouses in London or Liverpool. Their signature lines were mohair sweaters, jelly sandals, Marlow crepe-sole shoes and peg trousers, which they sold in an array of peacock colours – bright pink, fluorescent green, electric blue.

The shop attracted a remarkable range of customers, some of them already famous – Rudolf Nureyev the ballet dancer, or Daryl Hall of Hall & Oates – some about to be, like Patti Smith and a lanky kid called Sid Vicious. The soundtrack in the shop had moved from soul to roots reggae and live tapes of the new New York punk bands. Bob Marley became another regular visitor. Change was afoot. Before long there would be those who would abandon the Soul scene in favour of this new punk rock thing.

According to Kevin Kirk, who had worked alongside Mark Roman at Crackers, this split wasn't simply musical but also racial, as the club changed DJs.

> When George Power and Paul Anderson came along, the club got blacker . . . the split went top heavy towards the Black boys. I think a lot of the white West End soul boys who went punk did so because they were feeling left out . . . The first club they took over from the soul scene was the 100 Club . . . The early punk scene definitely split things along a racial line.[13]

This was mostly still in the (near) future though, in the summer of '76. The last hurrah of the season came with the August bank holiday weekender in Margate. Hundreds of soul boys and girls descended on the Kent town – just as the mods had done a style generation or two earlier.

Margate then was coming to the end of its heyday as a holiday

destination of choice for working-class Londoners. Ten years later it would be sliding into disrepair, as the crowds who'd once flocked to the crescent beach and the Dreamland amusement park, had all disappeared off to Spain instead. But the baking summer of '76 brought the hordes down from London one more time. At the Winter Gardens theatre they could see the comedy duo Mike and Bernie Winters, the child star Lena Zavaroni, or the popular folksy poet Pam Ayres. If you wanted to get out of the sun, you could watch *Confessions of a Driving Instructor* at the Dreamland cinema. If you went to the less discerning kind of disco you could hear local lad Judge Dredd's new record 'Y Viva Suspenders' – a lame parody with publicity photos all shot on the Margate Sands.

Dredd was the most seventies of characters, a big white former bouncer at Brixton reggae clubs who'd made a mint reciting filthy nursery rhymes in a mock Jamaican accent over lite reggae backings. The BBC consistently banned his records which gave them a bit of undeserved cool. The B-side to 'Y Viva Suspenders', incidentally, was called 'Confessions of a Bouncer'.

The soul crew, of course, had their own weekend agenda. Johnny Woollard, then a teenage soul boy from Gravesend, remembered how the weekenders worked:

> We stayed in people's houses or in a bed and breakfast, sometimes we snuck into the old train depots and slept in the parked-up trains or sometimes six, seven, eight of us would sneak into someone else's bed and breakfast. There was always a do on each night during the bank holidays so we went down and spent time at Dreamland and had a muck about on the beach.[14]

The main dance venues were the Bali Hai, in the Dreamland funfair and entertainment complex, and the nearby Atlantis disco. Woollard

continues: 'My favourite was the Atlantis down in Margate. That one just blew me away at times, it was crazy travelling down there, they had dancers, a load of different things went on there in this basement club. On the walls they had pictures of mermaids and sea creatures.'[15]

In Norman Jay's memory, though, Margate was still a place – as it had been in the sixties, when the mods and rockers fought pitched battles – where trouble was never too far away. There were lines being drawn all over the place.

> That summer, there was a huge event going on in Margate. A couple of my mates owned cars, so we're gonna get out of town, go up to Margate. There was a club there called Atlantis and I can remember loads of soul boys. This was the summer when the whole punk thing blew up massively in the media, and there was a kind of an allegiance between the punks and the soul boys, and they were being harassed and persecuted and just distressed. Anybody who dressed a certain way was considered fair game.[16]

Wayne Butfoy was one of those soul boys wearing what was starting to be seen as 'punk' clothing and told me what that led to:

> Got ambushed by a mob of Teds in the car park behind, only around eight of us, we're all 17/18 years old in our Stanley Adams, Laurence Corner, Acme etc. clobber and they think we're punks. Anyhow [there's] this crew of Teds around 28/30 years old, we thought we was going to get a proper hiding. When all of a sudden Jabba appeared with a couple of his mates!
>
> He said to their Face, 'Listen they ain't punks they're soul boys/girls, if you wanna have a pop you come through me!' Their Face said 'OK' and they just left! Nasty gits they was too! Jabba knew me and my mate from Crackers, lovely geeza.

Jabba, a tall muscled Black guy with short dreadlocks, was one of the ace dancers on the scene. And with his martial arts training, a very good man to have on your side in a fight. A few years later, when the Margate soul crew were attacked by a big group of Nazi skinheads, Jabba went to his car, got out his nunchucks and launched a counterattack which saw the skins running back to the station.

Not every fight ended well though. Norman Jay again, remembering the August bank holiday weekend:

> We go to Atlantis, a big fight breaks out on the beach . . . But there weren't enough of us. And basically all the soul boys were Black, so that gave them even more ammunition, because you knew it was pretty right wing. We got run out of town, chased back to the station. We were back in London by about three o'clock in the afternoon. So we were like, 'Where shall we go?' Reluctantly, well there's nowhere else. Let's just go down to carnival.[17]

This was a decision that, as we shall see, amounted to jumping from frying pan into fire.

COMEDY

DEREK AND CLIVE

Comedy albums had long been popular with the public. Records by comedians like Bob Newhart or Peter Sellers had sold in vast quantities; pride of place in Joan Armatrading's record collection was given to a Tony Hancock collection. In the seventies the big hitters were the regularly released Monty Python albums. In the days before videos or DVDs these albums were pored over, revered and played again and again by schoolboys like me. Many of us learned the sketches by heart. That's why a whole generation still trots out lines from the 'Four Yorkshiremen' routine – *who'd have thought forty years ago . . .*

So it wasn't completely surprising that the underground hit album of the late summer should have been a comedy record. Though what was curious, if not positively unsettling, was that it should have been a record of such extreme filth, relentless nihilism and with scarcely anything resembling an actual joke. But such was *Derek and Clive (Live)*.

Derek and Clive were the gutter-mouthed alter egos of Dudley Moore and Peter Cook – the remarkably talented and much-loved comic duo whose success had moved from stage to TV to film across the sixties and early seventies. Derek and Clive were rather less lovable – 'a couple of erks who are just pissed off with the whole business,' as Dudley Moore described them to the *NME*.

The duo had improvised routines as these characters simply to amuse each other. And in the summer of 1973, while they were performing

a show called *Good Evening in New York*, they went into a recording studio and laid down an album's worth of wilfully offensive material. Chris Blackwell from Island Records had paid for the recording studio, but at the time it seemed far too extreme to be released to the public. Still Blackwell circulated tapes to selected friends and the material began to accrue a reputation. And before long there were bootleg tapes circulating widely.

In 1976 Blackwell decided to give the tapes an official release, with a deliberately primitive black-and-white sleeve intended to make it look like a bootleg. Word-of-mouth among teenage boys made it an immediate hit. My school was full of people relating particularly choice bits of material to each other. Most popular was the opening track, 'What's The Worst Job You've Ever Had', in which Derek and Clive, who are supposed to be toilet attendants, try to outdo each other with ever fouler imaginary occupations. The winner, by popular consent, was Peter Cook/Clive's claim to have had to retrieve the lobsters from Jayne Mansfield's bum.

That did have, at least, a certain surreal edge to it, but perhaps the definitive Derek and Clive routine is the one entitled 'This Bloke Came Up To Me'. Dudley/Derek starts off by talking about a bloke who comes up to him and calls him a cunt, to which he replies by calling the bloke a fucking cunt, and it escalates from there. Peter/Clive then takes it to the next level. He describes a bloke coming up to him at a Spurs match and saying 'hello', to which grievous provocation he responds by giving the bloke a kicking, culminating in the lines, 'so I bunged him hard in the ear with a left boot. And d'you know, he still had the audacity to come out with "eeeyuurrrr I'm dying".'

The humour here, unfortunately, had its roots in everyday life in Britain in the seventies. So well did it chime with the times that *Derek and Clive (Live)* ended up selling 100,000 copies. And if one of them

wasn't bought by Steve Jones of the Sex Pistols, he certainly must have heard it. For a few months later, when the Sex Pistols famously appeared on the Bill Grundy show and ended up in a televised swearing match, it was unmistakably Derek and Clive that Jones was channelling as he called Grundy 'a fucking rotter'.

PRETTY VACANT: THE INVENTION OF PUNK ROCK

At the start of the summer of '76 almost no one had heard of 'punk rock' or its leading proponents, the Sex Pistols. And yet by the end of the summer practically everyone with even the vaguest interest in rock music certainly had. Somehow this new movement had taken over British rock'n'roll without a shot being fired or a single record released. So just how did that happen?

The engine of this transformation of the landscape was surely the music press. At the time there were three weekly music papers focusing on rock'n'roll – the *New Musical Express* (*NME*), *Sounds* and *Melody Maker*. Their combined circulation was over half a million copies a week, which represented a really sizeable proportion of the young music-buying public. As a result they had an extraordinary level of influence. Especially as records themselves were expensive. An album cost over £3 (roughly £30 today), so you didn't just take a chance on buying one without at least reading a review first.

This was a time, after all, when radio and TV paid very little attention to the tastes of the millions of rock fans. BBC Radio 1 was the only station playing contemporary pop. But if you wanted to hear anything other than chart pop singles, the only options were the John Peel show late at night, and just a few other shows at the fringes of the schedule, on evenings and weekends. On TV, apart from the chart-tastic *Top of the Pops*, there was only *The Old Grey Whistle Test*, with its overarching fondness for 'serious' rock bands.

So the music papers were crucial gatekeepers of popular taste. They

Pretty Vacant: The Sex Pistols play to forty people in Manchester.

weren't all the same. *Melody Maker* was skewed towards older readers, with plenty of coverage of jazz and folk, plus lots of adverts for musical equipment. The *NME* was the market leader, with its stable of star writers, like Nick Kent and Charles Shaar Murray, who were doing their best to turn rock criticism into a hipster artform. Finally there was *Sounds*, which was newer and mostly following in the *NME*'s footsteps.

I read the *NME* and *Sounds* every week and sometimes *Melody Maker* as well. And I read nearly every word, including reviews of albums that I would never dream of listening to – names like Barclay James Harvest or Terje Rypdal come to mind – and interviews with anyone and everyone. *Sounds* and the *NME* conjured up a whole world that I and countless others longed to be part of, and I suppose I thought that the more I knew about this world, the more chance I had of being allowed to enter it on that blessed day when I finished school.

So when, in February 1976, there was a live review of a band I'd never heard of called the Sex Pistols, of course I read it. And like many others I was immediately intrigued. The strapline grabbed my attention – 'Don't Look over Your Shoulder, but the Sex Pistols are Coming' – and then I read with increasing enthusiasm about this band who were clearly intent on breaking all the rules. Their singer, Johnny Rotten, threw a chair at the stage. They had a song called 'Pretty Vacant'. And best of all, one of the band told the journalist that 'We're not into music, we're into chaos.'

To a thoroughly alienated 14-year-old this just sounded great, and I looked out eagerly for further news of these Sex Pistols. I didn't have to wait too long. At the beginning of May, they reappeared in the news pages of the *NME*, and it was clear that something was going on out there.

*

The *NME* photo in the first week of May 1976 was of a brawl in which the band appear to be fighting with the audience, led by Johnny Rotten himself. Below the photo was an account of the gig, in a West London pub called the Nashville Rooms, sent into the paper by a 21-year-old journalist called Neil Tennant, five years before he formed the Pet Shop Boys. He describes the Sex Pistols as 'three nice, clean, middle-class art students, and a real live dementoid, Johnny Rotten'. That's not quite correct, as the Sex Pistols – Johnny Rotten, Steve Jones, Glen Matlock and Paul Cook – were all working-class boys, just one of whom – Matlock – went to art school. But he's right about Rotten. Tennant goes on to say that the gig wasn't really catching fire. Rotten was looking bored, but then their fans came to the rescue:

> So how do the Pistols create their atmosphere when their music has failed? By beating up a member of the audience. How else? One of their coterie of fag hags picks a fight with the girl sitting next to her. The girl isn't interested but the fag hag succeeds in getting a reaction from her boyfriend. He ain't really an aggressive type but Ms Hag perseveres . . . and seven or eight of the band's chums leap over to the scene of the crime from all parts of the Nashville and proceed to beat the shit out of the bloke. Fists aren't the only weapons.[18]

After that, wrote Tennant, 'Johnny Rotten comes alive'. The 'fag hag' in question was none other than Vivienne Westwood. She was the partner of the Sex Pistols manager Malcolm McLaren. Their shop, Sex, sold the strange mixture of rubber fetish wear and outrageous T-shirts that were coming to be associated with this new scene. Westwood was the design talent in the partnership. She was also a natural provocateur as Simon Barker, one of the first of these scenesters, the so-called Bromley

Contingent, remembered: 'Every time she had to start a fight to prove she was there . . . She got so drunk and obnoxious, it was almost retarded behaviour.'[19]

But for all Johnny Rotten's dementoid energy, at this stage these Sex Pistols were still a dubious prospect for mainstream appeal. To London insiders they seemed to be basically a promotional tool for McLaren and Westwood's shop, more concerned with selling clothes than making records. They had a bunch of incredibly posey followers, most of whom were Bowie fans who were obsessed with the films *Cabaret* and *The Night Porter*. So were they any more than the next art school rave? Just like another new band called the Doctors of Madness, whose singer called himself Richard Strange? Most of the Sex Pistols gigs seemed to be in art schools and colleges, after all.

In fact there's a good argument that as far as punk and the Sex Pistols were concerned it really was the clothes that came first rather than the music. The fashion-forward soul boys had been among the first to notice that there was something new going on. Norman Jay was a Crackers regular who saw the new styles emerge: 'I first saw bondage trousers in Crackers before I saw them on the King's Road.'[20]

Likewise, Robert Elms remembers the moment he became aware of a new tribe taking their fashion lead from McLaren and Westwood's Sex shop:

I was on my own sitting in a tube train and a bunch of kids got on, a little bit older than me, probably eighteen, nineteen. In retrospect, it has to have been the Bromley Contingent, because there were girls in peephole bras, boys with their hair dyed pillbox red or gunmetal blue. Safety pins probably, and bin liners. There was kind of fetish gear. I remember sitting there slack-jawed thinking, 'Oh my god, this

is coming.' I almost got off and followed them because they were so exciting to look at.

He wasn't initially too interested in this nascent movement because the music itself didn't sound appealing. A friend invited him along to a very early Sex Pistols gig with the assurance that they were 'absolutely terrible but brilliant'. This failed to compute: 'We were soul boys, we were into musicality! We talked about keyboard solos, all that sort of stuff. I remember thinking I don't want to go and see a band who are terrible. Why would I want to do that?'

The jury was still out a week later, at the beginning of the first hot weekend of the summer, when they played at a disco called Babalu in Swiss Cottage, London. Among the sparse audience were the cultural commentator Ted Polhemus, who knew the band's manager Malcolm McLaren, and a young scenester called Dorothy Prior (aka Max). She recalled what it was like in her memoir of the time: 'Almost empty on this weekday evening with just a smattering of locals staring with hostile curiosity at the band and their entourage – a huddle of misfits dressed in an interesting assortment of leather jackets, PVC leggings, Sex T-shirts, berets and distressed looking beatnik jumpers.'[21]

She was surprised by how conventionally beat group-ish the band was, but thoroughly won over by Johnny Rotten himself, describing him as 'this terrible, terrifyingly wild singer who fixes us with a deadly stare. He can't sing in tune but his phrasing is perfect.'

At this point, though, there was a discernible change of approach. The Sex Pistols began to focus on honing their skills as a regular rock band, rather than just an art school sensation. In time-honoured fashion they headed off up north to play gigs in unpromising locations to

potentially hostile audiences and sharpen up their act. They played 28 gigs across the summer months, most of them to tiny audiences in such venues as Bishop Grosseteste College in Lincoln and the Penthouse in Scarborough, for £50 or so a night – 'weird gaffs full of Northerners with moustaches wearing flares [who] took an instant dislike to us', as the band's guitarist Steve Jones remembered[22].

In between these out-of-town gigs they also snared a weekly residency at the 100 Club on Oxford Street, whose manager, Ron Watts, had seen the potential in the band. And yet it's hard to know whether all this would have made the Sex Pistols any more than another Doctors of Madness, if it hadn't been for the music press and its enthusiastic promotion of what they were now starting to call 'punk rock'.

As of early 1976, punk rock was a niche term known only to music journalists and record shop aficionados, and it referred to the primitive rock'n'roll made by teenage bands from the USA in the mid-sixties, also known as garage rock. The music had been codified by a New York writer and record shop guy called Lenny Kaye who'd put together a compilation called *Nuggets* featuring many prime examples of the genre, like 'Psychotic Reaction' by Count Five and 'Dirty Water' by the Standells.

Lately the term was starting to be applied to the new crop of New York bands who were taking rock back to its sixties basics, prioritising melody and attitude over musical sophistication. It was a label that seemed forced when applied to the artier of these combos, acts like Television, Talking Heads or the Patti Smith Group (which featured that same Lenny Kaye on guitar), but seemed absolutely right when applied to the band whose first album came out at the beginning of the summer: the Ramones.

The Ramones' self-titled first album didn't make much impression in

the US, outside of New York, but in the UK it was an immediate critical hit. Even before it was officially released in Britain, the *NME*'s Nick Kent gave it a long review. This was written in peak seventies rock critic style, full of a hipster shorthand that you either understood or, if you were a newcomer to this world like me, really wanted to understand. Thus he refers to 'early Stooges retard bop' and 'disco-death-rot music', bemoans the state of Heavy Metal and the Rolling Stones' obsession with achieving 'blacknuss', before concluding that 'We need the likes of the Ramones to reacquaint us loser white kids with our roots more than ever. The Ramones don't say much. They're pretty vacant. But they rock out with a vengeance.'[23]

This was just what the people who'd read about the Sex Pistols wanted to hear. Those really in the know could smirk to themselves as they read the words 'they're pretty vacant', spotting the Pistols reference. These Ramones sounded perfect. It was just a shame that their album wasn't released in the UK yet. So how could anyone get to hear it? That problem was soon solved. John Peel was lent a copy by a guy in a Virgin Records shop, and quickly realised that this was a record that would change everything. He played a track on his show that night, and many more across the month of May. His audience was split: the older musos mostly hated it, the younger listeners responded immediately to these two-minute bursts of manic cartoonish rock'n'roll energy. The tunes were great and – crucially – easy to play, with nice simple chords. The only difficult bit was keeping up the breakneck speed.

Come early June, most young people who were seriously interested in music were aware of the Sex Pistols' existence and had heard the Ramones on John Peel. Punk rock, as we would come to know it, now had its two key building blocks. There was the musical template laid down by the Ramones, coupled with the obnoxious attitude that people

had gleaned from the Sex Pistols coverage in the press. And, of course, the clothes from the King's Road.

Yet there was still a sense that this was all a fleeting fad that could blow over in no time. One band from New York playing the 'Blitzkrieg Bop', one band from London gigging around the clubs. Punk rock was still a lot of foot soldiers short of a movement.

This would soon change across these blazing summer months. There were plenty of Sex Pistols shows around the country that inspired a band or two, here and there, but their two Manchester shows provided the clearest evidence that beneath the nation's sun blasted savannahs, something was stirring.

The two Manchester shows, both at the Lesser Free Trade Hall, were promoted by two Bolton students, Howard Devoto and Pete Shelley. They had come down to London to see the Sex Pistols earlier in the year, based on nothing more than reading that first *NME* review. Howard Devoto explained how that came about: 'We're not into music, we're into chaos – there was that line in there . . . it clicked with me and it just so happened I could borrow a car that weekend . . . It was the weekend that changed our lives.'[24]

After seeing two Sex Pistols shows that weekend, they were completely converted to the cause, and immediately decided to form a band. They'd bought a copy of the London listings magazine *Time Out*, which featured the article about *Rock Follies*, the one with the headline 'It's a buzz, cock!', and that provided them with the name for their putative band – Buzzcocks. They made contact with Malcolm McLaren and promised to organise a Manchester show for the Sex Pistols, with Buzzcocks as the support band.

The show took place on 4 June. As it happened, Buzzcocks weren't

ready to perform in time – still lacking a bass player and drummer – so the actual support was a hard rock covers band called Solstice, chosen because Devoto used to work with one of them. Interval music was provided by Devoto's own import copy of the Ramones album.

Thirty or forty people turned up, all drawn in by the music press coverage of the Sex Pistols. It was a small crowd but, as it turned out, an influential one. Among the lucky few were the future Joy Division musicians Bernard Sumner and Peter Hook ('when it finished we just looked at each other and said we want to be in a group'), the writer Paul Morley and the broadcaster Tony Wilson. Standing at the back with a notebook was a studious teenager called Steven Morrissey, some years away from forming The Smiths.

Steven Morrissey's name was already quite well known to those of us who read the music press religiously. The letters pages of all the papers were lively forums for those outside the magic circle to make their opinions known. And one of the most regular correspondents was this Steven Morrissey of Kings Road, Stretford, Manchester. He had an obsession with the New York Dolls and was forever writing in to complain that such and such a band wasn't a patch on the Dolls.

Morrissey evidently adopted a scattershot approach, sending out lots of letters and seeing what made it through to the actual paper. After the Sex Pistols gig he sent letters to both *Sounds* and *NME* with his thoughts about these latest contenders, and both papers printed his thoughts. The *NME* letter is particularly entertaining, not least for its fantastically Adrian Mole-like opening line: 'I pen this epistle after witnessing the infamous Sex Pistols "in concert" at the Manchester Lesser Free Trade Hall.' He conceded that Johnny Rotten deserved to be mentioned in the same breath as Dolls' frontman David Johansen, before concluding with the zinger, 'I'd love to see the Pistols make it.

Maybe they'll be able to afford some clothes that don't look like they've been slept in.'

The next step up from making your opinions known by writing into the music press, was to print your own magazine. This was something one of the other attendees, Paul Welsh, had been doing for a little while. He had produced a cheaply printed rock fanzine called *Penetration* (after an Iggy and the Stooges song) for a couple of years. Until now it had covered prog and pub rock bands mostly, but issue number eight had a report on the Sex Pistols show.

A copy or two of the fanzine must have made it down to London, as it helped inspire a bank clerk called Mark Perry to start a fanzine of his own, after seeing the Ramones' first British gig in July. It would be the first British fanzine explicitly devoted to 'punk rock', and took its name, *Sniffin' Glue*, from a Ramones song. And so the house magazine of punk's brief heyday was born. The first couple of issues were primitive photocopies that only sold in tiny numbers. The writers had plenty of attitude – what they lacked was anything much to write about. The punk movement was up and running, but the Sex Pistols were still its only British representatives.

That would change in a matter of weeks. Two brand-new 'punk' bands would support the Sex Pistols at the beginning of July, both having roots in the Sex Pistols' circle. Malcolm McLaren had a long-time friend and associate called Bernie Rhodes. When Malcolm started managing the Sex Pistols, Bernie decided to find a group of his own. This was the unfortunately named London SS. London SS never came to anything: they never played a gig and couldn't settle on a line-up. However, several of its members would go on to appear in leading punk bands. First out of the traps was the guitarist Mick Jones. Formerly a wannabe Rolling Stone, he cut his hair and put together a new band featuring bass player Paul Simonon, lead guitarist Keith Levine and a

singer called Joe Strummer, who they pinched from the pub rock band the 101ers.

The new band arranged to play their first gig supporting the Sex Pistols on 4 July in Sheffield. On the original poster they were billed as the Weak Heartdrops, but at the last minute they changed their name to the Clash. They drove up to Sheffield in a van on one of the very hottest days of the entire summer, as Paul Simonon remembered: 'It was the first time I ever played on stage. The night before it felt frightening but once we were on the way I began larking about. I tied one of Keith's shoes to a piece of string and hung it out of the back of the van. The door had to be open anyway so we could breathe.'[25]

Two days later the Sex Pistols were back at the 100 Club in London, and this time their support band featured another London SS member named Brian James. This new band were called the Damned.

Between the Clash and the Damned, it was already possible to see the different shapes punk bands would take. The Damned were all about frantic energy and good times. The Clash were more 'serious' with lyrics that addressed social issues: police harassment, joblessness etc.

So far so good, but these new bands were still drawn from a small pool of interconnected Londoners. This emergent punk rock needed to show that it was more than just a fashionable London phenomenon.

That opportunity came on 20 July when the Sex Pistols headed back up the M1 and M6 motorways to Manchester and the Lesser Free Trade Hall. Howard Devoto and Pete Shelley organised the show again and this time their band, Buzzcocks, were ready to be the support act. To

round out the bill they brought in a popular local band whose high-energy approach sounded as if it might be compatible. They were called Slaughter and the Dogs.

All the signs were there that something was happening. Just six baking hot weeks after they first played to 40 people, the Sex Pistols returned to an audience of at least three times as many. And as with the debuts of the Clash and the Damned, the support acts were a study in contrasts. Buzzcocks were chaotic but arty and ambitious, big on irony. Slaughter and the Dogs, teenage glam rock scallies from working-class Wythenshawe, were essentially the group the Sex Pistols might have been if they'd had a regular rock'n'roll frontman, and not Johnny Rotten.

The punk taste-makers embraced Buzzcocks ('I was knocked out that there was another band on the same lines as us' said Glen Matlock) but saw Slaughter and the Dogs, with their longer hair and glam affectation as inauthentic and naff. They were probably the first band to be accused of being punk bandwagon jumpers. Which proved at least that there was now a bandwagon to be jumping on.

When the Sex Pistols played, the violence of the music swiftly provoked actual violence in the crowd. A bunch of Londoners had come up to see the band and clashed with the Manchester lot. Then, within the Manchester contingent, there was fighting between the Wythenshawe mob and the rest. There was even a fight between members of Buzzcocks and Slaughter and the Dogs. Bottles were thrown and things threatened to get seriously nasty. As Howard Bates from Slaughter put it, 'It wasn't a kid's party atmosphere, that's for sure.'

Nevertheless, most of those who attended came away thoroughly impressed by the Sex Pistols. Their hard-working summer of gigging was paying off. They were much tighter musically and they were writing new songs. One of those was premiered at

the Manchester gig – 'Anarchy In The UK'. It was the sound of oncoming change.

Following the show, Tony Wilson, then a local TV broadcaster, booked the Pistols to appear on his new TV show, *So It Goes*. And, in retrospect, he thought the Lesser Free Trade Hall shows made a profound impact on Manchester: 'It was a fulcrum moment which transformed us from being an ordinary British city with a couple of good bands every few years, to being this battery farm for geniuses.' Peter Hook concurred: 'It certainly changed my life. It made me think in a completely different way.'

As this long summer of riot and resistance wore on, this nascent punk movement became increasingly identified with violence. There was the football terrace-like trouble in Manchester and then there was the incident at another 100 Club show in London. Nick Kent was there. By his account he was sitting at a table when, as the Pistols started playing, one of their entourage, a tall spiky haired lad known as Sid, deliberately stood in front of him. Kent related what happened next in the *NME*:

> That night he looked positively scary, as if he'd partaken in a gargantuan quantity of amphetamines just prior to his arrival . . . Asking him to move aside is what did it. A couple of insults, and before I had time to think, he'd whipped out this ugly-looking rusty bike chain and was brandishing it, bouncing up and down, his teeth gritted and eyes almost literally bursting out of their sockets.[26]

Kent and a mate started to remonstrate when a second Pistols associate, known as Wobble, hoved to for a bit before disappearing. Sid

moved away too but not before lashing Kent across the head with his bike chain.

Kent left the gig immediately, blood pouring from the wound on his head (though thankfully he wasn't seriously hurt). His assailant now had a new surname to go with his nickname – arise Sid Vicious. As for his mate, this was a man called John Wardle, better known as Jah Wobble. As is common with altercations like this, he remembers things a little differently:

> Nick Kent, and I think one or two others, was standing behind me and Sid at the concert. It was a pretty full room but lots of space around the sides where we were, so no need to push anyone for a better view. Anyway they started hassling Sid, pushing him in the back and sort of invading his space a bit – not an uncommon thing to happen at a punk concert to be fair, but unnecessary. They seemed quite old to be behaving the way they were.
>
> It suddenly escalated and Sid swung a bike chain at them. I got in between and grabbed one of them, Nick Kent I think, by the scruff of the neck, and told him and his mates to fuck off, or they would be dealing with me. As I recall they moved away, possibly from the club let alone from that area of it.

Looking back at those days more generally, Wobble told me that it was a remarkably violent time, as he echoes Derek and Clive:

> When I look back, I'm shocked at the amount of violence. You had that kind of weird thing in the seventies, a casual attitude towards violence. I remember fellers I used to go to Tottenham with. They reminded me of *Clockwork Orange* – it was casual violence, recreational violence. Anyone who wasn't a football hooligan they called a 'social'. If there

311

was a fight in a pub and some 'social' gets knocked out and falls across a table, that was seen as a jolly good wheeze.

He's keen, though, to stress that he was never the instigator of any trouble:

> I wasn't looking for it, you literally couldn't avoid it . . . I didn't like it because it just means you're in fight or flight mode. People think I'm a tough guy. I don't fucking want to fight. If I had a fight with someone now I could break a knuckle, going to hurt me fingers . . . It's just horrible.

This laudable sentiment is somewhat undermined by another of Wobble's memories of the hot summer nights of '76, when he would stay up for days on end, fuelled by amphetamines:

> There was a place in Maida Vale. I remember me and my friend Dave Crowe dangling John Grey [another friend and, like Wobble, one of the so called 'Four Johns' – the other two being John Lydon and John Beverley aka Sid Vicious] out of the window there, tied with wire flex from a phone. And I remember him really impressing me with his bravery, because he at no point begged for his life. Or did anything except keep insulting us!

Drugs were a significant ingredient in the punk rock mix. The conventional summary is that hippies smoked dope while punks took speed (amphetamines). It's a gross simplification of course, plenty of punks smoked dope and some hippies took speed. But it's fair to say that 22-minute prog rock suites worked better with dope, while 1 minute 45-second blasts of the Ramones certainly went well with the rush of amphetamines.

Amphetamines had been popular in the sixties, when they were widely prescribed by chemists in pill form. That access tightened up considerably by the end of the decade, and in 1971 amphetamines were moved from being rated as class 3 to class 2 drugs, with much more serious penalties for dealing or possession. Nevertheless people soon discovered that amphetamine sulphate was an easy drug for a home chemist to manufacture, and it started to circulate widely in powder form.

The Northern Soul scene, where dancers kept going all night, was heavily fuelled by amphetamines. Bikers and pub rockers were likewise partial to its use. The leading pub rock band, Dr Feelgood, were a notably speed-driven combo. And the punks carried on the tradition enthusiastically.

For all the violence and macho posing of some of the bands it's notable that it was not only straight young men who were attracted to punk. The Bromley Contingent were largely gay, as was Pete Shelley of Buzzcocks. Tom Robinson had clearly seen the liberating potential of punk. That went for women too. Marion Fudger of *Spare Rib* had been playing in a squatland band called the Derelicts, gigging alongside Joe Strummer's 101ers (and at one point Strummer asked her to join his band), when punk came along and she was immediately struck by it: 'For women it was really important, because suddenly your inhibitions about performing, about not being the best, just didn't matter any more. It was very imaginative and exciting and all sorts of creative people jumped in.' Fudger herself would soon join early punk combo the Art Attacks.

The final Sex Pistols show of the summer was on the August bank holiday at the Screen on the Green cinema in Islington. Support acts were Buzzcocks and the Clash. It was a late-night gig on the Sunday

night of that bank holiday weekend that would mark the end of the scorching summer.

The *NME* sent their other star writer, Charles Shaar Murray, to cover the gig. He started his review with a pertinent quote from Alex Harvey from three years earlier – 'Someone's got to come along and say to all of us, "All your ideas about rock and roll . . . are a load of wank." Someone's got to come along and say, "Fuck you".'

So were these Sex Pistols the iconoclasts who were going to do just that? Murray was determined to find out. He observed the crowd first, correctly identifying them as largely the kind of kids he used to see all dressed up at Bowie gigs. Among them is 'a chick in SM drag with *tits out*'. This was Siouxsie, soon to be the female face of punk rock. And unsurprisingly the main illustration for the piece is a photo of her in defiant fetish wear.

Murray missed Buzzcocks, which was probably lucky for them as he dismissed the Clash as 'The sort of garage band who should be speedily returned to the garage, preferably with the motor running.'

The Sex Pistols, though, completely won him over: 'They play loud, clean and tight . . . and watching them gives that same clenched-gut feeling that you get walking through Shepherds Bush just after the pubs shut and you see The Lads hanging out on the corner.'

The Sex Pistols, he concluded, were exactly the band that the critics had claimed to be longing for. And if that came with a side order of violence and chaos, well what did they expect?

Ultimately if the whole concept of punk means anything it means Nasty Kids and if punk rock means anything it means music of, by and for Nasty Kids. So when a group of real live Nasty Kids come along playing Nasty Kids music and actually behaving like Nasty Kids, it is no bleeding good at all for those who have been loudly thirsting for

someone to come along and blow them old farts away to throw up their hands in prissy-ass horror.[27]

Finally, on this last weekend of the long hot summer, he signs off with 'Believe it: this ain't the summer of love.'

Robert Elms came to the same conclusion:

As that summer went on and on and on and it got hotter and hotter and hotter, you did get that sense of something. This is going to break, there's gonna be something . . . There was a moment there in '76, for almost anyone who was 17, when you had to decide what side you were on. A lot of the soul boys, that early generation of soul boys, quite a few of them became punks. But quite a few of them didn't and I think they retreated to the shires. They went out to Essex, carried on with the whole jazz-funk thing.

I think it was an absolutely pivotal moment. I think that summer was like, you know how when you heat things up chemical reactions happen faster? That's what was happening out on the streets that summer. It was almost as if this new vision of England was being formed out of this cauldron.

MUSIC

ROCK AGAINST RACISM

The sense of dissatisfaction that permeated most aspects of British life in 1976 even made it to the elite rock star level. Come the summer, two of the biggest British names – David Bowie and Eric Clapton – both made it into the news by first complaining about the state of modern Britain, and then suggesting that the solution might be fascism of one sort or another.

The Bowie story had come right at the beginning of the summer, when he arrived back in Britain for a series of shows. He took a chartered train from Dover to Victoria Station on 2 May – the first time he'd been back in London for two years. He'd been holed up in Berlin lately, which appeared to have given him ideas: When he got off the train and walked into an open-top Mercedes that had been allowed to pull up next to the platform, there were two thousand fans waiting to greet him. He was all in black, with slicked-back platinum-blond hair – absolutely inhabiting his Thin White Duke persona. He waved at the crowd, though the picture in the *NME* had been tweaked to make his wave look suspiciously like a Sieg Heil. The magazine ran with that idea, captioning the photo with a quote Bowie had recently given a Swedish journalist: 'As I see it, I am the only alternative for the premier in England. I believe Britain could benefit from a fascist leader. After all, fascism is really nationalism.' Chuck in the fact that he had had a load of Nazi memorabilia confiscated a few months earlier, when he took a train journey into Russia, and people

could have been forgiven for thinking that the Thin White Duke had become an actual Nazi.

Thankfully, in Bowie's case, that was both the beginning and the end of his flirtation with the far right. He was no sort of racist and the kind of fascism he momentarily espoused was the kind that comes from doing too much Nietzsche and cocaine in tandem. Cocaine is a drug justly notorious for promoting delusions of grandeur.

The Eric Clapton affair was far more troubling and had much wider implications. There was no need for a doctored photo to make a point this time.

On 5 August Eric Clapton and his band played a show at the Odeon, Birmingham. At the time Clapton still had considerable status. He was rated – by his fans at least – as the finest living rock guitar player, dating back to his time in John Mayall's Bluesbreakers – and he'd had a succession of solo hits in the seventies, from 'Layla' to a Bob Marley cover version, 'I Shot The Sheriff'.

The Birmingham show was the sixth date of his tour of drought-ridden Britain, and there were already signs that something was amiss. A few days earlier he'd played a big open-air show at London's Crystal Palace Bowl. The review in the *NME* noted that Clapton was chain-smoking fags and chain-drinking cans of Carlsberg Special Brew super strength lager. At one point he asked the crowd if they were enjoying it as, 'I'm boring myself silly.'

Come show time in Birmingham, Clapton was already extremely drunk. The venue was packed and stiflingly hot. The band did their best to cover for him: The second guitar player, George Terry, took care of the solos. As for the vocals, they were lucky enough to have Clapton's friend Van Morrison come on to do a couple of numbers, and his backing singers both took turns. The Hawaiian American Yvonne Elliman sang lead on 'Can't Find My Way Home', with its all

too appropriate lyric, 'I'm wasted and I can't find my way home,' while Marcy Levy sang 'Innocent Times'.

There were two reviews in the press. The *Birmingham Evening Mail*'s Sandy Coutts seemed quite happy with the show. 'Midlands fans of Eric Clapton really got value for their money last night,' Coutts wrote, though most of the praise was reserved for the band and Van Morrison, rather than Clapton himself.

It was the other review that caused uproar. This was from Niall Cluley in *Sounds* and it began like this:

> Right from the start it was obvious it was going to be one of those nights. He shambled on with his head covered by some strange object, struggled to free himself and then began warning us all about 'foreigners' and telling us of last night's aggro and the need to vote for Enoch Powell whom Eric then described as a prophet.[28]

This was frankly extraordinary. Here was a man, Eric Clapton, who had based his entire career on his interpretations of Black music, telling his audience that Enoch Powell was right. This in a theatre just a few miles from where, eight years earlier, Powell had made his Rivers of Blood speech, in which he had described post-war immigration as an apocalyptic disaster. Since then, 'Enoch was right' had become the catchphrase of every racist up and down the land.

One of those in the audience that night was Caryl Phillips, then a teenager but soon to become one of the first black Britons to make their name as a novelist. Years later he remembered his reaction:

> When he started talking about Enoch Powell, and how 'Enoch was right', I felt embarrassed, and I could tell that my best friend felt embarrassed, and we couldn't really talk about it. But the thing that

made it really awful, aside from the actual racism of the comments, aside from the hostility that he was giving out, the venom from the stage, was that he would play a couple of songs and I'd think, 'Oh thank God, it's gone away now, it's not going to come back, we've dealt with it,' and then he would start up again . . .[29]

Perhaps the only people in the building who didn't understand the significance of Clapton's remarks were his fellow band members. Marcy Levy was then a backing singer and was soon to be the writer of one of Clapton's biggest hits, 'Lay Down Sally'. A decade later she would achieve stardom in her own right as half of Shakespears Sister, under her new stage name Marcella Detroit (for her home city). She told me how she remembered the evening:

We were on tour doing a gig, as usual, and suddenly Eric started talking about Enoch Powell in the middle of the show. The band were all Americans and I, personally, had no idea who Enoch Powell was or what his political views were; I didn't know much about British politics at the time except for some basics I was taught in school.

I remember looking around and listening, feeling a bit nonplussed, and after discerning what he was actually saying I felt very concerned and quite surprised by the content of this rant. It came out of left field, especially knowing Eric and having been working with him for two years by that time. And especially considering how much black music had influenced Eric. But in those days, you know, even Eric said (and I was witness to it) he would drink a half a bottle of brandy by lunchtime, and all the rest that went with touring life. I'm not defending it, it was a shock to all of us, and in no way shape or form have I ever subscribed to that way of thinking.

The rest of it is a bit blurry, as to what followed. We (the band) just kept to ourselves until things cooled down as we had no real understanding of what had happened or why, nor was it explained to us. Quite baffling.

At another time that might have been the end of the matter, but the music press in 1976 had a huge readership who scoured it eagerly for news. The brief live review in *Sounds* did not pass unnoticed at all. One of those who read it was a freelance photographer and activist called Red Saunders. He wrote a letter of protest to send to the music papers and got a number of fellow lefties to co-sign it. It began like this:

> When I read about Eric Clapton's Birmingham concert when he urged support for Enoch Powell I nearly puked. What's going on Eric? You've got a touch of brain damage . . . You've got to fight the racist poison.[30]

The letter went on to make a modest proposal:

> We want to organise a rank-and-file movement against the racist poison in rock music. We urge support. All of those interested please write to Rock Against Racism, Box M, 8 Cottons Gardens, London E2.

In that moment, a movement was born and hundreds of people wrote in to give their support. A first Rock Against Racism show, featuring a mix of black and white pub rockers, plus the reggae band Matumbi, took place in December. The following year the movement picked up support from the incoming tide of punk rockers, culminating in a couple of huge London shows where hundreds of thousands showed up to take a stand against the 'racist poison'.

As for Eric Clapton, his booze-stricken brain did take in that people

were upset. But the handwritten letter he sent into *Sounds* a month later did little to suggest that he understood their concerns:

> Dear Everybody. I openly apologise to all the foreigners in Brum . . . it's just that (as usual) I'd had a few before I went on, and one foreigner pinched my missus' bum and I proceeded to lose my bottle, well you know the rest, I'm off up the pub, and I don't live in America, and I think I think that Enoch is the only politician mad enough to run this country . . . yours eccentrically E C.[31]

There could hardly have been clearer evidence that British youth needed new and better heroes.

FILMS

Thank God for the rain which has helped wash away the
garbage and trash off the sidewalks

Taxi Driver

The one important film to be released in the UK in the summer of '76 came
at its very end. Martin Scorsese's *Taxi Driver* began with a downpour
washing the streets of New York City. It hit the cinemas in the last week
of August, and within days much of Britain was similarly awash.

Taxi Driver arrived in Britain trailing hype – it had been a big
box-office hit in the US and won the grand prize at the Cannes Film
Festival. But rarely has there been a bleaker hit movie. Robert De Niro
was extraordinary as Travis Bickle, a Vietnam veteran who drives a
taxi at night, in a vain attempt to get his insomnia under control. What
he sees around him horrifies and fascinates him: the commercial sex
and drugs, the hot neon sleaziness of everything. His obsession with
a 12-year-old prostitute called Iris (played with startling insouciance
by the 12-year-old Jodie Foster) leads to him re-inventing himself as
an avenging angel determined to clean up the streets. He's a very New
York angel: armed to the teeth, dressed in combat clothes, and his
head shaved into a Mohican – a haircut that looked freakish then but
would soon be adopted by the punks. A bloodbath follows.

An extraordinarily powerful and unsettling film, *Taxi Driver* dealt
with many of the same issues that arose in Britain over the summer of

'76 but, to borrow a phrase from Tom Hutchinson's review of the film, *as seen through a wing-mirror, darkly.*

There's the same sense of a society that needs, more than it knows, to change. There's plenty of racial tension – at one point Bickle is chased out of Harlem by angry youths. As for his street-cleaning mission, it was already being echoed, hideously, by Peter Sutcliffe's murderous attempt to remove the prostitutes from the streets of Yorkshire. There's even a solitary, bitterly ironic, mention of feminism. When Bickle tells Iris he wants to take her off the street, she says, 'Did you ever hear of women's lib?'

There were more glancing connections too. A politician claims that we are 'at a crossroads in history' – a phrase also beloved of the new Tory leader, Margaret Thatcher. Elsewhere Bickle's repeated line, 'You talkin' to me?' echoed Derek and Clive's reflex aggression. And the disturbing screen presence Jodie Foster was barely a year younger than the Olympics' great star Nadia Comăneci.

Travis Bickle, the taxi driver, offered an awful resonance to the viewers. He's a man who can't cope with either himself or the world he sees around him. The film handed over Travis's burden of impotent fear and disgust, and left the viewers to deal with it as best they could.

Everyone I knew went to see *Taxi Driver*, often multiple times. It was a film that perfectly caught the nihilistic mood of the nascent punk generation. More than that it was a film that showed us that we were, across the Western world, at a crossroads in history.

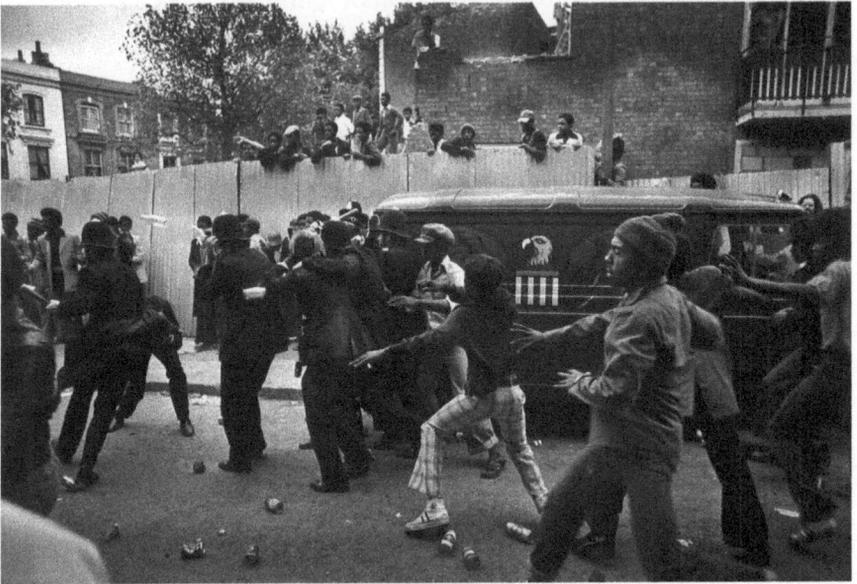

There's a riot going on: full-scale battle in Ladbroke Grove.

POLICE AND THIEVES IN THE STREET: NOTTING HILL CARNIVAL

You've reached the last day of summer, the August bank holiday Monday. As you're walking into Notting Hill you look up and see it's chary, uneasy weather, grey and overcast, you can sense it's finally on the turn. But then you're in the middle of the Carnival and it generates its own weather and it's hot hot hot.

This is the second day of the Carnival and it feels like the whole world is here. There are more Black people than have ever gathered together before in the UK, well over a hundred thousand, come from all over London and all over Britain. The streets around Portobello market are absolutely jammed up with people and the noise is unbelievable. It seems like every other house has speakers blaring out reggae, soul, funk. And then a float comes down the road towards you and there's people dancing in front of it and somehow a path clears itself and you can see and hear there's a band playing soca on the truck, up-tempo funky calypso, and there's women and men dancing, dressed up in the most incredible costumes, like a shimmer of giant hummingbirds coming your way.

You take a turn off the main road and it's just a little bit quieter on Kensington Park Road. There's a new record shop there, a place called Rough Trade that sells reggae records but also these new punk records and fanzines. They've got a sound system set up outside, The Mighty Observer, and it could be the loudest one yet, the bass is like nothing you've ever heard, feels like an earthquake beneath your feet.

Back up on Portobello and under the Westway, there's a stage set up but no one is performing right now, just more sound systems and it seems like all of them are playing the same song, 'Police and Thieves', the new hit from Jamaica, with a guy singing in a high, girlish voice about fighting with the cops, over a beat that could cleave mountains, it's so hard and swinging.

Along with the sounds is an incredible smellscape here, there's beer and sweat and a thousand home-made barbecues grilling corn and chicken and lamb and God knows what else, and over everything the sweet and pungent scent of sensemilla. There must be more dope being smoked in this London postcode in this afternoon than in all its history. And the crowd is getting tighter and tighter and people are jostling for space and the mood is still cheerful, but with more and more of an edge as the day wears on.

The police are out in force, cutting off the routes you can take, so you're all jammed in closer and closer and in among the crowd there's some, and it only needs some, who see easy pickings, a smorgasbord of valuables to steal, handbags and cameras and wallets to snatch and there are so many people pushing up against you now that how can you say who's the one that lifted your purse? And yes, it is most probably the white people who are getting robbed the most, because they are the ones who've turned up with their cameras, like they're going to the zoo, some of them anyway. But there's other white people here too, the hippies who've been living in the Grove as long as anyone, and these new kids they're calling punk rockers who don't look like they have anything worth stealing anyway.

And now it's just gone four in the afternoon and the police are moving in past the Westway, going after some kid who may be carrying something that isn't his. But the crowd around him aren't going to give

way. They're not letting the Babylon police come and arrest any one of them, and right now you know, you just know, it's all going to blow.

The Notting Hill Carnival was ten years old when it made the headlines for the first time at the very end of the summer of '76. Notting Hill, an area full of elegant Georgian and Victorian townhouses, had fallen into disrepair post-war, and become the province of slum landlords like Peter Rachman and Julian De Lisle, who rented out properties to the post-Windrush generation of Caribbean immigrants. In 1958 there had been rioting incited by white racists, but since then it had developed into a largely harmonious, if poor, multiracial neighbourhood – the rebellious stronghold of the new Black Britons, but also the heart of radical white hippie London.

The Carnival was a pure product of this lively, fractious melting pot. It had begun in 1966 with a local community activist called Rhaune Laslett, the kind of extraordinary character that the mayhem of the mid-twentieth century was good at producing. Born in the Jewish East End in 1919, her father Abraham was involved in the St Georges Jewish Settlement, a pioneering project that was part youth club, part community education service. By 1957 Rhaune was married and divorced and running a home for Hungarian refugee children in Essex.

Three years later found her in Ramsgate, Kent, running an unofficial hostel for unmarried mothers, many of whom had been cast out for having mixed-race children whose fathers were Black American GIs. This appears to have been a good-hearted but chaotically run organisation, perhaps like those run by Erin Pizzey or Camila Batmanghelidjh in later years, while Laslett herself seems to have been a curious mix of much-loved matriarch and wild fabulist, prone to

claiming to be a Native American, or to have been a prisoner of the Japanese during the war. Certainly there were financial irregularities, and she ended up being taken to court and sentenced to nine months in prison, following which she moved to Notting Hill.

There she set up a popular playgroup, catering to children of all the area's many communities. Now in her mid-forties, she nevertheless threw herself into the life of Notting Hill, making relationships with the West Indian community and with the new breed of young hippies who had started to move into the area. When some of these hippies, led by the photographer John 'Hoppy' Hopkins, started the London Free School, offering free alternative education classes, Mrs Laslett, as she was universally known, was quick to get involved. Through the Free School she met the maverick Trinidadian radical and conman Michael X, who took to her immediately: 'Her home is always full,' he wrote in his autobiography – 'sometimes as many as fifty kids playing there. There's nowhere else to go and she takes them all in. It's hard work but she revels in it . . . She's so sweet that I, whom the press say is a white-hater, go to her home at least twice weekly to get a glimpse of beauty.'[32] It was Michael X who persuaded his then friend Muhammad Ali to visit Mrs Laslett's playgroup when he was in London in May 1966, to fight Henry Cooper.

But it was Mrs Laslett herself who had the idea of holding a carnival in Notting Hill. Decades later she told the local paper that the idea came to her in a vision after she'd been dealing with some housing problems: 'We should take to the streets in song and dance, to ventilate all the pent-up frustrations.' Her fellow London Free School activists enthusiastically took up the idea and announced the new initiative in their newsletter. Mrs Laslett is quoted as saying that, 'We feel that although West Indians, Africans, Irish and many other nationalities all live in a very congested area, there is very little communication

between us.' The Carnival would be a chance for them all to come together.

Rhaune Laslett's dream was not of a specifically West Indian Carnival, but of a week-long celebration that would involve all the different communities of the area. Among the planned entertainments were acts as startlingly diverse as the London Irish Girl Pipers, led by Agnes O'Connell, Ginger Johnson's Afro-Cuban band, and Russell Henderson's jazz band, not to mention a Dickens and Drama Night, a Poetry and Choir night and a contribution from the Polish YMCA. Billed as the 'Notting Hill Fayre', it started on Michaelmas Sunday, 18 September 1966, with a pageant and procession.

It was this procession that lived up to the Free School's promise that 'much of the activity will be spontaneous'. Originally envisioned as a chance for the local children to parade around in their fancy-dress outfits – the involvement of local Trinidadian musicians, including Sterling Betancourt and Russell Henderson, turned it into something rather different, as Betancourt remembered:

Mrs Laslett asked Russell if we could come and play. She was having a carnival but it was a children's carnival, it wasn't a big thing. So everybody went down to Ladbroke Grove and we started to play. There were lots of children with donkey carts, false moustaches and an African drummer by the name of Ginger Johnson with drums made from an elephant's foot. While we were standing there, Russell said 'Let's all take a walk', we call it a road march, and we decided to move off. The crowd got bigger and we got crowds of people coming in with lots of different things – pots and pans, it was just like beginning of carnival in Trinidad. We passed the church and it had just finished and this woman came up with her purse and she just jumped in the band and started to dance with her purse. Some people didn't know what

it was, they thought it was a demonstration, they said: 'What are you demonstrating about? Why don't you go back to your own country?' They didn't know it was just a carnival, that we were just having fun.[33]

And so the tradition began. Mrs Laslett continued to preside over the Carnival for the next few years. A boundlessly energetic woman, she expanded her operations to include running the Notting Hill Neighbourhood Service, offering housing advice and help to locals, and building an adventure playground, nicknamed Shanty Town, out of disused gardens in Westbourne Park.

The following year, 1967, the parade was firmly at the centre of proceedings, and the local paper reported that over a thousand people were there to follow the steel band through the streets, along with an assortment of floats, including one from the adventure playground, and another from Queens Park Rangers football club. Again there was a week-long programme of festival events, including a folk night with Ram John Holder and John Martyn, and a performance of *Shakespeare In Harlem* from the Jamaican actor Keefe West. The programme notes offered this mission statement from Mrs Laslett: 'The peoples of North Kensington, regardless of race, colour and creed, have a common problem: bad housing conditions, extortionate rents and overcrowding. Therefore in this misery, people become one.'

Over the next couple of years the Carnival changed focus to become the familiar two-day event, taking place over the Sunday and Monday of the August bank holiday weekend. More steel bands got involved and the processions attracted much bigger crowds, but the evening concerts still mixed hippie combos, like local anarchists the Deviants and folk-rock pioneers Trees, alongside the steel bands and Calypsonians.

Come 1970 though and Mrs Laslett announced at the last minute that she was cancelling Carnival after the mini-riot that had broken

out just north of Notting Hill following a Black Power demonstration in support of the Mangrove restaurant. The Mangrove was a black community hub that was facing continual police harassment, and the arrests that followed the confrontation between demonstrators and police would lead to the celebrated Mangrove Nine trial, which laid bare just how alienated young Black people were becoming, and how ready they were to fight back.

In the end there was a Carnival of sorts: Mrs Laslett organised a children's event in the adventure playground, and an ad hoc committee arranged a procession through the streets, but without any steel bands it was something of a damp squib.

The Carnival limped on over the next couple of years, lacking Mrs Laslett's particular energy, and organised instead by an unwieldy Cultural Development Committee, which in 1971 split into two rival operations – the Caribbean Carnival and the People's Free Carnival – both claiming to be organising carnivals simultaneously. However, on the day they only had five floats between them, so they bowed to the inevitable and decided to join forces. Then the lead float broke down and a police Land Rover was needed to tow it along the route. This was probably the high point in cooperation between Carnival-goers and the Met.

The next year was a little better. The Cultural Development Committee, led by the steel pan drummer Selwyn Baptiste, were still notionally in charge, while a new generation of radical young Black people were starting to play a bigger part. The key figures were the leading black radical Darcus Howe, editor of *Race Today* magazine, the voice of Black British protest, and Frank Crichlow. Crichlow's restaurant, the Mangrove, in what was known as 'the frontline' of All Saints Road, was becoming a focal point of the celebrations. Thousands of people came out, but everything ran hours late and, in the words of the police spokesman, 'it was a bit of a shambles'.

At this point it looked as if the Carnival was in danger of collapsing. No one seemed to want the hassle of being responsible for it. Selwyn Baptiste had had enough. He told the papers that everyone was convinced he was somehow making a fortune from pocketing non-existent grants. In desperation an advert was placed in *Time Out* asking for volunteers to get involved in organising the 1973 Carnival. There were barely any responses, but one of them was crucial. It came from a 30-year-old local, Leslie Palmer, as he later explained.

> I was a schoolteacher at the time and wanted to take a break from teaching. Carnival seemed to be dying. There was an advert in *Time Out* for all those interested in Carnival to attend a meeting. There were only five people. I gave my ideas. I said, 'Carnival couldn't be one band.' There were no stalls, no costumes. I thought 'This cyah [can't] work.'[34]

What Leslie Palmer was getting at was that the conception of Carnival had become outdated. It was still cast in the image of the Trinidad Carnival, of which it could only be a very pale imitation. Notting Hill had once been a Trinidadian stronghold, but now Jamaicans were taking over both in numbers and in culture. The sound of the streets of Notting Hill and its adjuncts – Ladbroke Grove, Westbourne Grove, Kensal Town – wasn't calypso any more but reggae. What Palmer realised, though he was a Trinidadian himself, was that for Carnival to continue it needed to become more Jamaican. As for the hippies and the London Irish Girl Pipers, they were long gone.

> I said, 'Let's bring in the Jamaicans' and they were very keen . . . I went to blues dances and found out about the Jamaican sound systems. The sound systems were the voice of the youth and the people, and to have a carnival and to leave that out was to ignore the demands of the people.

Bringing in the sound systems changed the nature of Carnival, not just sonically but topographically. Instead of it being a moving procession you had to keep up with, now there were any number of fixed points along the route where the sound systems would be set up. Some of these were major outfits with huge block-rocking speakers, while others were little more than hi-fis blaring out from someone's balcony. Their involvement meant that all of Notting Hill was alive to the sound of music throughout the Carnival days. And now that people weren't just following the parade, but stopping to dance at their favourite sound systems, there were more opportunities for black businesses to sell food and drink. To help with this Palmer persuaded the regular market traders to rent out their stalls to Carnival entrepreneurs.

Nor did Palmer neglect the Trinidadian side of the Carnival. He made sure the best steel bands played, and alongside them the best costume designers. In particular, he recruited an ambitious young designer called Peter Minshall, a Trinidadian who had studied in London and started out in the theatre. Minshall's wildly creative reinterpretation of Carnival costumes would remake the spectacle, both in Trinidad and London.

In just a few months Leslie Palmer had taken the failing old carnival and reimagined it completely. He printed up posters and put them around the neighbourhood – *MAS in the Streets, PAN on the road, CARNIVAL IS GONNA HAPPEN!* (For the uninitiated, Mas(querade) refers to the Carnival costumes and Pan to the steel drums.)

The result was an immediate success. The 1973 Carnival was far and away the biggest, most successful one yet, truly representing the sound and style of young black Britain. The following year it was bigger still. *The Guardian*'s Martin Walker was much impressed:

The National Front may have been marching at the weekend, and the problem of unemployed young Black kids is just about to hit this country, but it was hard not to think that there were the seeds of a very happy and rather hopeful kind of society in the carnival. We learned last year at Lord's that the exuberance of the West Indians had probably saved cricket as a spectator's sport in this country. Over the weekend it felt as if they were injecting the same zest of life into London. It was a very happy place to be.[35]

One of the people who became involved in the new look Carnival was Wilf Walker. Walker had come to Notting Hill from Trinidad when he was sixteen, in 1961. His decade or so in Britain had been a tumultuous one. He had made friends with white hippie kids, driven to North Africa in an orange painted Land Rover, then had an LSD-induced breakdown. In 1969 he was arrested for possession of cannabis, along with twelve young white people. The case took two years to come to court. He told me how this brought him to a new consciousness of what it meant to be black in the Britain of that time:

> When the case finally comes to court I become conscious of being Black, for real. I've never experienced Blackness in the way it's dealt to you here. There is racism in Trinidad, but you don't see yourself as an oppressed person. I became radicalised during the period. By the time I stood up in court I was demanding trial by my own peers. They were trying a different person to the one they'd arrested. The judge said I was intelligent but seemed to have no regard for the law. I was found not guilty of possession, but guilty of conspiracy to supply.

Of the thirteen originally arrested, Wilf Walker was the only one sent to prison, a draconian sentence of three years in Wormwood Scrubs.

When he came out, he suffered a further lapse in his mental health, but recovered and got a job working in the library at the *Guardian* newspaper. And as a sideline he started buying up large quantities of oranges, and selling fresh orange juice from a stall on the Portobello Road Saturday market.

He was happy when Leslie Palmer took over running the Carnival – 'Leslie had a vigour for it. And he was very successful because lots of people came out on the street' – and so Walker got involved, both as a trader, selling orange juice and fresh fruit, and as a steward:

> In those days when you stewarded Carnival – you would be like the Flag Man at the front. You'd be in front of the band dancing. Moving the crowd away as you went. So you put a lot of energy into it. You'd be taking kids out who'd fallen under the truck or whatever. Finding lost kids, finding the parents . . . you were like, really Action Man!

The 1975 Carnival was a huge success, with well over 100,000 people attending, and some estimates suggesting the true number could have been as high as 250,000. And it was now an overwhelmingly Black and Caribbean event. But success brought its own problems. First off, Leslie Palmer decided he'd had enough. Chris Blackwell offered him a job at Island Records, working with his expanding roster of reggae artists, and he decided to take it, weary of the backbiting in the community: 'Sometimes, people can be so critical of you. I used to go to a pub and someone said to me, "Leslie, you looking good boy, all that Carnival money," implying that I teef the money. That hurt me, that burn me. I thought, "I don't need this." I said I'm ready to move on.'[36]

The 1976 Carnival would be run by a committee again, with Selwyn Baptiste back in the forefront, in an uneasy alliance with the

community's radical element, led by Darcus Howe and Frank Crichlow, the proprietor of the Mangrove. Immediately they had to fend off protests from the local council, which suggested that the whole event should be moved to Hyde Park. This terrible idea would be recycled many times over the years to come, but there was no way the Carnival committee was going to agree.

Then the police got involved, claiming that the 1975 Carnival had been marked by a wave of criminality. They invited the press to view a mountain of empty wallets that had allegedly been found at the end of the Carnival.

Wilf Walker agrees that there had been robberies at the Carnival, but is keen to put them in context. First off, he deals with the so-called 'gangs' of youths:

> These were young men who, in isolation, were being terrorised by the police, being done for Sus. All of a sudden they were in a position where they could be in groups, big groups, strong groups. Where they could respond to the police in a way, with a level of protection. Yeah. So that feeling was a fun thing for the youth.

This sense of power would be expressed by surging through the crowds, emphasising that the streets belonged to them. And if they saw any interlopers with easily snatched possessions, they would happily snatch them:

> It was a Black event. And at that time, white people still didn't know you couldn't just come in as a tourist because you were, you were like, easy pickings. They had no idea how to conduct themselves in a large crowd of black people. Their handbags would be hanging out and their jewellery, and the kids were running in packs and they just, you know . . .

When it became clear that Carnival 76 was going to go ahead despite their objections, the Metropolitan Police started to put together a plan to control it far more firmly than in the past, with a huge increase in numbers and a control centre right in the heart of the area. This would have disastrous consequences.

Carnival was due to take place, as ever, on the last weekend of August. By the time it arrived the Black community was not in a mood to accept any heavy-handed policing.

Robert Singh, one of the Trico strikers, had a way of being at the heart of things that summer. He'd been living in Southall when Gurdip Singh Chaggar was murdered, he was part of the Trico Strike that had run all summer, and he'd recently moved to a flat on Portobello Road. He told me that he'd soon picked up on the gathering tensions:

> Leading up to Carnival there was lots of police activity, stop and searches. There was a nightclub up in Cricklewood and a few months before the police had really laid into the black kids there. The police attitude was that they were the ones who would be running Carnival. So there was this undercurrent of expectation . . .

Carnival began on Sunday 29 August. The weather, though still very pleasant and warmer than average at 22 degrees, was significantly cooler than the 30 degrees of a few days earlier. There was a definite sense that summer must finally be coming to a close.

Those months of hot, dry, almost Caribbean weather had made the streets feel more than ever like an extension of the West Indies. All summer the West Indies cricket team had been rampaging across Britain, devastating the opposition with their mix of ferocious fast bowling and enterprising batting. Just days before the Carnival, they won the final

Test match at the Oval by a huge margin, roared on by a heavily West Indian crowd. Wilf Walker remembers the impact those matches had:

> The West Indies were here playing cricket, beating England badly. We were in the Oval and Lord's and it was like it was a Carnival. The Carnival vibe was in the stadiums when the West Indies were playing England throughout that summer and that was a wonderful thing. They didn't like that.

Add in the residual resentment of the police, and the kindling was ready and primed. On the face of it, this first day was relatively quiet: there were 70,000 people and no major incidents. But Darcus Howe was immediately aware that things weren't right. As he arrived at the Mangrove, he was greeted by someone saying, 'Oh God, Darcus, it's a police Carnival.' And sure enough there were police everywhere. They weren't patrolling the streets in ones or twos, looking out for these supposed pickpockets, but formed into battalions of forty men. There were coachloads of them, on Acklam Road and near the Mangrove, just sitting and waiting. As Howe observed: 'If they are on hand to search for pickpockets, then Robert Mark [Metropolitan Police Commissioner] has to explain how a police officer does that sitting all day in a bus. No. It is a reserve force ready for the confrontation Scotland Yard has predicted.'

Not only had Scotland Yard predicted trouble, but the police also seemed to be going out of their way to provoke it, by cracking down on anyone selling alcohol on the streets without a licence, something that had gone on routinely in previous years. And there was a clear plan behind the police presence – one wholly inappropriate to what should have been a simply joyful celebration of Caribbean culture. Howe again: 'At the first sign of trouble, the forty officers form a cordon, a long line across the street. At the other end reinforcements are called in

and the crowd is sandwiched between two lines of police officers. It is a military strategy to defeat a hostile rebellion.'

Already the resentment was building against this police invasion. And if Sunday passed without major incident, everyone could see that on Monday, the busier of the two days, there was surely going to be an explosion.

That Monday was cooler again and overcast. It felt like thunderstorms were on their way. There were over 150,000 people present and the vibe was edgy from the start. Robert Elms was paying his first visit, inspired to go along by the newfound popularity of reggae among the hip white youths like those who frequented Don Letts's Acme Attractions:

I remember I was with three friends. Nice middle-class boys from school. We had decided we wanted to go to the Carnival because of the reggae thing, reggae tunes were starting to cross over. 'Police and Thieves' was one of the big records of that summer. I'd heard about it [Carnival] before, but up until '76 it was still a very West Indian Caribbean affair. We were walking into the sort of defined Carnival area, and there was what I think was the Special Patrol Group. Really heavy looking police in this sort of black uniform. No identification, all of that.

They stopped us and they said, and I can remember the exact words the copper said to me, 'Why do you want to go in there with all the fucking n-words?' And he said, 'We're not letting anybody in.' And I said, 'I'm not going to the Carnival, I'm going to my nan's house,' and he sort of begrudgingly had to let us in.

There were lots of sort of proto-punks there that day at the sound systems. But you could also feel the tension rising. And [then] it all kicked off. I wasn't involved. I was terrified. I literally went to my nan's. But I think by the end of the summer, there was a sort of tension rising in the air like a storm coming.

The trouble kicked off in the afternoon, around 4.30. Wilf Walker was right at the heart of it. After his success with his stall in previous years, he had expanded his operation and had three stalls on the go – all of them in the very heart of the black community. One was in All Saints Road, by the Mangrove; one was on the market street, Portobello Road; and the third was on Acklam Road, right next to the big motorway flyover, the Westway, that had divided the area in two since its construction in the late sixties. As Walker remembers, it was on Acklam Road that the flashpoint came:

> Police went into the crowd to take out two youths. And they weren't allowed to take them out. And that's when it just erupted. That was the spark . . . I was on my stall on Acklam Road which is opposite the Carnival office and I saw it happening. And I went off into the Carnival and I found Selwyn Baptiste, who was meant to be our leader. And I said to him, 'It's about to fall apart.' I brought him back to the office, and I said, 'You need to speak to the [police] commander, he's just around the corner.' Selwyn says, 'I can't be seen to be talking to him!' He's trying to phone him. But then it literally fell apart.

The youths, emboldened by their numbers and fuelled by righteous anger, turned on the police and started hurling whatever they could. Joe Strummer and Paul Simonon, from new band the Clash, were some of the proto-punks who were right there in the thick of things. Strummer's account gives a sense of the sudden outbreak of anarchy:

> We got in a crowded bit under the Westway, a line of bobbies came pushing through the crowd their blue helmets sticking up like in a conga line, I saw one lonely Coca-Cola can come floating over and hit one of the helmets, in half a second there were twenty more cans and

340

the crowd drew back suddenly and the Notting Hill riots of 1976 was sparked, we were thrown back, women and children too, against a fence which sagged back dangerously over a drop . . . 200 screaming people moving in every direction . . . soon there was fighting ten blocks in every direction.[37]

Darcus Howe was at the Mangrove, already sure that there was going to be trouble, just waiting for the eruption, as he wrote in *Race Today*:

The news arrives. The confrontation has begun. The black youth have issued the counter challenge, 'under de bridge' [the Westway flyover]. Bottle and stone and no place to shelter. Within minutes the battle reaches All Saints Road, in front of the Mangrove. Scores of young blacks are on the move. Hit and run are their tactics . . . They stone the police, run away, regroup, stone again. I am told that a stand-up fight is out. The youth have been using the entire area as their terrain. Hit, run. Hit, run. I witness scores of policemen on the run, pursued by young blacks. As the police are chased by one group, another group would break into shops and take that wealth which in peace time is not available.[38]

One of the people in the Mangrove that afternoon was a boy called Piers Allardyce, whose mum knew Frank Crichlow. Piers had been brought along to help with the day's festivities:

The Mangrove was a hub, served up great Caribbean food and they wanted to make some money that day, so I was there selling ice cream from a serving hatch. It was hot and humid. I was only thirteen. As the violence erupted there was lots of shouting, lots of screaming, lots of things flying through the air. The police were using dustbin lids to

protect themselves. They were being absolutely battered. People weren't just fighting them on the streets, they were throwing things out of windows. So there was an avalanche of obstacles for them to deal with.

The riot wasn't all one-way traffic though, as Piers remembers: 'People started running into the Mangrove seeking sanctuary. I was told to get down. There were lots of people cowering on the ground under the counters. People were very, very frightened.'

A black youth who wished to remain anonymous gave *Race Today* a vivid account of what went down on the wider thoroughfare of Ladbroke Grove:

> Yards away from where 300 police are forming up behind dustbin lids, a Rastaman is haranguing the crowd. He stands in front of about 500 youths and he waves his red, green and gold stick at the police lines. 'Burn the wicked,' he shouts and the crowd watches, fascinated.
>
> 'Walk through fire,' he screams and begins walking towards the police ranks, waving his stick. The crowd behind him, more cautious than this valiant, are hurling bottles and cans at the police ranks from the safety of distance.
>
> 'Get them' is the cry from the police ranks as hundreds of mahogany sticks are raised in the air and a stampede of blue moves towards the crowd. The dustbin lids push towards us and the batons come down with skull-cracking determination. The Rastaman is overrun by what seems like a hundred policemen who seem to be making straight for his solitary figure.[39]

Another of the young people caught up in it all was Paul Gilroy, now one of Britain's leading cultural theorists. He told me that the Test

matches weren't the only recent events that inspired the youth to fight back against the police: 'I heard the Carnival crowd chanting, "Soweto Soweto" as the half bricks and bottles arced above my head.' *Race Today* quotes one of the rioters to the same effect: 'Last week it was Soweto, this week it's Notting Hill.'

Junior Murvin's big reggae hit of the Carnival, 'Police and Thieves', was written about the daily struggle in Jamaica, but it had obvious resonance in Notting Hill, and is the tune generally used to soundtrack documentaries about the Carnival riot. However, the musician Steve Jameson, who was there at the time, remembered that at the actual moment it all kicked off, the tune playing on the nearest sound system was the Bee Gees' cheerfully upbeat 'You Should Be Dancing'.

Wilf Walker remembers the moment that the police turned tail and fled under the hail of missiles, not as one of angry vengeance but of joyous liberation:

> And the youths, when they realised that they had the police on the run, it was like they started having fun, right? They had the police on the run and they were enjoying it. They weren't thinking 'let's chop their heads off', but let's just have them on the run. Just take the piss out of them. That's not the mentality of black people in general, you know, to be wanting revenge. If people were really vengeful, they could've burned down Ladbroke Grove. There was more violence on the part of the police than the youths.

Robert Singh's flat on Portobello Road was just yards from the Acklam Road flashpoint. He arrived back from a trip to Southall in the immediate aftermath of the riot:

I could see everything had kicked off. There were a lot of police around, all looking down and out and beaten. They were just waiting by street corners sitting down, and it was obvious that the fight had been taken out of them.

They weren't expecting that level of rebellion by the young Black kids – the level of anger and antagonism towards them. They'd got away with everything for a few years, stopping and searching kids and basically doing what they wanted.

Darcus Howe overheard a police officer returning from a battle charge, talking to his colleagues.

> 'Why the fuck did they bring us here?' he asks. None of his fellow coppers have an answer . . . Bewildered and frightened, the guts had left the boys in blue. Never in my 16 years in Britain have I seen police officers reluctant to exercise authority[40].

The victory was short-lived, of course. Later on the police came back en masse and took charge of the area, while traders like Wilf Walker were trying to secure their stalls and bemoaning their vanished profits. And there were plenty who had been arrested earlier in the day. *Race Today*'s anonymous contributor was one of them. He describes how he was taken by the cops:

> I am grabbed from behind as I run and a baton, or a thousand batons, batter my skull, and regulation boots and random kicks as I fall to the ground. I am dragged to the police van and thrown into it. In the van there are four others. The windows are covered by police coats. We are grabbed by the coppers inside who look threatened and frightened.

'Take down the coats,' says the Inspector, 'they mightn't stone us if they see n-----s inside.'[41]

Next morning, by Wilf Walker's account, the mood was mostly sombre. He toured the local hospitals looking to help any Carnival-goers now nursing injuries. It soon became clear, however, that the wounded had simply been thrown in police cells. Some Black people bemoaned the fact that the rioters had 'mash up the Carnival'. Others were just a bit dazed. 'No one could believe what had happened,' says Walker – 'but there was a sense of pride that the police were on the run.'

Robert Singh agrees, but suggests it took a little while for people to make sense of the chaos of that Monday afternoon:

> There was a meeting at the Metro Youth Club the day after. Cecil Gutzmore [a key community activist] spoke and there was a very high level of tension – people were talking about demonstrating. There was still a lot of anger about what had happened. I wouldn't talk about pride, I think that developed a bit later, when people were able to contemplate what had actually been achieved, that there had been a major confrontation with the police and people were able to humiliate them.

The newspapers and TV were full of coverage of the rioting. According to the figures put out by the Metropolitan Police, there had been 150,000 people present, with 1,500 police on duty. Following the riots, 325 police and 131 members of the public had been injured. Twenty-six police officers were detained in hospital, three of them seriously hurt. Figures for the numbers of civilians injured were not released. Fifty-two police vehicles and eight private cars were damaged. Significantly only three shops were reported to have been

looted. Of the 101 people who were arrested on charges including robbery, theft, threatening behaviour and possession of offensive weapons, 85 of them were Black.

As for the supposed plague of pickpockets that provided the ostensible reason for the huge police numbers, Darcus Howe was scornful: '[Met Police Commissioner] Mark propagandised that the police were out in force to protect the law-abiding blacks from 800 pickpockets. He registered 16 arrests for theft over two days. That says it all.'

After the facts and figures came the inevitable arguments as to who was to blame and what to make of it all. Sir Robert Mark said crime was crime and the police had to deal with it. Selwyn Baptiste pointed out that the number of police at the Carnival was way larger than had been agreed. The Southall MP, Sydney Barwell, who had had previous experience of rioting that summer, demanded an inquiry into the deterioration of relations between the police and young Black people.

Robert Mark did try to address this. He said that better community relations were 'the most important problem of the next few years [and] the prime responsibility of this force. It is more important than any other police function you can name.'

Fine words, but sadly at odds with what was happening on the ground. Asked why the rioters had been focused on fighting the police rather than, say, looting shops, he answered that it was simply 'because the police are the physical manifestation of authority. And because we are the manifestation of all the repressions from which they believe they suffer.'

The problem of course was that these 'repressions from which they believe they suffer' were all too real. As the Black People's Information Centre commented: 'The police pick you up for nothing, take you to court and it sticks. If the police keep doing this the Blacks are not going to stand for it.'

This was unarguable truth. But how to go forward? Selwyn Baptiste attempted to see the bigger picture: 'I think the Carnival is a sort of learning process for lots of us and the police are not exempt from that. I think all of us should get together and protect it [the Carnival] and make it something which would create a platform for us to live as civilised people.'[42]

Darcus Howe of *Race Today*, however, took a more militant line. In an open letter, he criticised the Carnival Development Committee for not having been alert to the police plans in advance. As far as Howe was concerned, the real aim of the police was to put an end to Carnival: 'One quarter of a million black people on the streets of Britain in 1976 is a political event. That is how the state sees it. It is not simply an artistic festival of fun-loving West Indians.'

Howe is clear that in his view the Carnival riots were in fact a straightforward battle for the right of the community to hold a Carnival free from an oppressive police presence. And he had no doubt as to who the real heroes of that struggle were: 'Young blacks took up the gauntlet as a result of your ineptitude, and rescued our community for what would otherwise have been a complete and utter humiliation.'

Finally, Howe made the point that they would have to fight to be allowed to stage the Carnival again the following year. That fight would be won, as the Carnival was allowed to continue, but lost, as it would continue to be bedevilled by heavy-handed policing. And, of course, heavy-handed policing of Black British people would continue to be a problem in the years to come, way beyond the confines of Carnival.

To use the words of a popular slogan of the time, that Monday afternoon in Notting Hill had proved beyond doubt that Black Britons were 'Here to stay, here to fight!' And in the extraordinary summer of 1976, they were not alone in their rebellion.

AFTERWORD

The rains spread across the country over the August bank holiday and then they kept on coming. The government said the drought wasn't finished – that it would take months of rain to replenish the reservoirs. Well, the wettest September and October since records began in 1727 did that job all right! By the beginning of November the reservoirs were overflowing. The nation's outdoor spaces turned back from brown to green, the tarmac stopped melting, the mounds of dead ladybirds were swept away and the standpipes were stood down. The menace of drought was almost immediately replaced by the threat of flooding. In Scotland, which had had rather less of a heatwave in the first place, there was even heavy snowfall in early September.

The autumn deluge was soundtracked by Pussycat's 'Mississippi', which was at the top of the charts right the way through October, sounding like Abba with a hangover. The dreamtime of the long hot summer was over, but even the remorseless British rain couldn't turn the clock back to how things were before.

It was in the autumn rain that many of the summer's changes came to fruition. The Trico women won their strike and went back to work. The Sex Pistols signed to EMI and recorded 'Anarchy In The UK'. Prime Minister Jim Callaghan made a speech decrying the supposed excesses of progressive teaching. The Chancellor, Denis Healey, was forced to go cap in hand to the IMF asking for a bailout. Rock Against Racism put on their first show. I went back to school and made new friends, banding together over our enthusiasm for this new thing called punk rock which had pulled in a cadre of kids like me who felt like outsiders, who may not yet have known what they wanted from life, but

definitely knew what they didn't want – the same old status quo taking us down, down, deeper and down.

For all the extent to which it has been fetishised since, I think punk was really important. Not in terms of its musical legacy, which is limited, but in the way that it opened things up. Its message was 'you can do it yourself'. Before that summer it seemed as if everyone was always asking for permission – for equal rights, for justice, to walk down the streets unmolested, to play in a band without being a 'classically trained' keyboard whiz – and continually being slapped down. After that summer we knew we would have to take these freedoms for ourselves.

Look back over the four months of that summer and it's easy to point at a string of key events that were both significant in themselves and, more importantly, catalysts for change. The Southall Youth Movement would inspire a host of similar initiatives. The Trico Strike helped encourage the Grunwick factory's mostly Asian workforce into similar strike action, which would become one of the great labour struggles of the decade. The Notting Hill Carnival would hold its ground in the face of police and political pressure and build into Europe's biggest annual celebration of Afro-Caribbean culture. Tom Robinson's 'Glad To Be Gay' would move from the Soho cabarets to the pop charts. The soul boys and girls would have in their ranks the architects of Britain's New Romantic street fashion revolution. The big events of this summer were not one-offs – they were the start of something new: the building blocks for a refreshed and better Britain.

Other changes had been set in motion too, of course. There were the seeds of what we would come to call Thatcherism, starting with the rise of the woman herself, who now looked like a viable candidate

for prime minister. A good example of this was the backlash against progressive schools that began with the William Tyndale affair. This protest against the supposed excesses of progressive education signalled the emergence of a new populist right, able to appeal to working-class voters as it pitted 'common sense' and 'traditional values' against the idealism of the left.

Punks too would become strange bedfellows with the Thatcherites. It was, after all, a movement led by entrepreneurial shopkeepers like Malcolm McLaren, and one that would encourage its adherents to set up their own record labels and fanzines, miniature businesses with little concern for 'red tape'.

Fifty years on, we live with all these changes. More diverse, more tolerant – despite what social media might suggest – but also more atomised and disconnected from each other.

Finally, though, when I look over the stories I've put together here, the one that really sticks with me is not obviously glamorous, featuring rioters or punk rockers. It's the saga of the Trico Strike, when a bunch of ordinary working-class women came to realise they'd had enough of being treated as second-class citizens, and simply sat out in the sun and waited for the world to change. And change it did.

During the student uprising of May '68 in Paris, the Situationists came up with a simple slogan, a compact manifesto for a better way of looking at the world: *Sous Les Paves, La Plage* (Beneath the Paving Stones, the Beach). The Costa del Trico brought that to life.

For Britain as a whole, the stormy end of the long, sweltering, exhilarating and finally exhausting summer ushered in a new era, an uncertain volatile time, but one full of the promise of unstoppable change.

NOTES

MAY

1. The Norman Scott affair is detailed in *Rinkagate: The Rise and Fall of Jeremy Thorpe*, Simon Freeman and Barrie Penrose, London: Bloomsbury, 1997. Andrew Newton was jailed for two years for firearms offences.
2. Sally Groves and Vernon Merritt, *Trico: A Victory to Remember*, London: Lawrence & Wishart, 2018.
3. Ibid.
4. *Women's Voice*, June 1976.
5. *Spare Rib* magazine, Issue 50, September 1976
6. Detailed in the 'Strike Breakers Incorporated' chapter of Groves and Merritt, *Trico: A Victory To Remember*.
7. Groves and Merritt, *Trico: A Victory to Remember*.
8. Ibid.
9. Ibid.
10. *Spare Rib* magazine, Issue 51, October 1976
11. https://boxingnewsonline.net/the-humble-scaffolder-who-fought-muhammad-ali/
12. Michael O'Connell, *Delusions of Innocence: The Tragic Case of Stefan Kiszko*, Hook: Waterside Press, 2017.
13. *Spare Rib* magazine, Issue 60, July 1977
14. Erica Jong, *Fear of Flying*, New York: Holt, Rinehart and Winston, 1973
15. *Spare Rib* magazine, Issue 45, April 1976
16. *Spare Rib* magazine, Issue 60, July 1977

JUNE

1. *Sunday Mirror*, 23 May 1976.
2. Quotes from *Young Rebels: The Story of the Southall Youth Movement* documentary, DigitalWorks, 2014: https://digital-works.co.uk/southall.html
3. *Greenford and Northolt Gazette*, Friday 6 May 1977.
4. As reported in the *Southall Gazette*, Friday 6 May 1977
5. Quotes from *Young Rebels* documentary, 2014.
6. Quote from *Young Rebels* documentary, 2014.
7. *Evening Standard*, 7 June 7 1976

8. *Southall Gazette*, 6 May 1977
9. Ibid.
10. As for their co-accused: Pat and Julian were acquitted of the charges against them, while Darren was found guilty on the minor charge of 'affray'. Their names have been changed.
11. *The Observer*, 13 June 1976.
12. Quote from *Young Rebels* documentary, 2014.
13. Dave Tomlin and Chris Dempsey admit to the crimes described here – and much, much more – in the extraordinary book they co-authored, *Fire Power* (Corgi, 1978).
14. *Remembering The Coleherne and the Earl's Court Gay Scene*, film by William Brougham, 2014: https://www.youtube.com/watch?v=S8SX-L9U1fY
15. *Gay News*, Number 96, 3–16 June 1976
16. *Gay Week*, 19 August 1976
17. NCCL press release, 9 March 1976 (National Archives)
18. *Gay Week*, 12 August 1976
19. Lenny Henry, *Who Am I, Again?* London: Faber, 2019.
20. *Melody Maker*, 26 June 1976.
21. *NME*, 19 June 1976.
22. Melody Maker, June 12, 1976
23. Martina Navratilova, *Being Myself*, New York: HarperCollins, 1985.
24. *Soul Survivors* magazine, June 2017.
25. *Guardian*, 2 July 2011.
26. *Sounds*, 19 June 1976.
27. *Guardian*, 2 July 2011.
28. Biddu, *Made in India: Adventures of a Lifetime*, Gurugram: HarperCollins India, 2011.
29. Ibid.
30. https://shows.acast.com/pjrchive/episodes/tina-charles-interview
31. Biddu, *Made in India: Adventures of a Lifetime*
32. Trevor Horn interview, Red Bull Music Academy: https://www.redbullmusicacademy.com/lectures/trevor-horn-buggles-in-the-bassbin
33. Tina Charles interview, *The PJRchive Podcast*, Episode 103: https://shows.acast.com/pjrchive/episodes/tina-charles-interview
34. Tina Charles interview, *Colly D Radio Show*: https://soundcloud.com/user-647876368/tina-charles-interview-on-colly-d-radio-show
35. *Colly D Radio Show*: https://soundcloud.com/user-647876368/tina-charles-interview-on-colly-d-radio-show
36. Trevor Horn interview, Red Bull Music Academy.

JULY

1. M. Barson, M. Bedford, C. Foreman et al., *Before We Was We: Madness by Madness*, London: Virgin Books, 2019.
2. https://sevenraggedmen.com/1977-2/
3. Ibid.
4. *The Observer*, 27 August 1995
5. *Daily Telegraph*, 20 July 1976
6. *The Observer*, 27 August 1995
7. *Evening Standard*, Friday 9 July 1976
8. *Evening Standard*, Tuesday 20 July 1976.
9. TV documentary: *The Radio One Story*, BBC 1997
10. *Sunday Mirror*, Sunday 29 August 1976.
11. *Sunday Mirror*, 29 August 1976
12. *Sunday Mirror*, 25 August 1974
13. *Cambridge Evening News*, 15 March 1976
14. *The Guardian*, 24 July 1976
15. Geoffrey Boycott, *Boycott: The Autobiography*, London: Macmillan, 1987. For more on Boycott's relationship with the England team, see, for example, https://www.cricketcountry.com/articles/ cricketing-rifts-11-multiple-issues-around-boycott-and-botham-12653/
16. Quoted in Abhishek Mukherjee, 'Roy Gilchrist: a fast-bowling terror whose career was cut short by his mercurial nature', *Cricket Country*, 28 June 2016: https:// www.cricketcountry.com/articles/roy-gilchrist-a-fast-bowling-terror-whose- career-was-cut-short-by-his-mercurial-nature-28399/
17. Pat Pocock, *Percy: The Perspicacious Memoirs of a Cricketing Man*, London: Frost, 1987.
18. Brian Close, *I Don't Bruise Easily*, London: Macdonald, 1978.
19. Pocock, *Percy: Perspicacious Memoirs*.
20. Ibid.
21. ibid
22. David Tossell, *Grovel!: The Story and Legacy of the Summer of 1976*, Chichester: Know the Score Books, 2007.
23. Ibid.
24. Quoted in Darren Walton, 'Goolagong Cawley's stunning confession', *The Senior*, 10 June 2021, https://www.thesenior.com.au/story/7291698/ goolagong-cawleys-stunning-confession/
25. Joan Armatrading, *Track Record*, A&M VHS video, 1986.
26. *Melody Maker*, 14 August 1976.

27. Floella Benjamin, *What Are You Doing Here?* London: Pan Macmillan, 2022.
28. *The Guardian*, 21 March 1973
29. *Spare Rib* magazine, Issue 23, May 1974.
30. Val Wilmer, *Mama Said There's Be Days Like This*, London: The Women's Press, 1989
31. Glyn Johns, *Sound Man*, London: Penguin, 2014.
32. Ibid.
32. *Melody Maker*, 14 August 1976
34. Johns, Glyn: *Sound Man.*
35. *Spare Rib* magazine, Issue 53, Dec 1976

AUGUST

1. *Daily Telegraph*, 2 August 1976
2. Phil Andrews, *1000 Memories of 1976*, Privately published, 2021.
3. https://www.bbc.co.uk/news/uk-northern-ireland-37026119
4. Weizmann Hamilton, 'South Africa: The Soweto uprising 1976', *Socialistworld.net*, 19 June 2006: https://www.socialistworld.net/2006/06/19/south-africa-the-soweto-uprising-1976/
5. The William Tyndale Junior and Infants Schools: Report of the public inquiry, ILEA 1976
6. John Gretton and Mark Jackson, *William Tyndale: Collapse of a School – or a System?*, London: Allen & Unwin, 1976.
7. *The Guardian*, 27 October 1975
8. Robert Elms, *The Way We Wore*, London: Picador, 2005.
9. Farley and Galloway, *The Dancers.*
10. https://crackersradio.com/2024/04/04/the-dancers-in-their-own-words/
11. Terry Farley and Roual Galloway, 'The Dancers: In Their Own Words', Red Bull Music Academy
12. Jeannette Lee and Don Letts, *Acme Attractions*, London: Rough Trade Books, 2020.
13. Farley and Galloway, 'The Dancers'.
14. https://www.museumofyouthculture.com/johnny-woollard/
15. Ibid.
16. Bill Brewster, 'Norman Jay has his groove rare', DJhistory: https://djhistory.com/read/norman-jay-has-his-groove-rare/
17. Ibid.
18. Neil Tennant, *NME*, 8 May 1976.

19. Defying Gravity – Jordan Mooney with Cathi Unsworth, Omnibus, London 2019
20. Brewster, 'Norman Jay'.
21. Dorothy Max Prior, *69 Exhibition Road*, London: Strange Attractor Press, 2023.
22. Steve Jones with Ben Thompson, *Lonely Boy*, London: Heinemann, 2016
23. *New Musical Express*, 15 May 1976
24. David Nolan, *I Swear I Was There*, London: John Blake, 2016.
25. The Clash: Strummer, Jones, Simonon, Headon, Atlantic, 2008
26. *New Musical Express*, 17 December 1977
27. Charles Shaar Murray, *NME*, 11 September 1976.
28. Niall Cluley, *Sounds*, 14 August 1976.
29. *Who Shot the Sheriff?* documentary film directed by Alan Miles, 2005.
30. *Melody Maker*, 28 August 1976
31. *Sounds*, September 11, 1976
32. Michael Abdul Malik, *From Michael de Freitas to Michael X*, London: André Deutsch, 1968.
33. John L. Williams, *Michael X: A Life in Black and White*, London: Century, 2008.
34. https://ilovecarnivall.co.uk/pioneers-of-notting-hill-carnival-leslie-palmer/
35. *The Guardian*, 27 August 1974
36. Leslie Palmer quotes: https://ilovecarnivall.co.uk/pioneers-of-notting-hill-carnival-leslie-palmer/
37. Sleeve notes, *The Story of the Clash* CD.
38. Anon., *Race Today*, September 1976.
39. Ibid.
40. Ibid.
41. Ibid.
42. *The Guardian*, 1 September 1976

AUTHOR'S ACKNOWLEDGEMENTS

Thanks to everyone who gave me an interview for inclusion in the book, but particularly Sally Groves, Robert Singh, Phyllis Green, Campbell Malone, Howard Schuman, Debsey Wykes, Tom Robinson, Andrew Anthony, John Lockwood, Robin Askwith, Jill Nicholls, Pam Isherwood, Marion Gilbert, Derek Green, Stephen Spooner, Robert Elms, Jah Wobble, Piers Allardyce and Wilf Walker.

Thanks to my agent Antony Topping, my editor Jake Lingwood along with Alex Stetter, Emily Campbell and the whole team at Monoray.

Thanks to any number of people who I've discussed this book with, including Travis Elborough, Richard Thomas, Garth Cartwright, Erin Cotter, Neil Thompson, Farrukh Dhondy, Val Wilmer and especially David Kynaston for his very helpful feedback on a draft version.

Thanks to my compadres in Cardiff's finest pub quiz team – Andrew, Gruff, Euros, Julie, Katell, Patrick and the exiled Paul.

Final thanks to Anna Davis for her editorial advice, forbearance and so much more. God knows what state this book – and my life – would be in without her.

PICTURE ACKNOWLEDGEMENTS

Opposite page 1 Rolls Press/Popperfoto via Getty Images; 16 © Angela Phillips/Report IFL Archive/reportdigital.co.uk; 48 Staff/ Mirrorpix via Getty Images; 74 Gems/Redferns/Getty Images; 96 © Chris Davies/reportdigital.co.uk; 122 PA Photos/TopFoto; 150 Chris Capstick/Shutterstock; 172 Metropolitan Police; 192 Ronald Grant Archive/Mary Evans Picture Library © Columbia; 210 Patrick Eagar/ Popperfoto via Getty Images; 232 Michael Putland/Getty Images; 258 © NLA/reportdigital.co.uk; 280 Ann Matsunaga; 298 Paul Welsh/ Redferns/Getty Images; 324 Kypros/Getty Images.

INDEX

documentaries 208–9
drama 208
ITV 75, 77–87, 191, 208
light entertainment 207, 208
LWT (London Weekend Television) 138
panel shows 208
sport 207, 213
see also named shows
Television (band) 303
The Tenderness of the Wolves (film) 63
Tennant, Neil 300
Terry, George 317
Tharp, Twyla 208
Thatcher, Margaret 9, 10, 165, 267–8, 323
Thin Lizzy 67
Thorpe, Jeremy 12–13
Three Degress 207
Time Out 87, 305, 332
The Times 9, 10
Tito, Marshal 14
Tomanová, Renáta 146
Tomkins, Dave 118, 120
Top of the Pops (TV show) 75, 157, 159, 187, 297
Toynbee, Polly 132
trade unions 11, 33
see also named unions and strikes
Trades Union Congress (TUC) 35–6
Trees 330
Trial By Combat (film) 64
Trico Factory strike 17–18, 19–38, 337, 350, 351
Tweedie, Jill 272
Twiggy 208

U-Roy 186
Ugandan Asians 168
Ulster Defence Association (UDA) 13, 94
Ulster Volunteer Force (UVF) 94

Ultravox 145
Underwood, Derek 220
Ure, Jim 'Midge' 143, 144–5

Van Morrison 317
Vanderbilt, Lee 157
Victory In Entebbe (film) 170
Vine, Barbara, *Fatal Inversion* 3
Virén, Finn Lasse 231
Visconti, Tony 156

Wade, Virginia 146, 147
Waits, Tom 142
Walker, Mrs Dolly 263, 266–7, 268, 271, 274
Walker, Johnnie 149, 187, 188
Walker, Martin 333–4
Walker, Rudolph 138
Walker, Wilf 334–5, 336, 338, 340, 343, 345
The War of the Worlds (TV show) 207
Ward, Eileen 24, 27, 31, 36
Wardle, John 'Jah Wobble' 310, 311–12
Waring, Eddie 203
Watkins, Jon 138
Watts, Ron 303
Wayne, John 208
Welsh, Paul 307
The West Coast Rock Show 142
West, Keefe 330
Westbrook, Mike 68
Western Mail 9
Westwood, Vivienne 105, 206, 277, 289, 300–301
Whitren, Jaki 140–41
Whittle, Lesley 115
Wilkinson, Trevor 59–60
William Tyndale school, Islington 259–74, 351

ABOUT THE AUTHOR

John L. Williams is a biographer, novelist and crime writer from Cardiff. His non-fiction includes his acclaimed biography of the Trinidadian polymath CLR James, and his account of the Cardiff Three miscarriage of justice case, *Bloody Valentine* ('A bloody good book' – Benjamin Zephaniah), as well as his portrait of urban America as seen through the prism of crime fiction, *Into The Badlands*. His biography of his fellow Cardiffian Shirley Bassey was proclaimed the music book of the year by *The Times*. He is the crime fiction reviewer for *The Mail on Sunday*. He is the co-founder and literary director of the Laugharne Weekend Festival in west Wales. The one single recorded by his punk band, The Puritan Guitars, is surprisingly collectible.